VOGUE
THE COVERS

BY DODIE KAZANJIAN

FOREWORD BY HAMISH BOWLES

Abrams, New York

Editor: Rebecca Kaplan
Production Manager: Anet Sirna-Bruder

Cataloging-in-Publication Data has been applied for and may
be obtained from the Library of Congress.

ISBN: 978-0-8109-9768-4

Printed and bound in China
10 9 8 7 6 5 4 3 2 1

Abrams books are available at special discounts when purchased
in quantity for premiums and promotions as well as fundraising
or educational use. Special editions can also be created to
specification. For details, contact specialsales@abramsbooks.com
or the address below.

THE ART OF BOOKS SINCE 1949

115 West 18th Street
New York, NY 10011
www.abramsbooks.com

CONTENTS

FOREWORD BY HAMISH BOWLES

I was a little boy, living on a little farm in the English countryside, when I first heard the siren call of the *Vogue* cover, luring me irresistibly toward the treacherous rocks of fashion obsession. While my school friends spent hours mastering the intricacies of Airfix kits—re-creating the *Cutty Sark* and the *Golden Hind* from irritating little bits of plastic and noxious glue—I was accumulating old 78s and listening to Jazz Age crooners warble Noël Coward and Ivor Novello on a wind-up gramophone. While they collected tropical fish, I spent hours laboriously cataloging my burgeoning collection of Edwardian button boots and Victorian guinea purses. And when my friends were old enough to be engaged by such things, they took down their Bay City Rollers and Slade posters and plastered their bedroom walls with pinups of Farrah Fawcett-Majors. Although I rather admired Debbie Harry's Stephen Sprouse wardrobe, I didn't feel the urge to add her to my walls, for these had long been garlanded with Athena reproductions of *Vogue*-cover posters.

So watching over me like prophetic angels—dressed by the flamboyant couturiere Lucile and choreographed by the impresario Ziegfeld—were those "visions of loveliness" that, little did I know (but as Dodie Kazanjian reveals in her sparkling introduction to this book), Alexander Liberman, in an art department across the Atlantic, was spending his career trying to erase.

Dating from the First World War period, which fascinated me then as now, these fancifully dressed elegantes reflected Condé Nast's desire to bring the sophistication of the *Gazette du Bon Ton* to American socialites and aspiring fashionistas. Bracketed by the voluptuous curves of Art Nouveau (represented on my walls by Alphonse Mucha's *Four Seasons*) and the jagged chic of Art Deco (Erté's improbably attenuated showgirls), these coy *Vogue* beauties, imagined by the artists George Wolfe Plank and Helen Dryden, were dressed in Ballets Russes extravaganzas or in romantic crinolines fondly evoking the costumes of dimpled early-Victorian heroines. These visions of alluring femininity may have been designed to warm the hearts of the soldiers lucky enough to return home from the carnage of the trenches, but they coddled me with the promise of a carefree, glamorous world as I returned to the sanctuary of my room after gathering the warm eggs from frantically clucking hens or mucking out the stables.

They also held a mirror up to their times, as *Vogue*'s covers have continued to do through the decades. As this book so delectably illustrates, those melting Dryden and Plank lovelies hardened into the brittle Jazz Age garçonnes of Lepape and Benito. These in turn developed gentle curves and a more three-dimensional aspect in the suave hands of Carl Erickson—then bloomed in full-color photography as Surrealist mavens or sportif sirens thanks to Horst P. Horst et al. They transmogrified into Crawford-lipped patriots during the Second World War and then disappeared into their hothouses to emerge as absurdly lacquered, wasp-waisted mid-century sophisticates. Diana Vreeland sent them into orbit, gave them individuality and kooky "pizzazz" with an exclamation point. Grace Mirabella gave them toothsome all-American good looks, lip gloss, and a statement earring. Anna Wintour turned stars into models,

models into stars, and continues to show us that it is all in the mix as she dresses them in T-shirts and ball gowns.

It was those quaintly period American *Vogue* covers that first beckoned me, but it was a British *Vogue* cover that brought my fashion obsession hurtling into the present day and set me on my primrose path in publishing. It was 1974, and my ten-year-old body might have been in a little corner shop in our local village in Kent, Garden of England, dithering between the pear drops and the Sherbet Fountains, but my soul was suddenly transported to the South of France, to a giddy world of cocktails and laughter, of Scott and Zelda, Gerald and Sara, Elsie and Elsa.

That 1974 British *Vogue* cover showed a couple who embodied an unimaginably scintillant glamour. Captured in languid embrace on a twilit beach, He, dressed in an ivory Gatsby suit with an ascot insouciantly tied at his neck, was turned from the viewer to focus on Her. And who could not? Wearing a plunging gown of eau de nil jersey and an ivory beret that suggested their style complicity, she had thrown her head back and draped her arm across his shoulder as the ocean roiled behind them. The art director had picked out each of the letters that spelled VOGUE against the dusk sky (or was the day breaking after a night to remember?) in a symphony of different and unusual colors—ultramarine, azure, Schiaparelli pink, scarlet, tango orange. HAPPY NEW YEAR, bade the cover line, and who indeed could be happier than this deliriously charmed duo?

I later discovered that the putative lovers were Manolo Blahnik and Anjelica Huston, that they had been photographed on a beach on the Côte d'Azur by David Bailey, and that the narrative and the clothes (her dress by Bruce Oldfield, recent graduate of the storied fashion department of St. Martin's School of Art, where I would follow less than a decade later) and the grand nostalgic spirit that the cover image and the fashion sitting inside evoked were the work of Grace Coddington, then a visionary fashion editor for British *Vogue* (as well as the flame-haired beauty who also appeared inside the magazine in that same Bailey story). I have been a slave to her alchemical fashion fantasies ever since, and my admiration has only grown deeper as I experience at first hand her passionate, obsessional working process at American *Vogue*.

Inspired by the lingering potency of that one arresting image, an image that seemed to unite the past and the present and to send off myriad sparks in the collision, at fourteen I entered British *Vogue*'s annual talent contest, writing, as I recall, an essay on Cecil Beaton as the Person Who Has Influenced Me Most and duly garnering a Special Mention (presumably for precocity) and a lunch at Vogue House. The rest, as they say, is history, and, following the irresistible invitation of Anna Wintour, I have spent the better part of two decades at American *Vogue* realizing the dream that all of those *Vogue* covers promised— and celebrating that dream for new generations of readers. The transformative power of a *Vogue* cover should never be underestimated. ∎

INTRODUCTION
BY DODIE KAZANJIAN

Vogue covers have been talking to us for 120 years, and the conversation has seldom failed to reveal interesting things about who we are and who we want to be. Take the very first example, dated December 17, 1892. A young lady in a floor-length evening dress with a corseted waist and gigot sleeves holds a bouquet of just-cut tea roses and looks out at us with a slightly mischievous, sidelong glance. Above her, two barefoot sylphs recline on either side of the word *Vogue;* one regards herself in a hand-held mirror, the other leafs through the pages of a magazine. Style, refinement, leisure, decorum, and affluence are all on display, along with just a hint of seduction. It's the upper-class American ideal of beauty at the fin de siècle. The caption underneath reads, VOGUE—A DEBUTANTE.

The new magazine cost ten cents a copy in its early years and came out every week. Arthur Baldwin Turnure, the publisher, a well-connected Princeton graduate, had announced that *Vogue* was to be the "authentic journal of society, fashion, and the ceremonial side of life." At first, it spoke to gentlemen as well as ladies, listing their weddings and debuts and cotillions, their entertainments and watering places, even the comings and goings of their cats and dogs. From the beginning, though, the ladies and their hats and their frocks took center stage on the cover. A man appears now and then in the black-and-white illustrations by mostly forgotten artists of that period, but what we see, far more often, is the well-to-do American female, a healthy and active species who takes time out from formal society to ride horses and bicycles, swing in hammocks, and go to the beach.

By the turn of the century, she has become a generic species, the Gibson Girl—although her creator, Turnure's friend Charles Dana Gibson, never did a *Vogue* cover because his services had already been claimed by *Life,* in its first, pre–Henry Luce incarnation. With her sturdy frame and upswept masses of curly hair, the Gibson Girl appears again and again on the cover, usually in color now, unruffled and steeped in virtue. The ideal woman of her era, she has no more personality than a cake of soap (as my husband's grandmother used to say). Then Condé Nast bought the magazine in 1909, and everything changed.

Nast, with his pince-nez, high collars, and commercial daring, had a very clear goal: By doubling *Vogue's* page size and making it a biweekly, he wanted to turn the magazine from a private society album (with a circulation of about 14,000) into a more professional publication for a select audience of about 100,000 pedigreed readers for whom taste and elegance were as important as income. Nast took a keen interest in the magazine's cover as a primary means to attract his target audience. He hired a series of young artists whose idiosyncratic styles made room for milder forms of modern art to appear on the cover—the sinuous arabesques of Art Nouveau at first, epitomized by George Wolfe Plank's fanciful lady riding on a peacock, which was such a hit that it appeared twice, in 1911 and 1918. Art Nouveau perfectly captured the flowing, uncorseted silhouette of Paul Poiret's revolutionary new Paris couture, which was just catching on over here, and also made way for the Orientalism craze first popularized by Diaghilev's Ballets Russes. In Plank's many covers and those of Helen Dryden, Frank X. Leydendecker, and a few others, the *Vogue* female undergoes a sea change, from Gibson Girl rectitude to the etherealized fantasy of Olive Tilton's 1913 white dreamer, with her plumed hat and white wolfhound, and the otherworldly romance of Dryden's 1919 redheaded goddess harvesting a cascade of cherry blossoms.

In relatively short order, these fey types were chased away by the flapper, whose red lips, cloche hats, and Art Deco surroundings are caught in jazzy designs by the Frenchman Georges Lepape and the Spaniard Eduardo Garcia Benito, who slipped in visual references to Brancusi and Modigliani, and to the newly fashionable dream world of Surrealism. As embodied by Benito's 1926 profile of a sophisticate in a red cloche, the lady is still an anonymous icon, not an individual. She may represent the racier, cocktail-infused freedoms of the Jazz Age, but she continues to keep an aloof and haughty distance.

What changes all this is the photograph. Edward Steichen, whose camera had already brought pictorial realism to the pages of *Vogue,* did the magazine's first color photograph for the cover, which appeared on July 1, 1932. A striking composition of a girl in a red bathing suit, holding a beach ball over her head, it was a real girl, in a real place, and it sounded the death knell of painted illustration. Although drawn covers by Lepape, Benito, Christian "Bébé" Bérard, and the dazzlingly inventive Carl Erickson, who signed his drawings "Eric," continued through the 1930s, by the end of that decade photographic covers by Steichen, Cecil Beaton, Horst P. Horst, George Hoyningen-Huene, and Toni Frissell had taken over.

In 1941, one year before Condé Nast died, he hired the man who would lead *Vogue* into its next chapter: a suave, 28-year-old Russian émigré named Alexander Liberman. The magazine was still under the straitlaced supervision of Nast's longtime editor in chief, Edna Woolman Chase, but Liberman, who had been assigned to the art department, soon caught everyone's attention with his design for the May 15, 1941, cover—a Horst photograph of a recumbent girl in a white bathing suit, legs in the air, balancing on her toes a large, red beach ball (*another* beach ball!) that Liberman

had turned into the *O* in *Vogue.* Once Liberman was named art director, in 1943, his rise was swift and emphatic. He soon banished the whimsical hand-lettering and fanciful designs of *Vogue's* logo (which for years had changed with each issue) in favor of the bold, no-nonsense, Franklin Gothic typeface used for headlines by the *New York Daily News* and other tabloids, and installed text blocks on the cover to announce the contents. As Liberman told me years later, when I was writing his biography, one of his first priorities in those days was "no more visions of loveliness." He felt that *Vogue* should be more like a news magazine. "I wanted to involve women in the life of the moment," he said, "and the war furthered this by destroying fantasy."

Liberman encouraged Irving Penn, a young artist he had hired as his personal assistant, to become a photographer, launching one of the great talents in photographic history. Penn's first *Vogue* cover, in 1943, was a still life—handbag, glove, belt, swatch of fabric, and a painting of five lemons—but it had the mysterious presence and insight of his later portraits and fashion shots (especially those of Lisa Fonssagrives, the most exquisite model of the time, who became Penn's wife). Liberman also hired Erwin Blumenfeld, a German-born photographer whose experimental brilliance led to some of the most arresting covers ever, epitomized by his 1950 image of the model Jean Patchett, her features reduced to an eye, bright lips, and a delectable mole.

Liberman's modernizing approach was aimed at a wider audience than Nast's selective elite, and it took in a deeper culture. An artist himself, whose abstract paintings and sculptures would soon appear in important New York galleries, he tried to bring advanced art into the mix at *Vogue.* Salvador Dalí, Giorgio de Chirico, and Marie Laurencin had done *Vogue* covers, and in 1943 Liberman asked

Marcel Duchamp, a legendary presence among the New York avant-garde, to do the cover of the February 1 "Americana" issue. Duchamp submitted a collage portrait of George Washington, made of surgical gauze stained with reddish-brown stripes that made it look distressingly like a used sanitary napkin. Liberman knew better than to show this unnerving little bombshell to the implacably proper Edna Woolman Chase. He sent it back to Duchamp, who sold it for $300 to André Breton; the Surrealist poet-in-chief then published it in the magazine *VVV*. Forty-four years later, it was sold at auction for $500,000, and it is now in the collection of the Pompidou museum in Paris—its fame tinged by a sulfurous whiff of contempt for the marriage of art and fashion.

Like the billowing skirts of Dior's New Look, *Vogue* covers loosened up in the fifties. Postwar affluence was in the air, circulation was zooming (365,000 in 1950), and the *Vogue* cover girl, while continuing to speak to us of refined elegance and good taste, was slowly becoming more accessible. William Klein, Liberman's new find, specialized in photographing women on the street. For the 1954 Christmas cover, Liberman selected a Clifford Coffin shot of a model in a red dress and repeated it 25 times—eight years before Andy Warhol did his multiple-image portrait of Marilyn Monroe. But all this was just a prelude to the explosive changes of the sixties.

Vogue covers registered the new climate almost immediately—they grabbed your attention and practically sat in your lap. The primary catalyst here was Diana Vreeland, who was lured from *Harper's Bazaar* by Liberman in 1962 to become *Vogue*'s new editor in chief. That same year, Samuel I. Newhouse, who had bought Condé Nast Publications in 1959, made Liberman the editorial director of all the Condé Nast magazines. The theory was that he would nurture Vreeland's genius and rein in her excesses and expenditures. For the March 15, 1966, cover, Richard Avedon, whom Vreeland had brought over from *Bazaar,* photographed Barbra Streisand nibbling a daffodil—the first of many Avedon covers over the next two decades. He and several other new photographers, including David Bailey and Bert Stern, were soon presenting Vreeland's fresh crop of young models in extreme close-up—lips parted, eyes boldly challenging the viewer. Saucy, sexy, and far less aristocratic-looking than their predecessors on the cover, the models themselves (Twiggy, Jean Shrimpton, Veruschka, Lauren Hutton) were no longer unreachable; each one had a particular look and a distinct personality. Their names were printed in the magazine and in the gossip columns; we were on a first-name basis with them. A new breed of celebrity had arrived: the Fashion Model. To keep her company, Vreeland put more and more movie stars on the cover—Audrey Hepburn, Sophia Loren, Elizabeth Taylor, Mia Farrow, Catherine Deneuve. For the first time, the magazine was not just a mirror of fashionable society but a participant in the accelerating triumph of what Vreeland called the "Youthquake," the new, youth-oriented popular culture.

Things quieted down after Vreeland left in 1971. Under Grace Mirabella, her successor, the up-close, "looking at you" cover formula ruled supreme, but the cover girls, whether photographed by Avedon or Helmut Newton or Francesco Scavullo, all seemed to present a unified take on American beauty—fresh, confident, ready to take full advantage of the feminist revolt. It was an ideal embodied by Beverly Johnson when she became the first black model to appear on the cover, in August 1974 (*Vogue* had become a monthly a year earlier). More and more cover lines frame the face, but the real message is consistent: It's the woman, not the clothes.

The 1980s saw a return to high-wattage glamour. Linda Evangelista, Naomi Campbell, Cindy Crawford, Claudia Schiffer, Christy Turlington, and Stephanie Seymour led the incoming parade of supermodels. Under Mirabella, many of them were canonized by Avedon in superalluring close-up. These were boom years for the economy and for *Vogue*. Circulation hit 1,245,000 in the mid-eighties, but in 1988, feeling it was time for a new look, Liberman and S. I. Newhouse (who became chairman of Condé Nast in 1975) brought in Anna Wintour as editor in chief, and another era began.

Wintour's debut cover (November 1988) broke the mold. A young, relatively unknown Israeli model with long, slightly tousled hair is caught on the street in an informal pose, wearing a $10,000 jewel-encrusted Christian Lacroix sweater over jeans. It's the first glimpse of jeans on a *Vogue* cover, and there's a generous slice of bare tummy showing, as well. The photo, by Peter Lindbergh, had been done for the fashion pages inside, not the cover, but it hit the note that Wintour was seeking. "I was interested in bringing real people and a sense of life to the magazine," she said. "I just loved that photograph, and I showed it to Alex, and he said, 'Absolutely—go for it.'" Wintour used it instead of the head-shot cover that Avedon had already done for that issue, effectively ending his connection to *Vogue*. Wintour was bringing fashion back to the cover, and she was looking for a mix of approaches and photographers. Instead of retouched studio head shots, she wanted to respond to and evoke the contemporary moment: Linda Evangelista on a beach, all legs and arms and happy smile; ten models in white shirts and white jeans from the Gap; Madonna in the water, with wet hair. "I had been brought to the magazine to change it," Wintour recalls, "and changing the cover is the biggest statement you can make."

Most of the real people on Wintour's covers were really famous—Oprah Winfrey, Hillary Clinton, and a seemingly endless procession of Hollywood's biggest film stars, notably Nicole Kidman (six covers, including Irving Penn's iconic shot of her in profile, bare back set off by a double rope of diamonds), Penélope Cruz, Gwyneth Paltrow, Keira Knightley, Sarah Jessica Parker, Kate Winslet, Angelina Jolie, Natalie Portman, and on and on. Nobody is anonymous here. Once again, *Vogue* was tapping into the cultural Zeitgeist. Supermodels were dwindling, and it was the actresses, as anyone could tell on Oscar night, who personified fashion's power to enthrall.

The cult of celebrity, which has become part of the air we breathe, reached its opulent apotheosis in *Vogue* covers by Annie Leibovitz, Herb Ritts, Steven Meisel, Patrick Demarchelier, and Mario Testino. (Now and then a famous guy turns up: Richard Gere with Cindy Crawford; George Clooney with Gisele Bündchen; LeBron James, also with Gisele.) The celebrities are right there with us, friendly and smiling, dazzling but accessible, no distance at all. Drew Barrymore may be cuddling up to a lion, but we just know she'd like us to join them. And there, in March 2009, right on cue, is Michelle Obama—"The First Lady the World's Been Waiting For," as the cover line announces—whose style, beauty, and intelligence make her the ultimate modern American woman.

Comparing Wintour's brand of daring with Vreeland's, Liberman said that Wintour's was "closer to pure femininity—her genius is feminine seduction." The hint of seduction in that first 1892 cover has come full circle, but the story continues. *Vogue* covers still talk to us about ourselves and the world we live in, and the conversation remains lively and full of surprises. As Anna says, "The best cover is always the next one, the one you haven't yet seen." ■

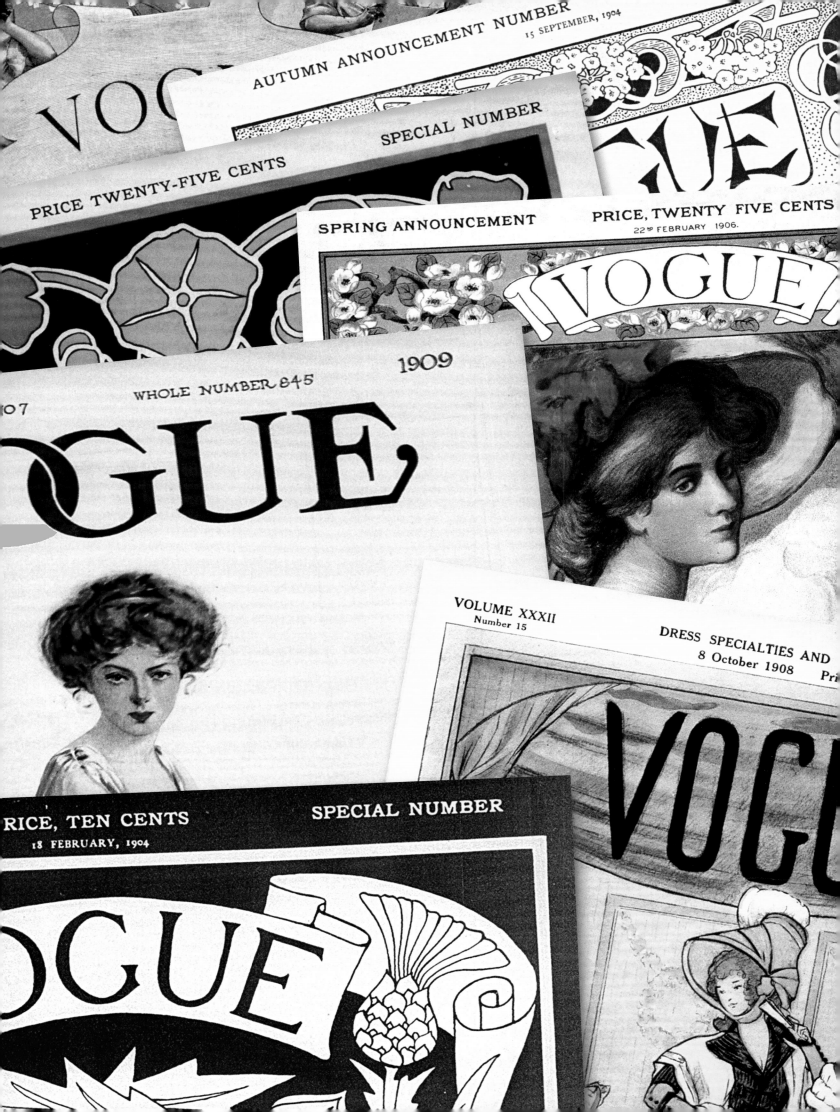

VOGUE

AUTUMN ANNOUNCEMENT NUMBER
15 SEPTEMBER, 1904

SPECIAL NUMBER

PRICE TWENTY-FIVE CENTS

SPRING ANNOUNCEMENT PRICE, TWENTY FIVE CENTS
22ND FEBRUARY 1906.

VOGUE

1909
WHOLE NUMBER 845
'07

GUE

VOLUME XXXII
Number 15

DRESS SPECIALTIES AND
8 October 1908 Pri

VOGU

RICE, TEN CENTS SPECIAL NUMBER
18 FEBRUARY, 1904

OGUE

SPECIAL NUMBER

E NUMBER
ents

SPECIAL NUMBER
Whole Number 826

1890s
TO
1900s

THE MAUVE DECADES

Women go mad for a new color, which the artist James McNeill Whistler describes as "just pink trying to be purple.". . . Everyone's talking about Consuelo Vanderbilt and her duke . . . reading Bram Stoker's *Dracula* and Edith Wharton's *The House of Mirth* . . . flocking to Oscar Wilde's *Importance of Being Earnest* . . . and snapping photos with George Eastman's lightweight, user-friendly Kodak box camera. . . . *Vogue* makes its debut. . . . Robber barons build Newport "cottages" with ballrooms (the craze for ballroom dancing has done in the waltz). . . . Gibson Girls rule. . . . Orville and Wilbur Wright leave the ground. . . . Einstein explains relativity, but nobody gets it. . . . The Model T Ford changes life as we know it; states set 20-mile-per-hour speed limits. . . . Picasso paints *Les Demoiselles d'Avignon,* giving birth to Cubism. . . . Gertrude Stein moves to Paris because that's "where the twentieth century was." . . . Paul Poiret liberates women from corsets and petticoats. . . . American girls take up cycling and discover bloomers.

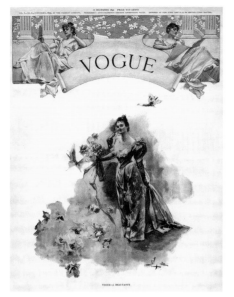

DECEMBER 17, 1892

ILLUSTRATION BY ALBERT B. WENZELL

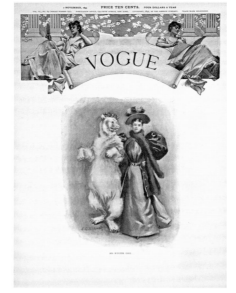

NOVEMBER 7, 1895

ILLUSTRATION BY ELLEN G. EMMET

OCTOBER 31, 1895

ILLUSTRATION BY I. B. PRICE

JUNE 13, 1895

ILLUSTRATION BY CHARLES M. RELYEA

SEPTEMBER 19, 1895

ILLUSTRATION UNCREDITED

MAY 2, 1895

ILLUSTRATION BY ELLEN G. EMMET

APRIL 18, 1895

ILLUSTRATION BY I. B. PRICE

MAY 10, 1894

ILLUSTRATION BY MAX F. KLEPPER

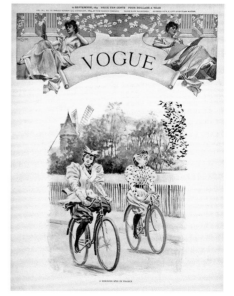

SEPTEMBER 20, 1894

ILLUSTRATION UNCREDITED

DECEMBER 13, 1894

ILLUSTRATION BY ALBERT D. BLASHFIELD

DECEMBER 20, 1894

ILLUSTRATION BY CHARLES M. RELYEA

AUGUST 16, 1894

ILLUSTRATION BY CHARLES M. RELYEA

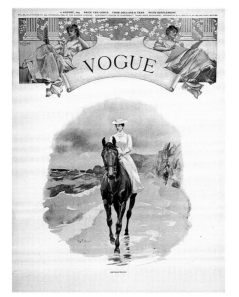

AUGUST 12, 1893

ILLUSTRATION BY MAX F. KLEPPER

DECEMBER 24, 1892

ILLUSTRATION BY ELLEN G. EMMET

NOVEMBER 5, 1896

ILLUSTRATION BY ETHEL BOARDMAN ROSE

JULY 16, 1896

ILLUSTRATION BY THOMAS B. ROBERTSON

MARCH 18, 1897

ILLUSTRATION UNCREDITED

APRIL 23, 1896

ILLUSTRATION BY THOMAS B. ROBERTSON

MARCH 12, 1896

ILLUSTRATION UNCREDITED

JUNE 24, 1893

ILLUSTRATION BY CHARLES M. RELYEA

JULY 21, 1898

ILLUSTRATION UNCREDITED

JANUARY 12, 1899

ILLUSTRATION UNCREDITED

OCTOBER 20, 1898

ILLUSTRATION BY I. B. PRICE

FEBRUARY 24, 1898

ILLUSTRATION BY ETHEL JOHNSON

APRIL 20, 1899

ILLUSTRATION BY BEATRICE STEVENS

MAY 18, 1899

ILLUSTRATION BY G. GREENE

JUNE 1, 1899

ILLUSTRATION BY G. GREENE

SEPTEMBER 2, 1893

ILLUSTRATION BY HARRY McVICKAR

AUGUST 3, 1899

ILLUSTRATION BY G. GREENE

SEPTEMBER 21, 1893

ILLUSTRATION BY GUY ROSE

NOVEMBER 30, 1893

ILLUSTRATION BY HARRY McVICKAR

MARCH 22, 1894

ILLUSTRATION BY MAX F. KLEPPER

MARCH 15, 1894

ILLUSTRATION UNCREDITED

OCTOBER 12, 1893

ILLUSTRATION BY CHARLES M. RELYEA

JUNE 3, 1893

ILLUSTRATION BY HARRY McVICKAR

FEBRUARY 25, 1893

ILLUSTRATION BY UNKNOWN

FEBRUARY 11, 1893

ILLUSTRATION BY ELLEN G. EMMET

JULY 18, 1907

ILLUSTRATION BY GEORGE HOWARD HILDER

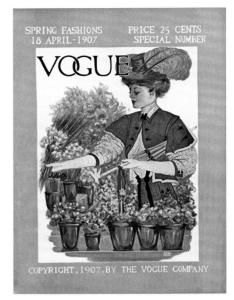

APRIL 18, 1907

ILLUSTRATION UNCREDITED

JULY 23, 1908

ILLUSTRATION BY GEORGE HOWARD HILDER

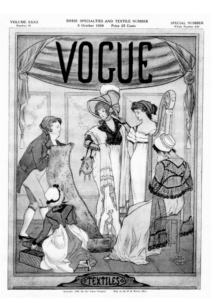

OCTOBER 8, 1908

ILLUSTRATION UNCREDITED

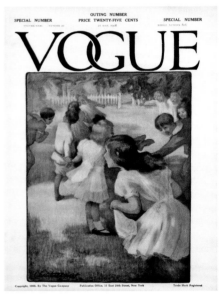

MAY 21, 1908

ILLUSTRATION BY CHRISTINE WRIGHT

NOVEMBER 5, 1908

ILLUSTRATION BY STUART TRAVIS

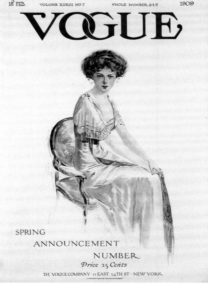

FEBRUARY 18, 1909

ILLUSTRATION BY JEAN PARKE

OCTOBER 16, 1909

COVER UNCREDITED

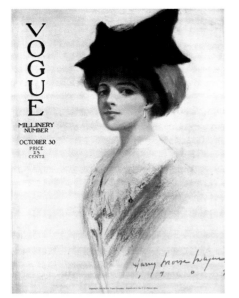

OCTOBER 30, 1909

ILLUSTRATION BY HARRY MORSE MEYERS

APRIL 16, 1903

ILLUSTRATION BY ETHEL WRIGHT

DECEMBER 3, 1903

ILLUSTRATION UNCREDITED

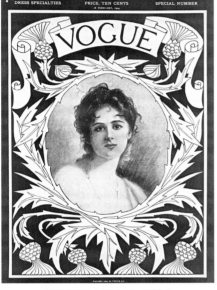

FEBRUARY 18, 1904

ILLUSTRATION UNCREDITED

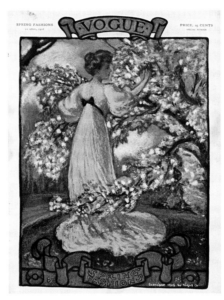

APRIL 12, 1906

ILLUSTRATION UNCREDITED

OCTOBER 10, 1907

ILLUSTRATION BY JEAN PARKE

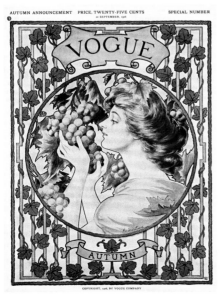

SEPTEMBER 20, 1906

ILLUSTRATION BY HUGH STUART CAMPBELL

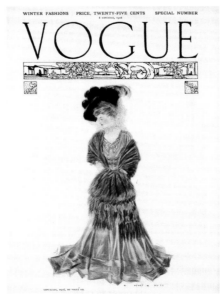

NOVEMBER 8, 1906

ILLUSTRATION BY HENRY HUTT

JANUARY 17, 1907

COVER UNCREDITED

OCTOBER 2, 1909
ILLUSTRATION BY GAYLE PORTER HOSKINS

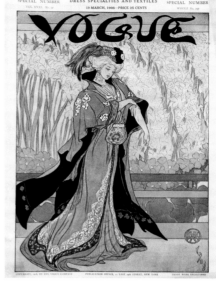

FEBRUARY 21, 1907

ILLUSTRATION BY JEAN PARKE

FEBRUARY 20, 1908

ILLUSTRATION BY WILL F. FOSTER

MARCH 19, 1908

ILLUSTRATION UNCREDITED

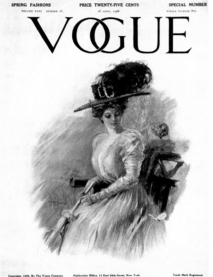

APRIL 16, 1908

ILLUSTRATION BY STUART TRAVIS

SEPTEMBER 11, 1909

ILLUSTRATION UNCREDITED

SEPTEMBER 18, 1909

ILLUSTRATION UNCREDITED

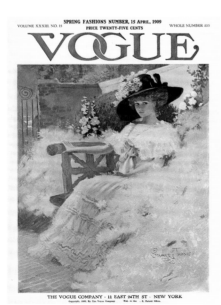

APRIL 15, 1909

ILLUSTRATION BY STUART TRAVIS

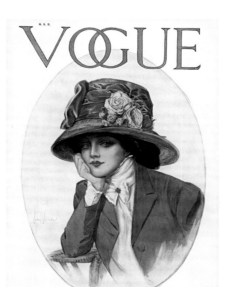

NOVEMBER 6, 1909

ILLUSTRATION BY VIVIEN VALDAIRE

NOVEMBER 13, 1909

ILLUSTRATION UNCREDITED

JUNE 24, 1909

ILLUSTRATION BY GEORGE HOWARD HILDER

JANUARY 21, 1904

ILLUSTRATION BY ALFRED JAMES DEWEY

DECEMBER 17, 1903

ILLUSTRATION BY
MARIE THÉRÈSE DUCHATEAU

FEBRUARY 20, 1902

ILLUSTRATION BY MAX F. KLEPPER

DECEMBER 4, 1902

ILLUSTRATION UNCREDITED

SEPTEMBER 24, 1903

ILLUSTRATION UNCREDITED

NOVEMBER 7, 1901

ILLUSTRATION BY C. ALLAN GILBERT

MAY 26, 1904

ILLUSTRATION BY NORMAN PRESCOTT-DAVIES

MAY 24, 1907

ILLUSTRATION BY C. ALLAN GILBERT

MARCH 17, 1904

ILLUSTRATION BY CHARLES F. FREEMAN

OCTOBER 26, 1905

ILLUSTRATION BY MAX F. KLEPPER

SEPTEMBER 21, 1905

ILLUSTRATION UNCREDITED

JULY 5, 1900

ILLUSTRATION BY BEATRICE STEVENS

MAY 18, 1905

ILLUSTRATION UNCREDITED

MAY 25, 1905

ILLUSTRATION UNCREDITED

SEPTEMBER 15, 1904

ILLUSTRATION BY M. GREINER

NOVEMBER 10, 1904

ILLUSTRATION BY CHARLES F. FREEMAN

APRIL 13, 1905

ILLUSTRATION UNCREDITED

APRIL 17, 1902

ILLUSTRATION BY HAMILTON KING

APRIL 14, 1904

ILLUSTRATION BY CARLTON FOWLER

NOVEMBER 5, 1903

ILLUSTRATION UNCREDITED

DECEMBER 8, 1904

ILLUSTRATION UNCREDITED

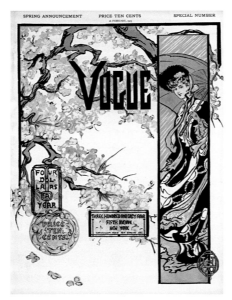

FEBRUARY 16, 1905

ILLUSTRATION UNCREDITED

FEBRUARY 22, 1906

ILLUSTRATION BY BOARDMAN ROBINSON

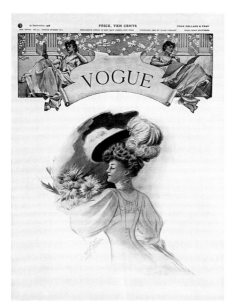

SEPTEMBER 27, 1906

ILLUSTRATION BY GEORGE HOWARD HILDER

NOVEMBER 7, 1907

ILLUSTRATION BY STUART TRAVIS

DECEMBER 5, 1907

ILLUSTRATION UNCREDITED

WINTER FASHIONS PRICE, TWENTY-FIVE CENTS SPECIAL NUMBER
6TH NOVEMBER 1902

VOGUE

NOVEMBER 6, 1902
ILLUSTRATION BY ETHEL WRIGHT

MARCH 30, 1905

ILLUSTRATION UNCREDITED

MARCH 15, 1906

ILLUSTRATION UNCREDITED

SEPTEMBER 19, 1907

ILLUSTRATION BY MEYNER

JANUARY 11, 1900

ILLUSTRATION BY THOMAS B. ROBERTSON

DECEMBER 6, 1906

ILLUSTRATION UNCREDITED

APRIL 19, 1906

ILLUSTRATION BY CHARLES F. FREEMAN

JUNE 6, 1907

ILLUSTRATION BY CHARLES F. FREEMAN

MARCH 14, 1907

ILLUSTRATION UNCREDITED

MAY 23, 1907

ILLUSTRATION UNCREDITED

DECEMBER 11, 1909
ILLUSTRATION UNCREDITED

DECEMBER 4, 1909
ILLUSTRATION BY WILL F. FOSTER

DECEMBER 3, 1908
ILLUSTRATION UNCREDITED

SEPTEMBER 17, 1908
ILLUSTRATION UNCREDITED

MARCH 18, 1909
ILLUSTRATION BY J. ALLEN ST. JOHN

OCTOBER 23, 1909
COVER UNCREDITED

MAY 20, 1909
ILLUSTRATION BY PEIRSON

NOVEMBER 27, 1909
ILLUSTRATION UNCREDITED

AUGUST 19, 1909
ILLUSTRATION UNCREDITED

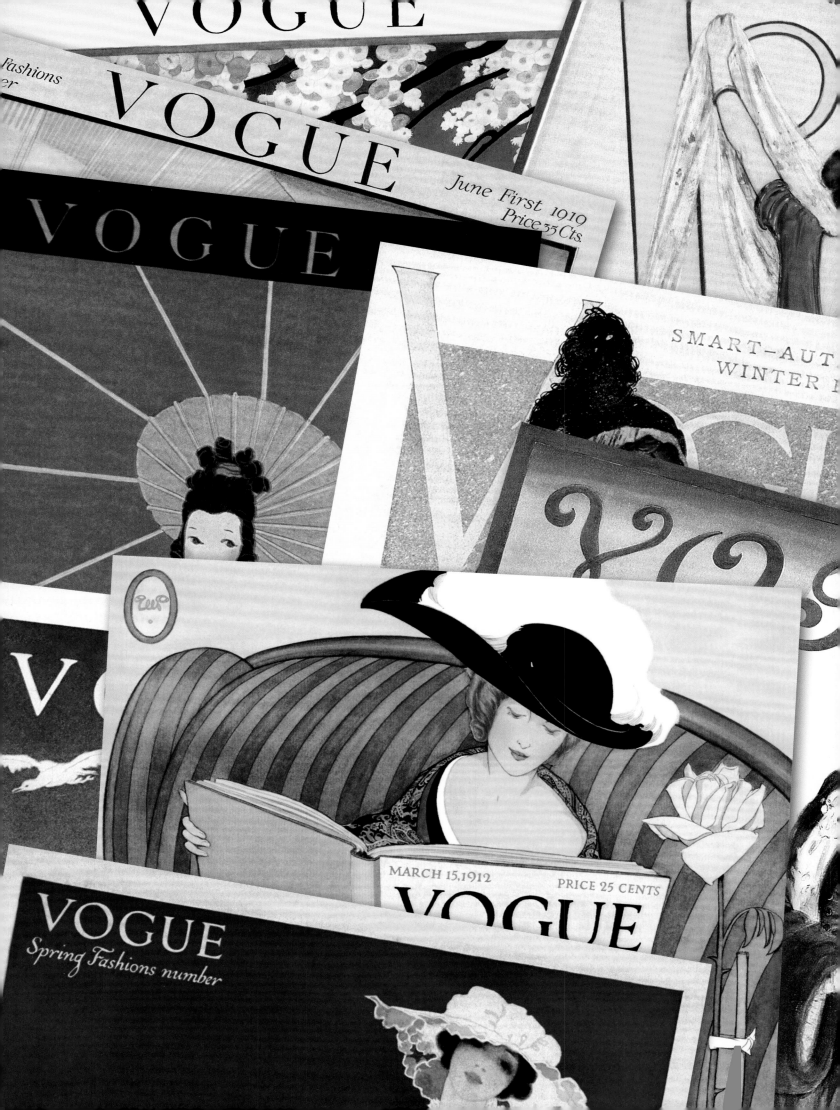

SHOCKS AND MURMURS

S uffragettes go on the march, in the streets and at Marble House in Newport, where Alva Belmont pleads their cause to society. . . . Isadora Duncan's barefoot sorcery and flowing chiffon scarves become the rage. . . . Marcel Duchamp's *Nude* descends the stairs at New York City's Armory show. . . . The great ship *Titanic* goes down. . . . Girl Scouts of America light a fire. . . . The hobble skirt yields to higher hemlines, freeing women's legs for the fox-trot (roll up the rugs and let yourself go). . . . Parisians riot over the Stravinsky-Diaghilev *Rite of Spring*. . . . U.S. citizens get the income tax. . . . Archduke Franz Ferdinand is assassinated in Sarajevo, and the world goes to war. . . . Dada's desperate cry against a world gone mad. . . . Coco Chanel invents a new silhouette: slender, girlish figures in simple jersey dresses and sportswear worn with big fake jewels. . . . Vernon and Irene Castle start a mania for the tango and the maxixe. . . . Walter Gropius founds the Bauhaus. . . . Marcel Proust unveils *Swann's Way*, the first volume of his epic paean to a dying society.

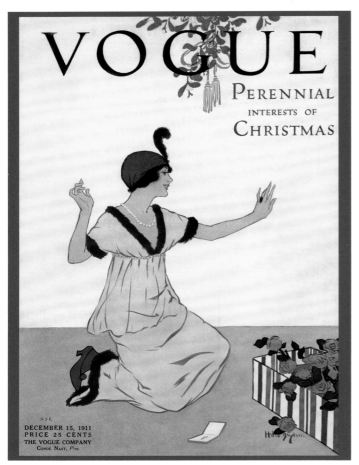

DECEMBER 15, 1911

ILLUSTRATION BY HELEN DRYDEN

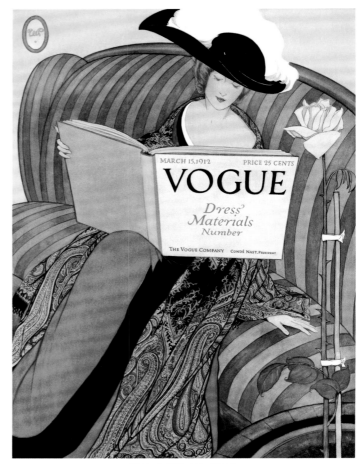

MARCH 15, 1912

ILLUSTRATION BY GEORGE WOLFE PLANK

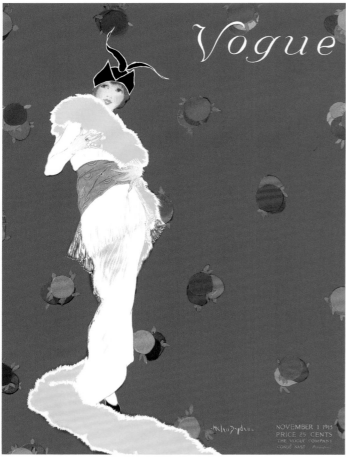

NOVEMBER 1, 1913

ILLUSTRATION BY HELEN DRYDEN

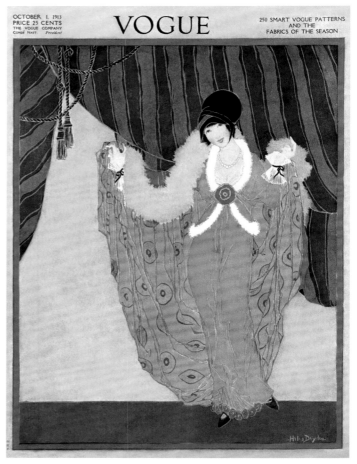

OCTOBER 1, 1913

ILLUSTRATION BY HELEN DRYDEN

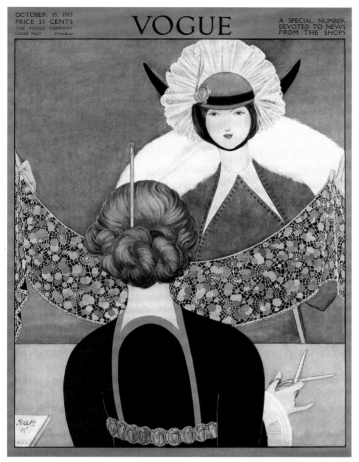

OCTOBER 15, 1913

ILLUSTRATION BY GEORGE WOLFE PLANK

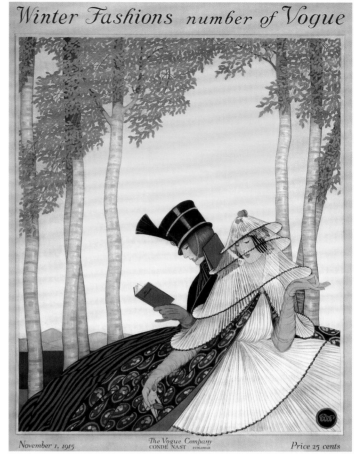

NOVEMBER 1, 1915

ILLUSTRATION BY GEORGE WOLFE PLANK

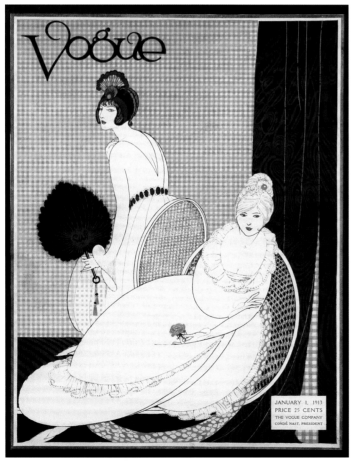

JANUARY 1, 1913

ILLUSTRATION BY GEORGE WOLFE PLANK

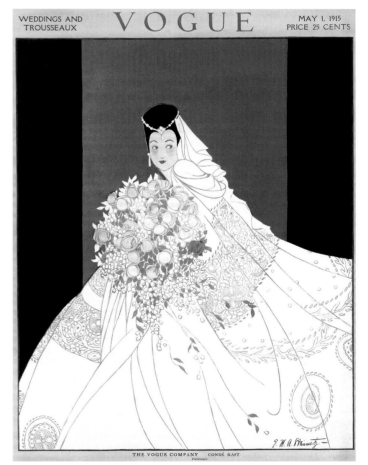

MAY 1, 1915

ILLUSTRATION BY E.M.A. STEINMETZ

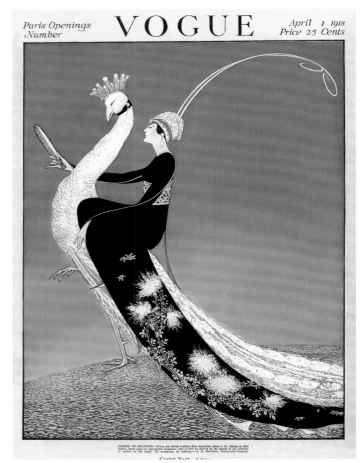

MARCH 15, 1919

ILLUSTRATION BY HELEN DRYDEN

APRIL 1, 1918

ILLUSTRATION BY GEORGE WOLFE PLANK

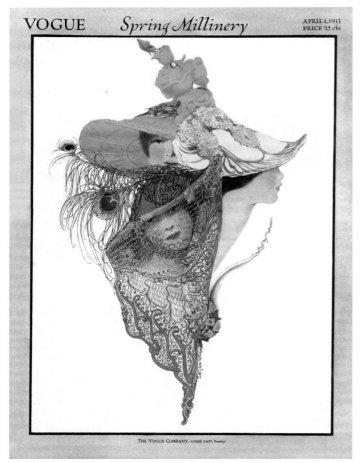

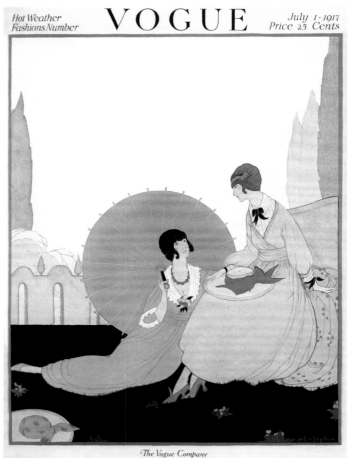

APRIL 1, 1913

ILLUSTRATION BY SARAH S. STILWELL WEBER

JULY 1, 1917

ILLUSTRATION BY HELEN DRYDEN

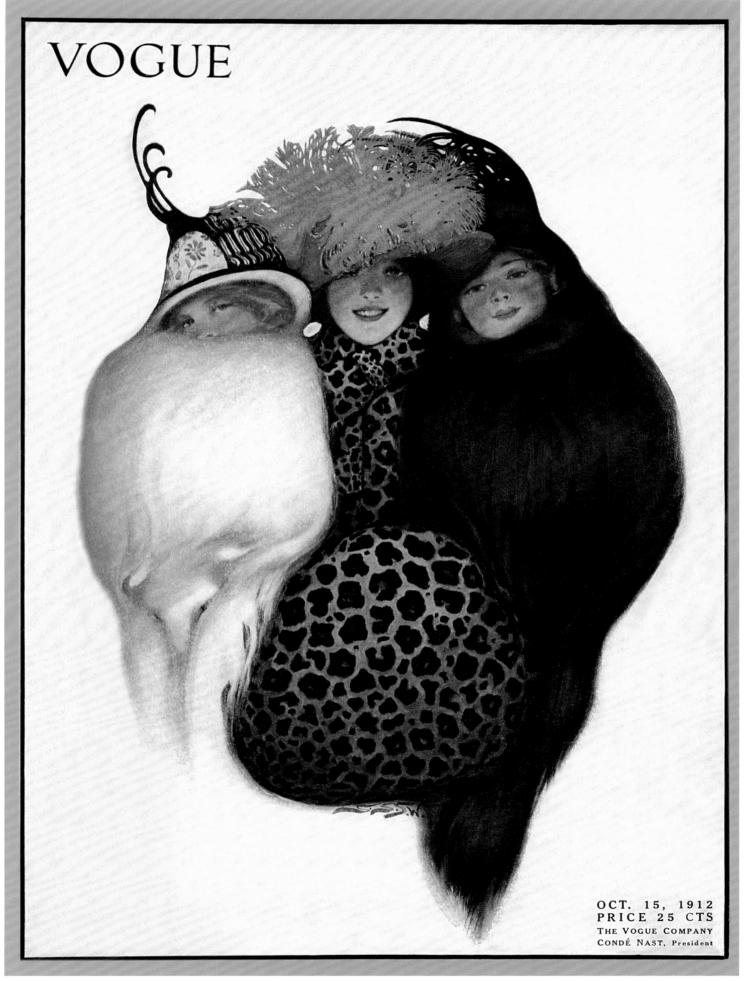

OCTOBER 15, 1912
ILLUSTRATION BY SARAH S. STILWELL WEBER

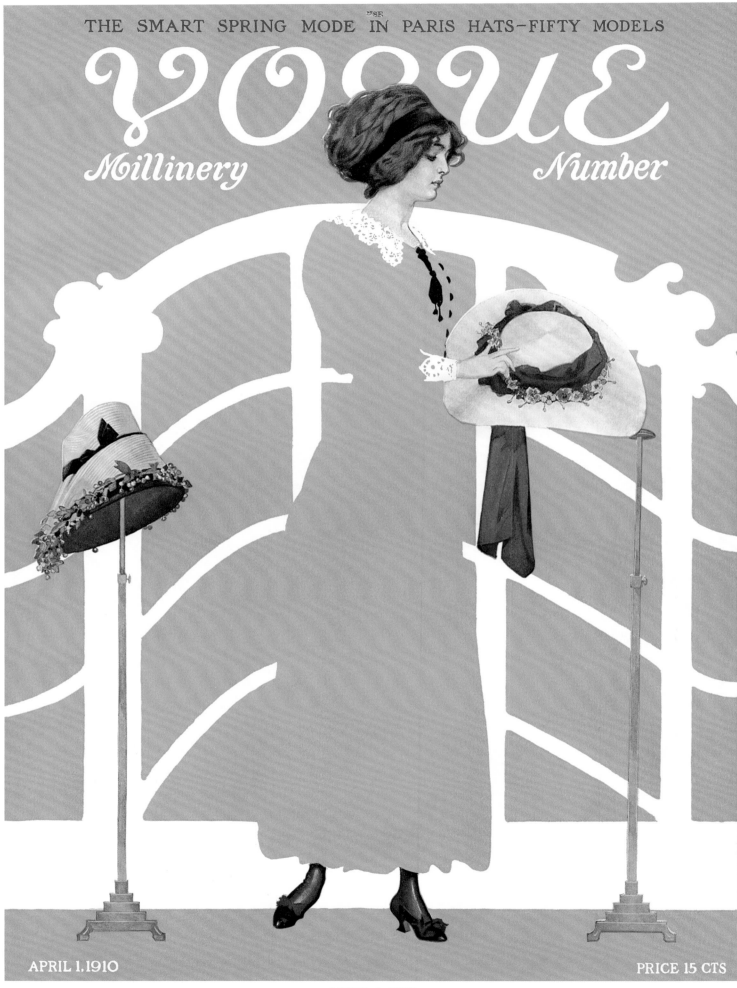

APRIL 1, 1910
ILLUSTRATION UNCREDITED

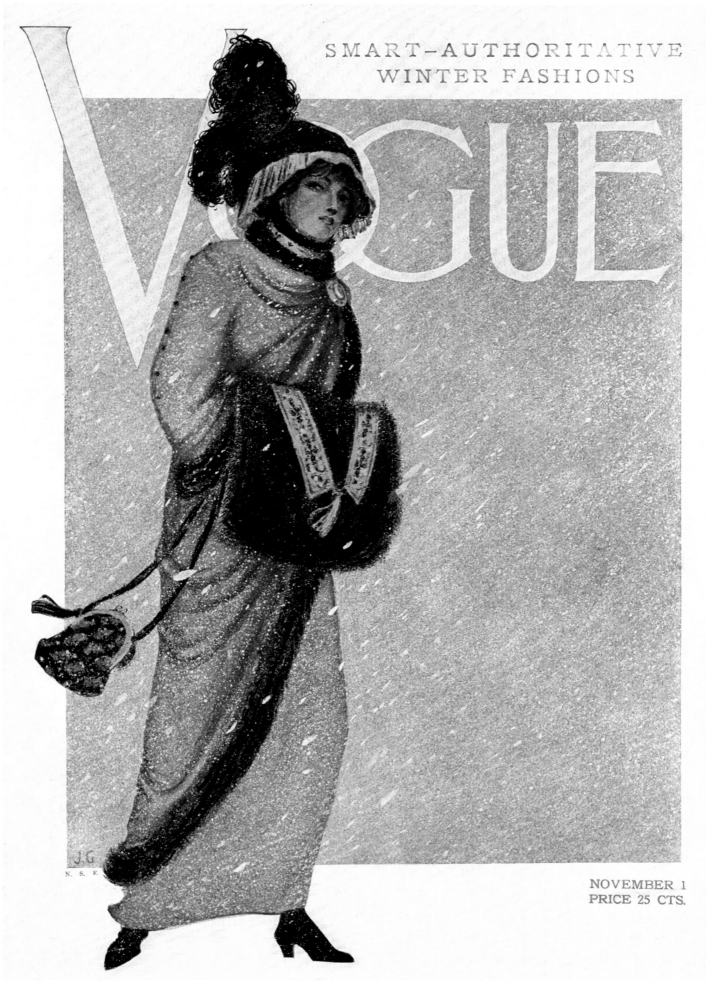

SMART—AUTHORITATIVE
WINTER FASHIONS

VOGUE

NOVEMBER 1
PRICE 25 CTS.

NOVEMBER 1, 1910
ILLUSTRATION SIGNED BY J.G.

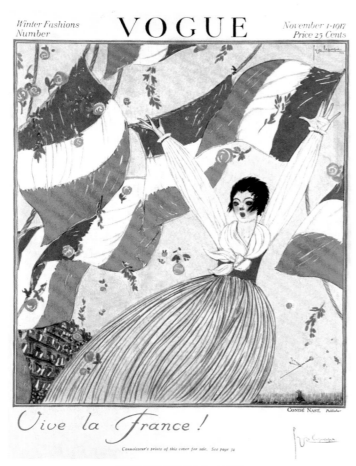

NOVEMBER 1, 1917

ILLUSTRATION BY GEORGES LEPAPE

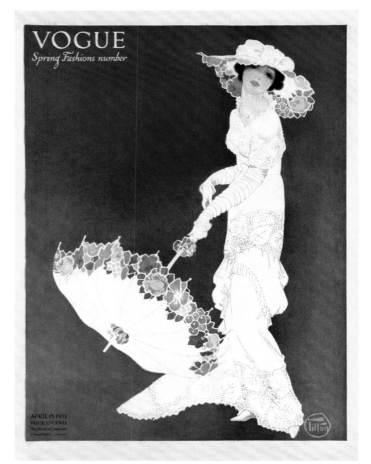

APRIL 15, 1913

ILLUSTRATION BY OLIVE TILTON

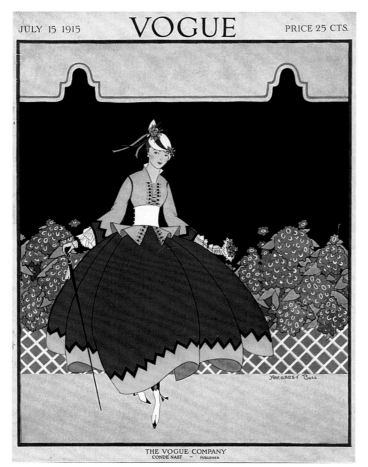

JULY 15, 1915

ILLUSTRATION BY MARGARET B. BULL

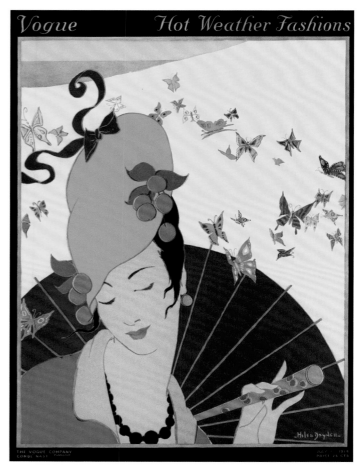

JULY 1, 1914

ILLUSTRATION BY HELEN DRYDEN

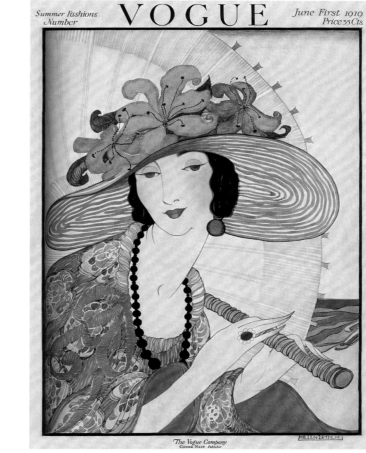

JANUARY 15, 1918

ILLUSTRATION BY HELEN DRYDEN

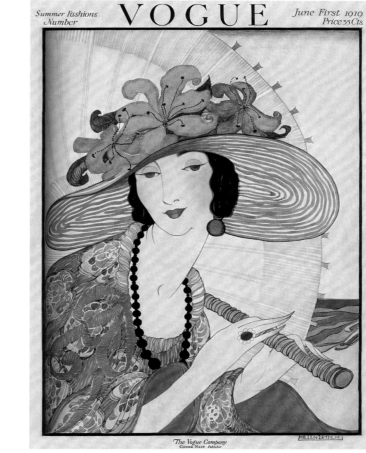

JUNE 1, 1919

ILLUSTRATION BY HELEN DRYDEN

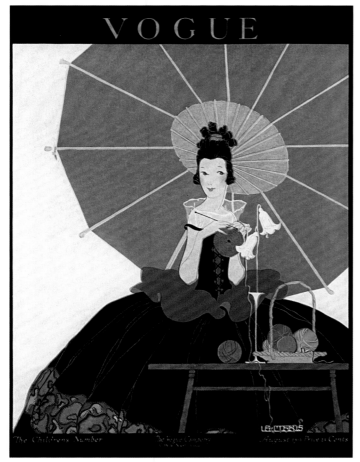

AUGUST 15, 1916

ILLUSTRATION BY MISS MORRIS

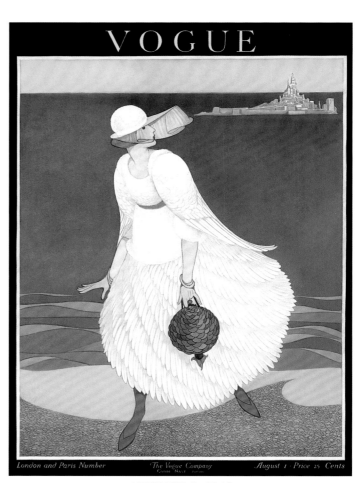

AUGUST 1, 1916

ILLUSTRATION BY GEORGE WOLFE PLANK

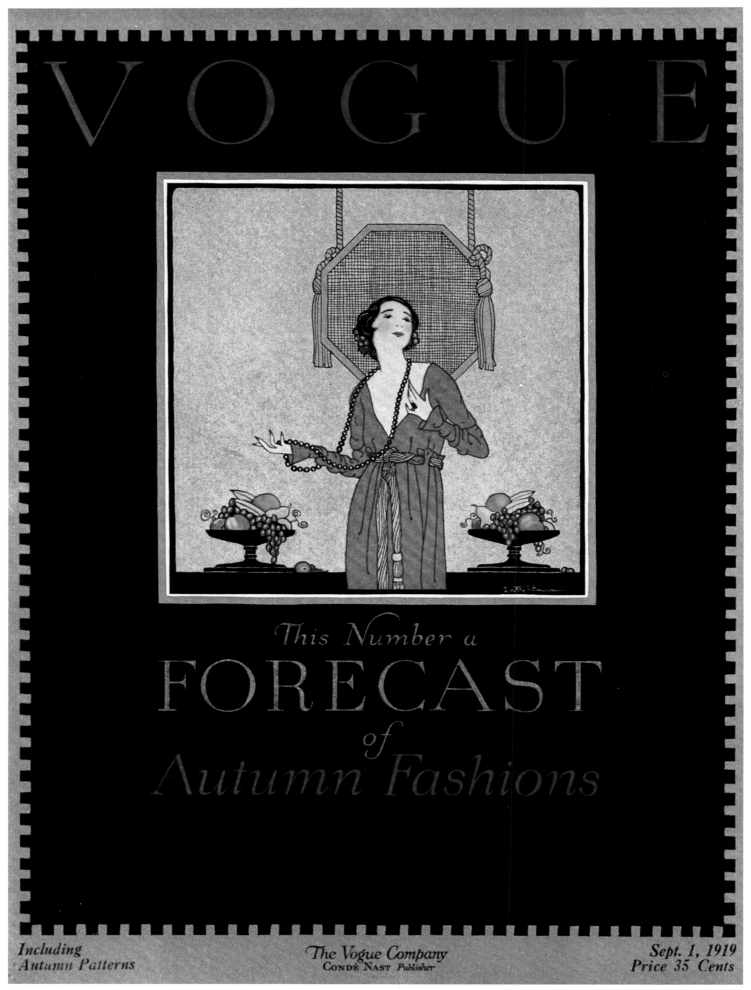

SEPTEMBER 1, 1919
ILLUSTRATION BY DOROTHY HOLMAN

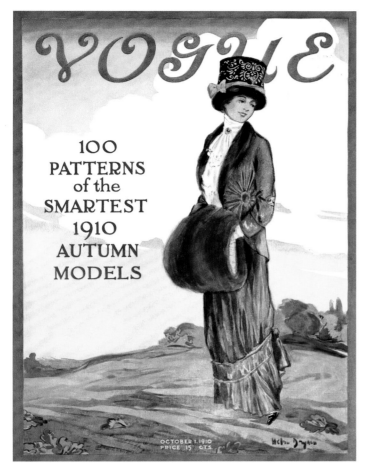

OCTOBER 1, 1910

ILLUSTRATION BY HELEN DRYDEN

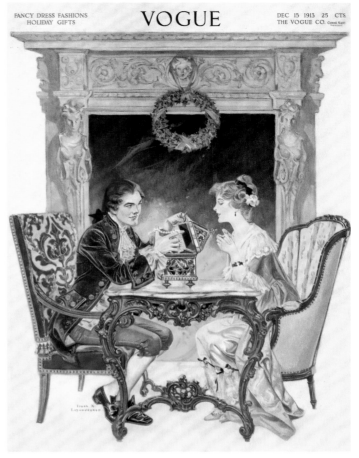

DECEMBER 15, 1913

ILLUSTRATION BY FRANK X. LEYENDECKER

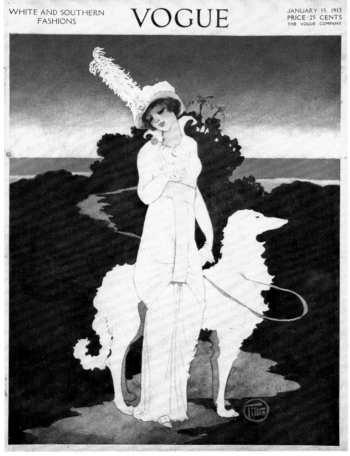

JANUARY 15, 1913

ILLUSTRATION BY OLIVE TILTON

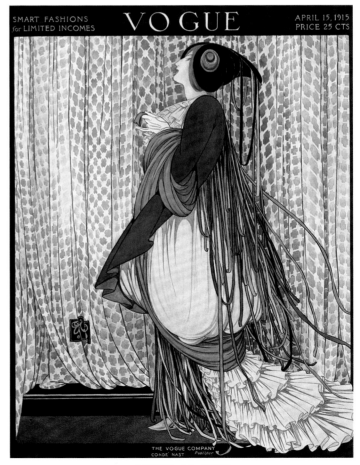

APRIL 15, 1915

ILLUSTRATION BY GEORGE WOLFE PLANK

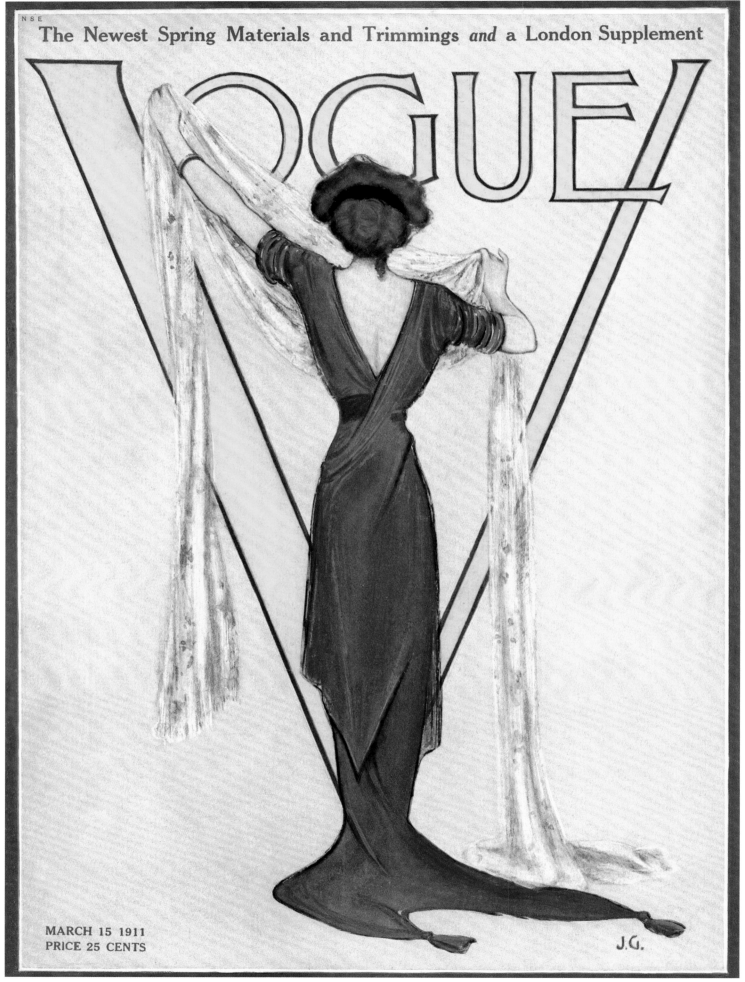

MARCH 15, 1911
ILLUSTRATION SIGNED BY J.G.

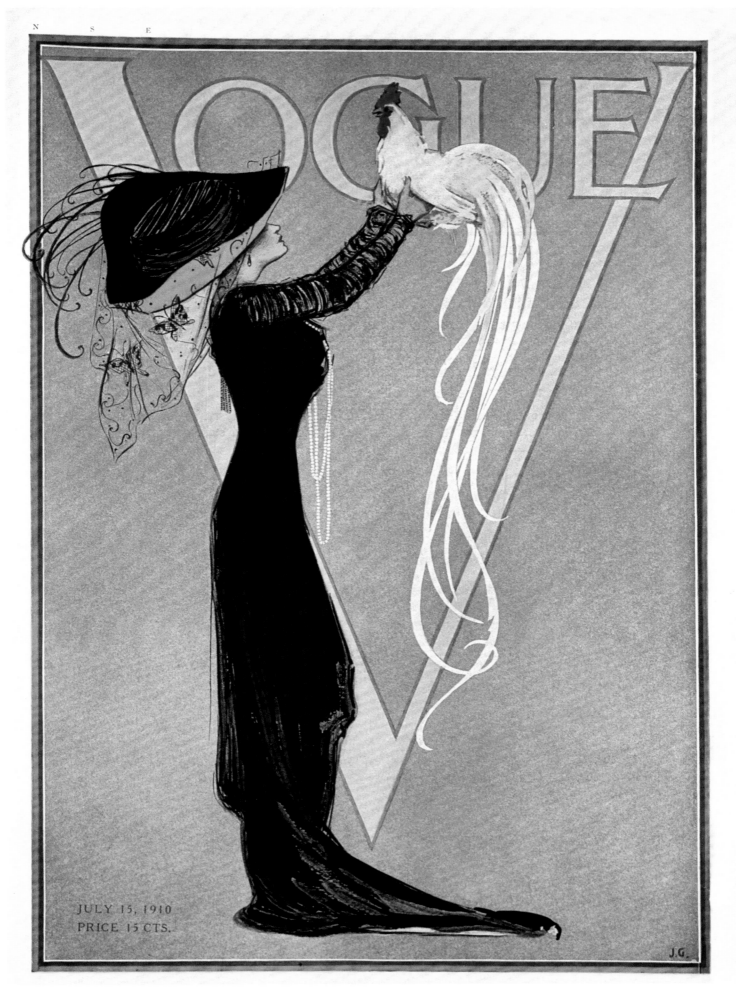

JULY 15, 1910
PRICE 15 CTS.

JULY 15, 1910
ILLUSTRATION SIGNED BY J.G.

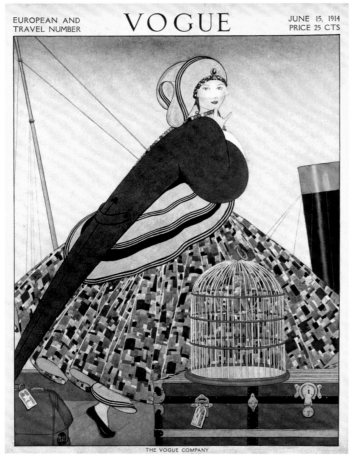

JUNE 15, 1914

ILLUSTRATION BY GEORGE WOLFE PLANK

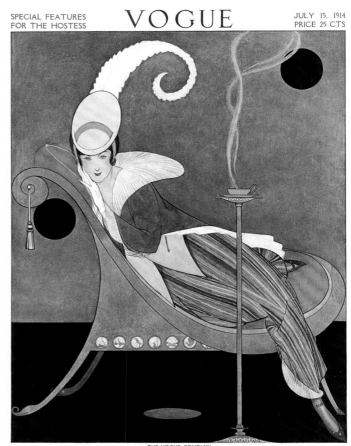

JULY 15, 1914

ILLUSTRATION BY GEORGE WOLFE PLANK

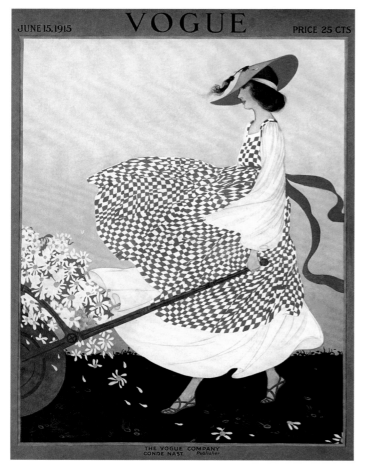

JUNE 15, 1915

ILLUSTRATION BY RITA SENGER

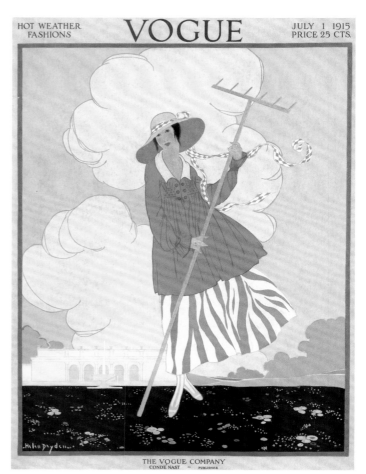

JULY 1, 1915

ILLUSTRATION BY HELEN DRYDEN

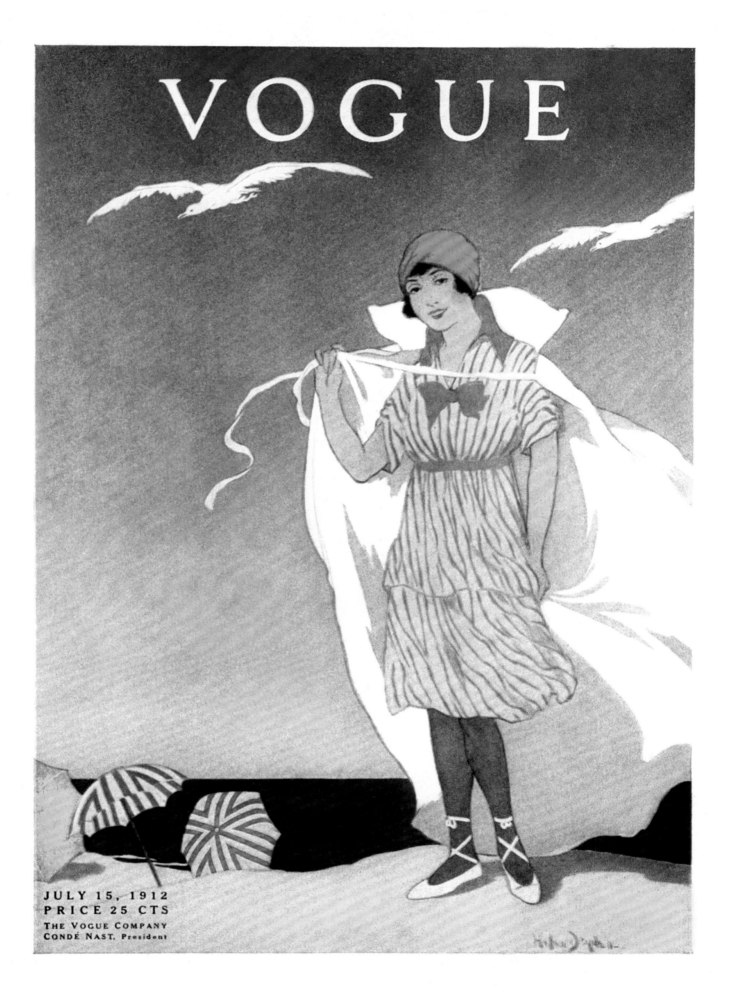

JULY 15, 1912
ILLUSTRATION BY HELEN DRYDEN

THE TWENTIES ROAR

American women get the vote—at last. . . . Prohibition spoils the fun but paves the way for gangsters, speakeasies, and jazz. . . . Sixteen-year-old Margaret Gorman (30-25-32) is the first Miss America. . . . Rudolph Valentino throbs all hearts in *The Sheik*. . . . Ready-to-wear catches on. . . . James Joyce's *Ulysses* and Virginia Woolf's *To the Lighthouse* reinvent the novel, and T. S. Eliot's *The Waste Land* does the same for poetry. . . . The flapper arrives: bobbed hair, no bosom, no waistline, shorter skirts, lots of makeup, and cloche hats. . . . "To show the forehead would have been a scandal," says *Vogue* editor Edna Woolman Chase. . . . Art Deco reigns supreme, and Surrealism is on the rise. . . . *The New Yorker* gets going. . . . Everyone's doing the Charleston, the Black Bottom, and the Shimmy. . . . Ernest Hemingway and F. Scott Fitzgerald head to Paris. . . . Sara and Gerald Murphy, whose barge party on the Seine for the Ballets Russes is the talk of Paris, colonize the Riviera as a summer resort. . . . Charles Lindbergh flies across the Atlantic, and one year later Amelia Earhart does, too. . . . *Lady Chatterley's Lover* is banned. . . . The first Academy Award goes to *Wings,* with Clara Bow and Gary Cooper. . . . The Museum of Modern Art opens its doors. . . . Black Thursday (October 24, 1929) precipitates THE CRASH.

'20s

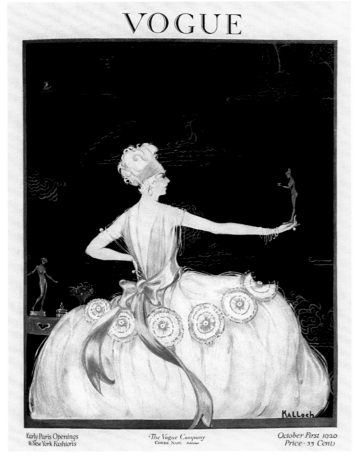

OCTOBER 1, 1920

ILLUSTRATION BY ROBERT KALLOCH

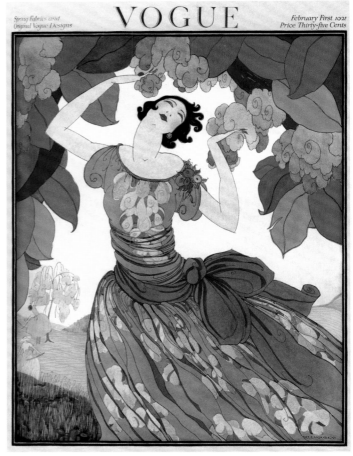

FEBRUARY 1, 1921

ILLUSTRATION BY HELEN DRYDEN

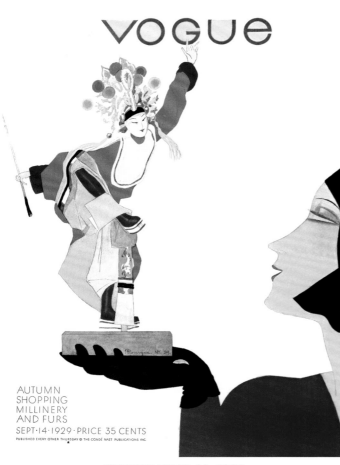

SEPTEMBER 14, 1929

ILLUSTRATION BY PIERRE MOURGUE

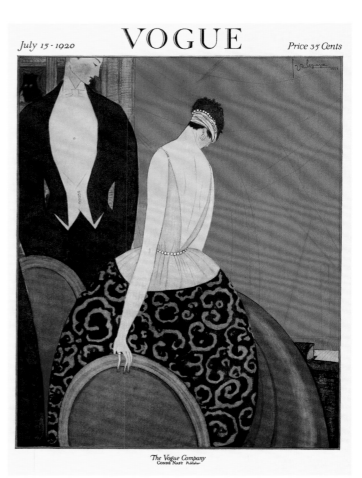

JULY 15, 1920

ILLUSTRATION BY GEORGES LEPAPE

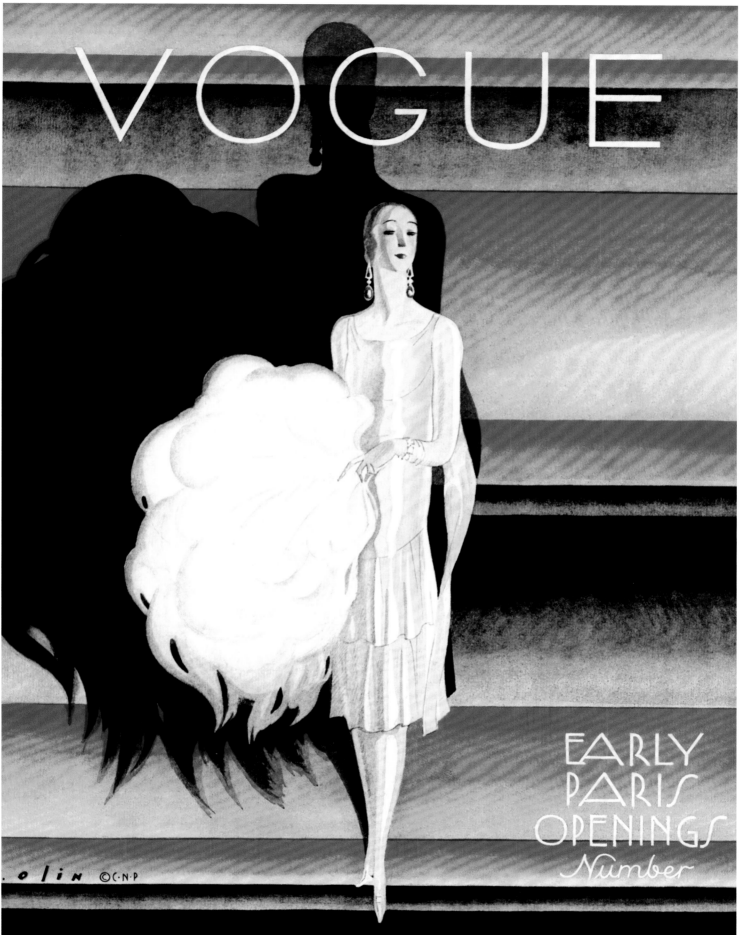

OCTOBER 1, 1925
ILLUSTRATION BY GUILLERMO BOLIN

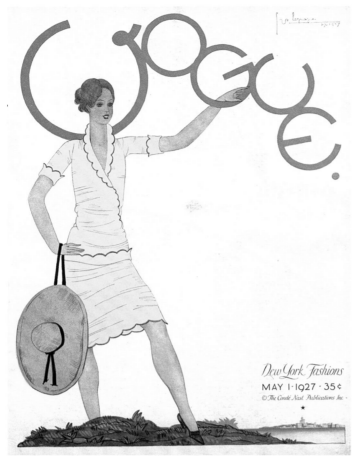

MAY 1, 1927

ILLUSTRATION BY GEORGES LEPAPE

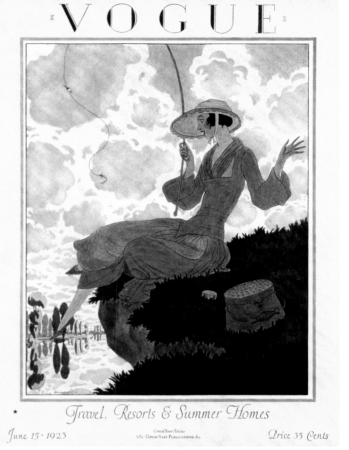

JUNE 15, 1923

ILLUSTRATION BY PIERRE BRISSAUD

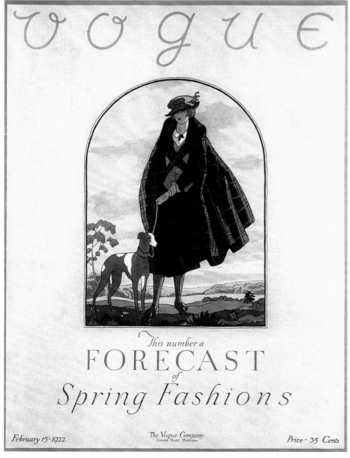

FEBRUARY 15, 1922

ILLUSTRATION BY LESLIE SAALBURG

SEPTEMBER 15, 1920

ILLUSTRATION BY GEORGES LEPAPE

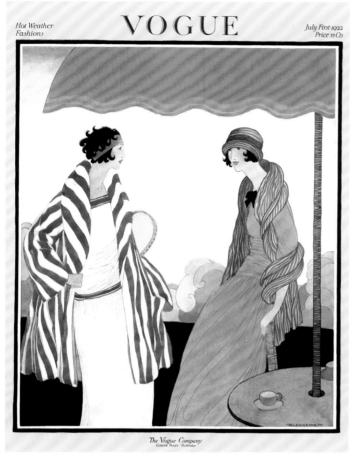

JULY 1, 1922

ILLUSTRATION BY HELEN DRYDEN

APRIL 1, 1922

ILLUSTRATION BY PIERRE BRISSAUD

JANUARY 1, 1925

ILLUSTRATION BY GEORGES LEPAPE

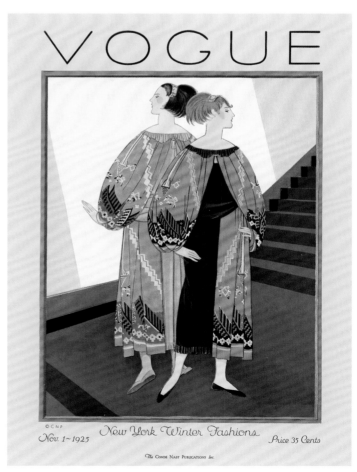

NOVEMBER 1, 1925

ILLUSTRATION BY GEORGES LEPAPE

OCTOBER 15, 1922

ILLUSTRATION BY HELEN DRYDEN

MAY 15, 1925

ILLUSTRATION BY PIERRE BRISSAUD

MARCH 1, 1924

ILLUSTRATION BY HARRIET MESEROLE

MARCH 1, 1921

ILLUSTRATION BY GEORGE WOLFE PLANK

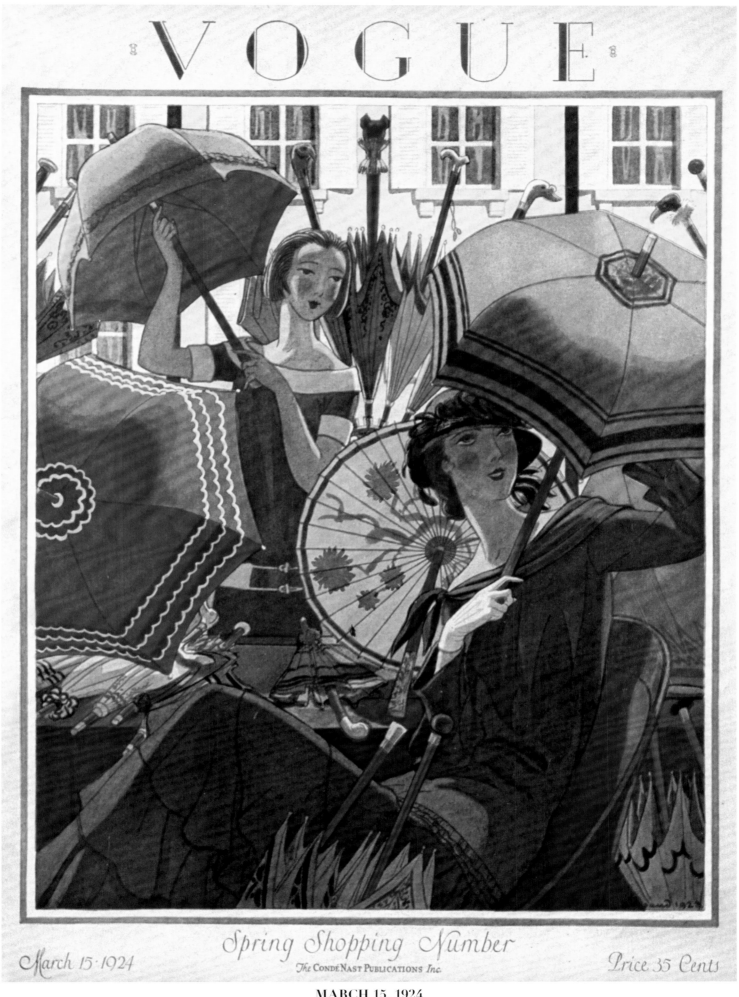

MARCH 15, 1924
ILLUSTRATION BY PIERRE BRISSAUD

MARCH 15, 1927

ILLUSTRATION OF LEE MILLER BY GEORGES LEPAPE

NOVEMBER 15, 1927

ILLUSTRATION BY GEORGES LEPAPE

NOVEMBER 15, 1926

ILLUSTRATION BY EDUARDO GARCIA BENITO

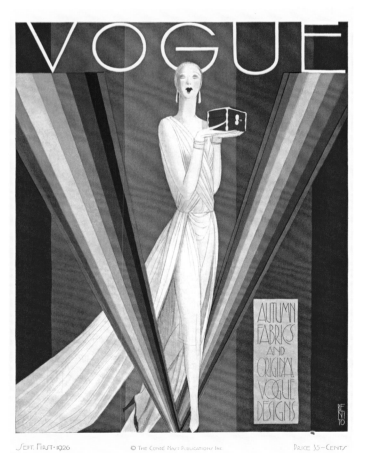

SEPTEMBER 1, 1926

ILLUSTRATION BY EDUARDO GARCIA BENITO

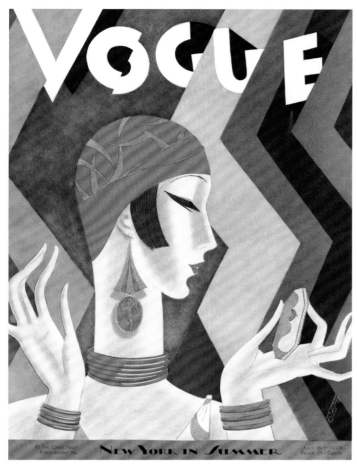

JULY 15, 1926
ILLUSTRATION BY EDUARDO GARCIA BENITO

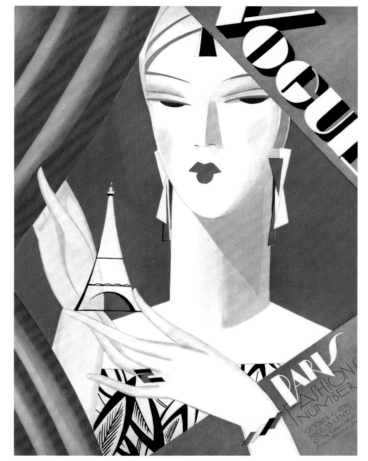

OCTOBER 15, 1926
ILLUSTRATION BY EDUARDO GARCIA BENITO

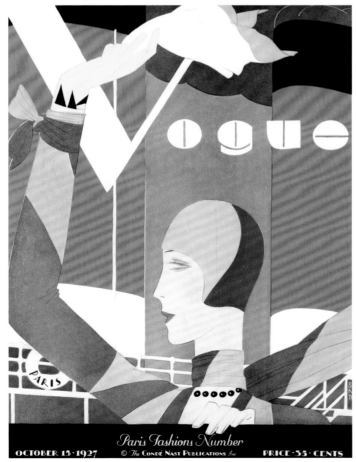

OCTOBER 15, 1927
ILLUSTRATION BY EDUARDO GARCIA BENITO

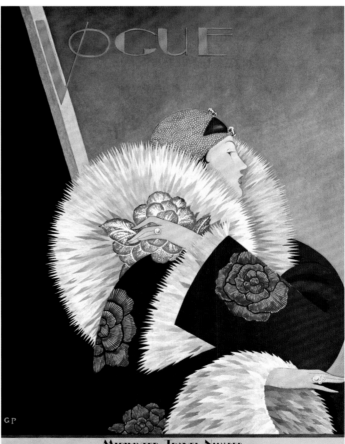

JANUARY 1, 1927
ILLUSTRATION BY GEORGE WOLFE PLANK

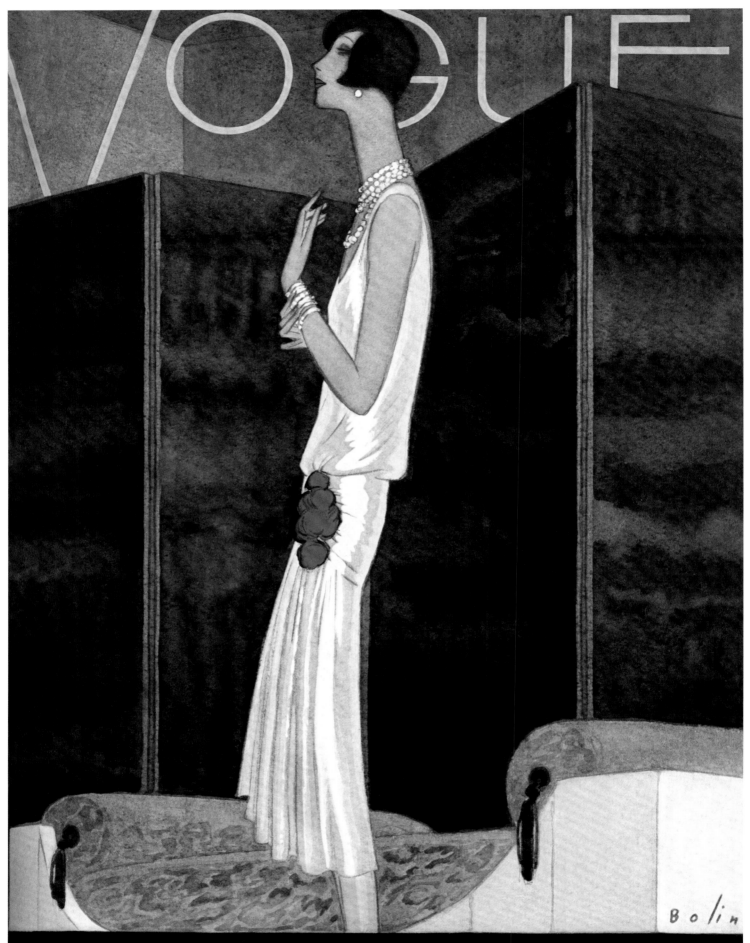

Fashions for the Older Woman and New Accessories

NOVEMBER 10, 1928
ILLUSTRATION BY GUILLERMO BOLIN

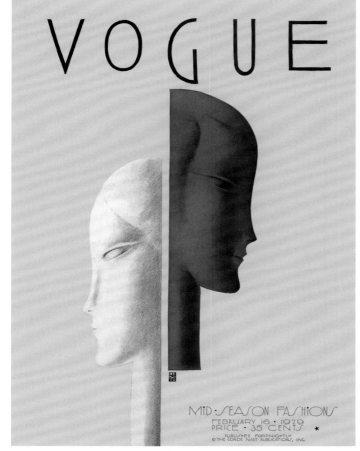

FEBRUARY 16, 1929
ILLUSTRATION BY EDUARDO GARCIA BENITO

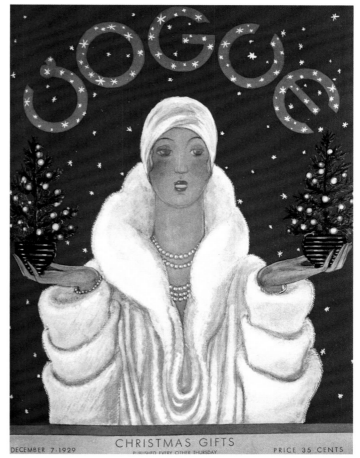

DECEMBER 7, 1929
ILLUSTRATION BY GEORGES LEPAPE

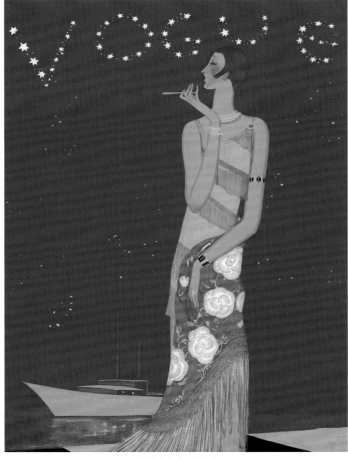

JULY 1, 1926
ILLUSTRATION BY EDUARDO GARCIA BENITO

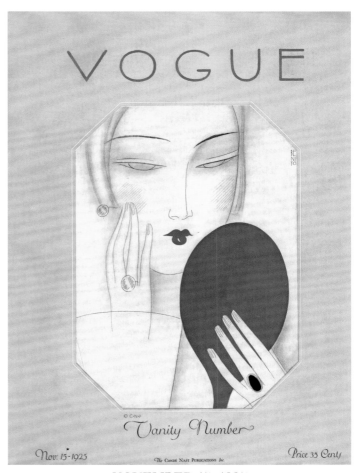

NOVEMBER 15, 1925
ILLUSTRATION BY EDUARDO GARCIA BENITO

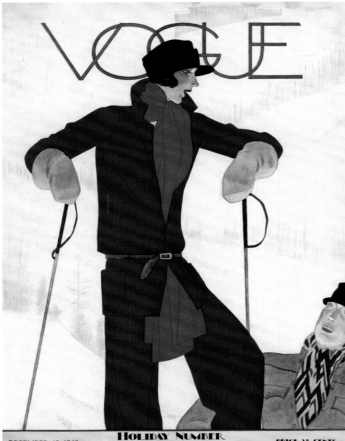

DECEMBER 15, 1927

ILLUSTRATION BY PIERRE MOURGUE

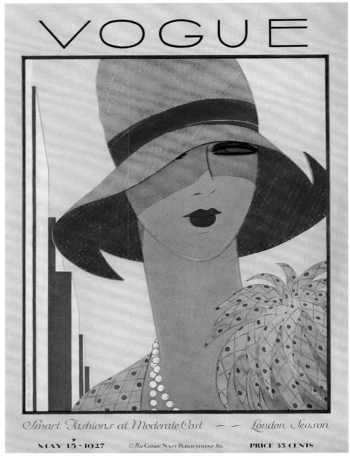

MAY 15, 1927

ILLUSTRATION BY HARRIET MESEROLE

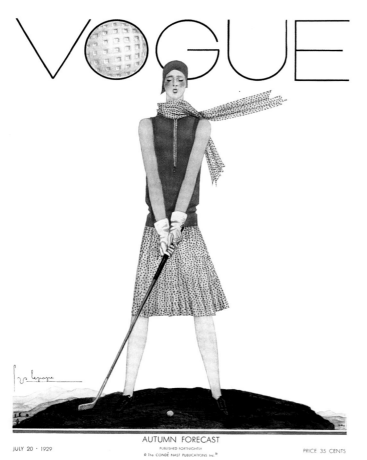

JULY 20, 1929

ILLUSTRATION BY GEORGES LEPAPE

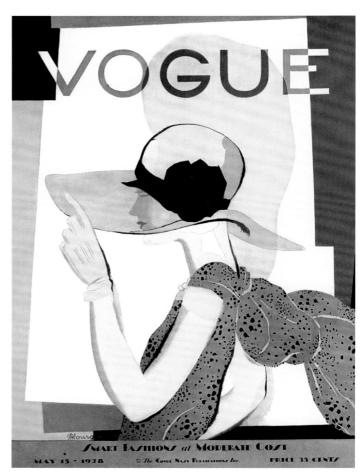

MAY 15, 1928

ILLUSTRATION BY PIERRE MOURGUE

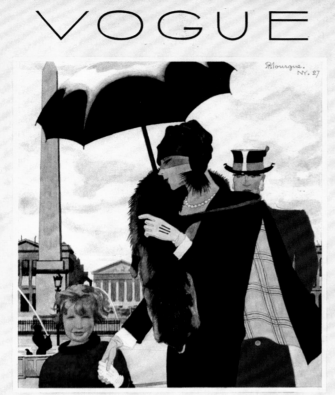

OCTOBER 1, 1927
ILLUSTRATION BY PIERRE MOURGUE

MARCH 15, 1925
ILLUSTRATION BY PIERRE BRISSAUD

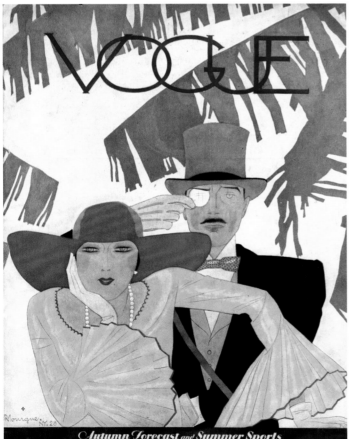

JULY 15, 1928
ILLUSTRATION BY PIERRE MOURGUE

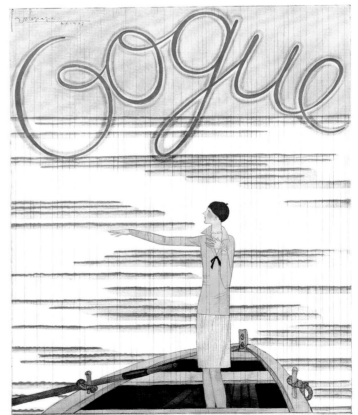

JUNE 1, 1927
ILLUSTRATION BY GEORGES LEPAPE

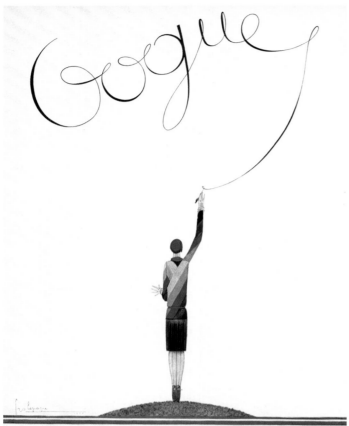

FEBRUARY 2, 1929
ILLUSTRATION BY GEORGES LEPAPE

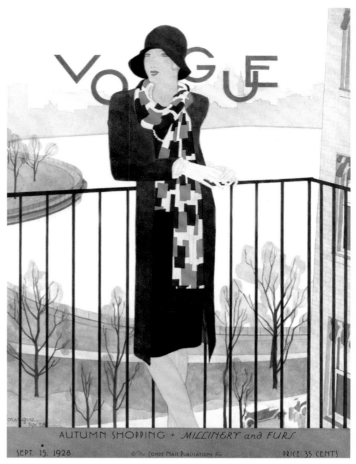

SEPTEMBER 15, 1928
ILLUSTRATION BY PIERRE MOURGUE

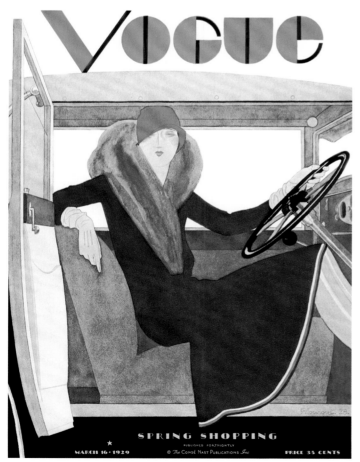

MARCH 16, 1929
ILLUSTRATION BY PIERRE MOURGUE

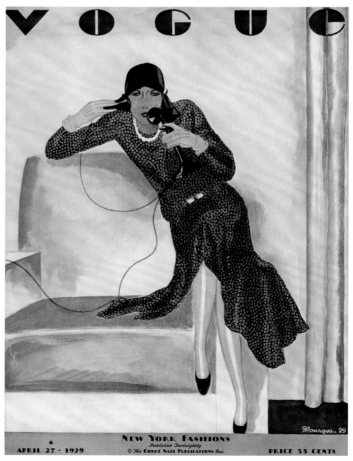

APRIL 27, 1929
ILLUSTRATION BY PIERRE MOURGUE

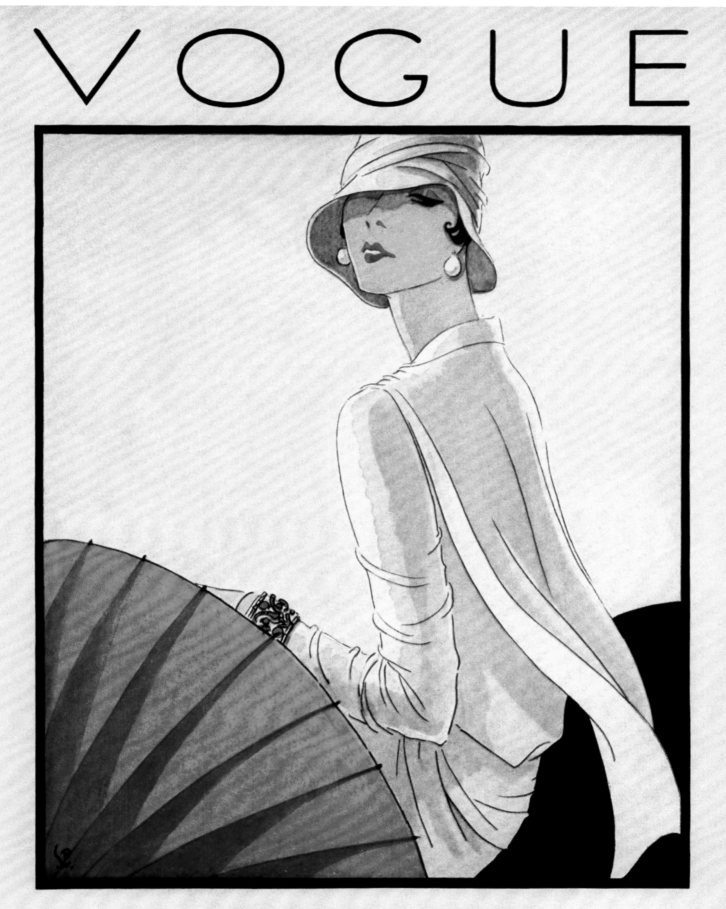

JANUARY 15, 1928
ILLUSTRATION BY PETER WOODRUFF

'30s

NIGHT AND DAY

Cole Porter hits the right notes. . . . Stocks keep falling, and so do hemlines, but skyscrapers like the Chrysler and Empire State buildings reach new heights. . . . Hollywood's golden age dawns—Clark Gable, Greta Garbo, Marlene Dietrich, Cary Grant, Bette Davis, Errol Flynn, et al win our hearts, and fashion takes notice (Dietrich's tuxedo in *Blonde Venus*). . . . Café society percolates at El Morocco and the Stork Club. . . . The whole family plays Monopoly. . . . Fred Astaire makes tap dancing a high art. . . . FDR's fireside chats lift our spirit: "The only thing we have to fear is fear itself.". . . America swings to the big bands—Benny Goodman, Duke Ellington, Glenn Miller, Tommy Dorsey—and tunes in to network radio: *The Lone Ranger, The Shadow,* and Orson Welles's *War of the Worlds.* . . . Jesse Owens goes for the gold at the 1936 Berlin Olympics. . . . Edward VIII steps down, and Wallis Simpson steps out. . . . Eleanor Roosevelt quits the Daughters of the American Revolution after they refuse to let Marian Anderson sing at Constitution Hall; FDR authorizes Anderson's outdoor concert on the steps of the Lincoln Memorial. . . . The 1939 New York World's Fair attracts 25 million people.

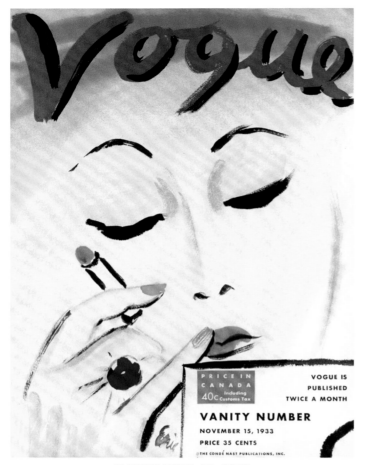

NOVEMBER 15, 1933
ILLUSTRATION BY CARL ERICKSON

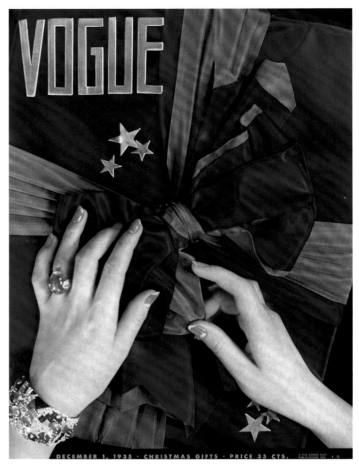

DECEMBER 1, 1935
PHOTOGRAPH BY BRUEHL-BOURGES

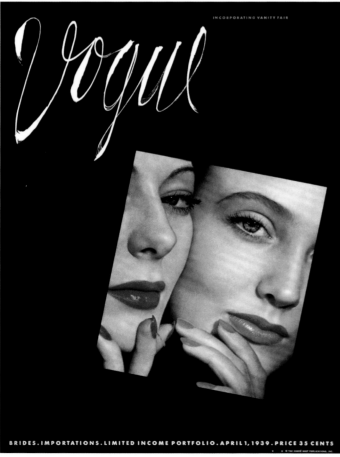

APRIL 1, 1939
PHOTOGRAPH OF MURIEL MAXWELL (LEFT) AND
RUTH KNOX ELDEN BY HORST P. HORST

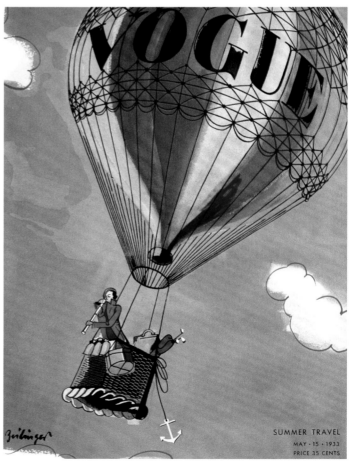

MAY 15, 1933
ILLUSTRATION BY ALIX ZEILINGER

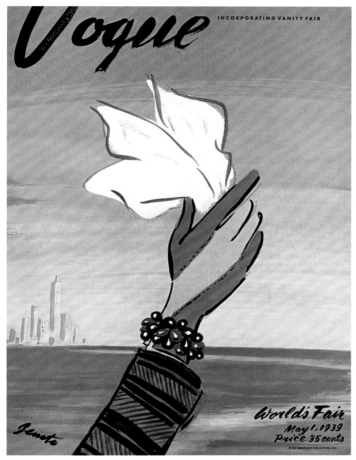

MAY 1, 1939
ILLUSTRATION BY EDUARDO GARCIA BENITO

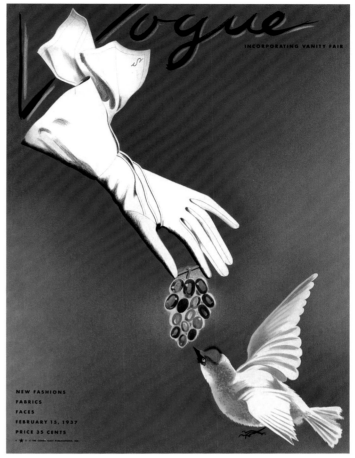

FEBRUARY 15, 1937
ILLUSTRATION BY RAYMOND DE LAVERERIE

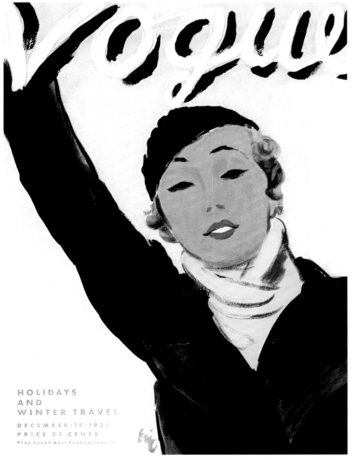

DECEMBER 15, 1932
ILLUSTRATION BY CARL ERICKSON

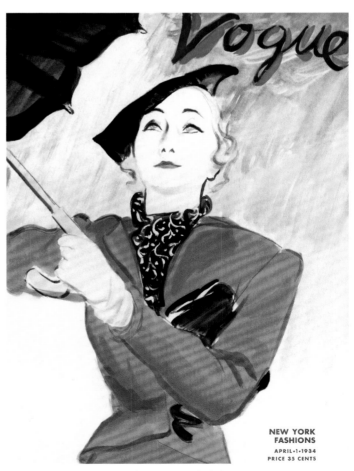

APRIL 1, 1934
ILLUSTRATION BY CARL ERICKSON

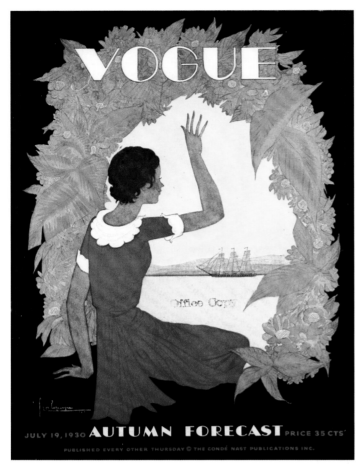

JULY 19, 1930
ILLUSTRATION BY GEORGES LEPAPE

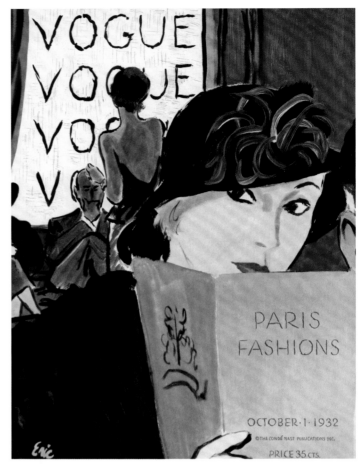

OCTOBER 1, 1932
ILLUSTRATION BY CARL ERICKSON

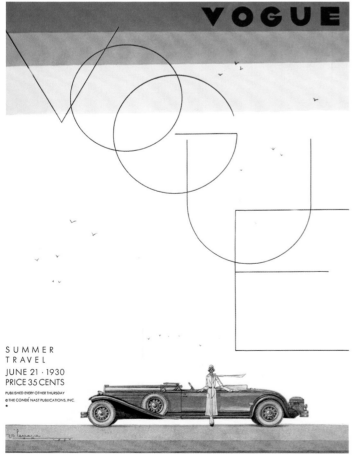

JUNE 21, 1930
ILLUSTRATION BY GEORGES LEPAPE

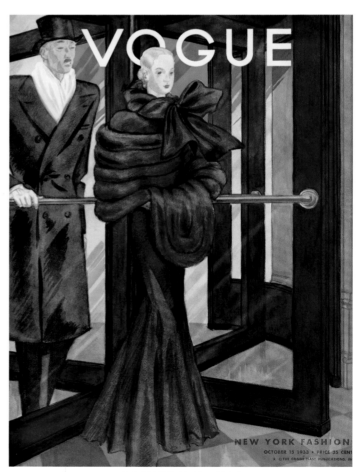

OCTOBER 15, 1933
ILLUSTRATION BY GEORGES LEPAPE

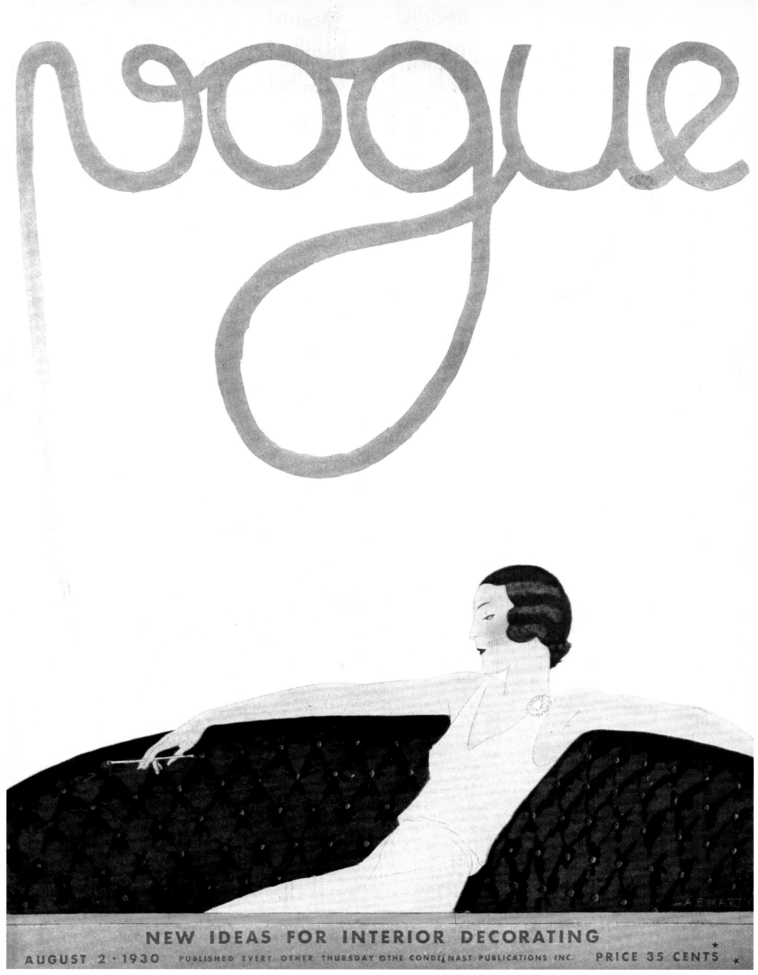

AUGUST 2, 1930
ILLUSTRATION BY ANDRÉ E. MARTY

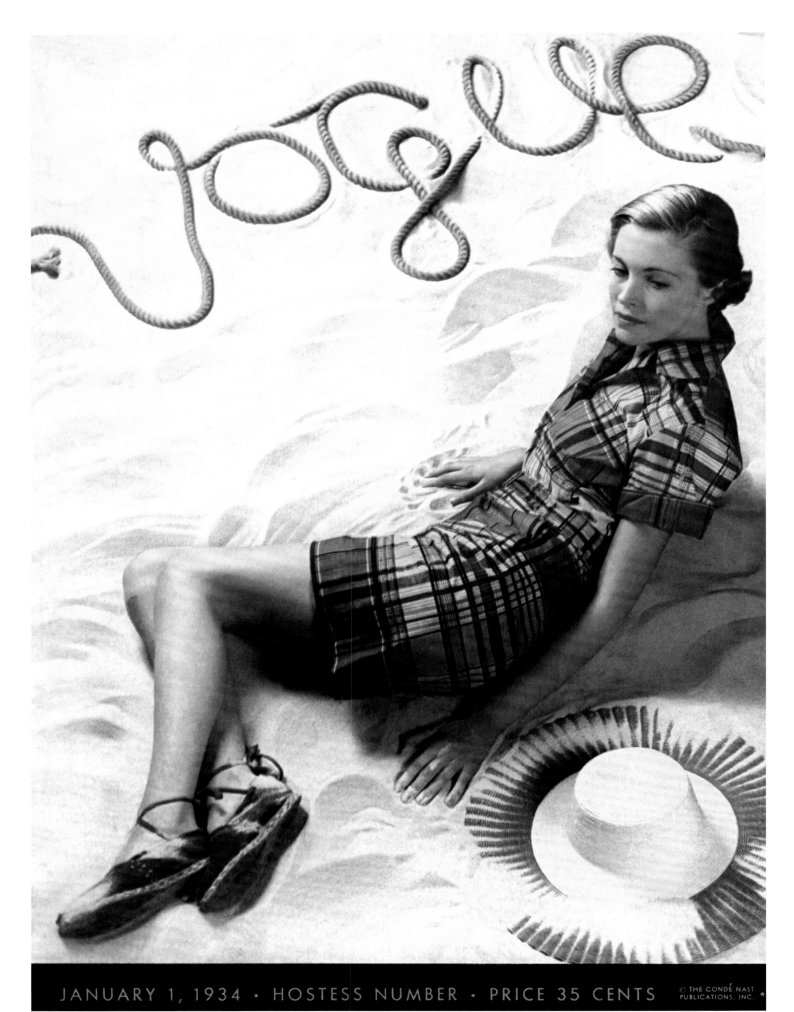

JANUARY 1, 1934 · HOSTESS NUMBER · PRICE 35 CENTS

JANUARY 1, 1934
PHOTOGRAPH BY BRUEHL-BOURGES

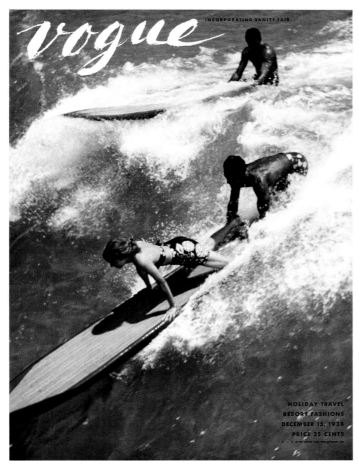

DECEMBER 15, 1938
PHOTOGRAPH BY TONI FRISSELL

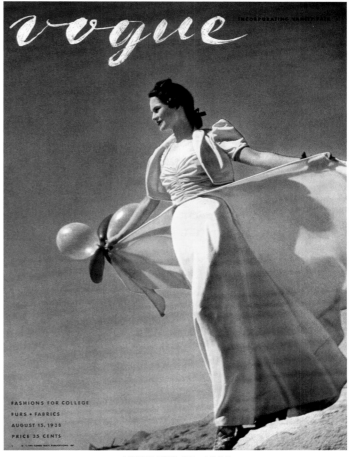

AUGUST 15, 1938
PHOTOGRAPH BY TONI FRISSELL

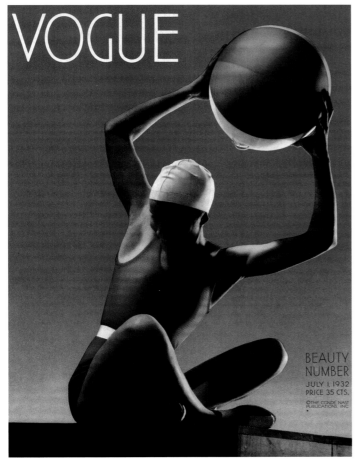

JULY 1, 1932
PHOTOGRAPH BY EDWARD STEICHEN

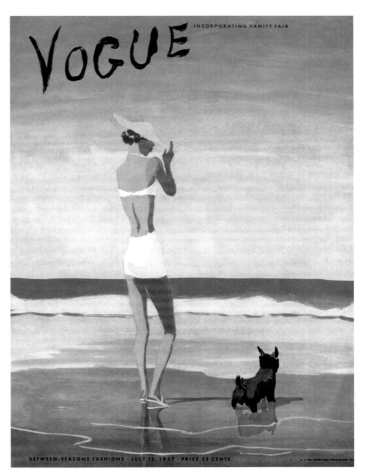

JULY 15, 1937
ILLUSTRATION BY EDUARDO GARCIA BENITO

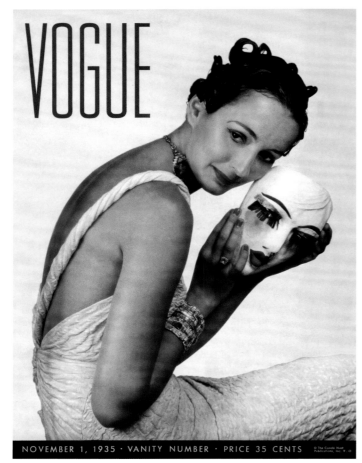

NOVEMBER 1, 1935

PHOTOGRAPH BY EDWARD STEICHEN

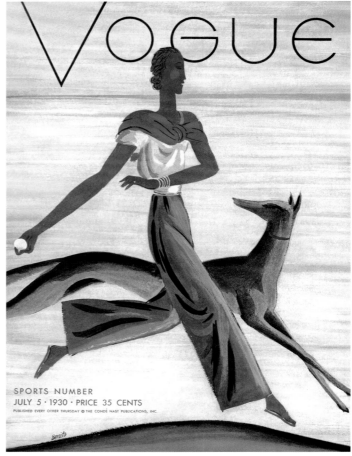

JULY 5, 1930

ILLUSTRATION BY EDUARDO GARCIA BENITO

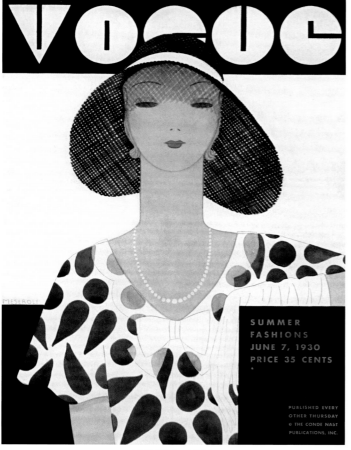

JUNE 7, 1930

ILLUSTRATION BY HARRIET MESEROLE

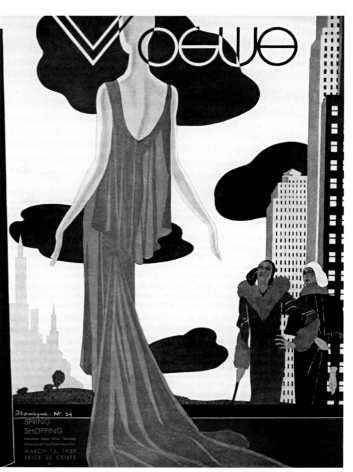

MARCH 15, 1930

ILLUSTRATION BY PIERRE MOURGUE

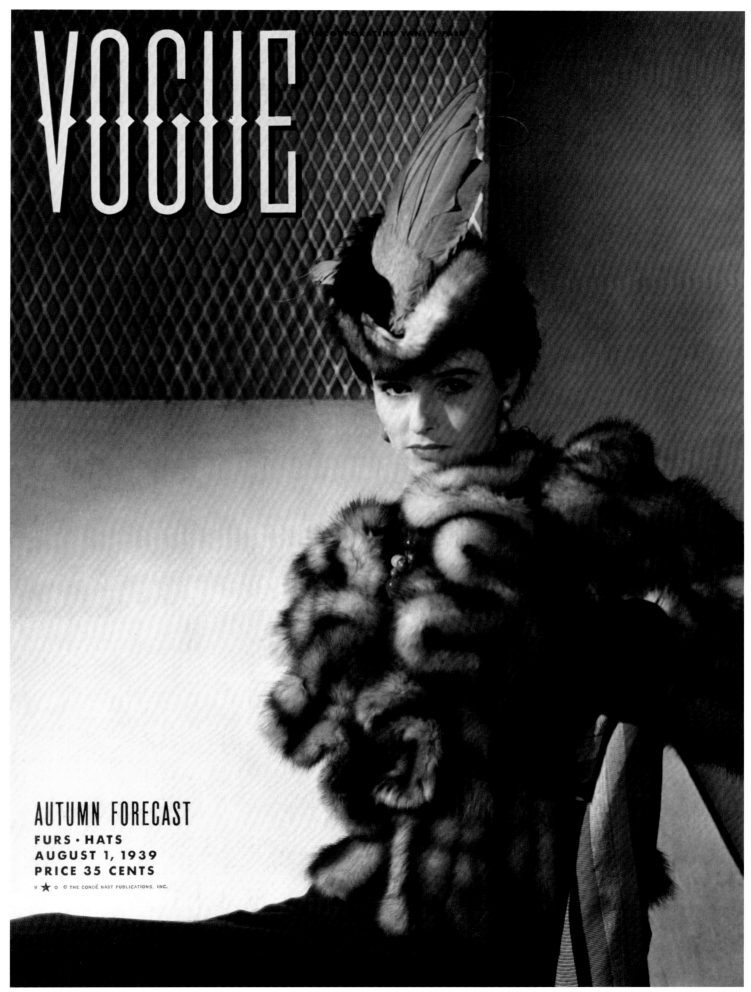

VOGUE

AUTUMN FORECAST
FURS · HATS
AUGUST 1, 1939
PRICE 35 CENTS

V ★ O © THE CONDÉ NAST PUBLICATIONS, INC.

AUGUST 1, 1939
PHOTOGRAPH OF BABE PALEY BY HORST P. HORST

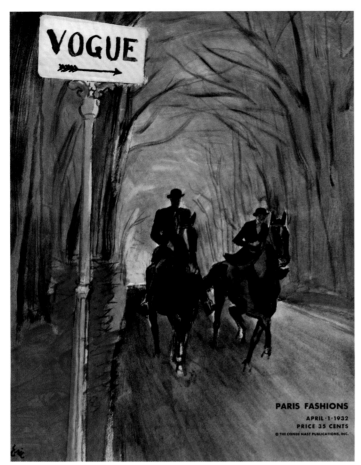

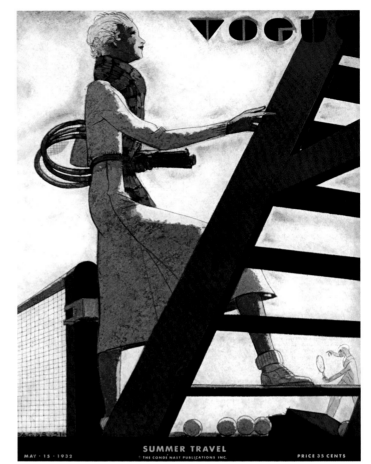

APRIL 1, 1932

ILLUSTRATION BY CARL ERICKSON

MAY 15, 1932

ILLUSTRATION BY JEAN PAGES

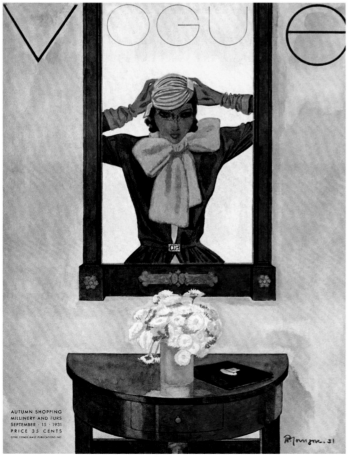

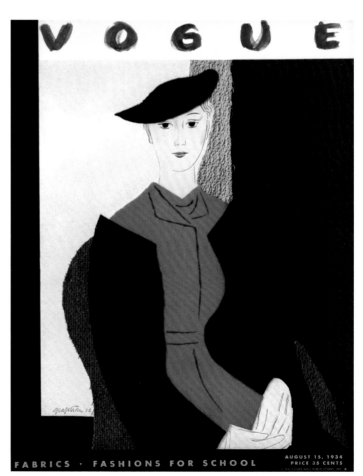

SEPTEMBER 15, 1931

ILLUSTRATION BY PIERRE MOURGUE

AUGUST 15, 1934

ILLUSTRATION BY R. S. GRAFSTROM

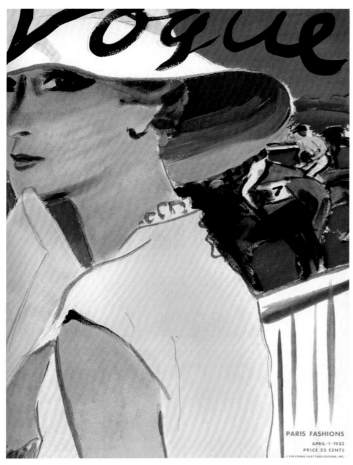

APRIL 1, 1933

ILLUSTRATION BY CARL ERICKSON

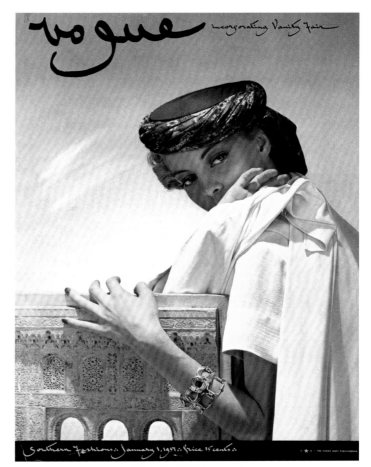

JANUARY 1, 1937

PHOTOGRAPH BY HORST P. HORST

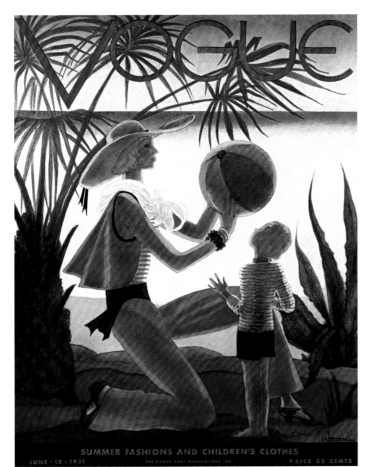

JUNE 15, 1931

ILLUSTRATION BY PIERRE MOURGUE

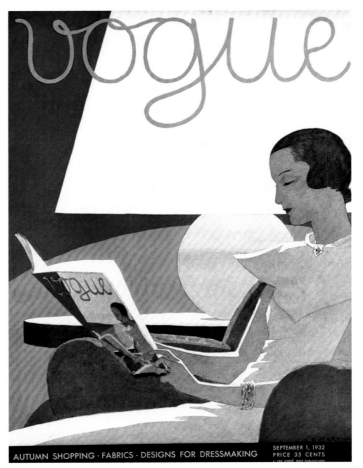

SEPTEMBER 1, 1932

ILLUSTRATION BY ANDRÉ E. MARTY

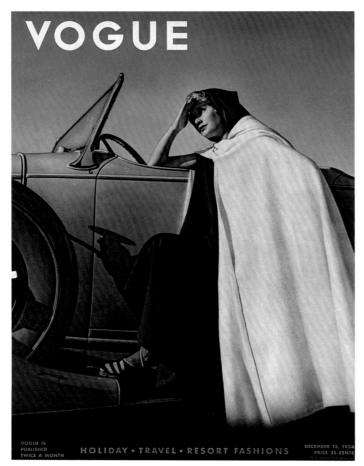

DECEMBER 15, 1934

PHOTOGRAPH OF MIRIAM HOPKINS BY GEORGE HOYNINGEN-HUENE

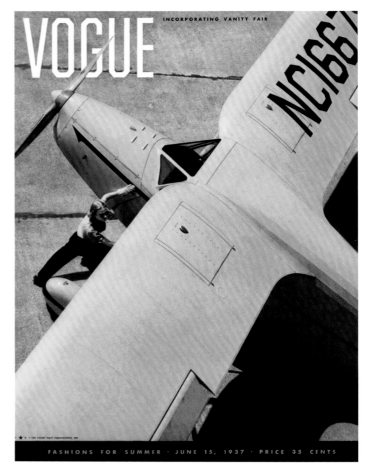

JUNE 15, 1937

PHOTOGRAPH BY ANTON BRUEHL

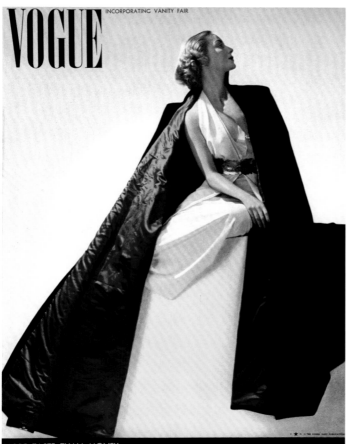

NOVEMBER 15, 1936

PHOTOGRAPH BY HORST P. HORST

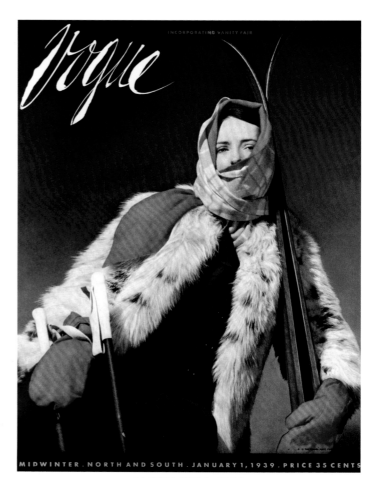

JANUARY 1, 1939

PHOTOGRAPH BY HORST P. HORST

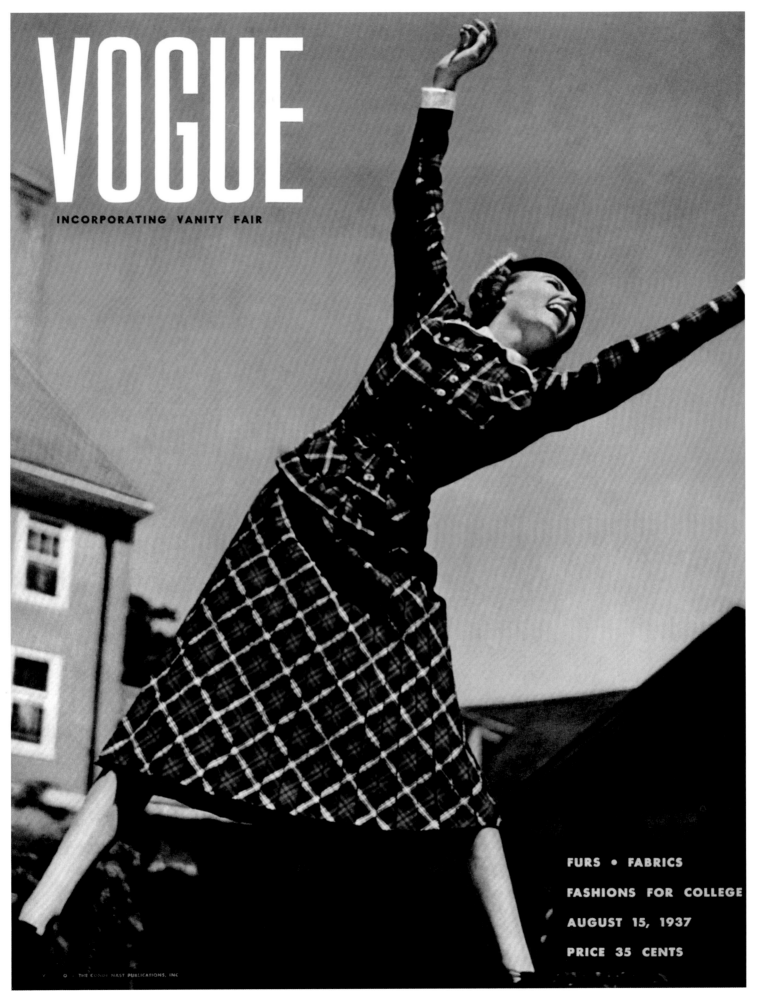

VOGUE

INCORPORATING VANITY FAIR

FURS • FABRICS

FASHIONS FOR COLLEGE

AUGUST 15, 1937

PRICE 35 CENTS

AUGUST 15, 1937
PHOTOGRAPH BY TONI FRISSELL

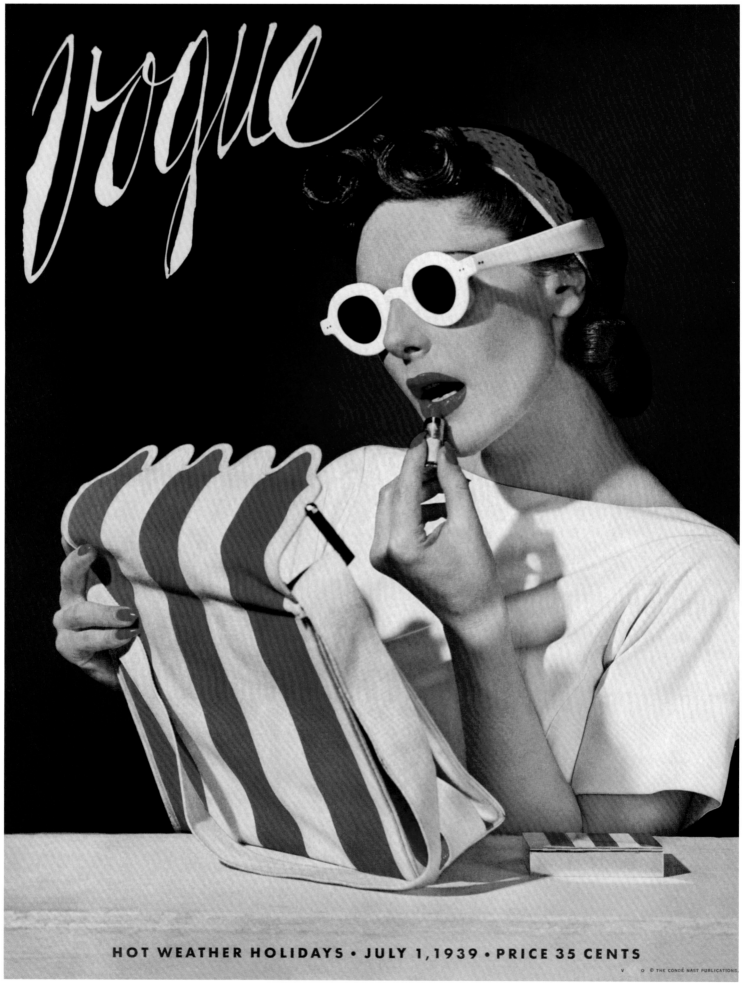

Vogue

HOT WEATHER HOLIDAYS · JULY 1, 1939 · PRICE 35 CENTS

JULY 1, 1939
PHOTOGRAPH OF MURIEL MAXWELL BY HORST P. HORST

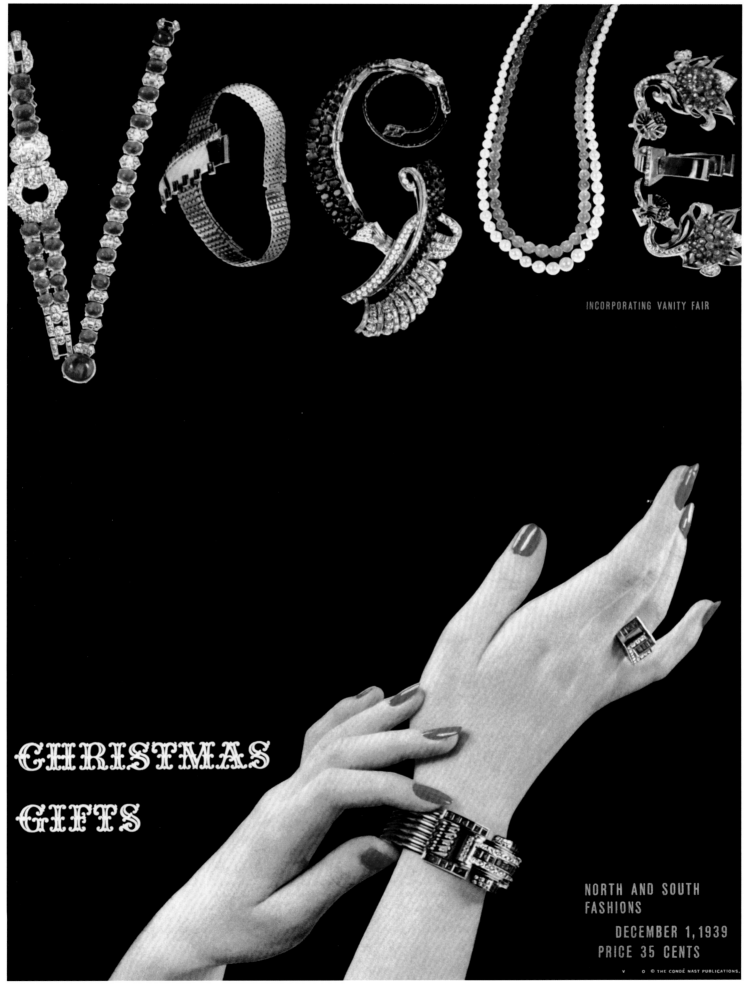

DECEMBER 1, 1939
PHOTOGRAPH BY ANTON BRUEHL

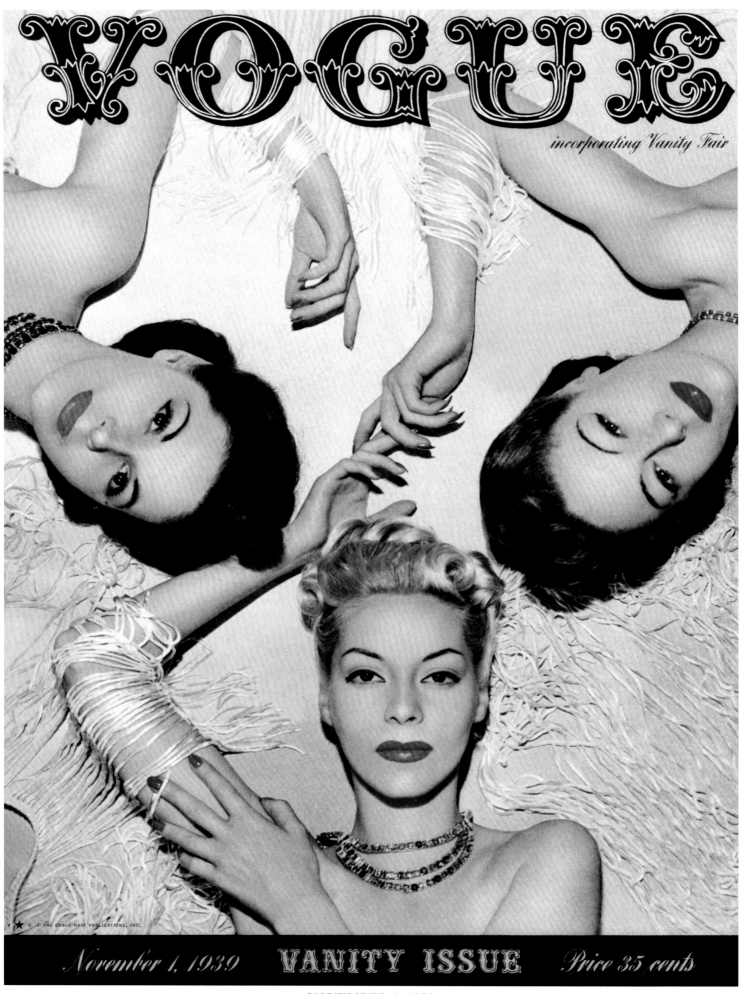

NOVEMBER 1, 1939
PHOTOGRAPH OF (FROM LEFT) BETTINA BOLEGARD, HELEN BENNETT, AND MURIEL MAXWELL BY HORST P. HORST

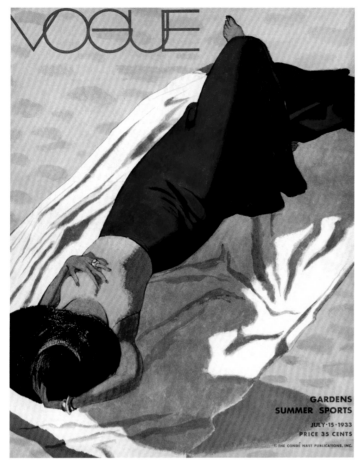

JULY 15, 1933

ILLUSTRATION BY PIERRE MOURGUE

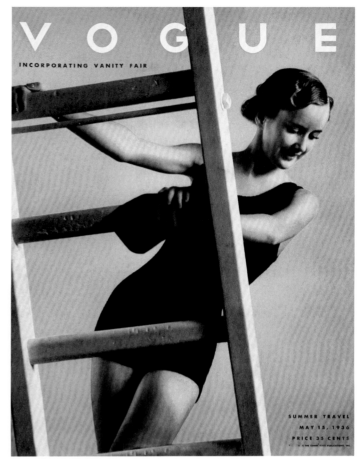

MAY 15, 1936

PHOTOGRAPH BY ANTON BRUEHL

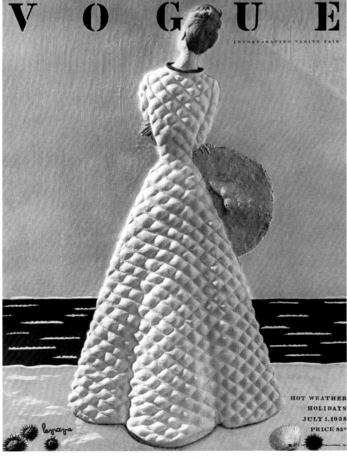

JULY 1, 1938

ILLUSTRATION BY GEORGES LEPAPE

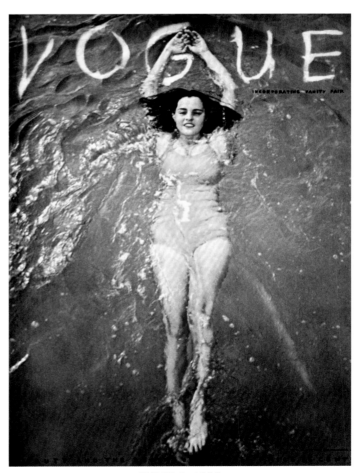

JUNE 1, 1938

PHOTOGRAPH BY IVAN DMITRI

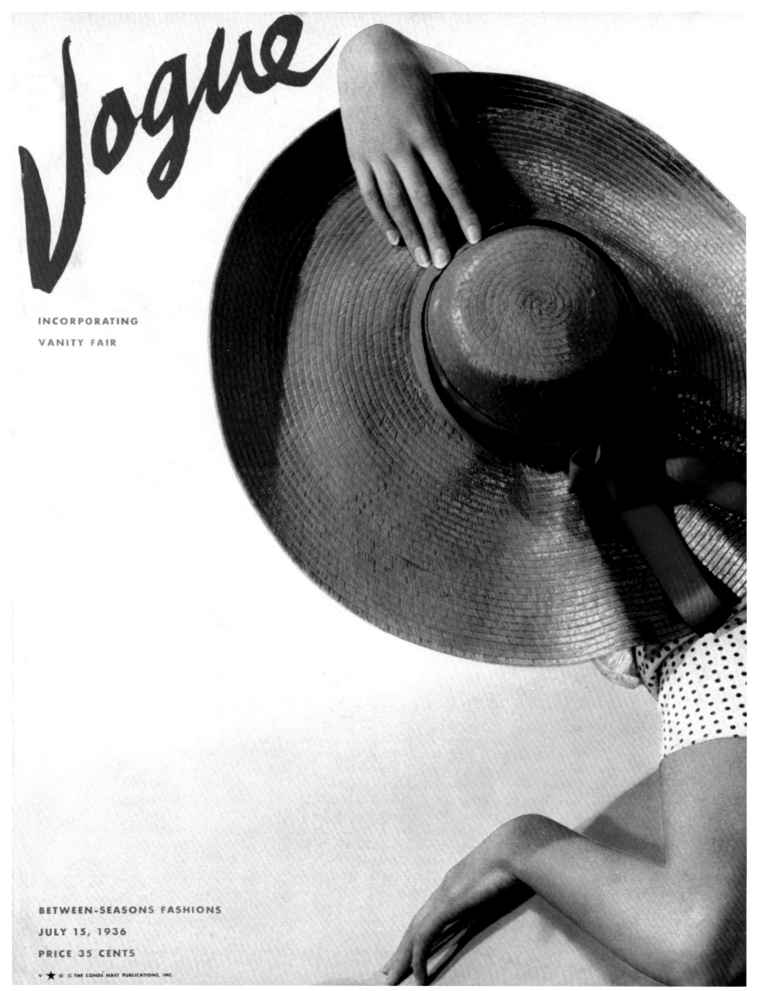

Vogue

INCORPORATING
VANITY FAIR

BETWEEN-SEASONS FASHIONS

JULY 15, 1936

PRICE 35 CENTS

JULY 15, 1936
PHOTOGRAPH BY HORST P. HORST

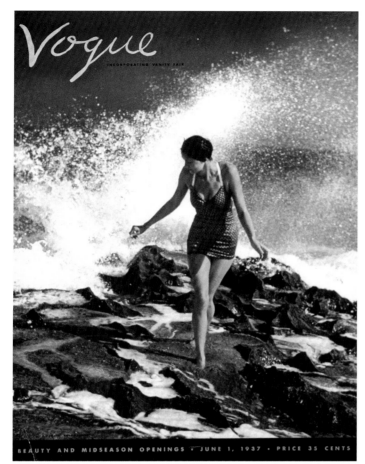

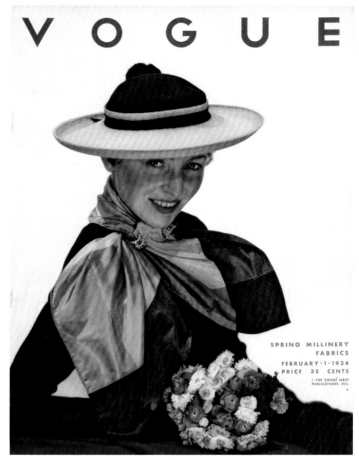

JUNE 1, 1937
PHOTOGRAPH BY TONI FRISSELL

FEBRUARY 1, 1934
PHOTOGRAPH BY GEORGE HOYNINGEN-HUENE

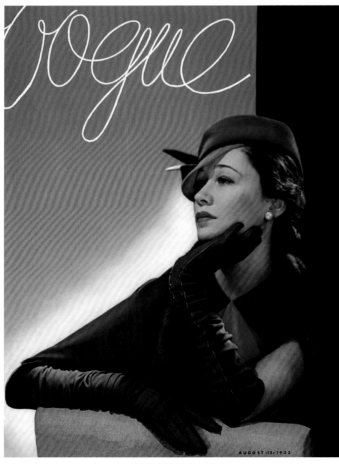

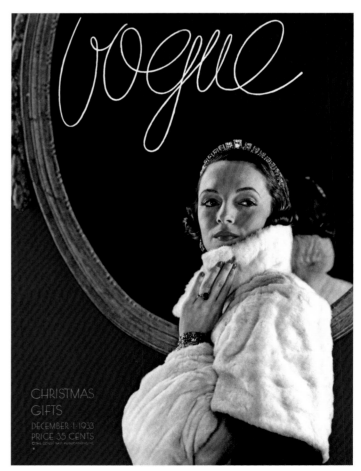

AUGUST 15, 1933
PHOTOGRAPH BY GEORGE HOYNINGEN-HUENE

DECEMBER 1, 1933
PHOTOGRAPH BY EDWARD STEICHEN

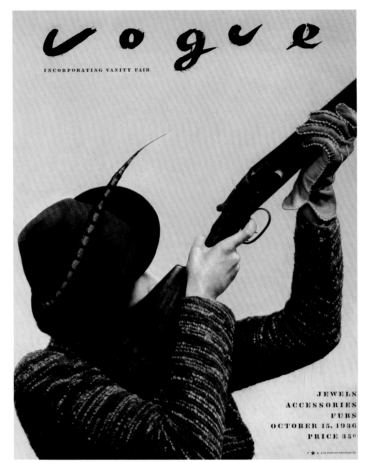

OCTOBER 15, 1936
PHOTOGRAPH BY BRUEHL-BOURGES

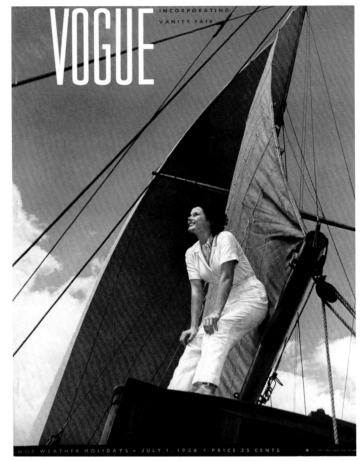

JULY 1, 1936
PHOTOGRAPH BY ANTON BRUEHL

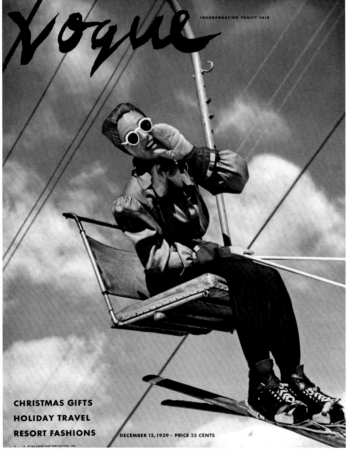

DECEMBER 15, 1939
PHOTOGRAPH BY TONI FRISSELL

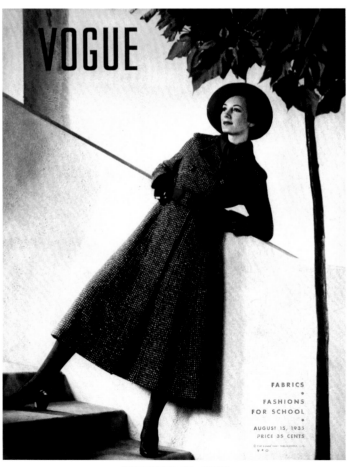

AUGUST 15, 1935
PHOTOGRAPH BY ANTON BRUEHL

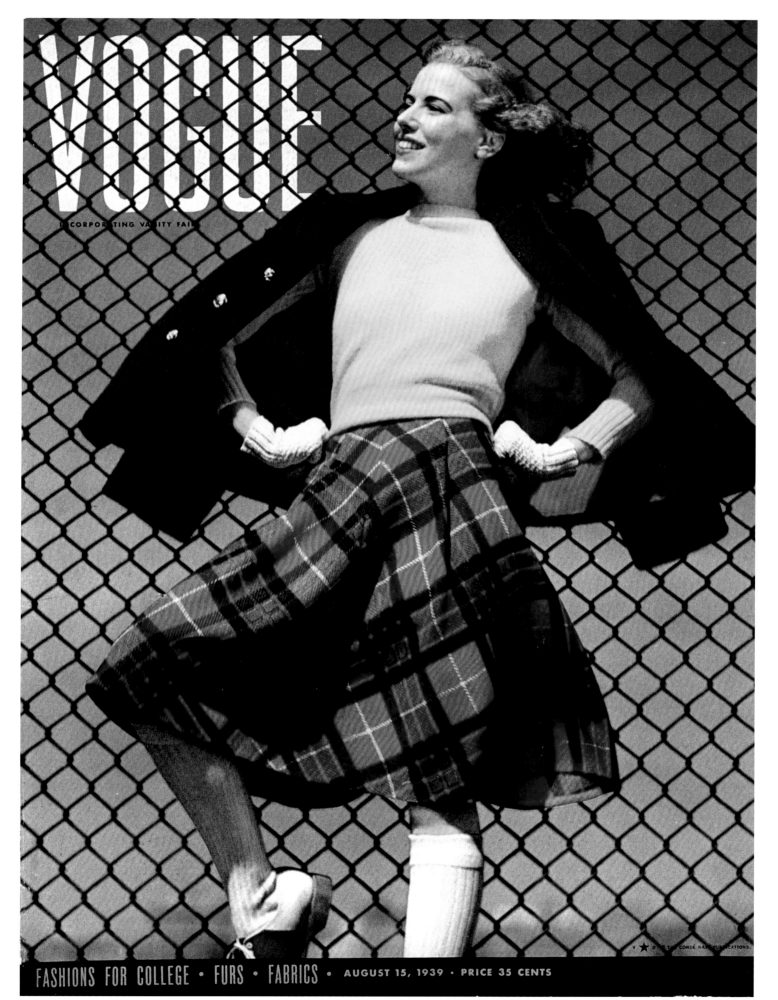

AUGUST 15, 1939
PHOTOGRAPH BY ANDRE DE DIENES

'40s

I'LL BE SEEING YOU

Men go to war, women go to work. . . . Hepburn, Garbo, and Dietrich wear pants and shoulder pads on and off the screen. . . . With Paris couture shut down, Claire McCardell and other American designers come front and center. . . . European artists sitting out the war in New York help galvanize Abstract Expressionism (Jackson Pollock, Willem de Kooning, Franz Kline, and the New York School). . . . Enter the new jazz—bebop, rhythm and blues, and the genius of Charlie Parker, Dizzy Gillespie, Thelonious Monk, and Miles Davis. . . . Lisa Fonssagrives is the face of *Vogue,* appearing on five covers. . . . Frank Sinatra keeps them swooning. . . . Elizabeth Taylor makes a splash in *National Velvet.* . . . FDR dies. . . . The war is over. . . . Dr. Spock brings common sense to child rearing. . . . Dior's New Look takes over. . . . Jitterbug-crazy teenagers improvise their own moves. . . . Literary culture gets serious—Norman Mailer's *The Naked and the Dead,* George Orwell's *Nineteen Eighty-Four,* and Tennessee Williams's *A Streetcar Named Desire*—and Hollywood does, too: *Citizen Kane, Casablanca,* and *The Best Years of Our Lives.*

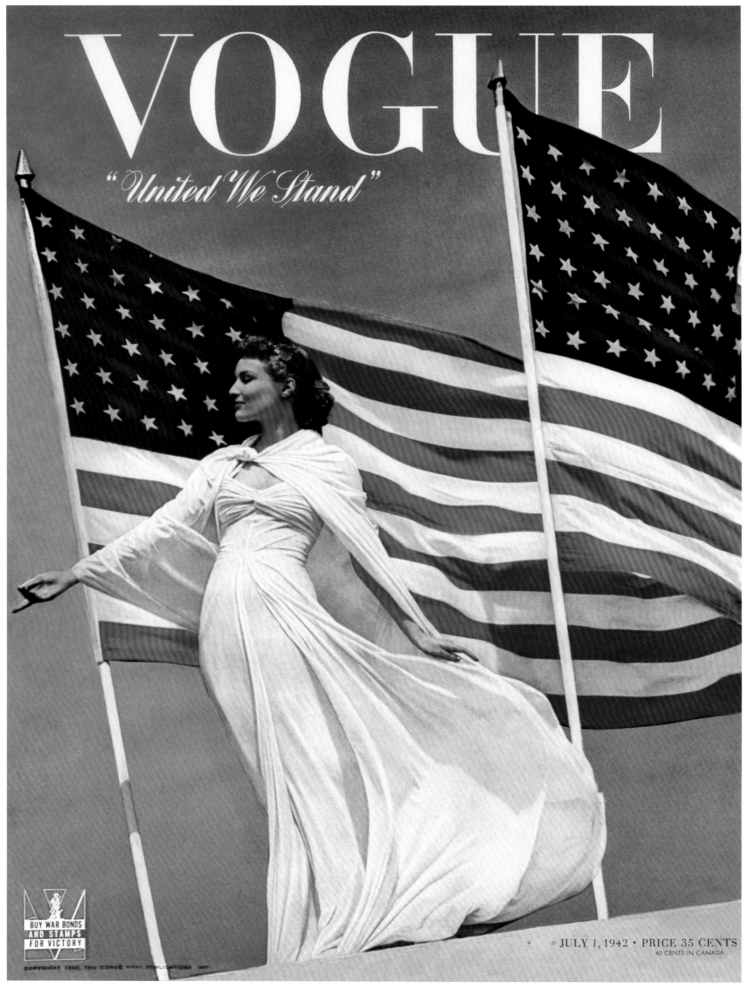

JULY 1, 1942
PHOTOGRAPH BY TONI FRISSELL

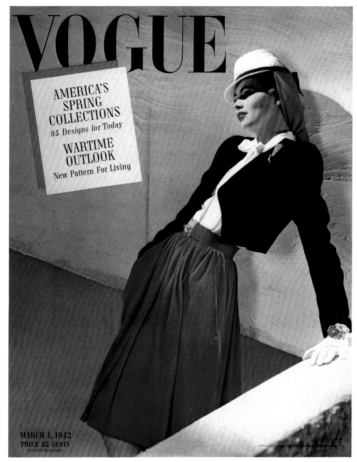

MARCH 1, 1942

PHOTOGRAPH BY HORST P. HORST

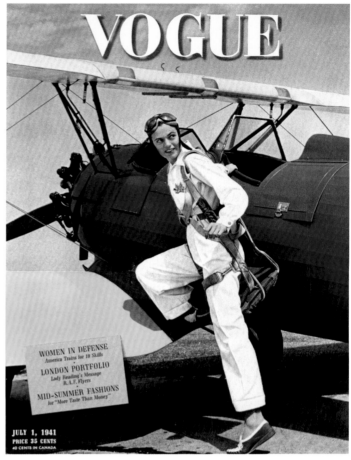

JULY 1, 1941

PHOTOGRAPH OF SANDY RICE BY TONI FRISSELL

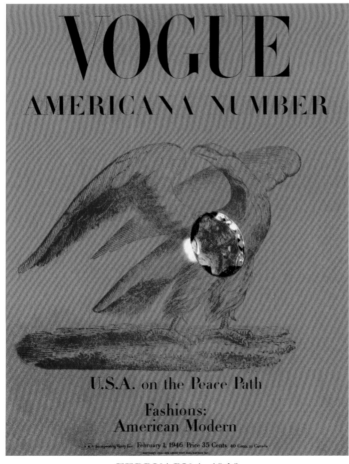

FEBRUARY 1, 1946

PHOTOGRAPH BY IRVING PENN

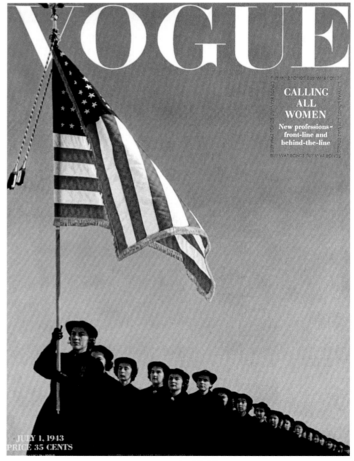

JULY 1, 1943

PHOTOGRAPH OF WAVES BY U.S. NAVY

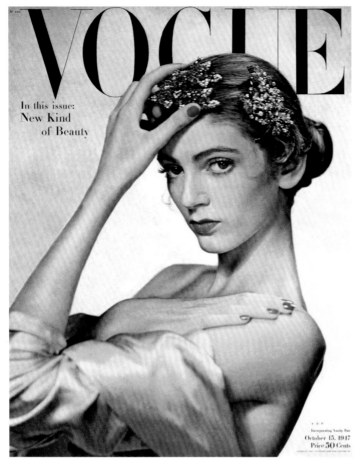

OCTOBER 15, 1947

PHOTOGRAPH OF CARMEN DELL'OREFICE BY ERWIN BLUMENFELD

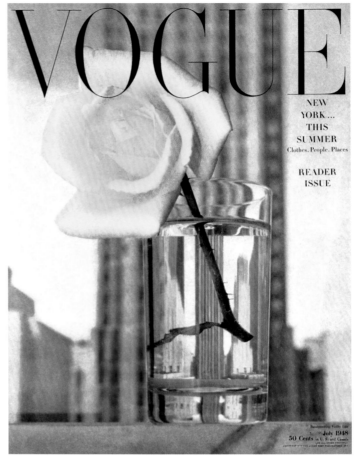

JULY 1, 1948

PHOTOGRAPH BY IRVING PENN

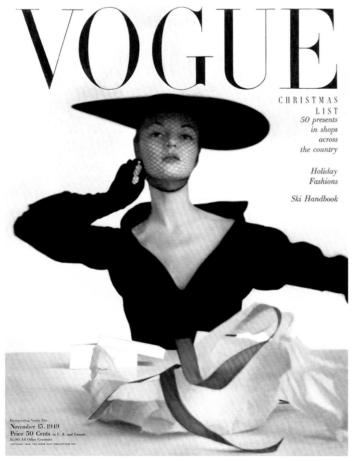

NOVEMBER 15, 1949

PHOTOGRAPH OF JEAN PATCHETT BY IRVING PENN

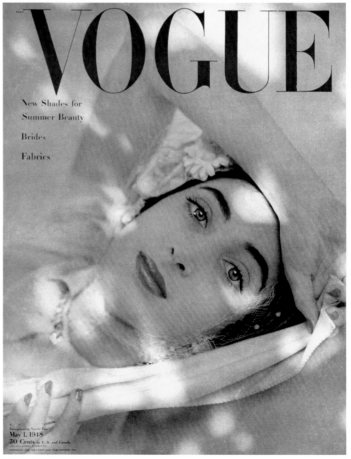

MAY 1, 1948

PHOTOGRAPH BY HERBERT MATTER

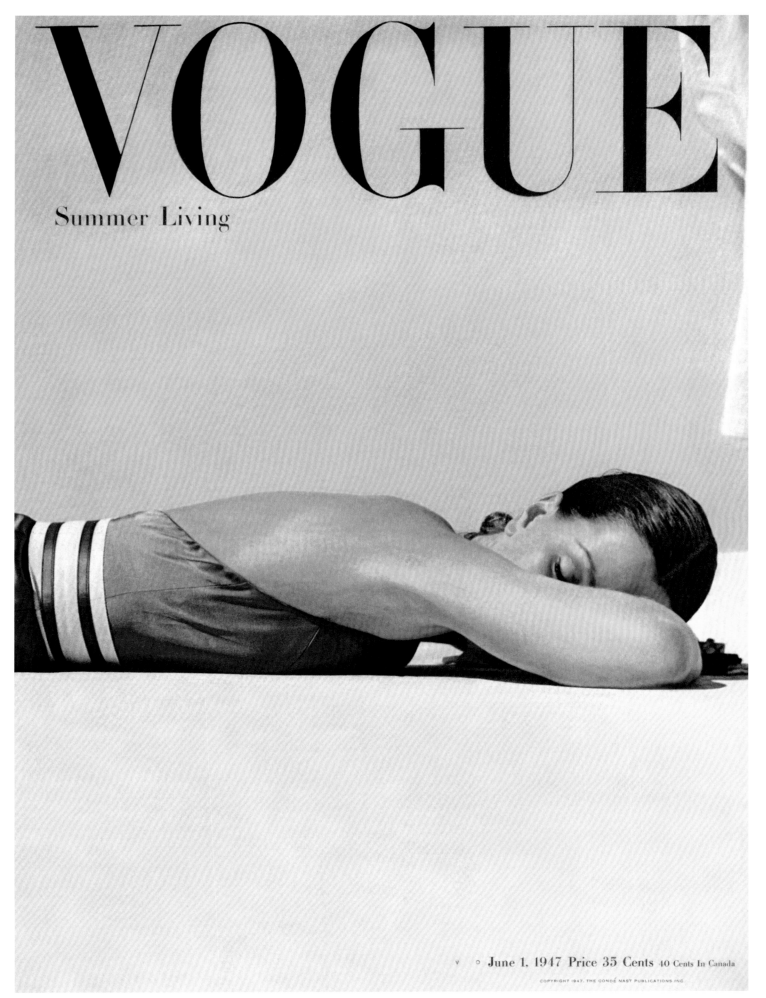

VOGUE

Summer Living

June 1, 1947 Price 35 Cents 40 Cents In Canada

JUNE 1, 1947
PHOTOGRAPH BY JOHN RAWLINGS

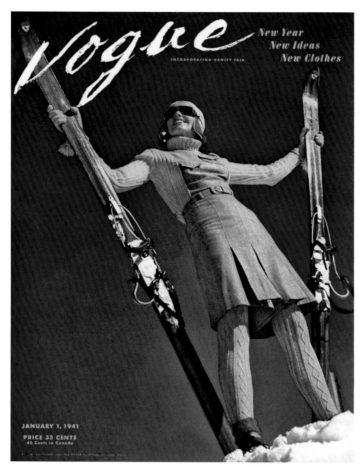

JANUARY 1, 1941
PHOTOGRAPH BY TONI FRISSELL

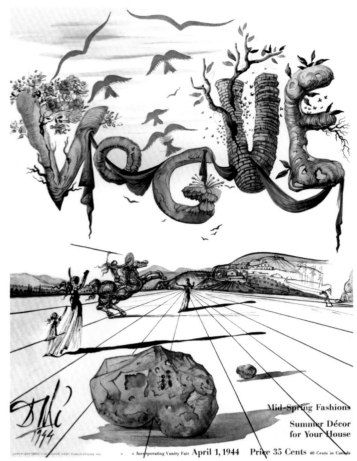

APRIL 1, 1944
ILLUSTRATION BY SALVADOR DALÍ

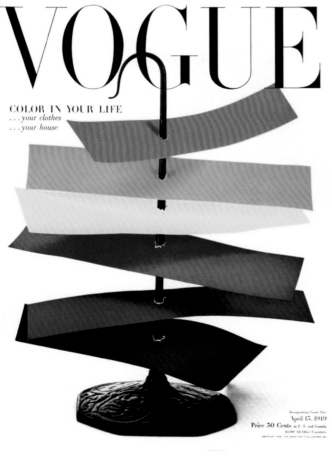

APRIL 15, 1949
PHOTOGRAPH UNCREDITED

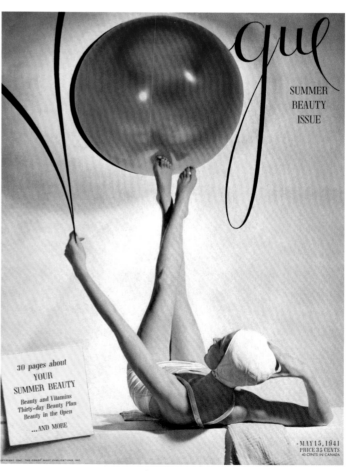

MAY 15, 1941
PHOTOGRAPH BY HORST P. HORST

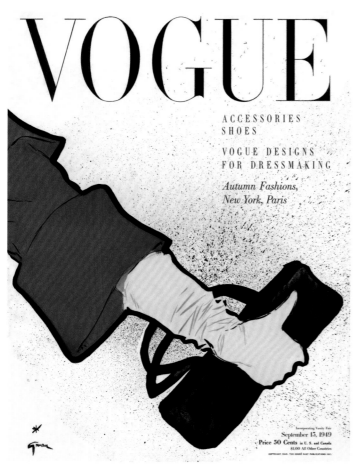

SEPTEMBER 15, 1949

ILLUSTRATION BY RENÉ GRUAU

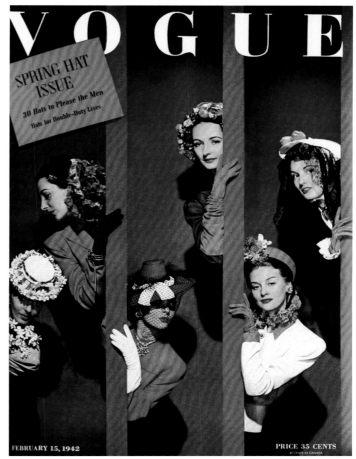

FEBRUARY 15, 1942

PHOTOGRAPH BY JOHN RAWLINGS

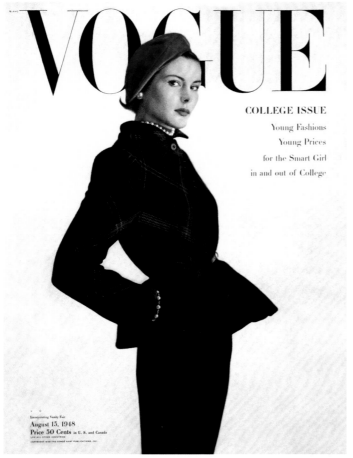

AUGUST 15, 1948

PHOTOGRAPH BY IRVING PENN

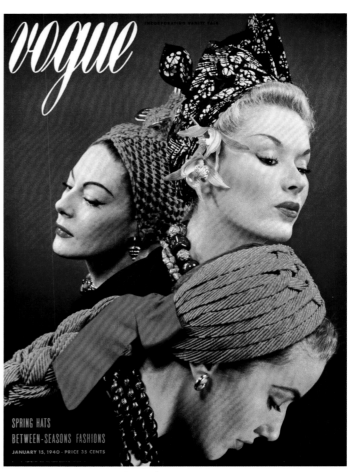

JANUARY 15, 1940

PHOTOGRAPH BY ANTON BRUEHL

VOGUE

Beauty Issue

Summer
Fashions

Incorporating Vanity Fair

May 1945

Price 35 Cents

40 Cents In Canada

Vogue is regularly published twice a month. Because of wartime emergencies, it will be published once a month during May, June, July.

MAY 1945
PHOTOGRAPH BY ERWIN BLUMENFELD

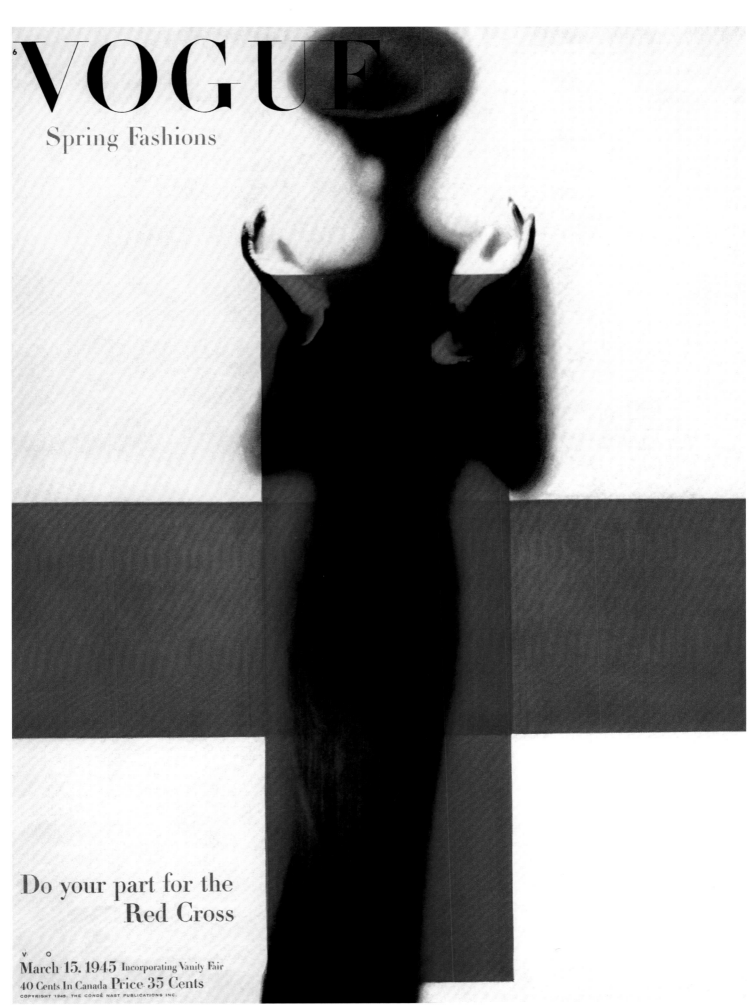

VOGUE

Spring Fashions

Do your part for the
Red Cross

March 15. 1945 Incorporating Vanity Fair
40 Cents In Canada Price 35 Cents
COPYRIGHT 1945, THE CONDÉ NAST PUBLICATIONS INC.

MARCH 15, 1945
PHOTOGRAPH BY ERWIN BLUMENFELD

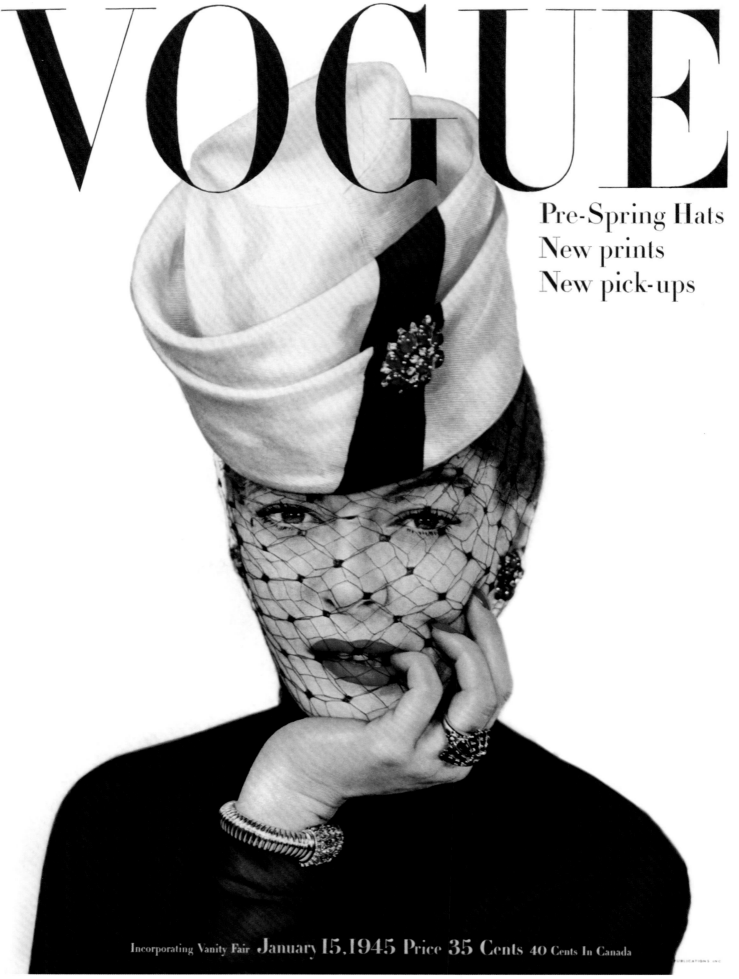

VOGUE

Pre-Spring Hats
New prints
New pick-ups

Incorporating Vanity Fair January 15, 1945 Price 35 Cents 40 Cents In Canada

JANUARY 15, 1945
PHOTOGRAPH OF MURIEL MAXWELL BY ERWIN BLUMENFELD

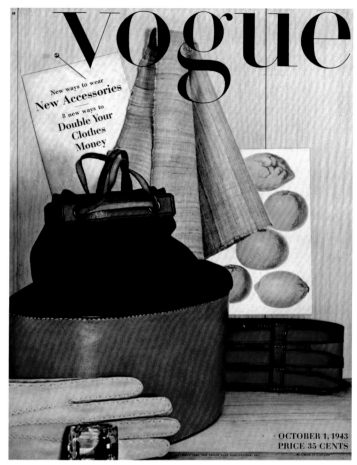

OCTOBER 1, 1943
PHOTOGRAPH BY IRVING PENN

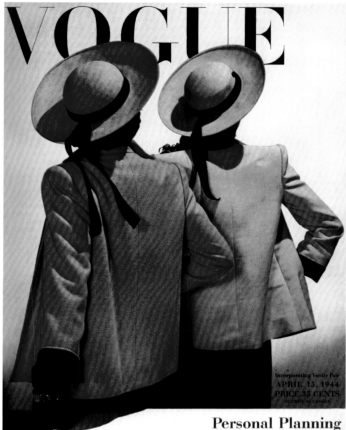

APRIL 15, 1944
PHOTOGRAPH BY JOHN RAWLINGS

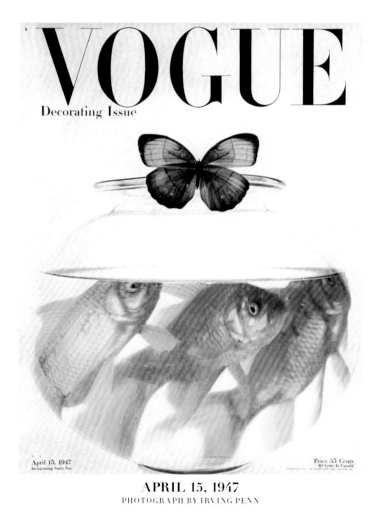

APRIL 15, 1947
PHOTOGRAPH BY IRVING PENN

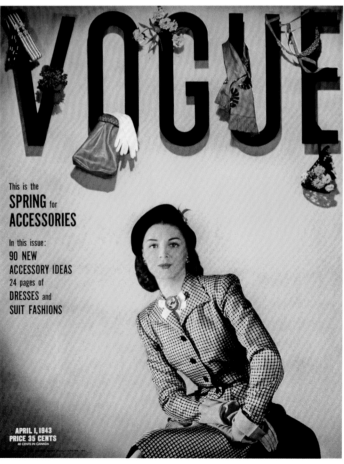

APRIL 1, 1943
PHOTOGRAPH BY JOHN RAWLINGS

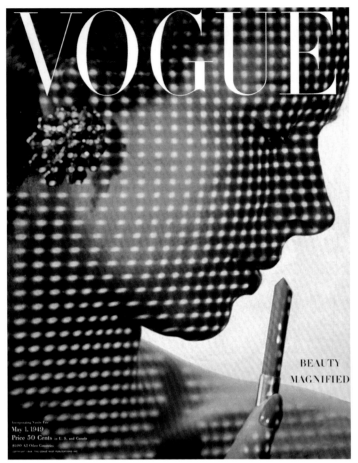

MAY 1, 1949

PHOTOGRAPH BY ERWIN BLUMENFELD

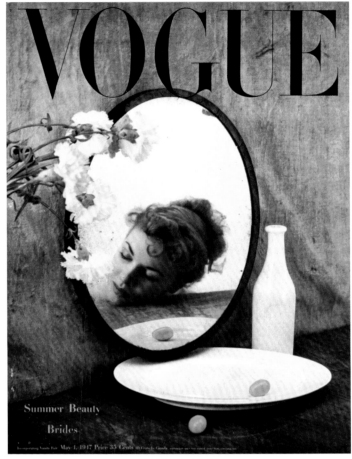

MAY 1, 1947

PHOTOGRAPH BY IRVING PENN

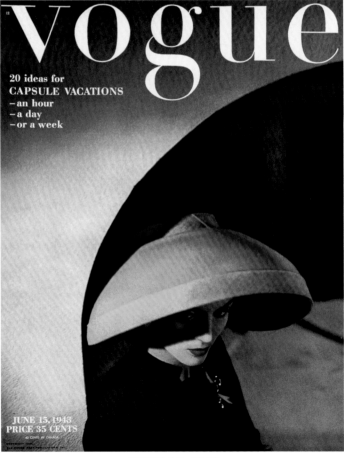

JUNE 15, 1943

PHOTOGRAPH BY HORST P. HORST

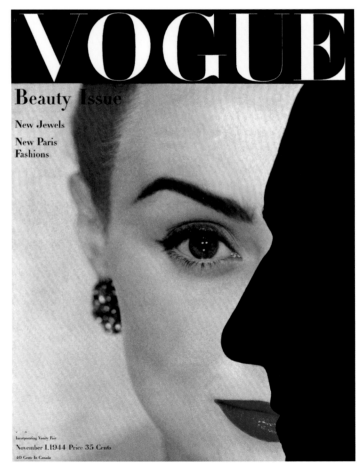

NOVEMBER 1, 1944

PHOTOGRAPH BY ERWIN BLUMENFELD

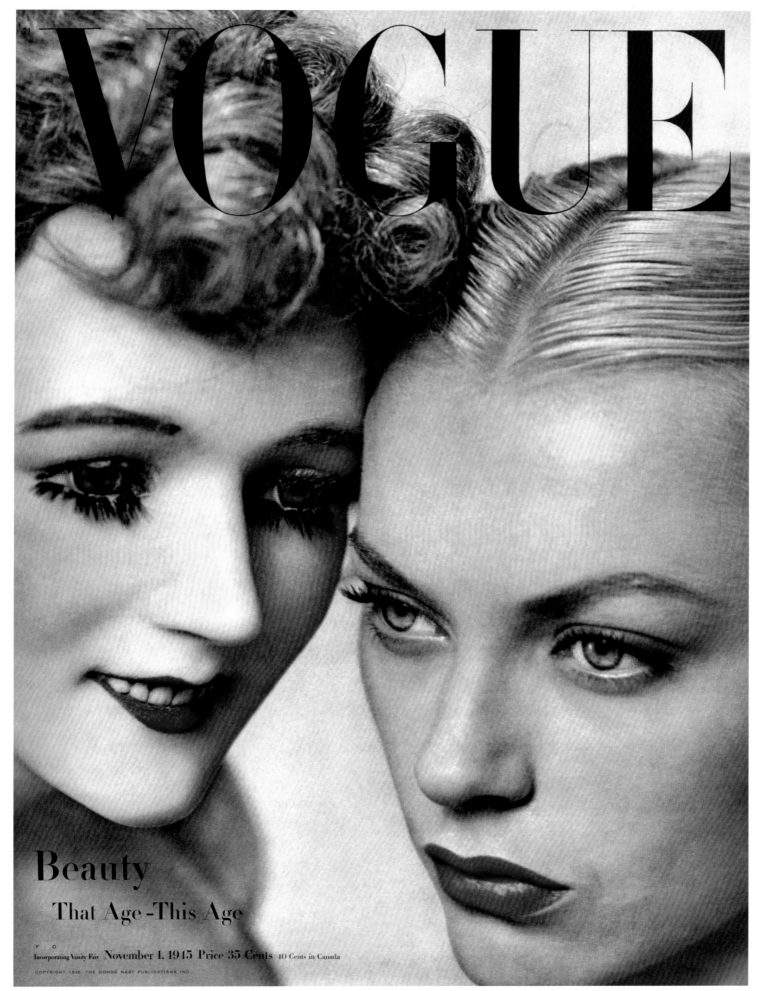

VOGUE

Beauty

That Age -This Age

Incorporating Vanity Fair November 1, 1945 Price 35 Cents 40 Cents in Canada

NOVEMBER 1, 1945
PHOTOGRAPH BY ERWIN BLUMENFELD

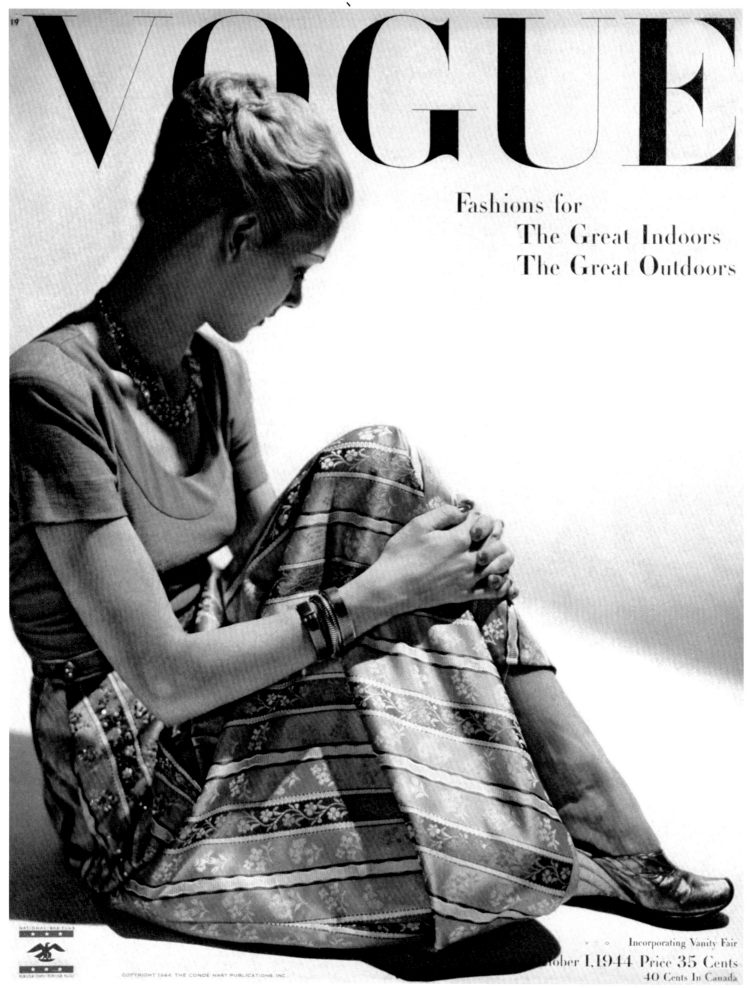

VOGUE

Fashions for
The Great Indoors
The Great Outdoors

Incorporating Vanity Fair

October 1, 1944 Price 35 Cents
40 Cents In Canada

OCTOBER 1, 1944
PHOTOGRAPH BY CONSTANTIN JOFFÉ

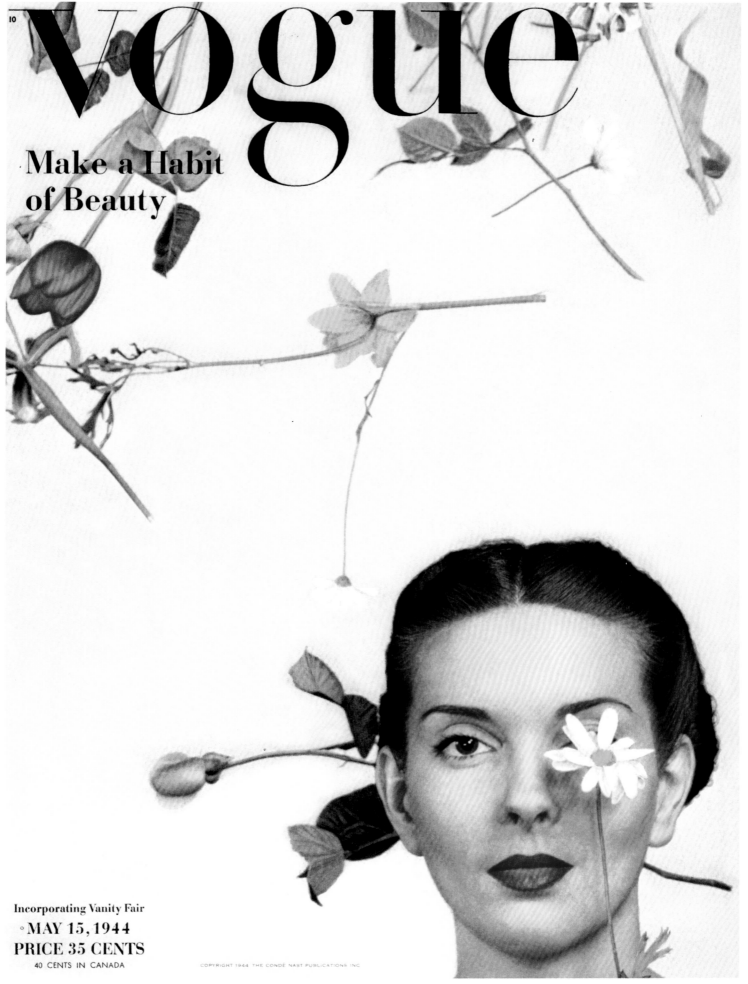

Vogue

10

Make a Habit of Beauty

Incorporating Vanity Fair

MAY 15, 1944

PRICE 35 CENTS

40 CENTS IN CANADA

MAY 15, 1944
PHOTOGRAPH OF BETTINA BOLEGARD BY GJON MILI

VOGUE

AN EYE TOWARD AUTUMN:

NEW COLOUR HANDBOOK
OF
FURS—FABRICS—SHOES

Incorporating Vanity Fair
August 1, 1949
Price 50 Cents in U. S. and Canada
$1.00 All Other Countries
COPYRIGHT 1949, THE CONDÉ NAST PUBLICATIONS INC.

AUGUST 1, 1949
PHOTOGRAPH OF SUE JENKS BY JOHN RAWLINGS

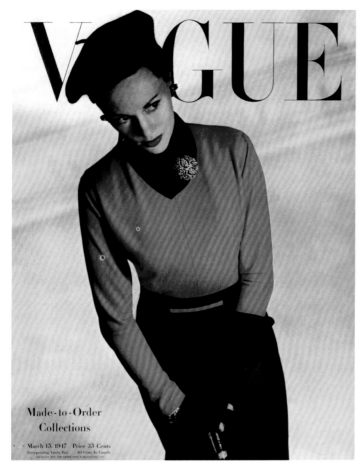

MARCH 15, 1947

PHOTOGRAPH OF MEG MUNDY BY HORST P. HORST

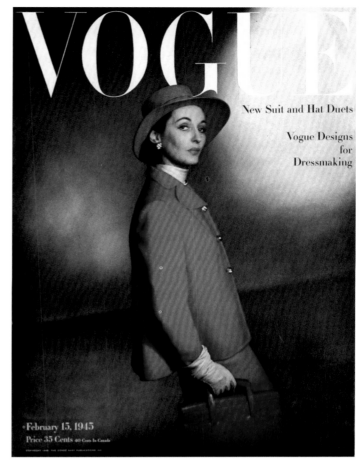

FEBRUARY 15, 1945

PHOTOGRAPH OF BETTY McLAUCHLEN DORSO BY HORST P. HORST

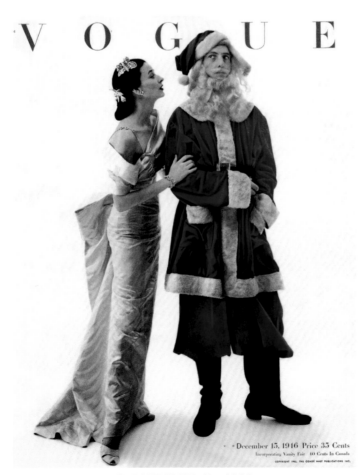

DECEMBER 15, 1946

PHOTOGRAPH OF DORIAN LEIGH (LEFT) AND RAY BOLGER BY IRVING PENN

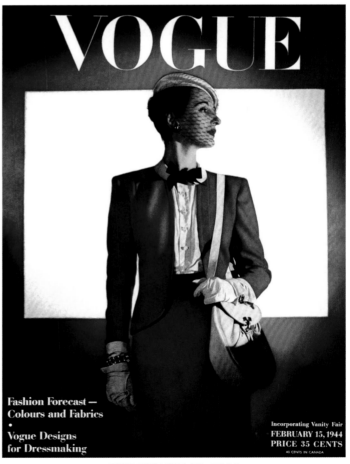

FEBRUARY 15, 1944

PHOTOGRAPH OF MURIEL MAXWELL BY JOHN RAWLINGS

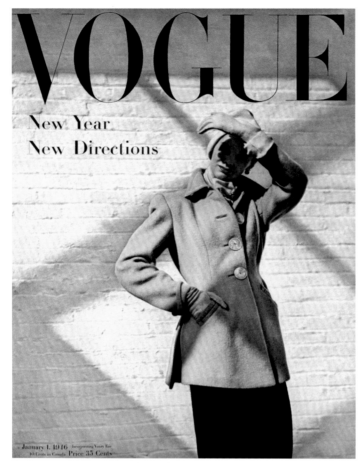

JANUARY 1, 1946

PHOTOGRAPH OF NATALIE PAINE BY JOHN RAWLINGS

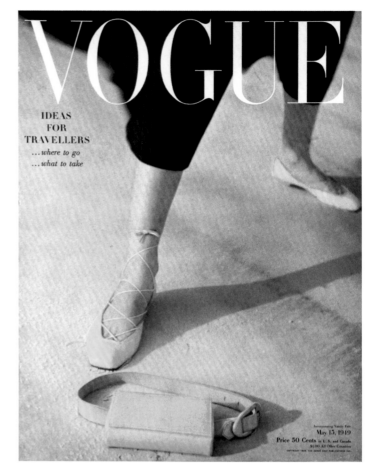

MAY 15, 1949

PHOTOGRAPH BY SERGE BALKIN

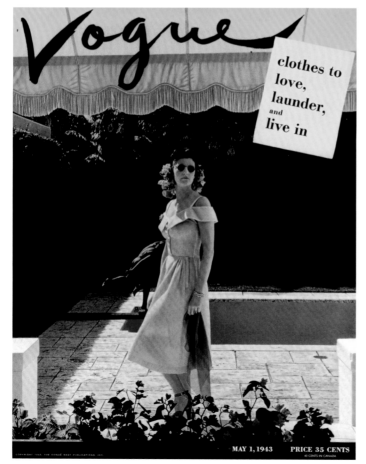

MAY 1, 1943

PHOTOGRAPH BY JOHN RAWLINGS

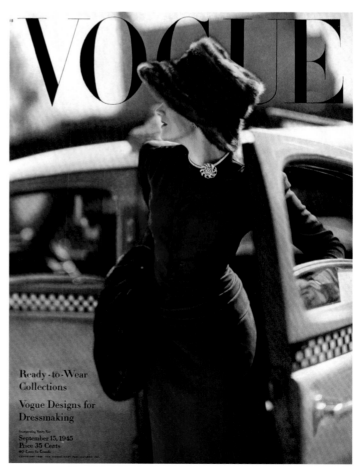

SEPTEMBER 15, 1945

PHOTOGRAPH BY CONSTANTIN JOFFÉ

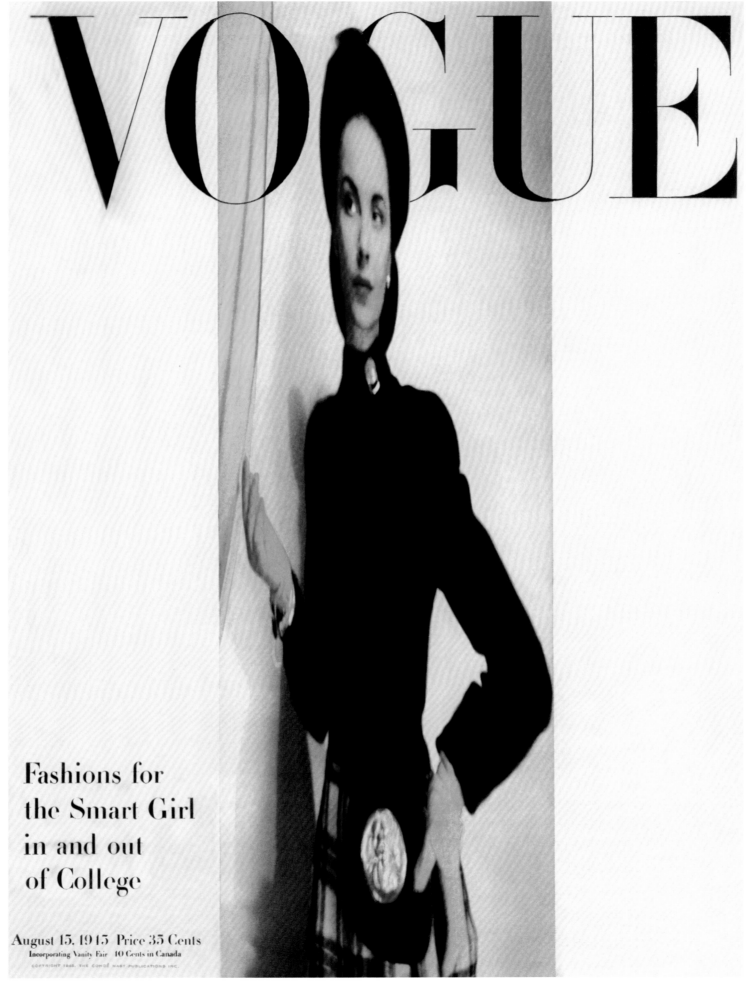

VOGUE

Fashions for
the Smart Girl
in and out
of College

August 15, 1945 Price 35 Cents
Incorporating Vanity Fair 40 Cents in Canada
COPYRIGHT 1945, THE CONDÉ NAST PUBLICATIONS INC.

AUGUST 15, 1945
PHOTOGRAPH BY ERWIN BLUMENFELD

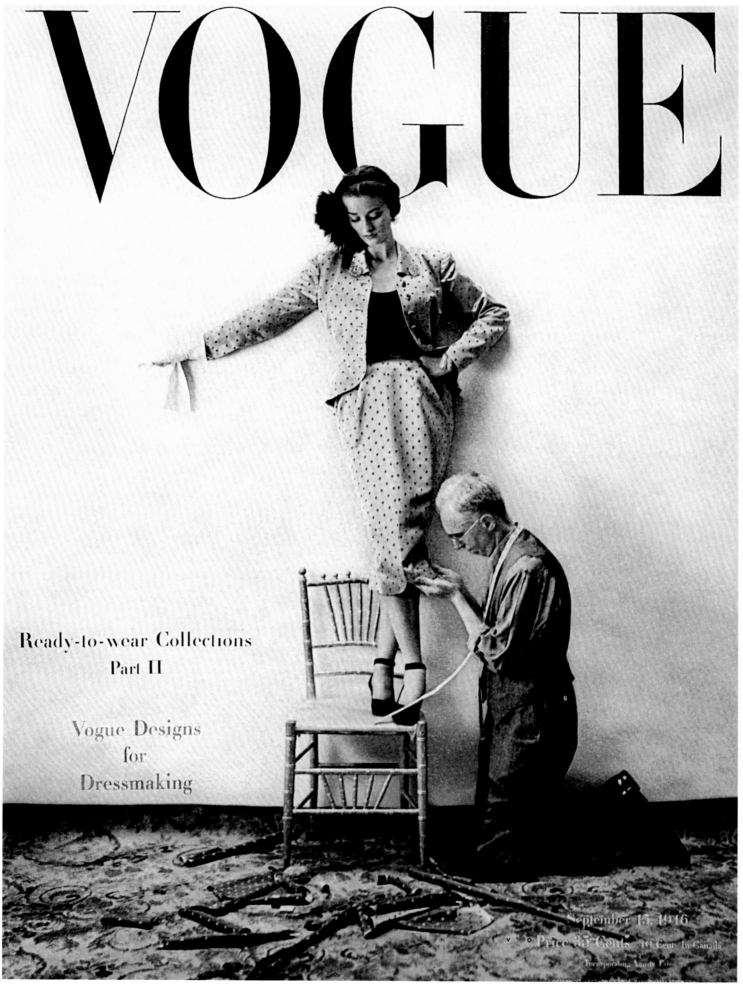

VOGUE

Ready-to-wear Collections
Part II

Vogue Designs
for
Dressmaking

September 15, 1946
Price 35 Cents 40 Cents in Canada
Incorporating Vanity Fair

SEPTEMBER 15, 1946
PHOTOGRAPH OF DORIAN LEIGH BY IRVING PENN

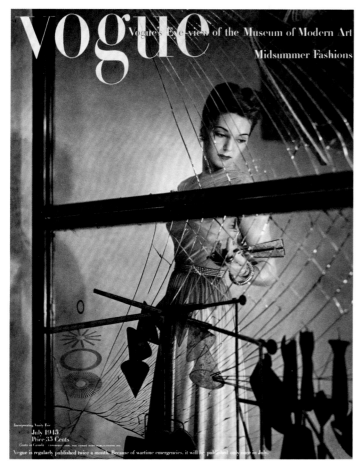

JULY 1945
PHOTOGRAPH BY ERWIN BLUMENFELD

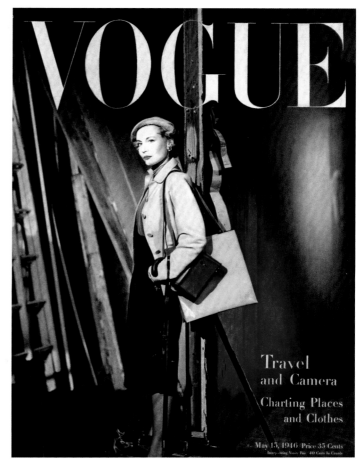

MAY 15, 1946
PHOTOGRAPH BY CECIL BEATON

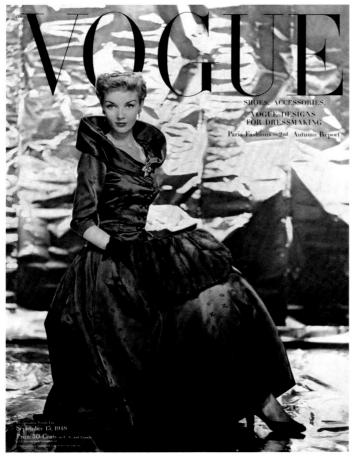

SEPTEMBER 15, 1948
PHOTOGRAPH BY ERWIN BLUMENFELD

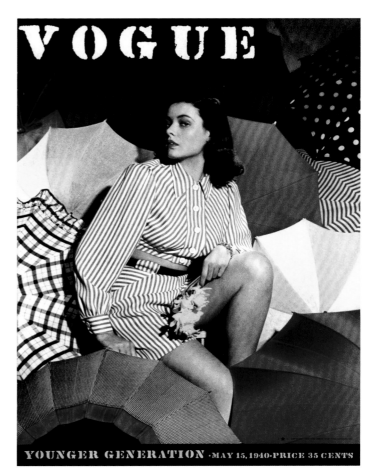

MAY 15, 1940
PHOTOGRAPH OF GENE TIERNEY BY HORST P. HORST

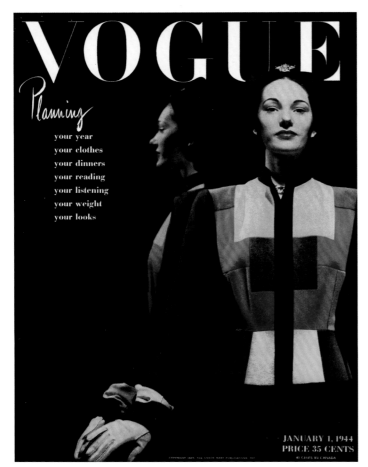

JANUARY 1, 1944

PHOTOGRAPH OF MARILYN AMBROSE BY JOHN RAWLINGS

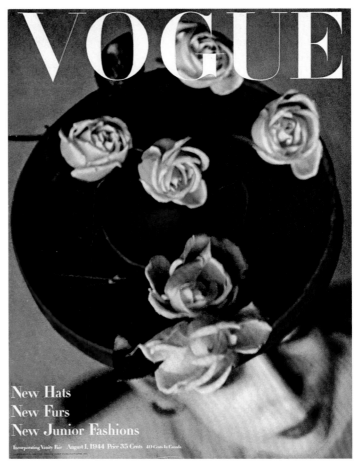

AUGUST 1, 1944

PHOTOGRAPH BY JOHN RAWLINGS

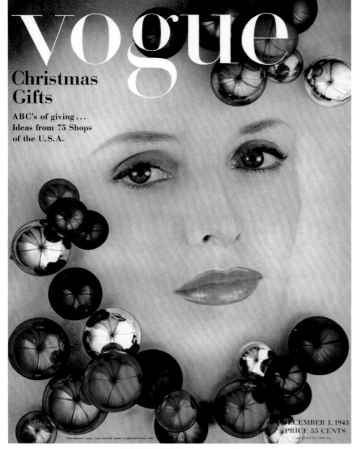

DECEMBER 1, 1943

PHOTOGRAPH BY IRVING PENN

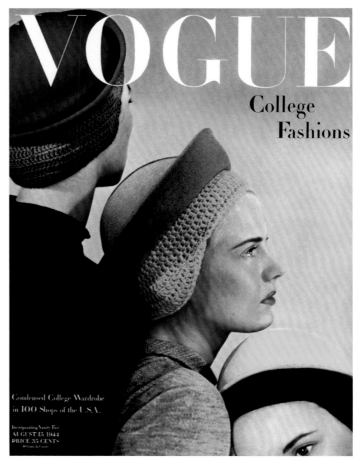

AUGUST 15, 1944

PHOTOGRAPH BY ERWIN BLUMENFELD

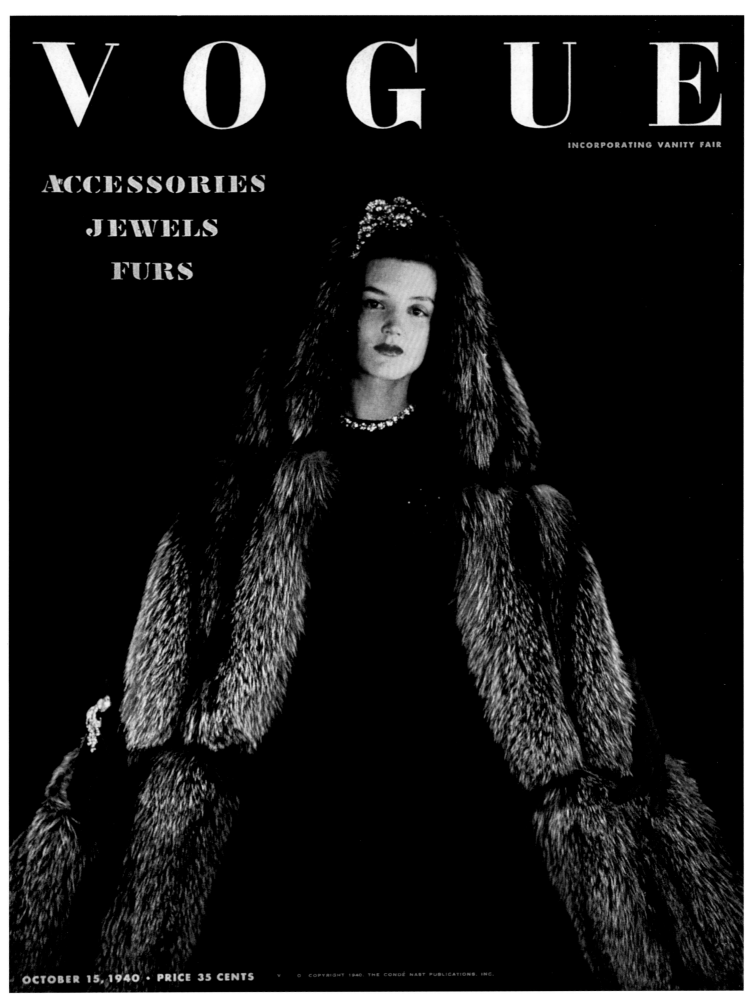

OCTOBER 15, 1940
PHOTOGRAPH BY HORST P. HORST

VOGUE

College Issue

Fashions for the Smart Girl

in and out of College

Incorporating Vanity Fair August 15, 1946 Price 35 Cents 40 Cents In Canada

COPYRIGHT 1946. THE CONDÉ NAST PUBLICATIONS INC.

AUGUST 15, 1946
PHOTOGRAPH BY IRVING PENN

VOGUE

MADE-TO-ORDER FASHIONS
AMERICAN · FRENCH

READY-TO-WEAR FASHIONS
MANY UNDER $100

Incorporating Vanity Fair
October 1, 1948
Price 50 Cents in U.S. and Canada
AND ALL OTHER COUNTRIES
COPYRIGHT 1948 THE CONDE NAST PUBLICATIONS, INC.

OCTOBER 1, 1948
ILLUSTRATION BY CARL ERICKSON

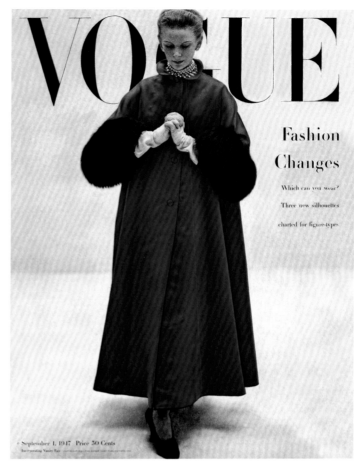

VOGUE

Fashion

Changes

Which can you wear?

Three new silhouettes

charted for figure-types

· September 1, 1947 · Price 50 Cents
Incorporating Vanity Fair · COPYRIGHT 1947 THE CONDE NAST PUBLICATIONS, INC.

SEPTEMBER 1, 1947
PHOTOGRAPH BY IRVING PENN

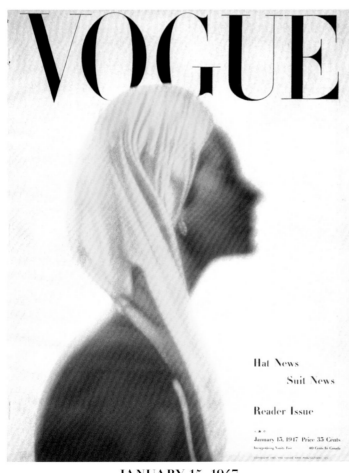

VOGUE

Hat News

Suit News

Reader Issue

· · ✶ ·
January 15, 1947 · Price 35 Cents
Incorporating Vanity Fair · 40 Cents In Canada
COPYRIGHT 1947 THE CONDE NAST PUBLICATIONS, INC.

JANUARY 15, 1947
PHOTOGRAPH BY RICHARD RUTLEDGE

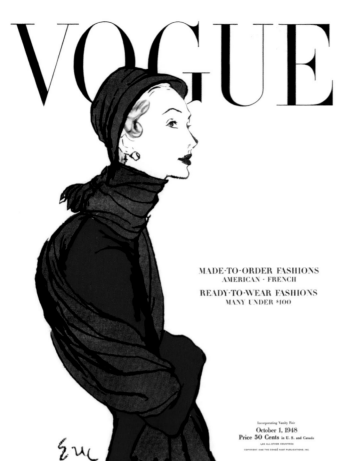

VOGUE

Decorating Issue
TASTE and TASTE
in fashions and furniture

Price 35 Cents · April 15, 1945
40 Cents In Canada Incorporating Vanity Fair
COPYRIGHT 1945 THE CONDE NAST PUBLICATIONS, INC.

APRIL 15, 1945
PHOTOGRAPH BY JOHN RAWLINGS

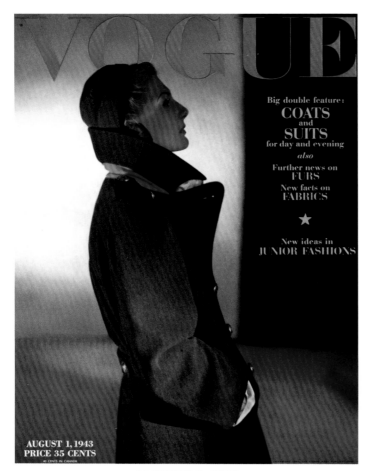

AUGUST 1, 1943

PHOTOGRAPH BY HORST P. HORST

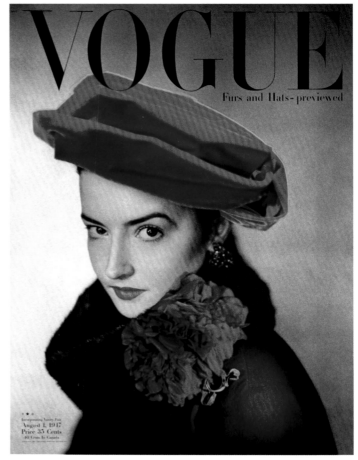

AUGUST 1, 1947

PHOTOGRAPH BY ERWIN BLUMENFELD

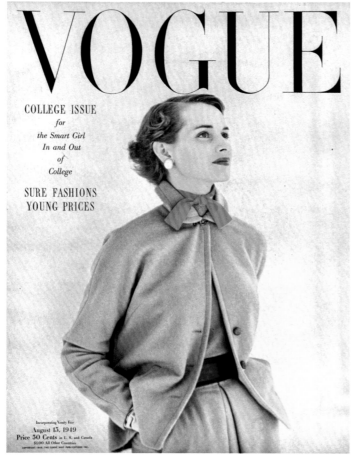

AUGUST 15, 1949

PHOTOGRAPH OF SUE JENKS BY JOHN RAWLINGS

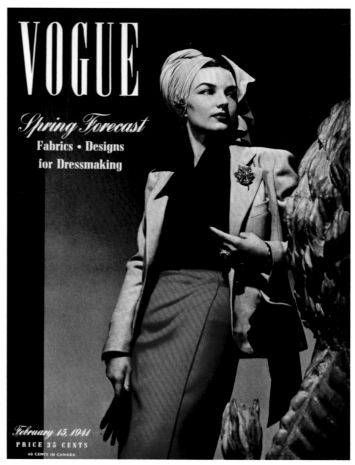

FEBRUARY 15, 1941

PHOTOGRAPH BY JOHN RAWLINGS

VOGUE

What to wear with what
New accessories
for changing fashions

Vogue designs for dressmaking

V O

September 15, 1947 Price 50 Cents Incorporating Vanity Fair

SEPTEMBER 15, 1947
PHOTOGRAPH OF KITTY KOPET BY RICHARD RUTLEDGE

VOGUE VOGUE VOGUE

VOGUE VOGUE

SUMMER

VOGUE

VOGUE

21 ANC NOV. 1

VOGUE

CHRISTMAS PRESENT
TIMETABLE

CLOTHES FOR
THE PARTIES

PARIS COPIES

5 Wardrobes for
5 Different Kinds of Wee

ION FORECAST

Influential New Woollens
Furs...Hats

4 Vogue Patterns
with the new wide skirt

'50s

HIGH SOCIETY

Salvador Dalí and Christian Dior design each other's costumes for "the party of the century"—Charles de Beistegui's masked costume ball in Venice. . . . TV arrives in force: Milton Berle, Ed Sullivan, the Mouseketeers, and TV dinners. . . . Holden Caulfield immortalizes adolescent angst in J. D. Salinger's *Catcher in the Rye.* . . . Grace Kelly defines mid-century glamour on-screen, then breaks our hearts by marrying Monaco's Prince Rainier. . . . Hermès's Kelly bag becomes the new "It" bag. . . . Elsa Maxwell launches the first annual April in Paris Ball at the Waldorf-Astoria. . . . E. B. White captivates young and old with *Charlotte's Web.* . . . James Dean bares his soul in *Rebel Without a Cause,* and Brigitte Bardot bares everything else in *And God Created Woman.* . . . Eliza Doolittle dances all night in *My Fair Lady.* . . . Anne Frank's diary brings home the Holocaust. . . . Rosa Parks refuses to give up her seat on a bus in Montgomery, Alabama. . . . Mary Quant opens a boutique on the King's Road, and Coco Chanel reopens hers on the Rue Cambon. . . . Christian Dior dies; Yves Saint Laurent takes command. . . . *I Love Lucy.* . . . Humbert Humbert loves Lolita. . . . We all love the pink Princess phone and the strapless princess silhouette. . . . Barbie is born. . . . Leo Castelli shows Jasper Johns and Robert Rauschenberg. . . . Everything is in motion: hula hoops and Elvis Presley's hips, Marilyn Monroe's windblown white halter dress in *The Seven Year Itch,* Sputnik, Frank Lloyd Wright's spiraling Guggenheim, skateboards, Jack Kerouac's *On the Road.* . . . Audrey Hepburn in Givenchy, forever.

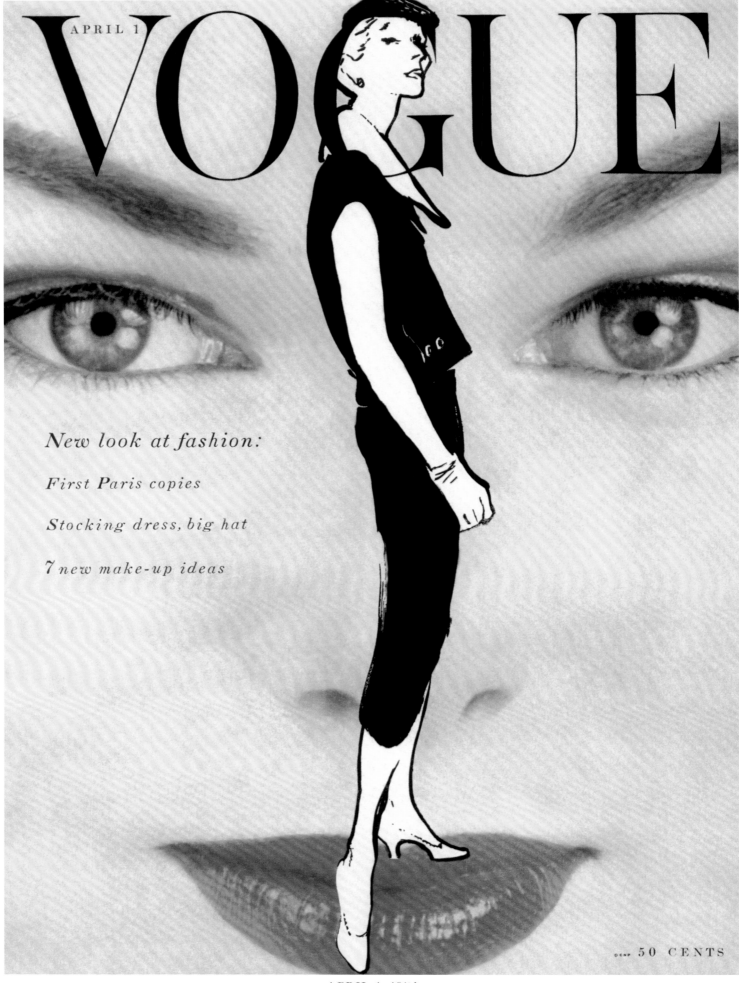

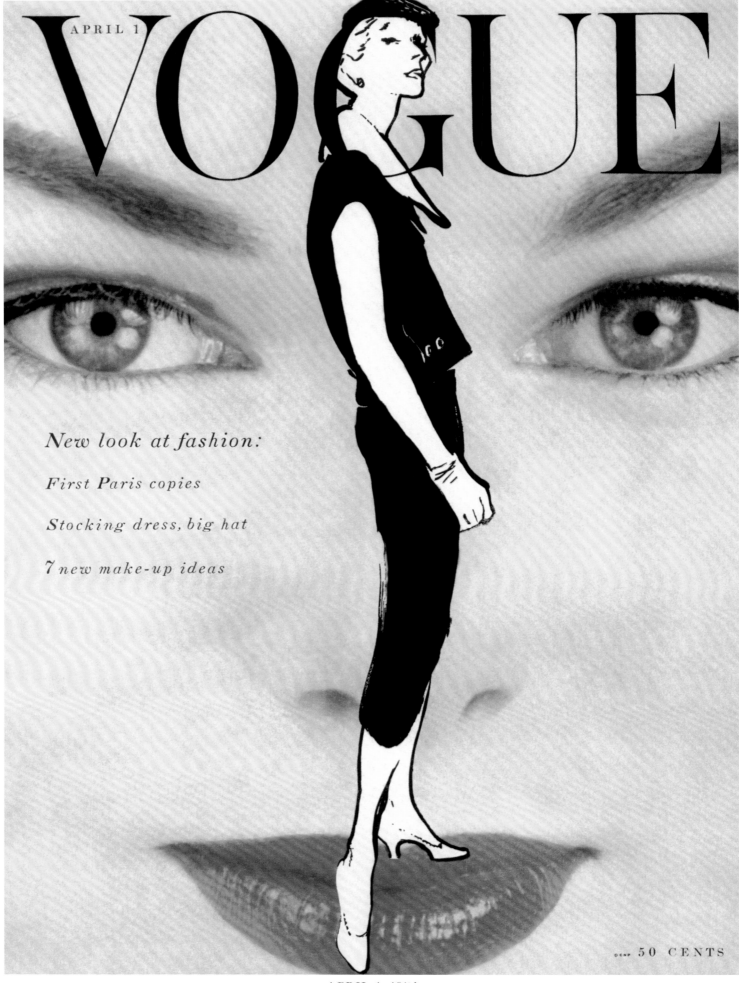APRIL 1

VOGUE

50 CENTS

New look at fashion:

First Paris copies

Stocking dress, big hat

7 new make-up ideas

APRIL 1, 1954
PHOTOGRAPH BY ERWIN BLUMENFELD

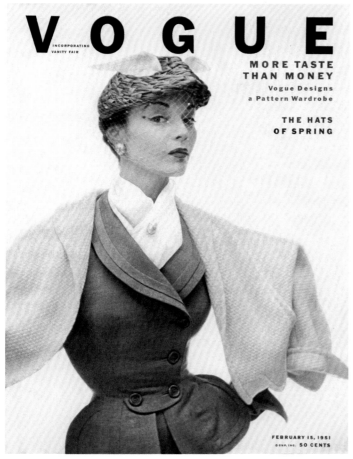

FEBRUARY 15, 1951

PHOTOGRAPH OF JEAN PATCHETT BY IRVING PENN

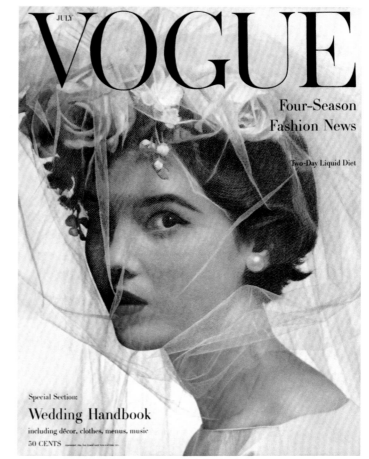

JULY 1956

PHOTOGRAPH OF DINA MORI BY IRVING PENN

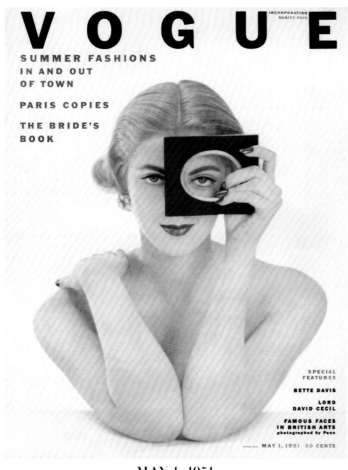

MAY 1, 1951

PHOTOGRAPH OF CARMEN DELL'OREFICE BY RICHARD RUTLEDGE

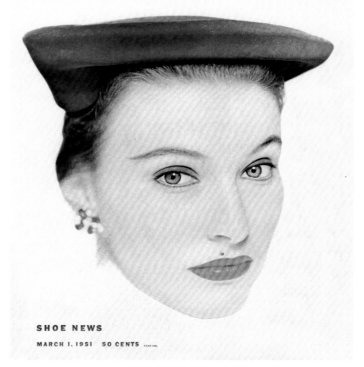

MARCH 1, 1951

PHOTOGRAPH OF MARTITA BY ERWIN BLUMENFELD

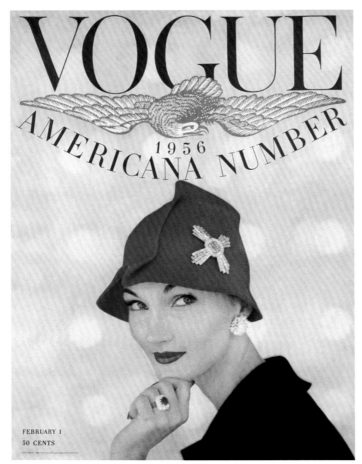

FEBRUARY 1, 1956

PHOTOGRAPH OF EVELYN TRIPP BY KAREN RADKAI

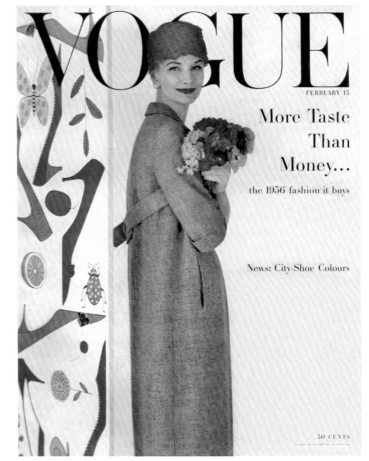

FEBRUARY 15, 1956

PHOTOGRAPH OF SUNNY HARNETT BY KAREN RADKAI

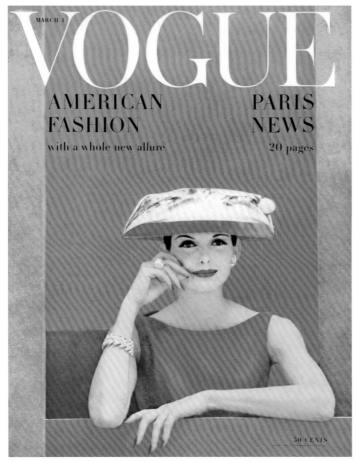

MARCH 1, 1956

PHOTOGRAPH OF ANNE ST. MARIE BY RICHARD RUTLEDGE

SEPTEMBER 15, 1955

PHOTOGRAPH OF MARY JANE RUSSELL BY RICHARD RUTLEDGE

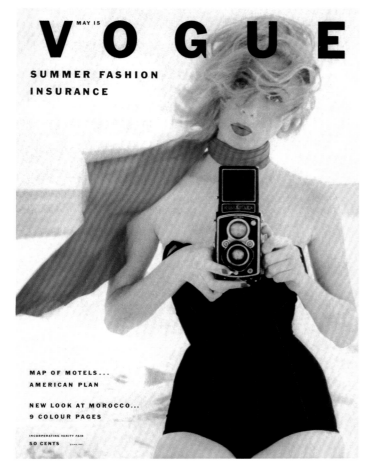

MAY 15, 1952
PHOTOGRAPH OF SUZY PARKER BY IRVING PENN

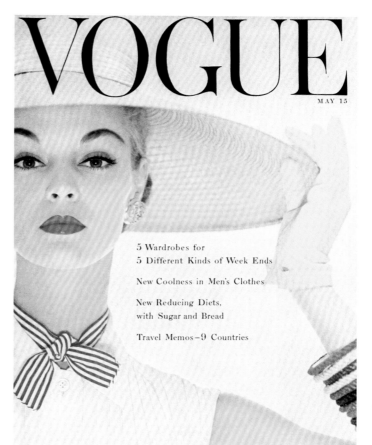

MAY 15, 1954
PHOTOGRAPH OF JEAN PATCHETT BY ERWIN BLUMENFELD

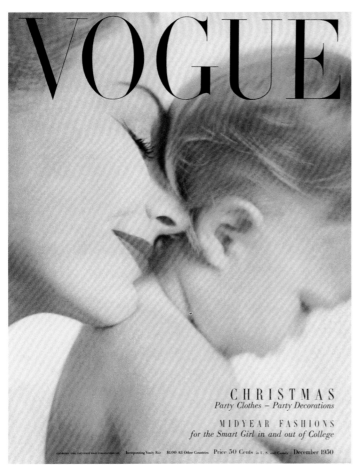

DECEMBER 1950
PHOTOGRAPH OF LISA FONSSAGRIVES BY IRVING PENN

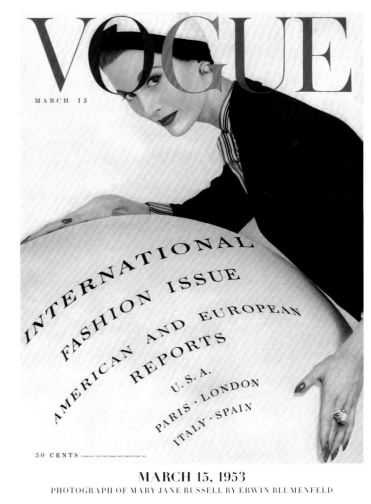

MARCH 15, 1953
PHOTOGRAPH OF MARY JANE RUSSELL BY ERWIN BLUMENFELD

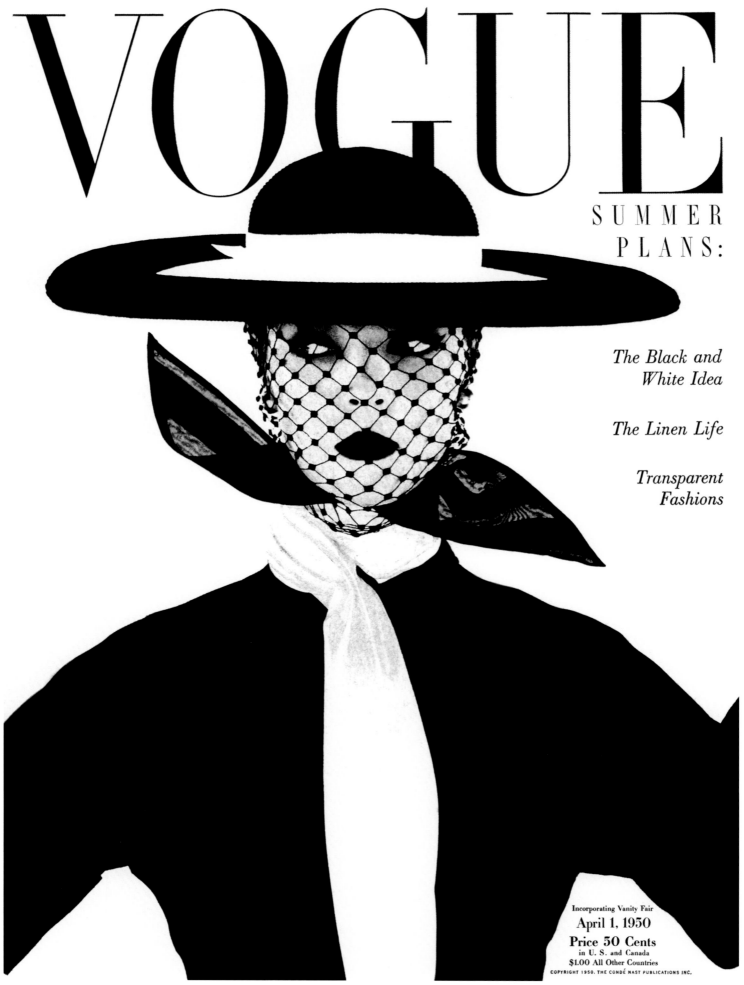

VOGUE

SUMMER PLANS:

*The Black and
White Idea*

The Linen Life

*Transparent
Fashions*

APRIL 1, 1950
PHOTOGRAPH OF JEAN PATCHETT BY IRVING PENN

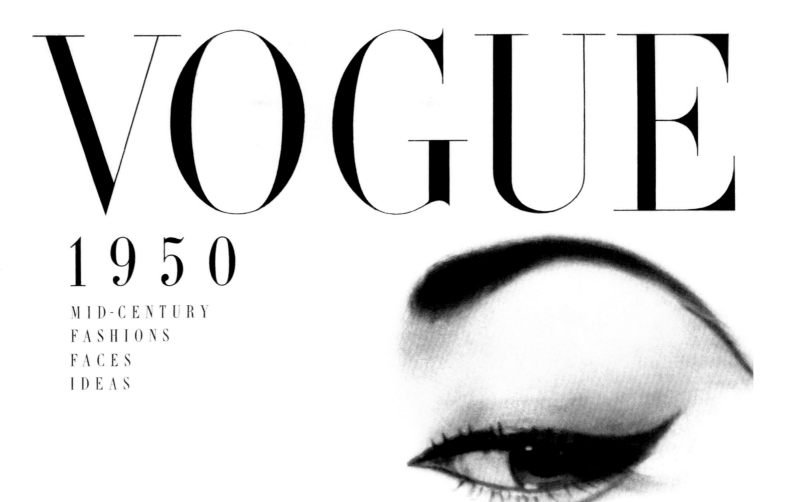

VOGUE

1950

MID-CENTURY
FASHIONS
FACES
IDEAS

T R A V E L
H A N D B O O K

Incorporating Vanity Fair
January 1950
Price 50 Cents in U. S. and Canada
$1.00 All Other Countries

JANUARY 1950
PHOTOGRAPH OF JEAN PATCHETT BY ERWIN BLUMENFELD

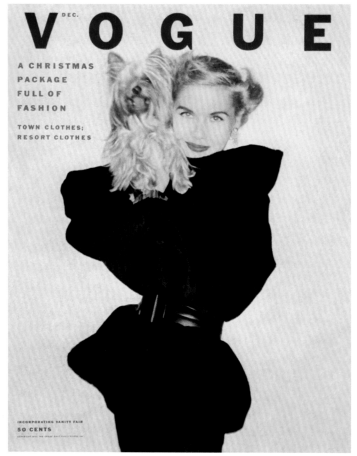

DECEMBER 1, 1952
PHOTOGRAPH BY CLIFFORD COFFIN

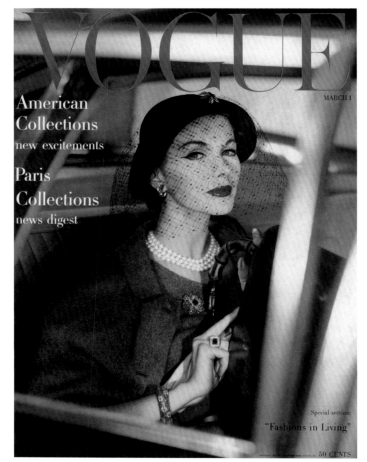

MARCH 1, 1957
PHOTOGRAPH OF JOAN FRIEDMAN BY CLIFFORD COFFIN

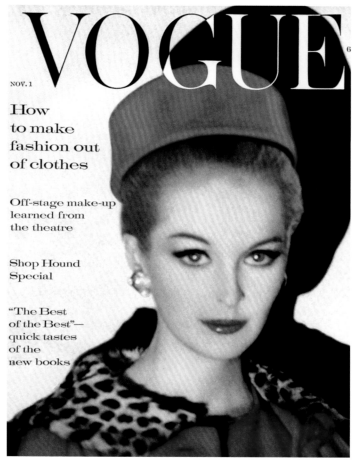

NOVEMBER 1, 1959
PHOTOGRAPH OF SARA THOM BY JOHN RAWLINGS

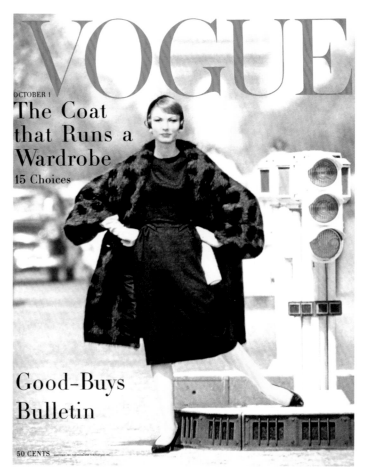

OCTOBER 1, 1957
PHOTOGRAPH OF MARY McLAUGHLIN BY WILLIAM KLEIN

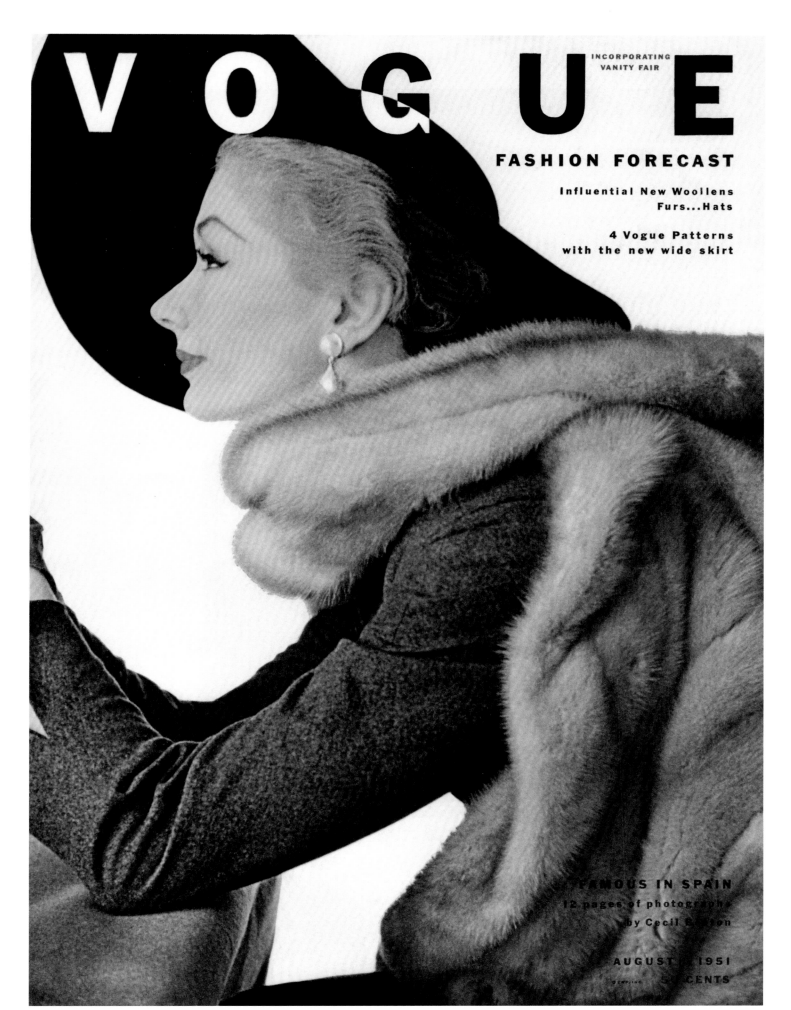

VOGUE

INCORPORATING
VANITY FAIR

FASHION FORECAST

Influential New Woollens
Furs...Hats

4 Vogue Patterns
with the new wide skirt

FAMOUS IN SPAIN
12 pages of photographs
by Cecil Beaton

AUGUST 1951
CENTS

AUGUST 1, 1951
PHOTOGRAPH OF LISA FONSSAGRIVES BY IRVING PENN

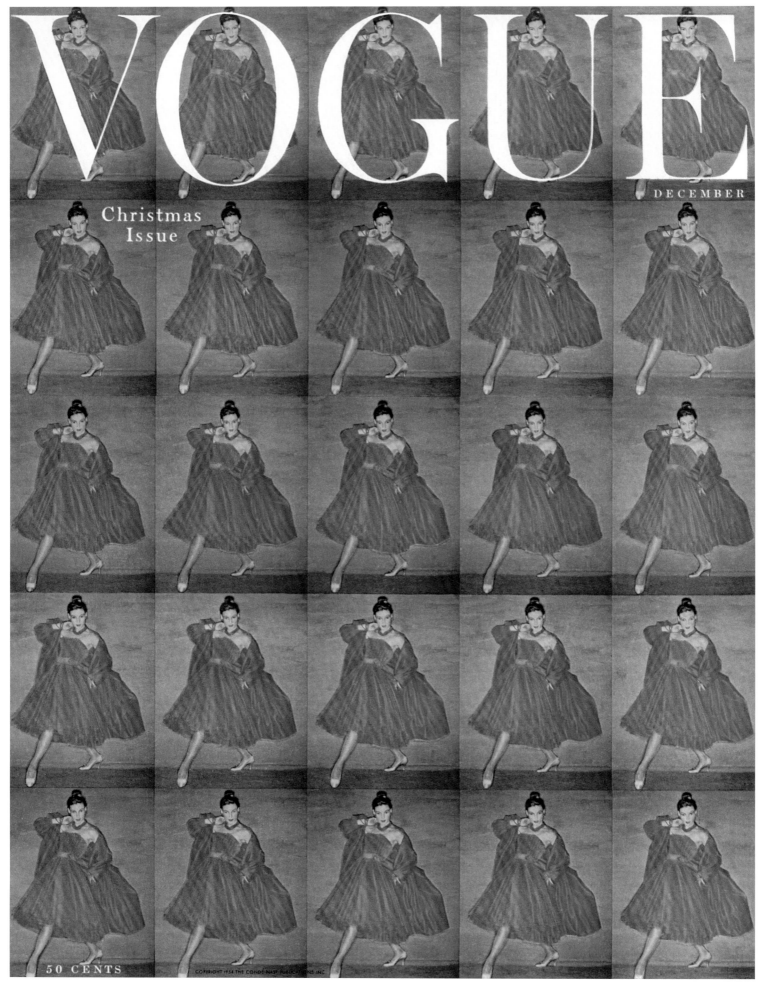

DECEMBER 1954
PHOTOGRAPH BY CLIFFORD COFFIN

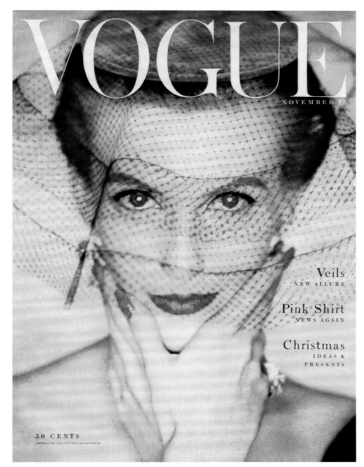

NOVEMBER 15, 1953
PHOTOGRAPH OF MARY JANE RUSSELL BY CLIFFORD COFFIN

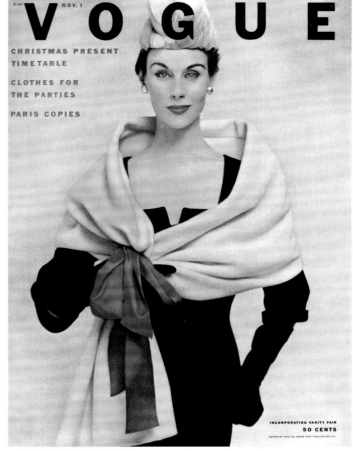

NOVEMBER 1, 1952
PHOTOGRAPH BY FRANCES McLAUGHLIN-GILL

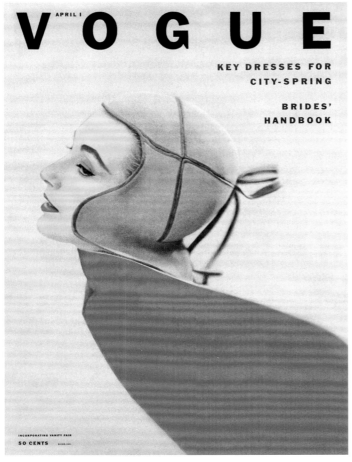

APRIL 1, 1952
PHOTOGRAPH OF SUE JENKS BY ROGER PRIGENT

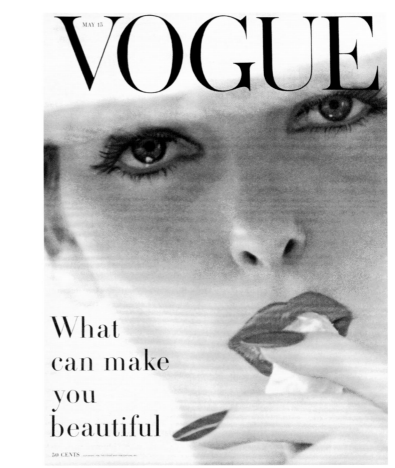

MAY 15, 1956
PHOTOGRAPH OF ANNE ST. MARIE BY IRVING PENN

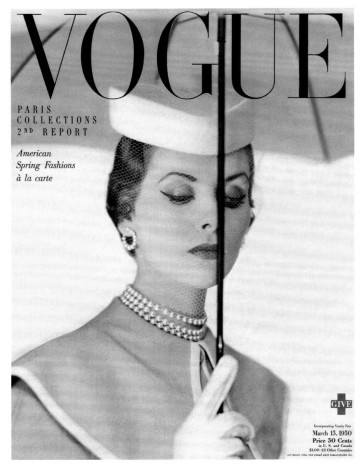

MARCH 15, 1950

PHOTOGRAPH BY ERWIN BLUMENFELD

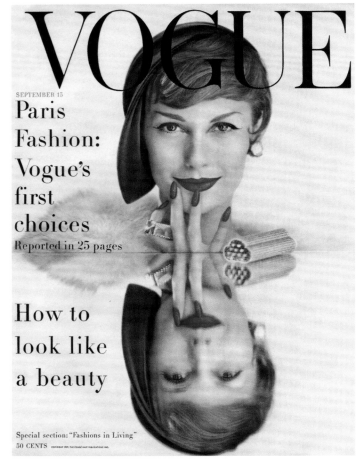

SEPTEMBER 15, 1957

PHOTOGRAPH OF MARY JANE RUSSELL BY JOHN RAWLINGS

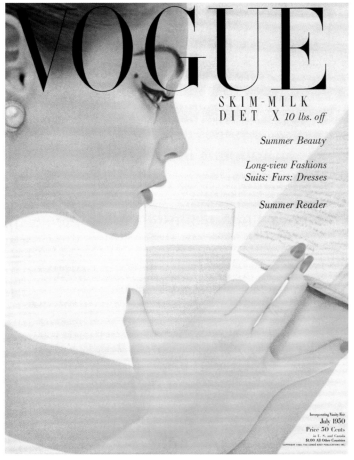

JULY 1950

PHOTOGRAPH OF JEAN PATCHETT BY IRVING PENN

APRIL 15, 1959

PHOTOGRAPH OF SARA THOM BY RICHARD RUTLEDGE

VOGUE

OCT. 15

BEAUTY ISSUE

FOR THE WOMAN
WHO WANTS TO
CHANGE HER LOOKS

INCORPORATING
VANITY FAIR
50 CENTS
COPYRIGHT 1952
THE CONDÉ NAST PUBLICATIONS INC.

OCTOBER 15, 1952
PHOTOGRAPH OF VICTORIA VON HAGEN BY ERWIN BLUMENFELD

VOGUE

INCORPORATING VANITY FAIR

25 DRESSES –
NEW UNDERCOAT STARS

50 MENUS FROM
FAMOUS HOSTESSES

NEW YORK TIP SHEET ON
NEW PLAYS–MUSIC–
EXHIBITIONS

NOVEMBER 1, 1951
©CNP, INC. 50 CENTS

NOVEMBER 1, 1951
PHOTOGRAPH OF JANET RANDY BY CLIFFORD COFFIN

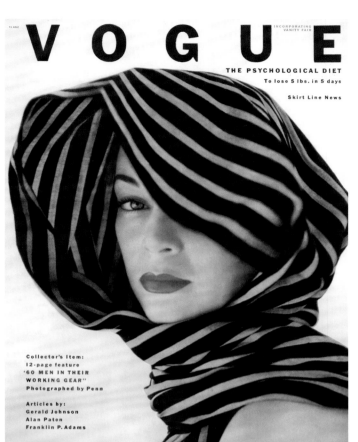

JULY 1951

PHOTOGRAPH OF JEAN PATCHETT BY CLIFFORD COFFIN

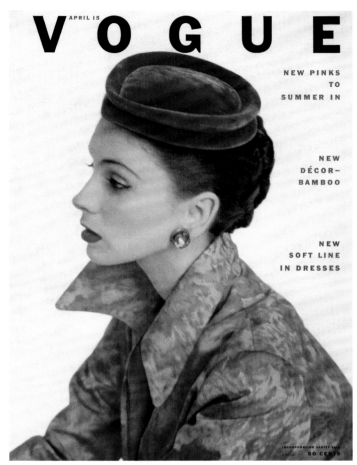

APRIL 15, 1952

PHOTOGRAPH OF SUZY PARKER BY JOHN RAWLINGS

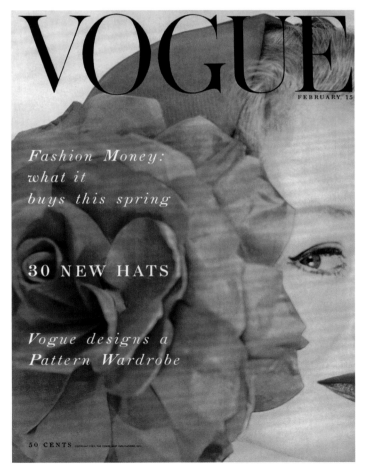

FEBRUARY 15, 1953

PHOTOGRAPH BY ERWIN BLUMENFELD

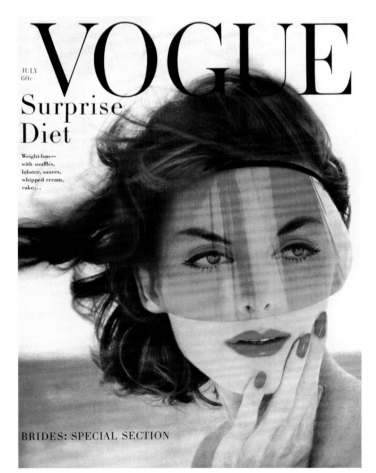

JULY 1958

PHOTOGRAPH OF ANNE ST. MARIE BY IRVING PENN

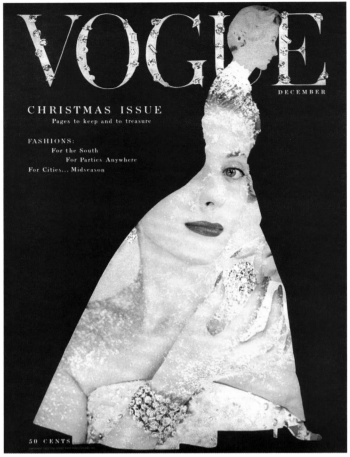

DECEMBER 1953
PHOTOGRAPH BY ERWIN BLUMENFELD

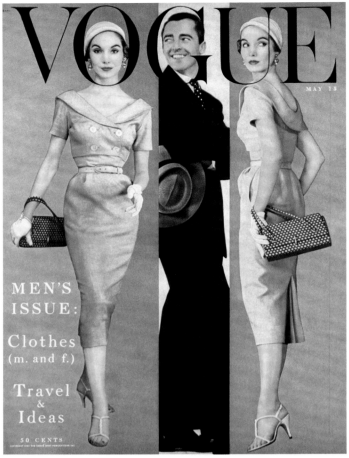

MAY 15, 1953
PHOTOGRAPH OF CHERRY NELMS BY ERWIN BLUMENFELD

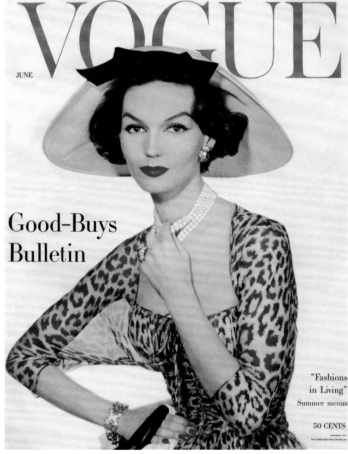

JUNE 1957
PHOTOGRAPH BY IRVING PENN

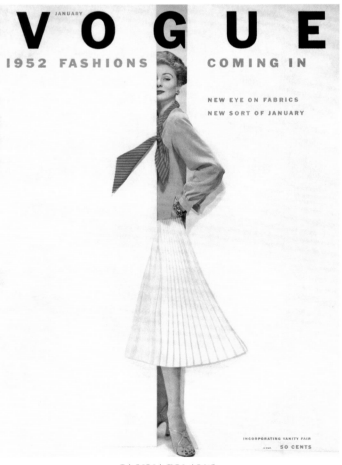

JANUARY 1952
PHOTOGRAPH OF SUZY PARKER BY ERWIN BLUMENFELD

VOGUE

MARCH 1

PARIS
COLLECTIONS:
Complete Report

AMERICAN
COLLECTIONS:
The New Spring Flavour

50 CENTS

MARCH 1, 1953
PHOTOGRAPH OF DOVIMA BY ERWIN BLUMENFELD

VOGUE

FEBRUARY 15

Spring <u>reds</u> in fashion

More-taste-than-<u>money</u> news

Vogue <u>one</u>-pattern wardrobes

50 CENTS

FEBRUARY 15, 1955
PHOTOGRAPH OF ANNE ST. MARIE BY ERWIN BLUMENFELD

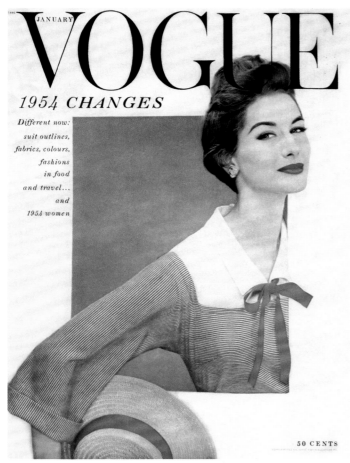

JANUARY 1954
PHOTOGRAPH OF NANCY BERG BY ERWIN BLUMENFELD

MARCH 15, 1956
PHOTOGRAPH OF EVELYN TRIPP BY KAREN RADKAI

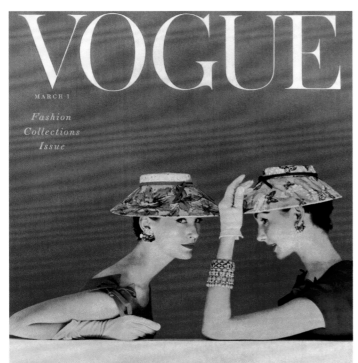

MARCH 1, 1954
PHOTOGRAPH OF MARY JANE RUSSELL (LEFT) AND
CHERRY NELMS BY RICHARD RUTLEDGE

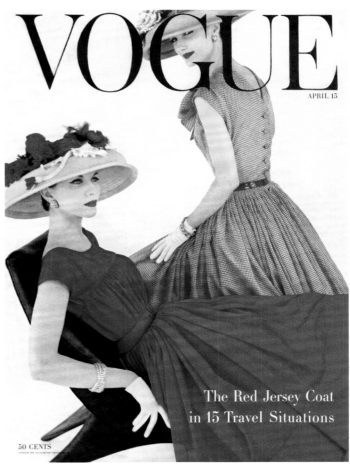

APRIL 15, 1956
PHOTOGRAPH OF JOAN FRIEDMAN (LEFT) AND
EVELYN TRIPP BY KAREN RADKAI

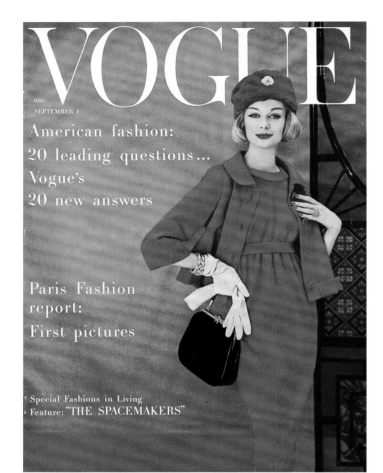

SEPTEMBER 1, 1958

PHOTOGRAPH OF MONIQUE LE FEVRE BY HENRY CLARKE

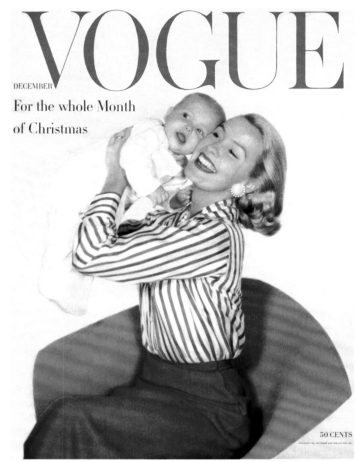

DECEMBER 1956

PHOTOGRAPH OF DINA MERRILL BY JOHN RAWLINGS

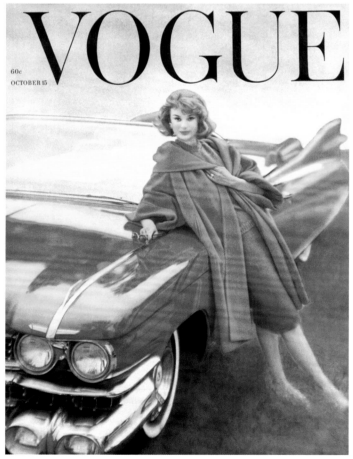

OCTOBER 15, 1958

PHOTOGRAPH OF ANNA CARIN BJORCK BY JOHN RAWLINGS

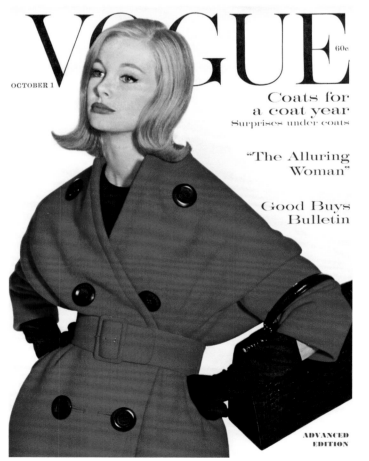

OCTOBER 1, 1959

PHOTOGRAPH OF MONIQUE LE FEVRE BY IRVING PENN

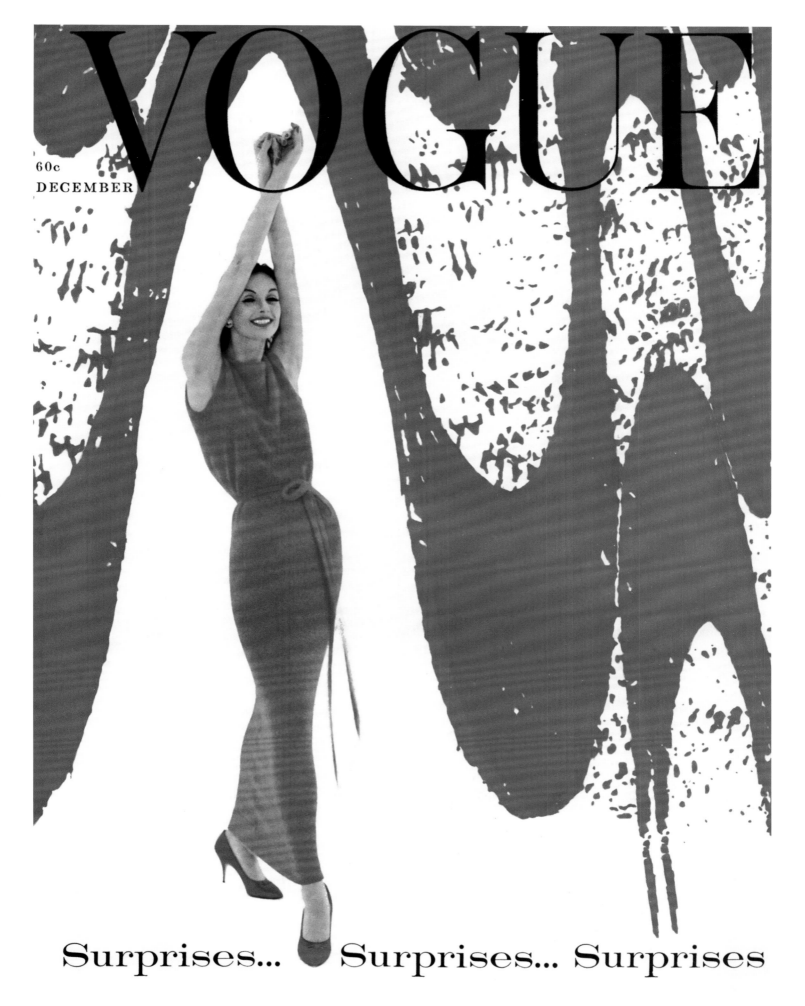

VOGUE

60c
DECEMBER

Surprises... Surprises... Surprises

DECEMBER 1958
PHOTOGRAPH OF ANNE ST. MARIE BY WILLIAM BELL

VOGUE

NOVEMBER 1

New ways
to look
for the new
kinds of parties

50
CENTS

NOVEMBER 1, 1954
PHOTOGRAPH OF NANCY BERG BY CLIFFORD COFFIN

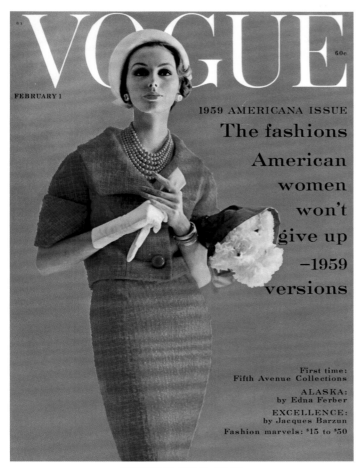

VOGUE

FEBRUARY 1

60c

1959 AMERICANA ISSUE

The fashions American women won't give up —1959 versions

First time:
Fifth Avenue Collections
ALASKA:
by Edna Ferber
EXCELLENCE:
by Jacques Barzun
Fashion marvels: $15 to $50

FEBRUARY 1, 1959
PHOTOGRAPH OF LUCINDA HOLLINGSWORTH BY KAREN RADKAI

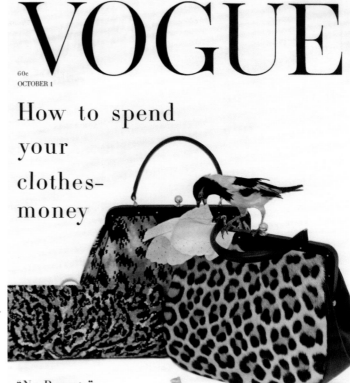

VOGUE

60c
OCTOBER 1

How to spend your clothes-money

"No Regrets"
By Victoria Lincoln

OCTOBER 1, 1958
PHOTOGRAPH BY RICHARD RUTLEDGE

VOGUE

1951
NEW FASHION TIMETABLE
Fabric news to wear all year
Suit news to wear all year

SPECIAL FEATURES:
Travel Headliners
"Laughter" by Christopher Fry
Memo on Germany

Incorporating Vanity Fair, January, 1951. 50 Cents U.S. & Canada. $1 elsewhere.

JANUARY 1951
PHOTOGRAPH BY ERWIN BLUMENFELD

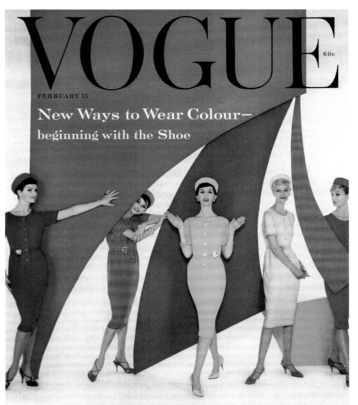

VOGUE

60c

FEBRUARY 15

New Ways to Wear Colour— beginning with the Shoe

Face-lifting by Exercise
Vogue Pattern Wardrobe: 8 pieces: 3 colours

FEBRUARY 15, 1959
PHOTOGRAPH BY WILLIAM BELL

VOGUE

60c

APRIL 1

Have you a fashion-personality? 2 women who do

New shopping system for travel clothes

"Who reads other people's letters?"

APRIL 1, 1959
PHOTOGRAPH OF ANNE ST. MARIE BY TOM PALUMBO

VOGUE

60c

NOVEMBER 15

The great accessory change

News to wear, to give...

The Lauren Bacall look–
in person; new clothes for it

Presents:
More Taste Than Money

NOVEMBER 15, 1959
PHOTOGRAPH BY EVELYN HOFER

VOGUE

MAY 1

THE UNSPENT SUMMER:
FASHION TIP SHEET

INCORPORATING VANITY FAIR
50 CENTS © CNP. INC.

MAY 1, 1952
PHOTOGRAPH OF LISA FONSSAGRIVES BY IRVING PENN

VOGUE

SEPT. 15

IN THIS ISSUE:

NEW FASHIONS FOR FLATTERY

NEW WARDROBE
IN VOGUE PATTERNS

NEWS IN SHOES,
STOCKINGS,
BAGS, GLOVES

INCORPORATING VANITY FAIR
50 CENTS

SEPTEMBER 15, 1952
PHOTOGRAPH BY IRVING PENN

VOGUE

INCORPORATING
VANITY FAIR

PRESENTS
FOR MEN

PRESENTS FOR MEN
TO GIVE WOMEN

NEW
DECEMBER HATS

FASHIONS
FOR SOUTH

DEBUTANTES:
NEW YORK
TO SAN FRANCISCO

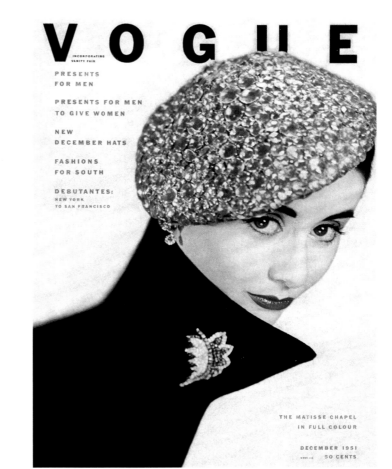

THE MATISSE CHAPEL
IN FULL COLOUR

DECEMBER 1951

50 CENTS

DECEMBER 1951
PHOTOGRAPH BY ERWIN BLUMENFELD

VOGUE

MARCH 15

ACCESSORIES
SPECIAL

PARIS
COLLECTIONS

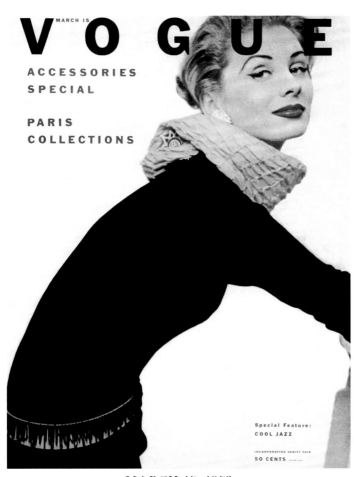

Special Feature:
COOL JAZZ

INCORPORATING VANITY FAIR
50 CENTS

MARCH 15, 1952
PHOTOGRAPH OF SUZY PARKER BY RICHARD RUTLEDGE

VOGUE

INCORPORATING
VANITY FAIR

FASHION
CHANGES

Which can you wear?
4 New Silhouettes
80 New American Fashions

HANDBOOK: HOW TO WEAR
WHAT YOU BUY

PARIS
COLLECTIONS

SEPTEMBER 1, 1951
50 CENTS

SEPTEMBER 1, 1951
PHOTOGRAPH OF LISA FONSSAGRIVES BY IRVING PENN

139

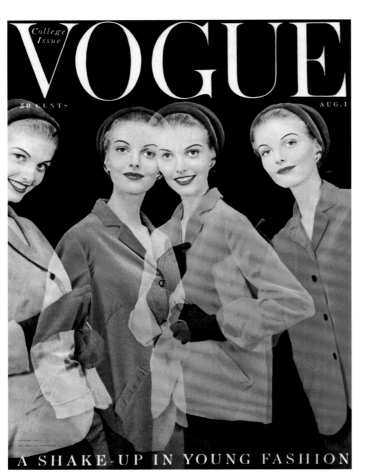

AUGUST 1, 1953

PHOTOGRAPH BY ERWIN BLUMENFELD

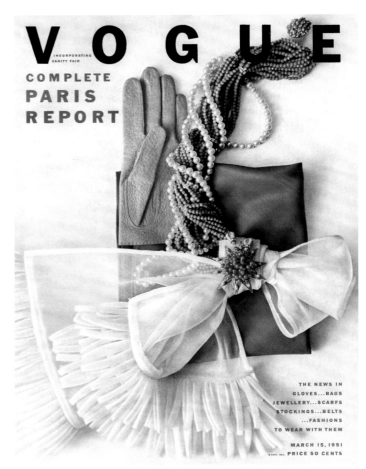

MARCH 15, 1951

PHOTOGRAPH BY RICHARD RUTLEDGE

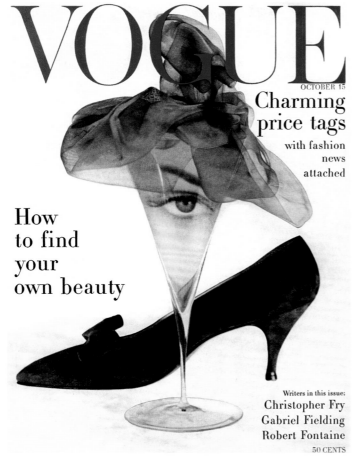

OCTOBER 15, 1957

PHOTOGRAPH BY JOHN RAWLINGS

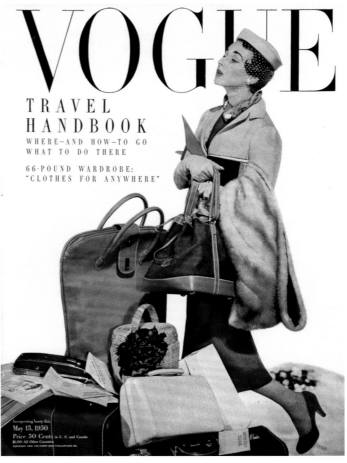

MAY 15, 1950

PHOTOGRAPH OF DORIAN LEIGH BY HORST P. HORST

VOGUE

INCORPORATING
VANITY FAIR

FASHIONS FOR THE SMART GIRL
IN AND OUT OF COLLEGE
60 NEW FASHIONS
ON 8 NEW THEMES
AN EAGLE EYE ON PRICE!

"EDNA ST. VINCENT MILLAY"
by Vincent Sheean,
and a hitherto
unpublished Millay poem

73 WASHINGTONIANS

"THE KING AND I"
as seen by Steig

AUGUST 15, 1951
© CNP, INC.
50 CENTS

AUGUST 15, 1951
PHOTOGRAPH BY RICHARD RUTLEDGE

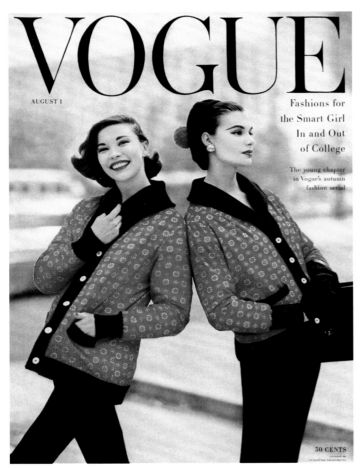

AUGUST 1, 1955
PHOTOGRAPH BY ROGER PRIGENT

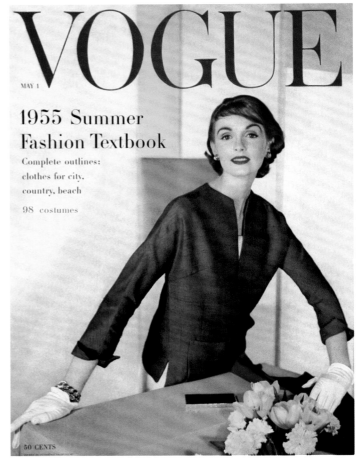

MAY 1, 1955
PHOTOGRAPH BY HORST P. HORST

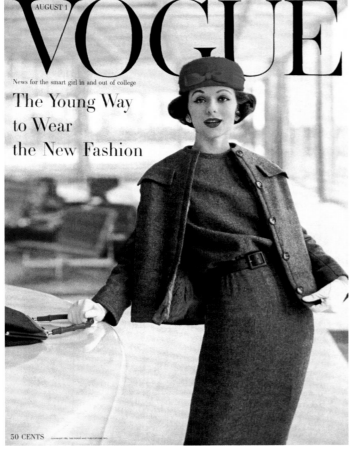

AUGUST 1, 1956
PHOTOGRAPH OF MARGO WARNER BY RICHARD RUTLEDGE

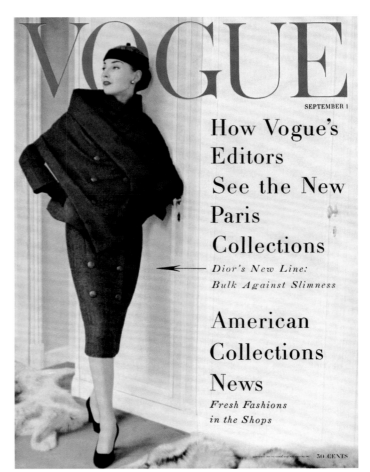

SEPTEMBER 1, 1955
PHOTOGRAPH BY HENRY CLARKE

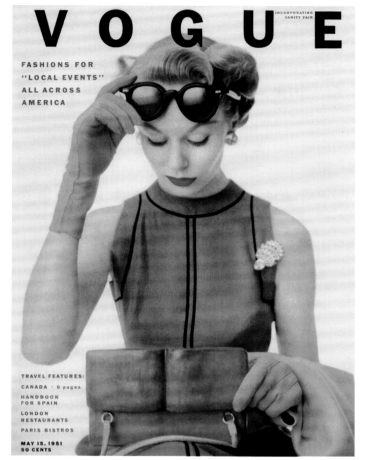

MAY 15, 1951

PHOTOGRAPH OF NINA DE VOE BY IRVING PENN

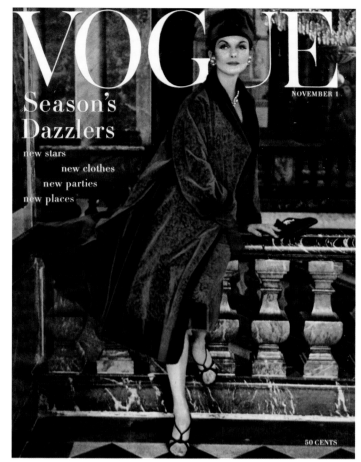

NOVEMBER 1, 1955

PHOTOGRAPH OF ANNE ST. MARIE BY HENRY CLARKE

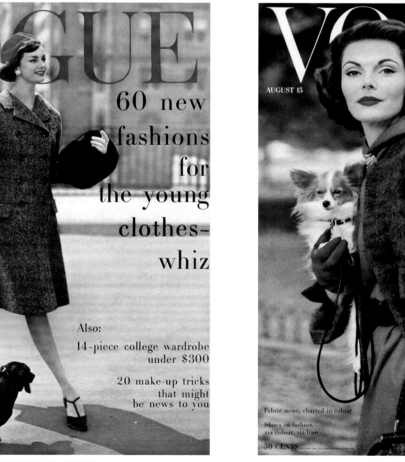

AUGUST 15, 1958

PHOTOGRAPH OF ANNA CARIN BJORCK BY SANTÉ FORLANO

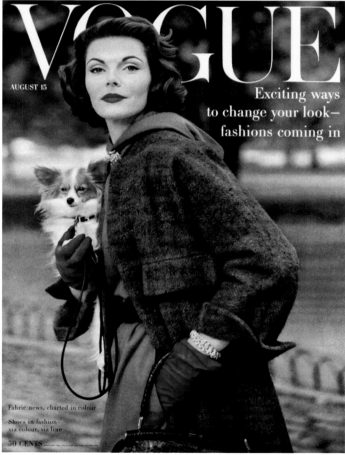

AUGUST 15, 1956

PHOTOGRAPH OF V. TAYLOR BY FRANCES McLAUGHLIN-GILL

VOGUE

EVERYBODY COOKS!
New Menus: New Time Techniques

Paris Copies,
Ready-To-Wear

BEAUTY–
LINGERIE

Incorporating Vanity Fair
November 1, 1950
Price 50 Cents
in U. S. and Canada
$1.00 All Other Countries

NOVEMBER 1, 1950
PHOTOGRAPH OF CATHY DENNIS BY NORMAN PARKINSON

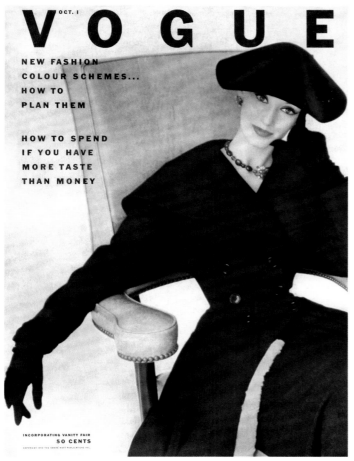

OCT. 1
VOGUE

NEW FASHION
COLOUR SCHEMES...
HOW TO
PLAN THEM

HOW TO SPEND
IF YOU HAVE
MORE TASTE
THAN MONEY

INCORPORATING VANITY FAIR
50 CENTS

OCTOBER 1, 1952

PHOTOGRAPH OF BARBARA MULLEN BY HORST P. HORST

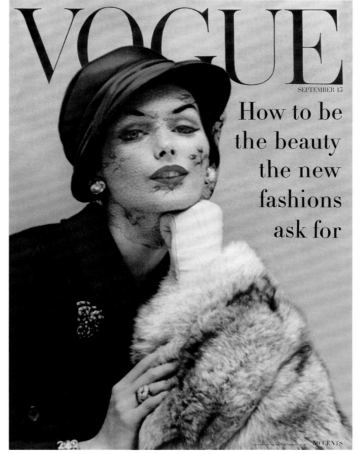

VOGUE
SEPTEMBER 15

How to be
the beauty
the new
fashions
ask for

50 CENTS

SEPTEMBER 15, 1956

PHOTOGRAPH OF LUCINDA HOLLINGSWORTH BY KAREN RADKAI

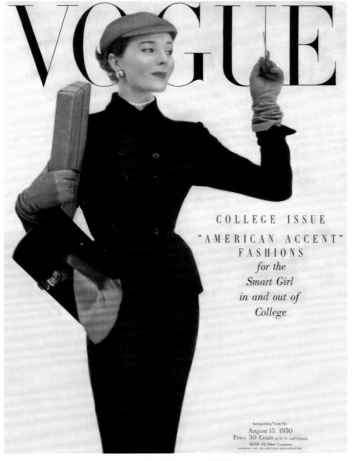

VOGUE

COLLEGE ISSUE
"AMERICAN ACCENT"
FASHIONS
*for the
Smart Girl
in and out of
College*

Incorporating Vanity Fair
August 15, 1950
Price 50 Cents in U. S. and Canada
$1.00 All Other Countries

AUGUST 15, 1950

PHOTOGRAPH OF BETTINA GRAZIANI BY IRVING PENN

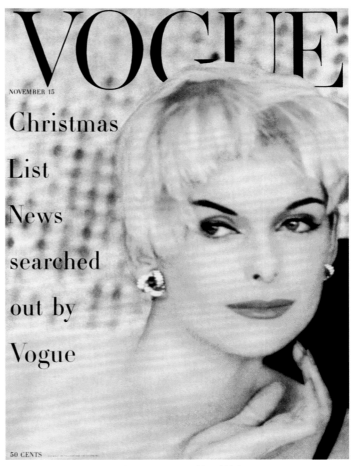

VOGUE
NOVEMBER 15

Christmas

List

News

searched

out by

Vogue

50 CENTS

NOVEMBER 15, 1955

PHOTOGRAPH OF ANNE ST. MARIE BY HENRY CLARKE

VOGUE

VOGUE

VOGUE

75¢
MAY

SPECIAL
ISSUE

THE
LIFE
THAT'S
IN
FASHION

VOGUE

POW...

75¢
JUNE

VOGUE

VOGUE

shoes
rt woman

ALL YOU NEED IS LOVE

JFK and Jackie bring the White House to life. . . . The pill-box hat. . . . The Pill launches the sexual revolution. . . . The three-martini lunch puts a damper on it. . . . Chubby Checker does the Twist. . . . The shower scene in *Psycho* gives us bad dreams. . . . Jean-Luc Godard's *Breathless* and François Truffaut's *The 400 Blows* usher in the French nouvelle vague. . . . Pop Art goes POW! . . . *Who's Afraid of Virginia Woolf?* . . . Not Holly Golightly, whose Little Black Dress rules the world after *Breakfast at Tiffany's*. . . . Rachel Carson's *Silent Spring* sparks the environmental movement. . . . Ursula Andress's *Dr. No* bikini turns boys into men, and vice versa. . . . Twiggy's and Penelope Tree's youth and liberated sexuality trump elegance. . . . Rod Laver wins tennis's Grand Slam (twice). . . . The Beatles hold our hand, and the Rolling Stones demand satisfaction. . . . The Cuban Missile Crisis evokes the unthinkable. . . . Sylvia Plath commits suicide. . . . Betty Friedan's *The Feminine Mystique* jump-starts militant feminism. . . . Camelot dies with JFK in Dallas. . . . LBJ signs the historic Civil Rights Act and escalates U.S. involvement in Vietnam. . . . Julia Child's *The French Chef* on TV makes cooking fun and funny. . . . Julie Christie's miniskirt in *Darling* makes mod à la mode. . . . Updike's Rabbit and Roth's Portnoy are the new fictional antiheroes. . . . The Supremes stop in the name of love. . . . Truman Capote throws his Black and White Ball at the Plaza. . . . Microwave ovens and faster foods. . . . Dustin Hoffman's red Alfa Romeo convertible in *The Graduate*. . . . Rosemary has a baby. . . . More assassinations: Malcolm X, Martin Luther King, Jr., Bobby Kennedy. . . . U.S. campuses and ghettos explode; students revolt in Paris. . . . Andy Warhol adds *Interview* magazine to his multimedia circus. . . . Hippies of the world unite at Woodstock to make peace, not war. . . . *Apollo 11* lands on the moon.

'60s

VOGUE

75c
APR.15

FASHIONS THAT MAKE YOUR BEST SUMMER LOOKS

THE PILL— AND MORE
LATEST EXPERIMENTS IN BIRTH CONTROL

BEAUTY
WHAT TO DO WHEN YOUR LOOKS GO WRONG

TAYLOR AND BURTON ON LOCATION

TRUMAN CAPOTE'S PRIVATE LOG

BALENCIAGA, GIVENCHY, MAINBOCHER

APRIL 15, 1967
PHOTOGRAPH OF TWIGGY BY BERT STERN

VOGUE

75¢
MAR. 15

THE
PRETTIEST
TAILORING
NOW...
PRECIOUS
AND
DOUBLE-
FACED

BARBRA STREISAND
AT THE PARIS
COLLECTIONS

INTERNATIONAL
BEAUTY NOTES

MARCH 15, 1966

PHOTOGRAPH OF BARBRA STREISAND BY RICHARD AVEDON

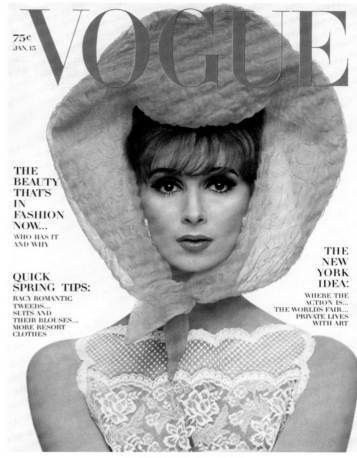

VOGUE

75¢
JAN. 15

THE
BEAUTY
THAT'S
IN
FASHION
NOW...
WHO HAS IT
AND WHY

QUICK
SPRING TIPS:

RACY ROMANTIC
TWEEDS...
SUITS AND
THEIR BLOUSES...
MORE RESORT
CLOTHES

THE
NEW
YORK
IDEA:
WHERE THE
ACTION IS...
THE WORLD'S FAIR...
PRIVATE LIVES
WITH ART

JANUARY 15, 1964

PHOTOGRAPH OF WILHELMINA BY BERT STERN

VOGUE

75¢
OCT. 1

FEEL
LIKE A
BEAUTY:
LOOKS
TO
KEEP...
LOOKS
TO
CHANGE
FASHION THAT
TURNS
THEM ON

"BEAUTY AND HEART"
BY LUIGI BARZINI

THE TASTE OF FRANCE:
HOUSES...FOOD...
DECOR...GARDENS...
INSTANT FASHION...
THE NEW
ROMANTIC HERO

OCTOBER 1, 1966

PHOTOGRAPH OF CELIA HAMMOND BY DAVID BAILEY

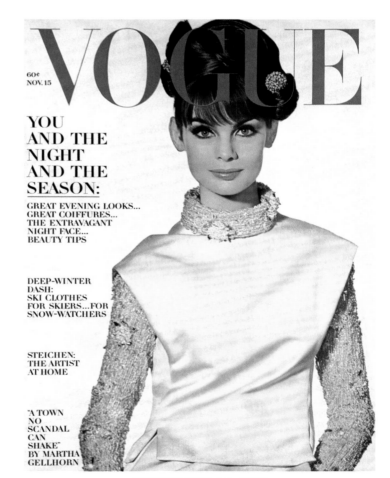

VOGUE

60¢
NOV. 15

YOU
AND THE
NIGHT
AND THE
SEASON:

GREAT EVENING LOOKS...
GREAT COIFFURES...
THE EXTRAVAGANT
NIGHT FACE...
BEAUTY TIPS

DEEP-WINTER
DASH:
SKI CLOTHES
FOR SKIERS...FOR
SNOW-WATCHERS

STEICHEN:
THE ARTIST
AT HOME

"A TOWN
NO
SCANDAL
CAN
SHAKE"
BY MARTHA
GELLHORN

NOVEMBER 15, 1963

PHOTOGRAPH OF JEAN SHRIMPTON BY IRVING PENN

VOGUE

60¢
APRIL 1

ACCESSORIES
PLOTTED FOR CHIC

WHITE:
WHAT MAKES IT NEW
AND EXCITING

THE CLOTHES
TO BUY
RIGHT NOW

"Women and Money"
 by Albert E. Schwabacher, Jr.

"The Snobs of Paris"
 by Pierre Daninos

Articles by
Walter Kerr
Gilbert Highet

APRIL 1, 1963
PHOTOGRAPH OF JEAN SHRIMPTON BY WILLIAM KLEIN

VOGUE

AMERICANA ISSUE

VOGUE'S PICK OF THE GREAT AMERICAN CLOTHES
a coast-to-coast fashion report

Bargains in chic U.S.A.

FEBRUARY 1, 1964
PHOTOGRAPH OF WILHELMINA BY BERT STERN

VOGUE

75¢
MAY

SPECIAL
ISSUE

THE
LIFE
THAT'S
IN
FASHION

THE AMERICAN WOMAN 1967... LOVE... MONEY... HUSBAND-STEALING... PSYCHIATRY... ART... WORK... FUN... ENTERTAINING... THE GOOD LIFE WHERE THE ACTION IS... WOMEN ALL OVER THE MAP OF THE U.S.A.

MAY 1967
PHOTOGRAPH OF CANDICE BERGEN BY BERT STERN

152

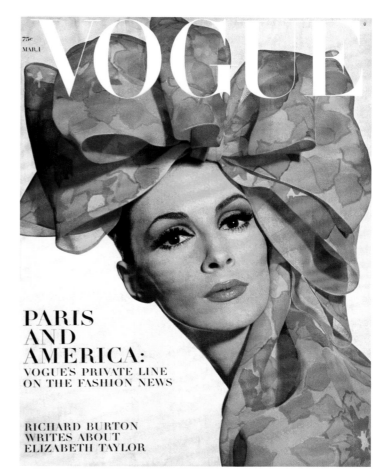

VOGUE

75¢
NOV. 15

THE
LURE
OF
THE
LIFE
AT
HOME

NEW
ENTICEMENTS
IN FASHION,
BEAUTY,
DECORATING

VOGUE'S
CASEBOOK:
4 YOUNG
COUPLES— AND THE
LIFE THAT COUNTS

BEAUTY: THE UPSHOT
OF BARENESS

YOUNG ADVENTURE
IN A CASTLE IN IRELAND

NOVEMBER 15, 1964
PHOTOGRAPH OF ASTRID HEEREN BY IRVING PENN

VOGUE

75¢
MAR. 1

PARIS
AND
AMERICA:
VOGUE'S PRIVATE LINE
ON THE FASHION NEWS

RICHARD BURTON
WRITES ABOUT
ELIZABETH TAYLOR

MARCH 1, 1965
PHOTOGRAPH OF WILHELMINA BY IRVING PENN

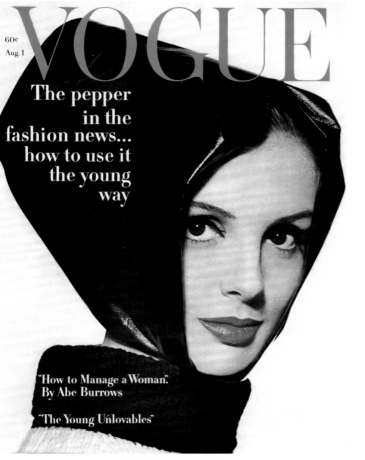

VOGUE

60¢
Aug. 1

The pepper
in the
fashion news...
how to use it
the young
way

"How to Manage a Woman."
By Abe Burrows

"The Young Unlovables"

AUGUST 1, 1962
PHOTOGRAPH OF TILLY TIZZANI BY IRVING PENN

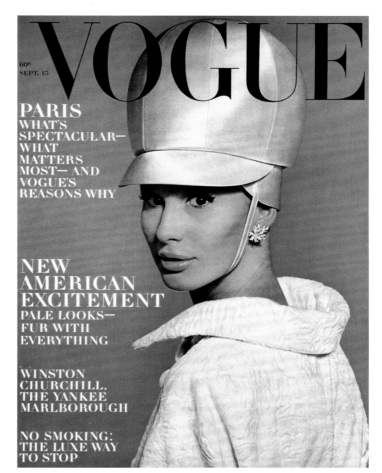

VOGUE

60¢
SEPT. 15

PARIS
WHAT'S
SPECTACULAR—
WHAT
MATTERS
MOST— AND
VOGUE'S
REASONS WHY

NEW
AMERICAN
EXCITEMENT
PALE LOOKS—
FUR WITH
EVERYTHING

WINSTON
CHURCHILL,
THE YANKEE
MARLBOROUGH

NO SMOKING:
THE LUXE WAY
TO STOP

SEPTEMBER 15, 1963
PHOTOGRAPH OF BRIGITTE BAUER BY DAVID BAILEY

153

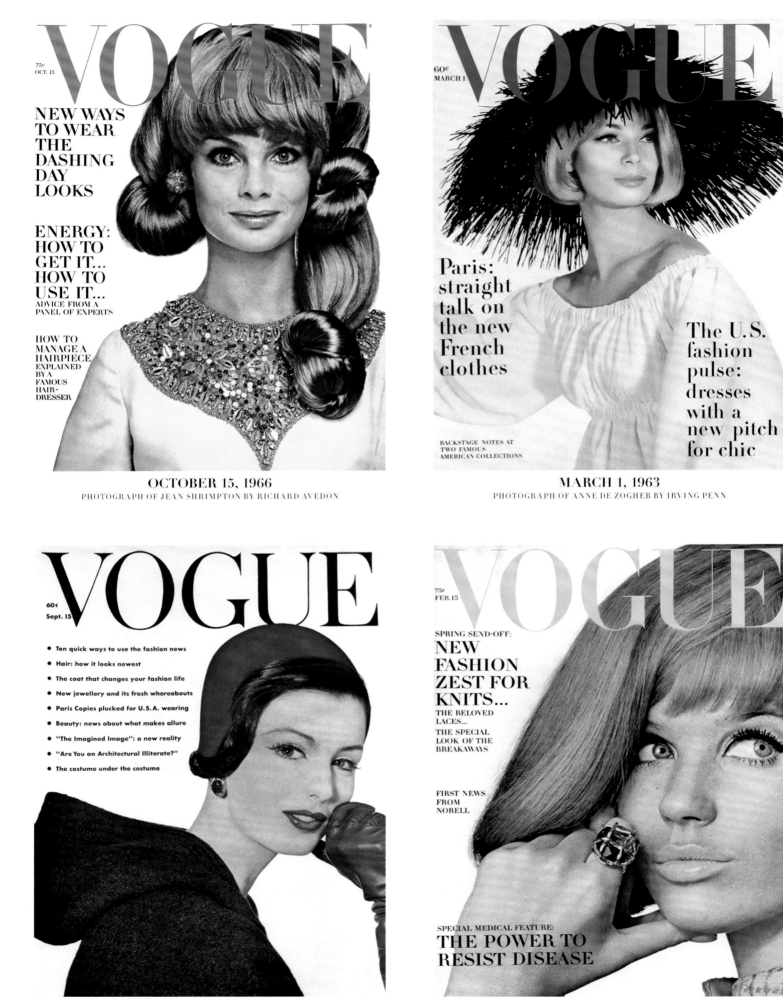

VOGUE

75¢
OCT. 15

NEW WAYS
TO WEAR
THE
DASHING
DAY
LOOKS

ENERGY:
HOW TO
GET IT...
HOW TO
USE IT...
ADVICE FROM A
PANEL OF EXPERTS

HOW TO
MANAGE A
HAIRPIECE
EXPLAINED
BY A
FAMOUS
HAIR-
DRESSER

OCTOBER 15, 1966
PHOTOGRAPH OF JEAN SHRIMPTON BY RICHARD AVEDON

VOGUE

60¢
MARCH 1

Paris:
straight
talk on
the new
French
clothes

The U.S.
fashion
pulse:
dresses
with a
new pitch
for chic

BACKSTAGE NOTES AT
TWO FAMOUS
AMERICAN COLLECTIONS

MARCH 1, 1963
PHOTOGRAPH OF ANNE DE ZOGHEB BY IRVING PENN

VOGUE

60¢
Sept. 15

• Ten quick ways to use the fashion news

• Hair: how it looks newest

• The coat that changes your fashion life

• New jewellery and its fresh whereabouts

• Paris Copies plucked for U.S.A. wearing

• Beauty: news about what makes allure

• "The Imagined Image": a new reality

• "Are You an Architectural Illiterate?"

• The costume under the costume

SEPTEMBER 15, 1961
PHOTOGRAPH OF DOROTHEA McGOWAN BY IRVING PENN

VOGUE

75¢
FEB. 15

SPRING SEND-OFF:
NEW
FASHION
ZEST FOR
KNITS...
THE BELOVED
LACES...
THE SPECIAL
LOOK OF THE
BREAKAWAYS

FIRST NEWS
FROM
NORELL

SPECIAL MEDICAL FEATURE:
THE POWER TO
RESIST DISEASE

FEBRUARY 15, 1966
PHOTOGRAPH OF VERUSCHKA BY IRVING PENN

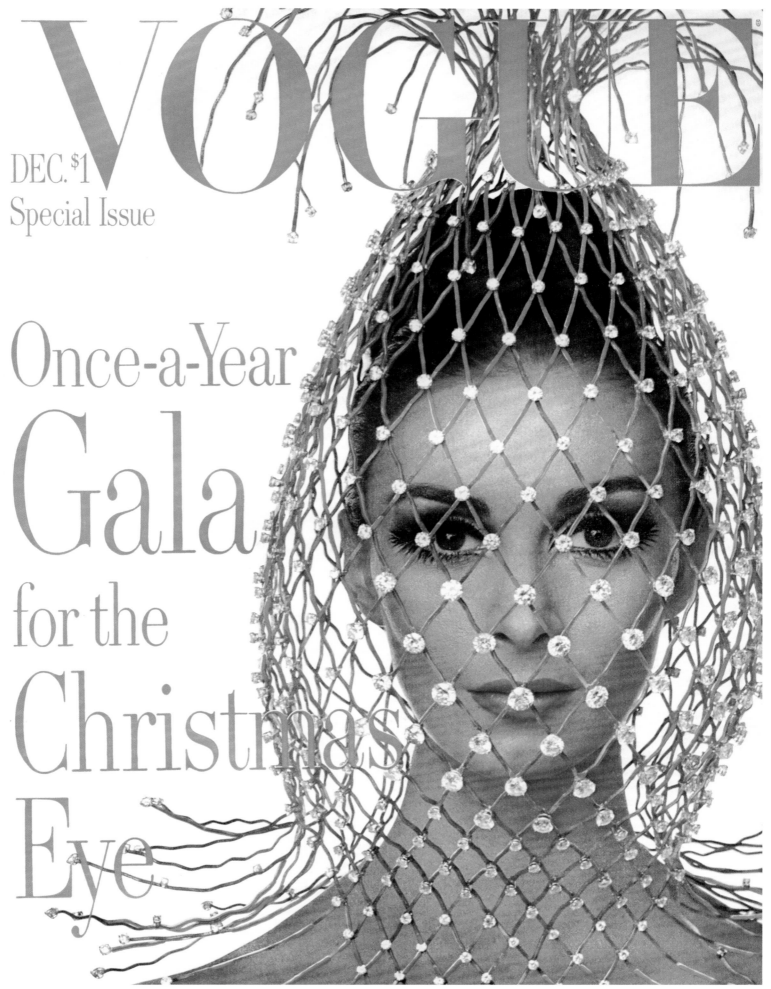

VOGUE

DEC. $1
Special Issue

Once-a-Year
Gala
for the
Christmas
Eve

DECEMBER 1965
PHOTOGRAPH OF WILHELMINA BY IRVING PENN

VOGUE

75¢
SEPT. 15

THE ORNAMENTAL EYE

THE PARIS FASCINATION
VOGUE'S SECOND REPORT
ON THE NEW
FRENCH CLOTHES

IN THE U.S.A.
LOOKS IN THE LEAD FOR
THE NIFTY AMERICAN

THE ELIGIBLE BACHELORS OF BRITAIN
AND BY CLEVELAND AMORY—"MRS. PAYSON'S BALL PARK"

SEPTEMBER 15, 1964
PHOTOGRAPH OF VERONICA HAMEL BY IRVING PENN

156

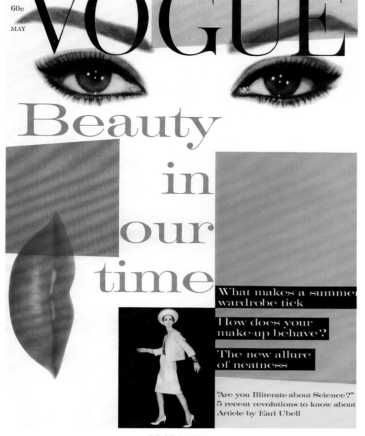

VOGUE

60c
MAY

Beauty
in
our
time

What makes a summer wardrobe tick

How does your make-up behave?

The new allure of neatness

"Are you Illiterate about Science?"
5 recent revolutions to know about
Article by Earl Ubell

MAY 1961

COLLAGE OF SOPHIA LOREN'S EYES AND LIPS; INSET, ANNE ST. MARIE

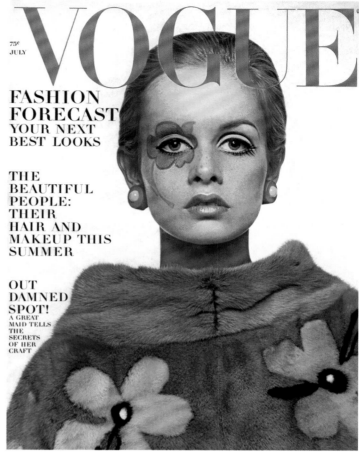

VOGUE

75¢
JULY

FASHION FORECAST
YOUR NEXT BEST LOOKS

THE BEAUTIFUL PEOPLE: THEIR HAIR AND MAKEUP THIS SUMMER

OUT DAMNED SPOT!
A GREAT MAID TELLS THE SECRETS OF HER CRAFT

JULY 1967

PHOTOGRAPH OF TWIGGY BY RICHARD AVEDON

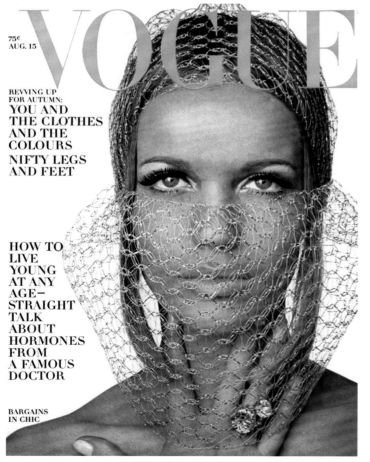

VOGUE

75¢
AUG. 15

REVVING UP FOR AUTUMN:
YOU AND THE CLOTHES AND THE COLOURS
NIFTY LEGS AND FEET

HOW TO LIVE YOUNG AT ANY AGE—STRAIGHT TALK ABOUT HORMONES FROM A FAMOUS DOCTOR

BARGAINS IN CHIC

AUGUST 15, 1965

PHOTOGRAPH OF VERUSCHKA BY IRVING PENN

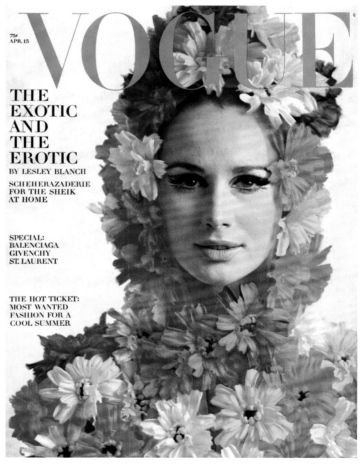

VOGUE

75¢
APR. 15

THE EXOTIC AND THE EROTIC
BY LESLEY BLANCH

SCHEHERAZADERIE FOR THE SHEIK AT HOME

SPECIAL: BALENCIAGA GIVENCHY ST. LAURENT

THE HOT TICKET: MOST WANTED FASHION FOR A COOL SUMMER

APRIL 15, 1965

PHOTOGRAPH OF BRIGITTE BAUER BY WILLIAM KLEIN

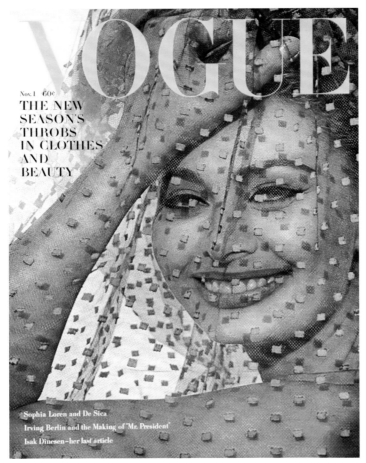

VOGUE

Nov. 1 60¢

THE NEW
SEASON'S
THROBS
IN CLOTHES
AND
BEAUTY

Sophia Loren and De Sica
Irving Berlin and the Making of "Mr. President"
Isak Dinesen—her last article

NOVEMBER 1, 1962

PHOTOGRAPH OF SOPHIA LOREN BY BERT STERN

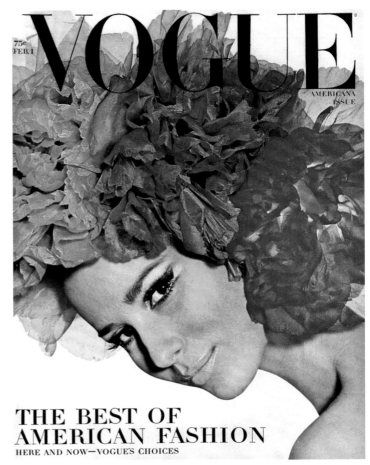

VOGUE

75¢
FEB. 1

AMERICANA
ISSUE

THE BEST OF
AMERICAN FASHION
HERE AND NOW—VOGUE'S CHOICES

FEBRUARY 1, 1965

PHOTOGRAPH OF BRIGITTE BAUER BY IRVING PENN

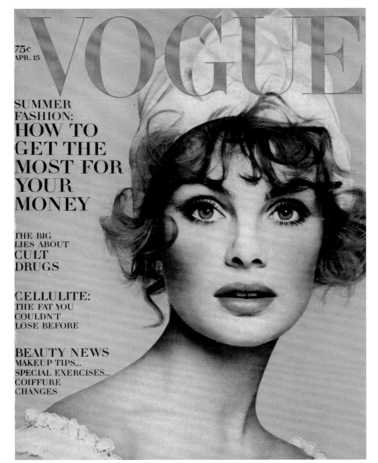

VOGUE

75¢
APR. 15

SUMMER
FASHION:
HOW TO
GET THE
MOST FOR
YOUR
MONEY

THE BIG
LIES ABOUT
CULT
DRUGS

CELLULITE:
THE FAT YOU
COULDN'T
LOSE BEFORE

BEAUTY NEWS
MAKEUP TIPS...
SPECIAL EXERCISES...
COIFFURE
CHANGES

APRIL 15, 1968

PHOTOGRAPH OF JEAN SHRIMPTON BY RICHARD AVEDON

VOGUE

60¢
APRIL 15

THE NEWEST
DRESS
FASCINATION

"Love—in Other Words"
By Harper Lee

The worldly cotton suit—
10 pages of this year's best

APRIL 15, 1961

PHOTOGRAPH OF ISABELLA ALBONICO BY WILLIAM KLEIN

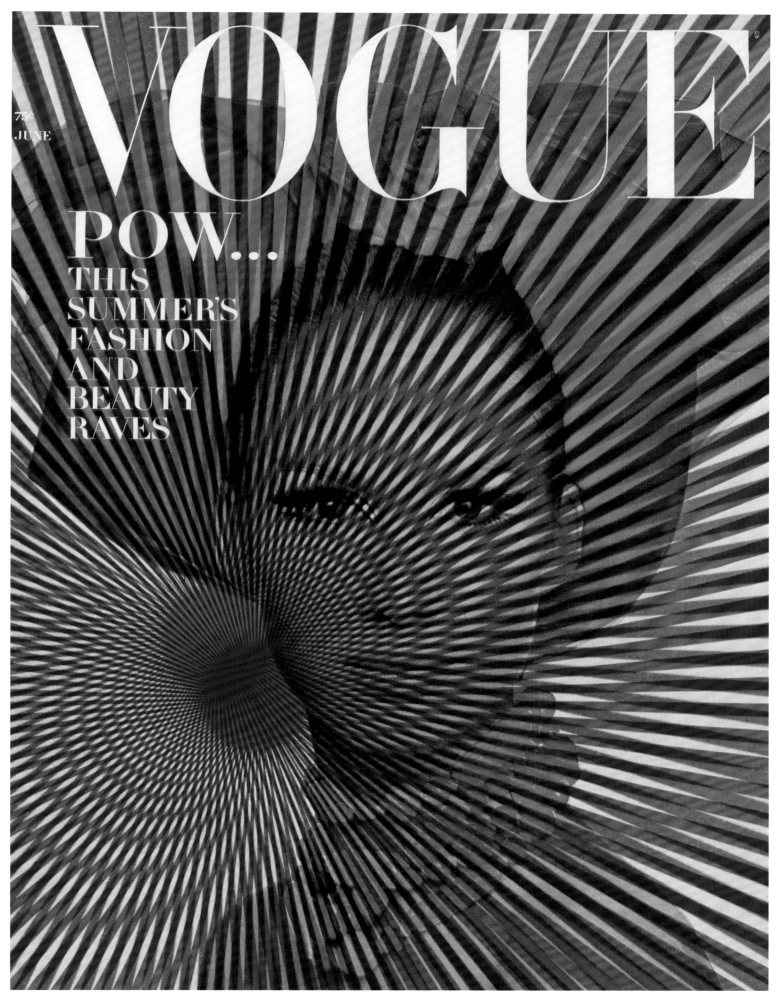

JUNE 1965
PHOTOGRAPH OF BRIGITTE BAUER BY IRVING PENN

VOGUE

75¢
APR. 1

FORECAST FOR SUMMMER

STARRY-EVENING
LOOKS...
THE BRISK SWEET
LOOK OF
LINEN FOR DAY

MAINBOCHER

ITALIAN COLLECTIONS

THE BEAUTIFUL PEOPLE
IN MEXICO

APRIL 1, 1965
PHOTOGRAPH OF WILHELMINA BY IRVING PENN

160

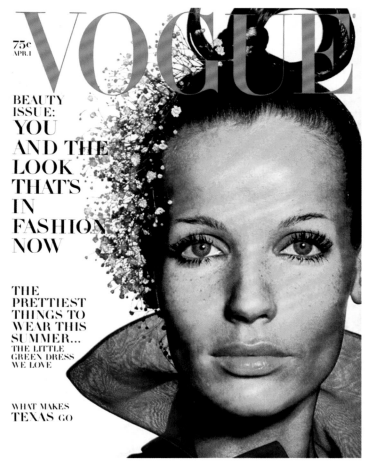

VOGUE

75¢
FEB. 15

Spring fashion tip sheet

marvellous day looks...

fantasy legs and feet...

new ways to wear a shirt

Bargains in chic

What makes the body fit the fashion now

FEBRUARY 15, 1965
PHOTOGRAPH OF BRIGITTE BAUER BY BERT STERN

VOGUE

75¢
APR. 1

**BEAUTY ISSUE:
YOU AND THE LOOK THAT'S IN FASHION NOW**

THE PRETTIEST THINGS TO WEAR THIS SUMMER...
THE LITTLE GREEN DRESS WE LOVE

WHAT MAKES TEXAS GO

APRIL 1, 1968
PHOTOGRAPH OF VERUSCHKA BY IRVING PENN

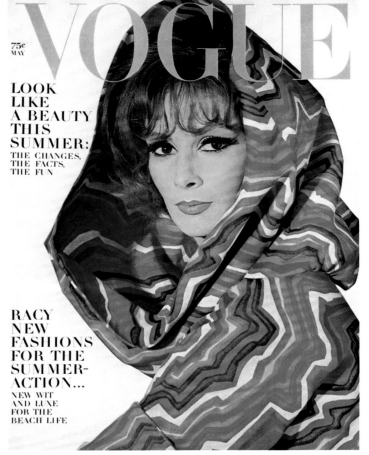

VOGUE

75¢
MAY

LOOK LIKE A BEAUTY THIS SUMMER:
THE CHANGES, THE FACTS, THE FUN

RACY NEW FASHIONS FOR THE SUMMER-ACTION...
NEW WIT AND LUXE FOR THE BEACH LIFE

MAY 1964
PHOTOGRAPH OF WILHELMINA BY IRVING PENN

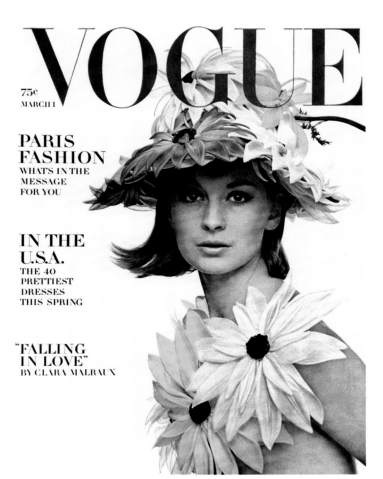

VOGUE

75¢
MARCH 1

PARIS FASHION
WHAT'S IN THE MESSAGE FOR YOU

IN THE U.S.A.
THE 40 PRETTIEST DRESSES THIS SPRING

"FALLING IN LOVE"
BY CLARA MALRAUX

MARCH 1, 1964
PHOTOGRAPH OF SANDRA PAUL BY BERT STERN

VOGUE

75¢
OCT.15

LOOKING GREAT DAY AND NIGHT... 55 NEW WAYS

TOWN CLOTHES
THAT GO AWAY...
COUNTRY
CLOTHES THAT
GO TO TOWN...
FUR COATS
FOR EVERYONE...
GLORIOUS EVENINGS

A FAMOUS BEAUTY'S MAKEUP
WHAT MAKES IT
LAST THE NIGHT

ORGAN TRANSPLANTS
SURPRISING
FACTS YOU
SHOULD KNOW

OCTOBER 15, 1968
PHOTOGRAPH OF WINDSOR ELLIOTT BY GIANNI PENATI

VOGUE

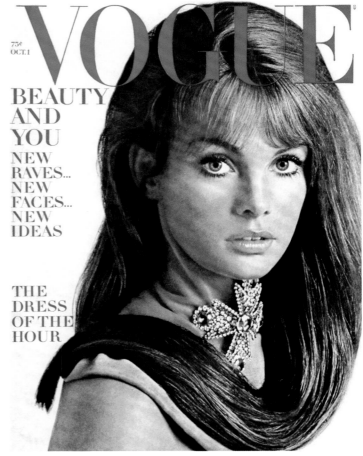

75¢
OCT.1

BEAUTY AND YOU
NEW RAVES...
NEW FACES...
NEW IDEAS

THE DRESS OF THE HOUR

OCTOBER 1, 1967
PHOTOGRAPH OF JEAN SHRIMPTON BY RICHARD AVEDON

VOGUE

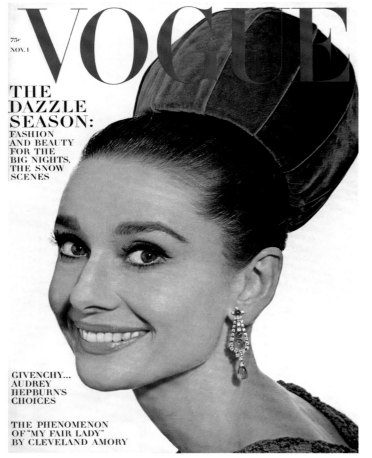

75¢
NOV. 1

THE DAZZLE SEASON:
FASHION
AND BEAUTY
FOR THE
BIG NIGHTS,
THE SNOW
SCENES

**GIVENCHY...
AUDREY HEPBURN'S CHOICES**

THE PHENOMENON OF "MY FAIR LADY" BY CLEVELAND AMORY

NOVEMBER 1, 1964
PHOTOGRAPH OF AUDREY HEPBURN BY IRVING PENN

VOGUE

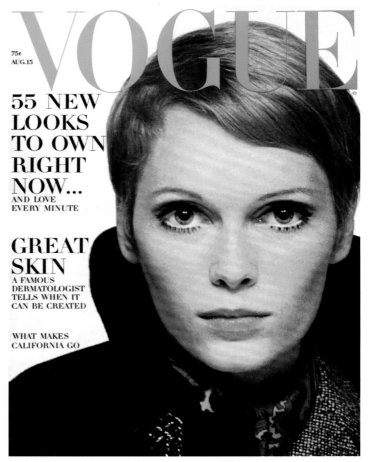

75¢
AUG.15

55 NEW LOOKS TO OWN RIGHT NOW...
AND LOVE
EVERY MINUTE

GREAT SKIN
A FAMOUS
DERMATOLOGIST
TELLS WHEN IT
CAN BE CREATED

WHAT MAKES CALIFORNIA GO

AUGUST 15, 1967
PHOTOGRAPH OF MIA FARROW BY DAVID BAILEY

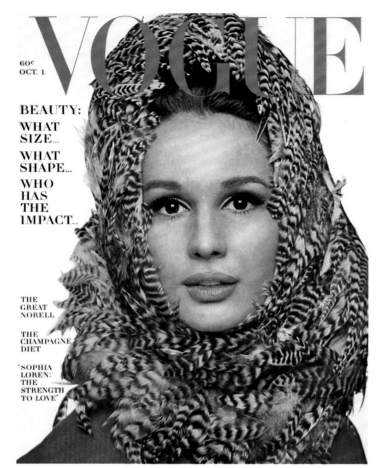

VOGUE

60¢
OCT. 1.

BEAUTY:
WHAT
SIZE...

WHAT
SHAPE...

WHO
HAS
THE
IMPACT...

THE
GREAT
NORELL

THE
CHAMPAGNE
DIET

"SOPHIA
LOREN:
THE
STRENGTH
TO LOVE"

OCTOBER 1, 1963
PHOTOGRAPH OF BRIGITTE BAUER BY BERT STERN

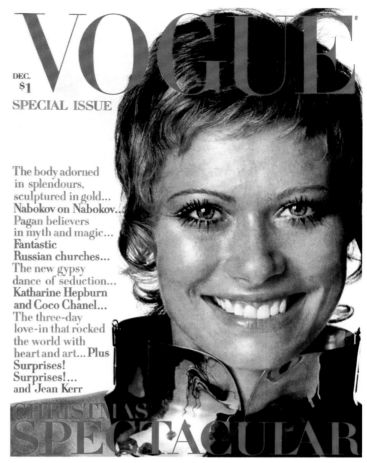

VOGUE

DEC.
$1

SPECIAL ISSUE

The body adorned
in splendours,
sculptured in gold...
Nabokov on Nabokov...
Pagan believers
in myth and magic...
Fantastic
Russian churches...
The new gypsy
dance of seduction...
Katharine Hepburn
and Coco Chanel...
The three-day
love-in that rocked
the world with
heart and art... Plus
Surprises!
Surprises!...
and Jean Kerr

CHRISTMAS
SPECTACULAR

DECEMBER 1969
PHOTOGRAPH OF SUSAN SCHOENBORN BY IRVING PENN

VOGUE

75¢
JAN. 1.

**THE LOOK
THAT'S 1964**

**FASHION
AND BEAUTY
ON THE
BRINK
OF FAME**

CLOTHES
FOR SOUTHERN
RESORTS

JEAN COCTEAU'S
EXTRAORDINARY
MESSAGE TO
THE YOUTH
OF THE FUTURE

BETTINA:
A MODERN
ROMANTIC...HER
NILE TRAVELS...
HER HOUSES

SWINGING
ART DEALERS:
THE MARLBOROUGH
BOYS IN NEW YORK
BY JOHN RUSSELL

JANUARY 1, 1964
PHOTOGRAPH OF SANDRA PAUL BY IRVING PENN

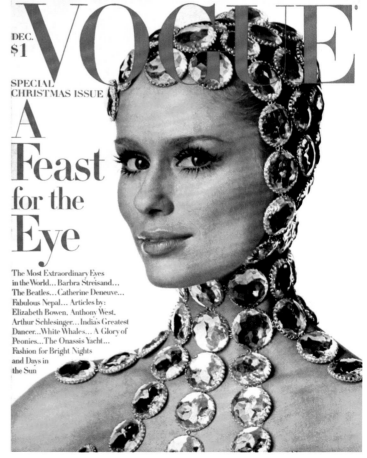

VOGUE

DEC.
$1

SPECIAL
CHRISTMAS ISSUE

**A
Feast
for the
Eye**

The Most Extraordinary Eyes
in the World... Barbra Streisand...
The Beatles... Catherine Deneuve...
Fabulous Nepal... Articles by:
Elizabeth Bowen, Anthony West,
Arthur Schlesinger... India's Greatest
Dancer...White Whales... A Glory of
Peonies... The Onassis Yacht...
Fashion for Bright Nights
and Days in
the Sun

DECEMBER 1968
PHOTOGRAPH OF LAUREN HUTTON BY IRVING PENN

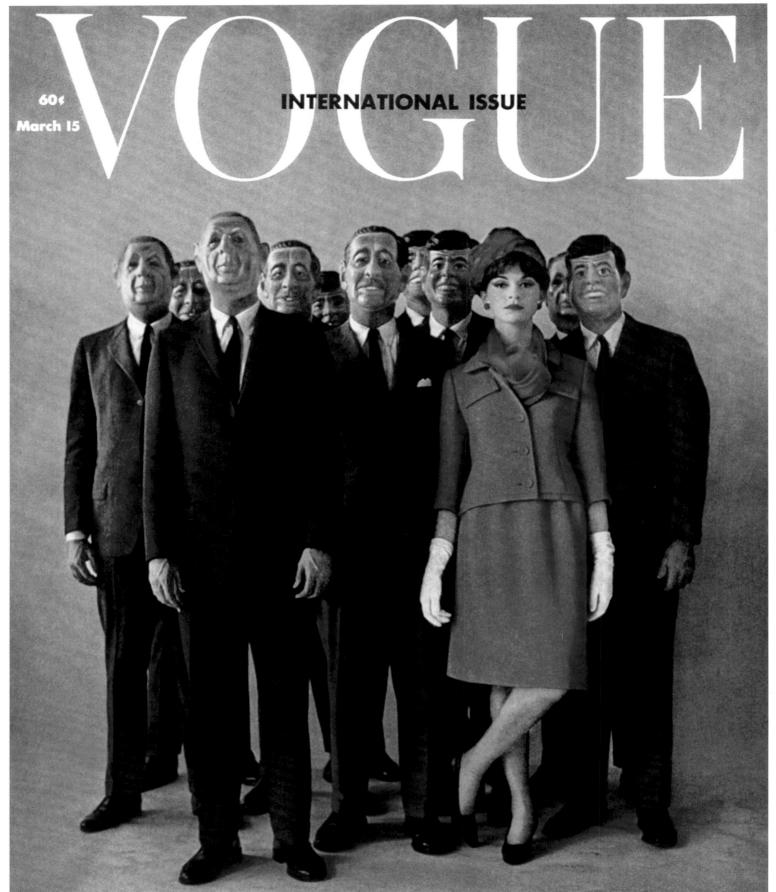

VOGUE

60¢
March 15

INTERNATIONAL ISSUE

CLOTHES FOR THE WOMAN WHO LIVES IN THE WORLD
Fashion talk for women with men in their lives
YES-s and NO-s at the Paris Collections . . . IN-LOOKS in the U.S.A.

MARCH 15, 1962
PHOTOGRAPH OF GILLIS M^cbGIL BY ART KANE

164

VOGUE

60c

FEB. 1

What American
fashion has to say
to you now
75 new looks that
move with the times

Clues in the
handwriting of
famous Americans

"The Champs"
U.S.A.'s best
in 20 fields

AMERICANA ISSUE 1961

The dime-a-dozen face:
make-up to avoid it

FEBRUARY 1, 1961
PHOTOGRAPH OF DOROTHEA McGOWAN BY HERBERT MATTER

VOGUE

60c

MARCH 1

When to yield
to fashion
temptation

New key looks:
Paris. America

"Who's Got the Difference?"
the people people flip over

MARCH 1, 1961
PHOTOGRAPH OF ISABELLA ALBONICO BY IRVING PENN

VOGUE

60¢
SEPT. 1

Fascination
what it is
who has it
...the new
clothes
that set
it stirring

Money-
fascination
A test to tell how
you feel about money

Paris
fashion
news:
Vogue's opinion

The new ways
to wear a suit

"The Best of the Best"
Quick Tastes of the New Books

SEPTEMBER 1, 1961
PHOTOGRAPH OF DOROTHEA McGOWAN BY BERT STERN

VOGUE

60¢
SEPT. 1

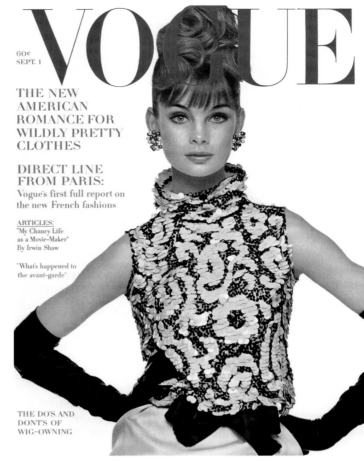

THE NEW
AMERICAN
ROMANCE FOR
WILDLY PRETTY
CLOTHES

DIRECT LINE
FROM PARIS:
Vogue's first full report on
the new French fashions

ARTICLES:
"My Chancy Life
as a Movie-Maker"
By Irwin Shaw

"What's happened to
the avant-garde"

THE DO'S AND
DONTS OF
WIG-OWNING

SEPTEMBER 1, 1963
PHOTOGRAPH OF JEAN SHRIMPTON BY BERT STERN

VOGUE

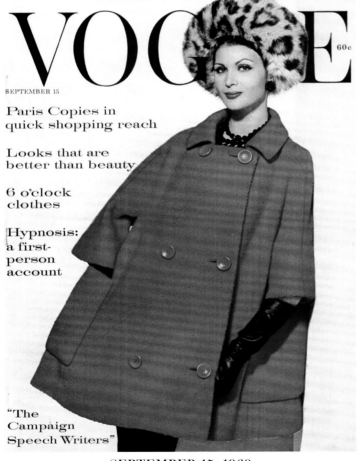

SEPTEMBER 15

60¢

Paris Copies in
quick shopping reach

Looks that are
better than beauty

6 o'clock
clothes

Hypnosis:
a first-
person
account

"The
Campaign
Speech Writers"

SEPTEMBER 15, 1960
PHOTOGRAPH OF ISABELLA ALBONICO BY TOM PALUMBO

VOGUE

75¢
MAR. 1

THE
FINAL
WORD
ON
SKIRT
LENGTH
NOW

THE 50
MOST
BECOMING
DRESSES
IN AMERICA

YOUR FABULOUS FACE:
MAKEUP THAT WILL
GIVE IT EVERYTHING

MARCH 1, 1968
PHOTOGRAPH OF SUSAN MURRAY BY IRVING PENN

VOGUE

JANUARY 15

60c

New fashion wave:
never-out-of-season
clothes

6 different ways
to wear your hair—
all smart

The 20
most-asked
fashion
questions

How to be
a successful
calorie-
chiseler

Small-house
perfection
managed without help

JANUARY 15, 1961

PHOTOGRAPH OF DOROTHEA McGOWAN BY FRANCES McLAUGHLIN-GILL

VOGUE

60c
JUNE

A BARGAIN IN CHIC
25 IDEAS

THE COOL CLEAN BLAZE OF
CATALONIAN WHITE

BEAUTY BULLETIN:
ONE FACE— 3 MAKE-UPS

ARTICLES BY
Cleveland Amory
Shelagh Delaney
Ian Fleming
James Johnson Sweeney

JUNE 1963

PHOTOGRAPH OF CELIA HAMMOND BY HORST P. HORST

VOGUE

75c
AUG. 1

FASHION

FOR

ALL

THE

PRETTY

WITTY

ROMANTICS

OF TODAY

BEAUTY NOTES
FROM THE BRIGHT
YOUNG PEOPLE

THE NEW YORK
ART SCENE:
WHO MAKES IT?

AUGUST 1, 1967

PHOTOGRAPH OF TWIGGY BY RICHARD AVEDON

VOGUE

60c
Sept. 1

New
American looks
to raise
the fashion pulse

Paris colour—
first report

"Mankind Does
Become Better."
By René Dubos

SEPTEMBER 1, 1962

PHOTOGRAPH OF KECIA NYMAN BY ART KANE

VOGUE

60c

JULY

The new enticements

Never-out-of-season wardrobe
charted, priced, long-range

The J. F. Kennedys—
a private view

How much do you tell
when you talk?"

How to *gain* weight

Brace yourself, dear—
I'm bringing
12 people for dinner;"
How the coping
was done

JULY 1961
PHOTOGRAPH OF DEBORAH DIXON BY BERT STERN

VOGUE

60c

OCT. 15

FASHION
NATURALS
U.S.A. –
what's in and why

The beautiful new leg life

ITALY: the clothes,
the life, the talk

"Putting the
Charm in Order"

OCTOBER 15, 1960
PHOTOGRAPH OF ANGELA HOWARD BY TOM PALUMBO

'70s

ALL THE PRESIDENT'S MEN

Endangered Earth gets its "Day." . . . Marisa Berenson strips bare in *Vogue.* . . . Gay Pride marches in New York City. . . . Ralph Lauren opens his first Polo boutique, on Rodeo Drive. . . . Ali vs. Frazier. . . . Naturalness and comfort replace outrageous high style. . . . Mary Tyler Moore wins us over. . . . The Watergate is broken into, and Deep Throat talks to Woodward and Bernstein. . . . Punk rocks and hip hops. . . . Nixon goes to China. . . . *The Godfather* owns the Oscars. . . . Mark Spitz wins seven gold medals, Secretariat wins the Triple Crown, Billie Jean King routs Bobby Riggs in the "Battle of the Sexes.". . . The Supreme Court legalizes abortion in *Roe* v. *Wade.* . . . Jørn Utzon finally finishes the Sydney Opera House. . . . Oil prices soar, and the economy tanks. . . . Philippe Petit rope dances between the Twin Towers, and a day later Nixon resigns. . . . Gloria Steinem's *Ms.* magazine rides the wave of feminism, and *People* caters to the cult of celebrity. . . . The Vietnam nightmare ends, nightmarishly. . . . The Centre Pompidou dazzles Paris. . . . *Saturday Night Live* and *Saturday Night Fever.* . . . Bill Gates's Microsoft and Steve Jobs's Apple. . . . "Tutankhamun" launches blockbuster museum shows. . . . Annie Hall wears neckties, tweed jackets, and a derby hat in Woody Allen's first big hit. . . . Cindy Sherman stars herself in *Untitled Film Stills.* . . . Studio 54 opens. . . . *Star Wars* rage. . . . Iranian students storm the U.S. embassy in Tehran, taking 90 hostages. . . . *Apocalypse Now:* Joseph Conrad, Francis Ford Coppola, Marlon Brando, and "Charlie don't surf."

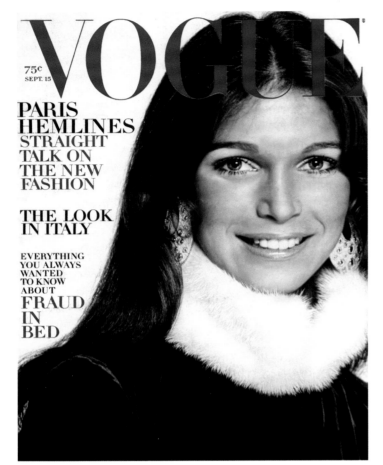

SEPTEMBER 15, 1970

PHOTOGRAPH OF ANN TURKEL BY DAVID BAILEY

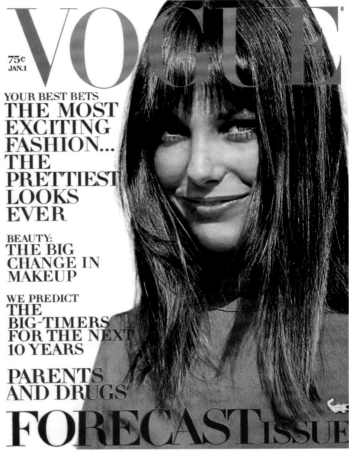

JANUARY 1, 1970

PHOTOGRAPH OF JANE BIRKIN BY JOHN COWAN

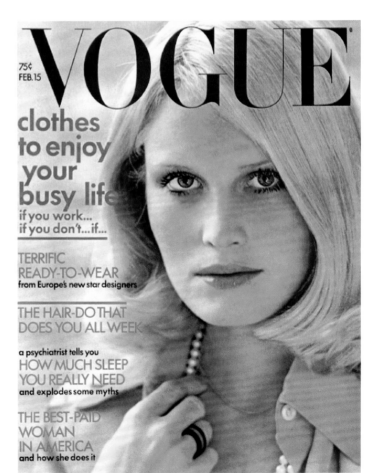

NOVEMBER 15, 1972

PHOTOGRAPH OF RAQUEL WELCH BY HENRY CLARKE

FEBRUARY 15, 1972

PHOTOGRAPH OF GUNILLA LINDBLAD BY HELMUT NEWTON

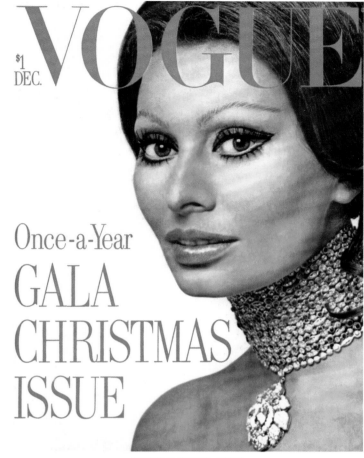

OCTOBER 1, 1971
PHOTOGRAPH OF DONNA MITCHELL BY RICHARD AVEDON

DECEMBER 1970
PHOTOGRAPH OF SOPHIA LOREN BY RICHARD AVEDON

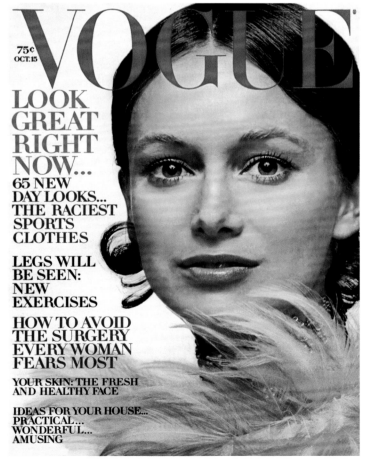

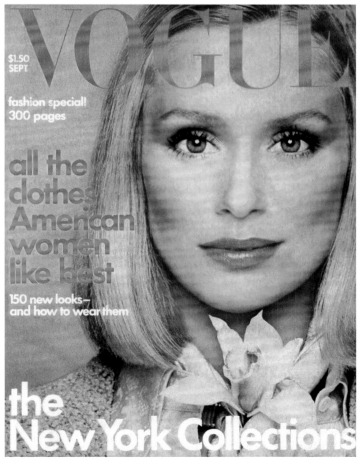

OCTOBER 15, 1970
PHOTOGRAPH OF KAREN GRAHAM BY BERT STERN

SEPTEMBER 1975
PHOTOGRAPH OF LAUREN HUTTON BY FRANCESCO SCAVULLO

175

VOGUE

Apr. 1
75¢

first look
at the
**new
real-life
summer
fashion
and
beauty**

your hair, your makeup…
the way you wear your
clothes…50 great looks

chér shows you
how to enjoy your looks

YOUR DIET
and what you should
know about fat cells

SUN WARNINGS
the real danger light can
do to your skin…your eyes

**42 WAYS YOU
CAN SAY NO**
politely…outrageously

**ARE YOU
A SNOB?**

APRIL 1, 1972
PHOTOGRAPH OF CHER BY RICHARD AVEDON

VOGUE

75¢
MAR. 15

GREAT NEW WAYS TO BE YOURSELF IN FASHION

AMERICA
ALL THE NEW LOOKS...
AND HOW
TO WEAR THEM

PARIS SPECIAL
THE HEMLINE NEWS

ITALIAN COLLECTION

DR. HAIM GINOTT:
HOW PSYCHOTHERAPISTS
DEAL WITH
THEIR CHILDREN

MARCH 15, 1970

PHOTOGRAPH OF LAUREN HUTTON BY IRVING PENN

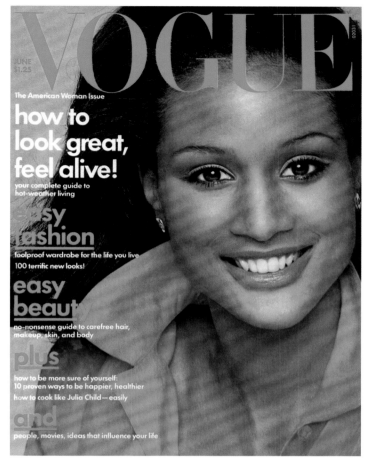

VOGUE

JUNE
$1.25

The American Woman Issue

how to look great, feel alive!

your complete guide to
hot-weather living

easy fashion

foolproof wardrobe for the life you live
100 terrific new looks!

easy beauty

no-nonsense guide to carefree hair,
makeup, skin, and body

plus

how to be more sure of yourself:
10 proven ways to be happier, healthier
how to cook like Julia Child—easily

and

people, movies, ideas that influence your life

JUNE 1975

PHOTOGRAPH OF BEVERLY JOHNSON BY FRANCESCO SCAVULLO

VOGUE

JUNE
$1

THE AMERICAN WOMAN ISSUE

how to look great, live well...

fashion! food! decorating!

your complete guide to
hot-weather dressing:
what to wear on the beach,
on the street, around
the house...all the time

your figure
how to choose the shape-up
routine that will work for you

mind exercises
a doctor tells you
how to relax and build your ego

the easiest diet
you've ever been on—
quick, cold, portable

the Robert Redford
you'd like to know—by Liz Smith

sex
makes fools of us all—
from Anita Loos' new book

JUNE 1974

PHOTOGRAPH OF LAUREN HUTTON BY RICHARD AVEDON

VOGUE

75¢
Apr. 15

your new
travel life

the snappiest new clothes to wear

here... there... and
on your way
50 great looks

SOPHIA LOREN
tells her travel secrets

NABOKOV SPEAKS
an exclusive interview with the most
inspired traveler of our time

SEEING CHINA NOW
Mrs. James Reston's eyewitness story

YOUR HEALTH AND CLIMATE
plus how to cope with time, food, shots

Vogue's own guide to wigs and hairpieces

insiders' tips on
HOW PEOPLE REALLY TRAVEL

HOW TO SOCIAL CLIMB
the travel way

APRIL 15, 1972

PHOTOGRAPH OF SOPHIA LOREN BY HENRY CLARKE

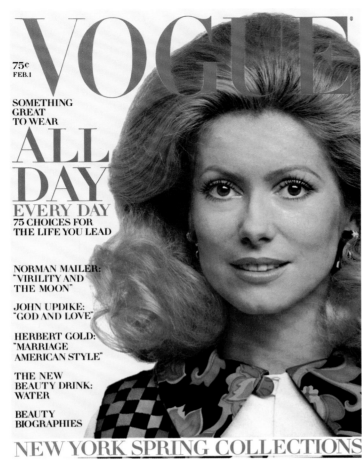

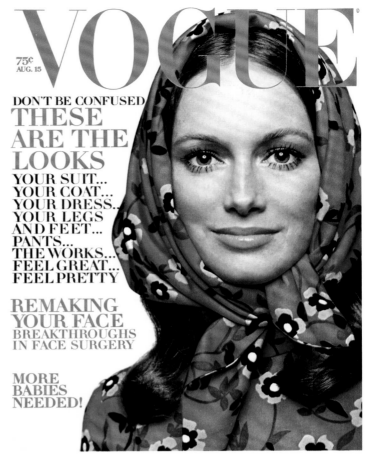

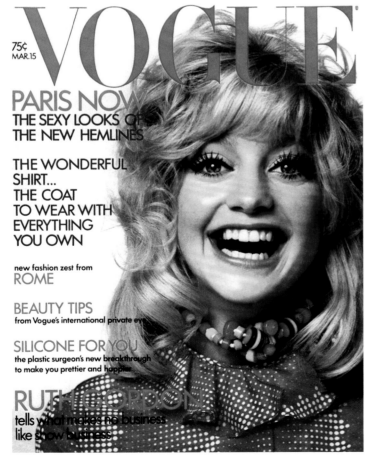

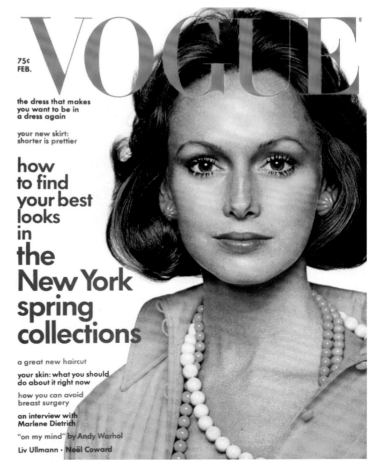

VOGUE

75¢
FEB.1

SOMETHING
GREAT
TO WEAR

ALL
DAY

EVERY DAY
75 CHOICES FOR
THE LIFE YOU LEAD

NORMAN MAILER:
"VIRILITY AND
THE MOON"

JOHN UPDIKE:
"GOD AND LOVE"

HERBERT GOLD:
"MARRIAGE
AMERICAN STYLE"

THE NEW
BEAUTY DRINK:
WATER

BEAUTY
BIOGRAPHIES

NEW YORK SPRING COLLECTIONS

FEBRUARY 1, 1971
PHOTOGRAPH OF CATHERINE DENEUVE BY JUST JAECKIN

VOGUE

75¢
AUG. 15

DON'T BE CONFUSED
THESE
ARE THE
LOOKS
YOUR SUIT...
YOUR COAT...
YOUR DRESS...
YOUR LEGS
AND FEET...
PANTS...
THE WORKS...
FEEL GREAT...
FEEL PRETTY

REMAKING
YOUR FACE
BREAKTHROUGHS
IN FACE SURGERY

MORE
BABIES
NEEDED!

AUGUST 15, 1970
PHOTOGRAPH OF KAREN GRAHAM BY BERT STERN

VOGUE

75¢
MAR.15

PARIS NOW
THE SEXY LOOKS OF
THE NEW HEMLINES

THE WONDERFUL
SHIRT...
THE COAT
TO WEAR WITH
EVERYTHING
YOU OWN

new fashion zest from
ROME

BEAUTY TIPS
from Vogue's international private eye

SILICONE FOR YOU
the plastic surgeon's new breakthrough
to make you prettier and happier

RUTH GORDON
tells what makes no business
like show business

MARCH 15, 1971
PHOTOGRAPH OF GOLDIE HAWN BY RICHARD AVEDON

VOGUE

75¢
FEB.

the dress that makes
you want to be in
a dress again

your new skirt:
shorter is prettier

how
to find
your best
looks
in
the
New York
spring
collections

a great new haircut

your skin: what you should
do about it right now

how you can avoid
breast surgery

an interview with
Marlene Dietrich

"on my mind" by Andy Warhol

Liv Ullmann · Noël Coward

FEBRUARY 1973
PHOTOGRAPH OF KAREN GRAHAM BY BOB STONE

VOGUE

75¢
FEB. 15

**TERRIFIC
NEW
LOOKS
FROM TOP
TO TOE**

YOUR HAIR
NEW WAYS TO WEAR IT...
NEW WIGS
AND HAIRPIECES

**WHY WOMEN
PANIC
ABOUT AGE**
AND WHAT DOCTORS
SAY ABOUT IT

SUZY
TELLS WHAT
IT COSTS
TO HAVE
AN AFFAIR

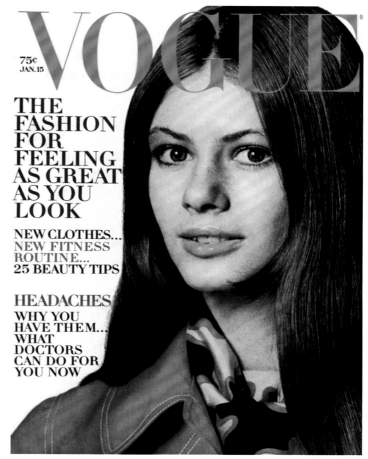

FEBRUARY 15, 1970
PHOTOGRAPH OF LYNN SUTHERLAND BY BERT STERN

VOGUE

75¢
JAN. 15

**THE
FASHION
FOR
FEELING
AS GREAT
AS YOU
LOOK**

**NEW CLOTHES...
NEW FITNESS
ROUTINE...
25 BEAUTY TIPS**

HEADACHES
WHY YOU
HAVE THEM...
WHAT
DOCTORS
CAN DO FOR
YOU NOW

JANUARY 15, 1970
PHOTOGRAPH OF MARIE GUSTAVSSON BY IRVING PENN

VOGUE

75¢
MAY

this summer
**look great...
feel fit...
have fun**

**THE BEST
LOOKING
SUMMER CLOTHES
YOU CAN WEAR**

Chanel...
about life...fashion...taste...love

**THE 10-DAY DIET
TO HIGH ENERGY**

**THE MOST BEAUTIFUL
WOMAN IN THE WORLD**
Richard Avedon tells you
why she looks that way

BEAUTY NOW
new ways to wear your hair...
make up your face...save your skin

MAY 1972
PHOTOGRAPH OF KAREN GRAHAM BY IRVING PENN

VOGUE

75¢
MAR. 1

**IT'S
A GREAT
YEAR
FOR
DRESSES...
SEXY...
EASY
TO WEAR...**
NEW SHAPES...
NEW LENGTHS

**THE BIG
MAKEUP
EXCITEMENT**
NEW COLOURS...
NEW WAYS
TO USE THEM

**ANDY WARHOL-
SUPER SUPERSTAR**

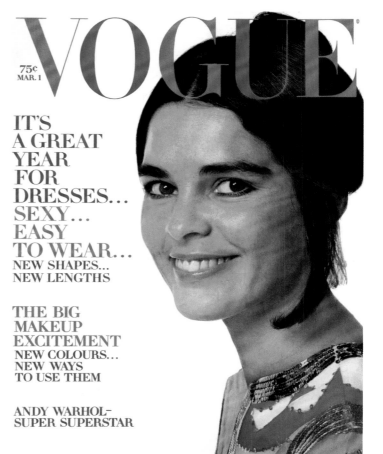

MARCH 1, 1970
PHOTOGRAPH OF ALI MacGRAW BY BERT STERN

VOGUE

$1
DEC.

Once-a-Year
GALA
CHRISTMAS
ISSUE

Princess Grace
of Monaco

DECEMBER 1971
PHOTOGRAPH OF PRINCESS GRACE BY RICHARD AVEDON

180

special holiday issue

VOGUE

$1
Dec.

the sexy
beat of Sonny
and Cher…
her looks…
her fashion…
his style

Halston's best
and newest
fashion in color

Woody Allen
plays the
funnymen –
Groucho, Chaplin,
Buster, Harpo

the glory of La Tour's Nativity
the compassion of the movie "Sounder"
the genius of Balanchine – greatest ballet year
blue for your tan: the new sun fashion
the glamorous night bathing suit
how to say thank you for impossible presents
what's in the stars for 1973
Zouzou: new movie heroine
Miró: the youngest old master
Joe Papp: theater's shot in the arm
Casino Zizi – ooh la la!
Visconti's vision on film
Cicely Tyson: newest star of the big black movies
Penn's fabulous lilies
health…food…living…people are talking about

DECEMBER 1972
PHOTOGRAPH OF CHER BY RICHARD AVEDON

181

VOGUE

DEC.
$1.25

our best-ever
holiday issue

fashion!

50 great looks to wear
wherever you are

beauty!

new makeup trick—color does it
10 simple steps that save your looks

food!

the quickest you'll ever cook

dazzle!

super-girl Cher: her fashion and beauty

fun!

the new Hollywood revealed
the stars, the hits, the excitement—
and, yes, Elizabeth Taylor!

art!

Michelangelo's divine circles
Impressionism: 100-year spectacular
more art than money—from $75

ideas!

the truth about Gore Vidal—from Gore Vidal

DECEMBER 1974
PHOTOGRAPH OF LISA TAYLOR BY FRANCESCO SCAVULLO

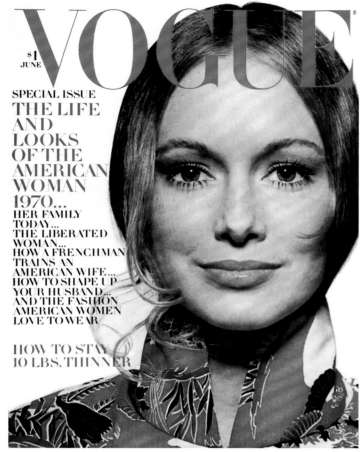

JUNE 1970

PHOTOGRAPH OF KAREN GRAHAM BY BERT STERN

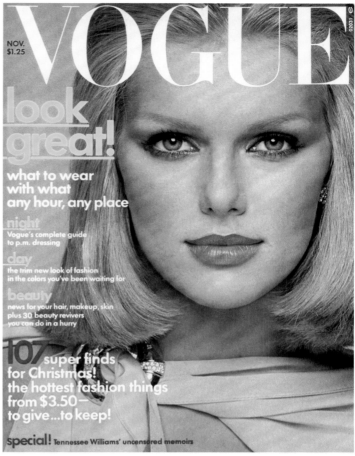

NOVEMBER 1975

PHOTOGRAPH OF PATTI HANSEN BY FRANCESCO SCAVULLO

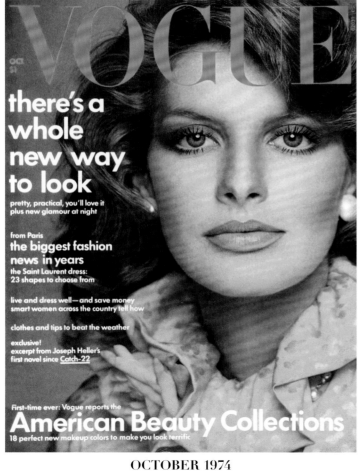

OCTOBER 1974

PHOTOGRAPH OF RENE RUSSO BY FRANCESCO SCAVULLO

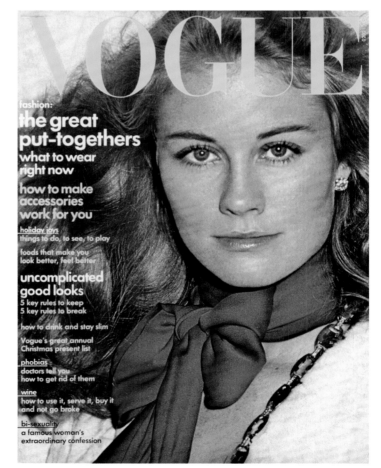

NOVEMBER 1973

PHOTOGRAPH OF CYBILL SHEPHERD BY HELMUT NEWTON

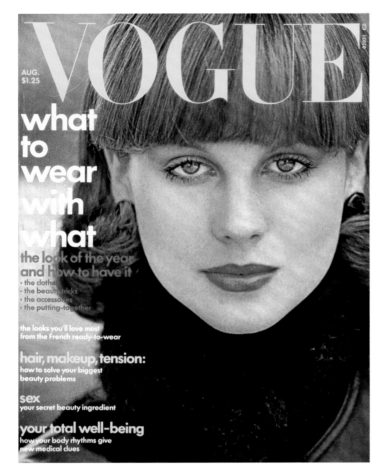

AUGUST 1975
PHOTOGRAPH OF ROSIE VELA BY ARTHUR ELGORT

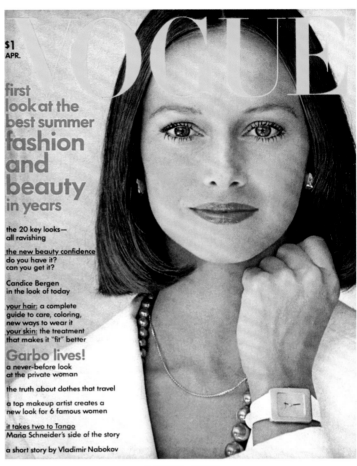

APRIL 1973
PHOTOGRAPH OF KAREN GRAHAM BY KOURKEN PAKCHANIAN

JULY 1979
PHOTOGRAPH OF ESMÉ MARSHALL BY PATRICK DEMARCHELIER

APRIL 1977
PHOTOGRAPH OF FARRAH FAWCETT-MAJORS BY RICHARD AVEDON

VOGUE

SEPT.
$1.75

our biggest
fashion special
350-plus pages

165
terrific new
looks and
how to
wear them

news from 11 key designers

easy winners!
the clothes that work best
for the way you live

the New York Collections

SEPTEMBER 1976
PHOTOGRAPH OF PATTI HANSEN BY FRANCESCO SCAVULLO

185

VOGUE

yes

NOV
$2.00

Dressing for delight

The looks you want now —
for resort…city and sun
for day/night…anywhere

100 Christmas finds

Your skin:
are you living right?

Your brain,
your nervous system —
who's in charge?

Seduction,
fashion photography,
and women

NOVEMBER 1979
PHOTOGRAPH OF KIM ALEXIS BY STAN MALINOWSKI

VOGUE

JULY
$1.50

style!

the most
alluring
fashion in
years
24 key
looks

Saint Laurent
at his best

marvelous shoes

believable health and fitness guide
exercise do's and don'ts

JULY 1978
PHOTOGRAPH OF FARRAH FAWCETT-MAJORS BY PATRICK DEMARCHELIER

VOGUE

JAN.
$1.25

fashion
and beauty '76

**the
word
is
pretty!**

80 great new looks
and how to
wear them

what's news, what's coming

Nancy Kissinger • weight-loss fast • non-stop energy
easy Italian buffet • gossip 1976 • mistreating women

JANUARY 1976
PHOTOGRAPH OF PATTI HANSEN BY ARTHUR ELGORT

APRIL 1975
PHOTOGRAPH OF RENE RUSSO BY FRANCESCO SCAVULLO

JULY 1976
PHOTOGRAPH OF RENE RUSSO BY ARTHUR ELGORT

JANUARY 1975
PHOTOGRAPH OF LAUREN HUTTON BY FRANCESCO SCAVULLO

MAY 1974
PHOTOGRAPH OF CHER BY CHRIS VON WANGENHEIM

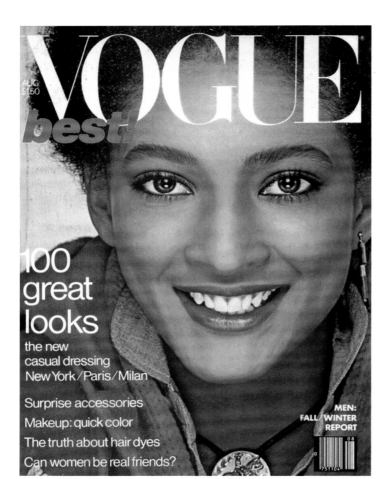

AUGUST 1978

PHOTOGRAPH OF PEGGY DILLARD BY ALBERT WATSON

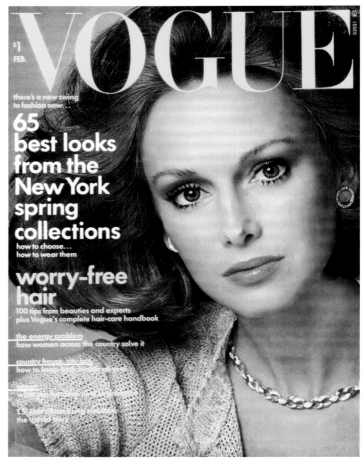

FEBRUARY 1974

PHOTOGRAPH OF KAREN GRAHAM BY FRANCESCO SCAVULLO

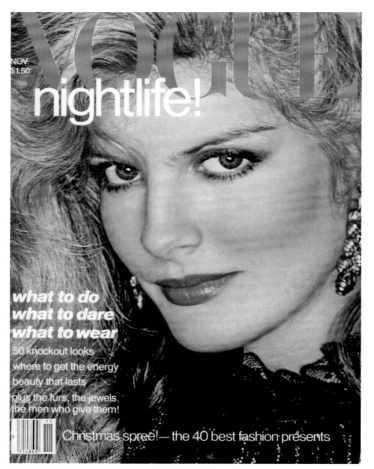

NOVEMBER 1977

PHOTOGRAPH OF RENE RUSSO BY PATRICK DEMARCHELIER

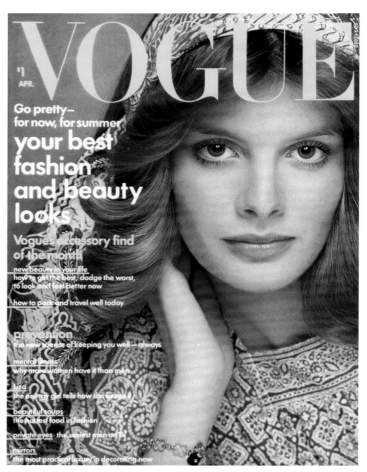

APRIL 1974

PHOTOGRAPH OF RENE RUSSO BY RICHARD AVEDON

VOGUE

APR.
$2.00

fresh...

the
new
look
of beauty

**Straight talk on good health,
diet, exercise, skin, makeup**

First look at summer fashion—
it's terrific!

Paris: the new mood—
what's in it for you

The great I.B.Singer speaks out—
on life, dreams, love, and terror

APRIL 1979
PHOTOGRAPH OF ESMÉ MARSHALL BY STAN SHAFFER

191

VOGUE

simplify, streamline, catch up, enjoy!

fashion you'll want

what's now, what's coming

3 great looks from 1 wonderful top

beautiful shoes!

the best all-year wardrobe from 6 easy patterns

beauty news

the haircut that updates your whole look

your new fall makeup— accent on eyes

your health

how antidepressants offer new hope

cool, zingy salads

and our own best-dressings list

women as friends

rewards and dangers

JULY 1975

PHOTOGRAPH OF RENE RUSSO BY FRANCESCO SCAVULLO

VOGUE

75¢
AUG.1

the Vogue look

the big swing to classics...

marvelous
sports clothes
and how
to wear them

BEAUTY SECRETS
from the ballet girls

ONCE-A-MONTH BIRTH CONTROL
what it is... how you use it

the big news in
CONTACT LENSES

MISTAKES SURGEONS MAKE MOST OFTEN...
what you can do
about them

AUGUST 1, 1971
PHOTOGRAPH OF PATRICIA DOW BY GIANNI PENATI

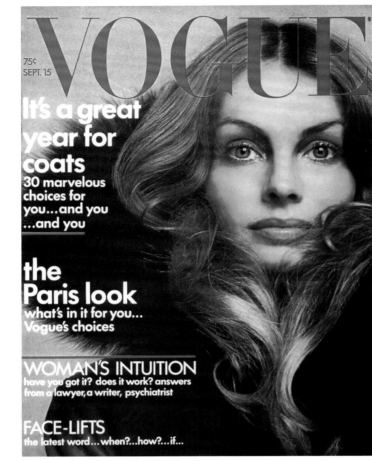

SEPTEMBER 15, 1971

PHOTOGRAPH OF JEAN SHRIMPTON BY DAVID BAILEY

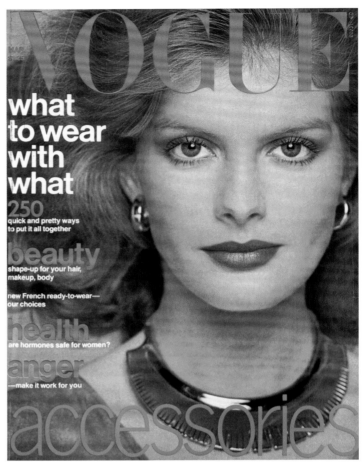

MARCH 1976

PHOTOGRAPH OF RENE RUSSO BY FRANCESCO SCAVULLO

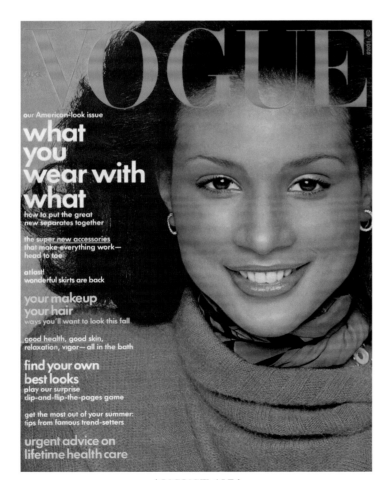

AUGUST 1974

PHOTOGRAPH OF BEVERLY JOHNSON BY FRANCESCO SCAVULLO

NOVEMBER 1, 1971

PHOTOGRAPH OF KAREN GRAHAM BY IRVING PENN

VOGUE

75¢
APR.15

SPECIAL
TRAVEL
ISSUE

TRAVELS WITH LIZ

BY RICHARD BURTON

THE SNAPPIEST NEW CLOTHES TO WEAR WHEREVER YOU ARE
knits...jersey...suede...leather...pretty city looks

HOW PEOPLE REALLY TRAVEL
inside tips on packing, books, customs, what's good where, and how to have fun

What makes an erotic hotel...
what to do about jet lag...
how to combine art and restaurants in the U.S.A....
where to indulge your island fever

BEAUTY
How to have the prettiest feet walking

APRIL 15, 1971
PHOTOGRAPH OF ELIZABETH TAYLOR BY SNOWDON

BOOMS
AND BUSTS

Goodbye, John Lennon. . . . Good morning, President Reagan. . . . A return to affluence and glamour, big shoulders and bigger jewelry, *Dallas* and *Dynasty*—nothing succeeds like excess. . . . "I want my MTV!" . . . Brooke Shields loves her Calvins. . . . Yuppies love yuppies. . . . Indiana Jones cracks the whip in *Raiders of the Lost Ark*. . . . Reagan is shot: "Honey, I forgot to duck.". . . Michael Jackson's *Thriller* becomes the best-selling album of all time. . . . Steven Spielberg's *E.T.* and Bono's U2. . . . Maya Lin's Vietnam Veterans Memorial is a minimalist masterpiece. . . . The AIDS epidemic is diagnosed. . . . The war on drugs: Nancy Reagan just says no. . . . Meryl Streep in picture after picture (*Sophie's Choice, Out of Africa*, et cetera). . . . Karl Lagerfeld takes over Chanel. . . . Madonna is like a virgin. . . . Oprah Winfrey goes national. . . . Donna Karan makes dressing easy for women execs. . . . Models become super—Linda Evangelista, Cindy Crawford, Naomi Campbell, Christy Turlington. . . . Chernobyl brings home the nuclear peril. . . . Contemporary art breaks auction records. . . . Gordon Gekko reveals the dark side of Wall Street. . . . Stocks collapse. . . . Salman Rushdie's *The Satanic Verses* ignites a fatwa. . . . Jeans make the cover of *Vogue*. . . . I. M. Pei builds a glass pyramid for the Louvre. . . . The innocents are massacred in Tiananmen Square. . . . The Berlin Wall comes down.

'80s

NOVEMBER $3.00

VOGUE

AUG.
$3.00

REAL
ANSWERS

FASHION
FOR THE
BUSY LIFE

THE MOST-WANTED
DAY LOOKS

stamina & success:
18 women at the top

08

37132

0 751164 6

ADDICTION:
HOW TO
FIGHT BACK

Liz Smith finds out
about Diane Sawyer...

AUGUST 1986
PHOTOGRAPH OF CINDY CRAWFORD BY RICHARD AVEDON

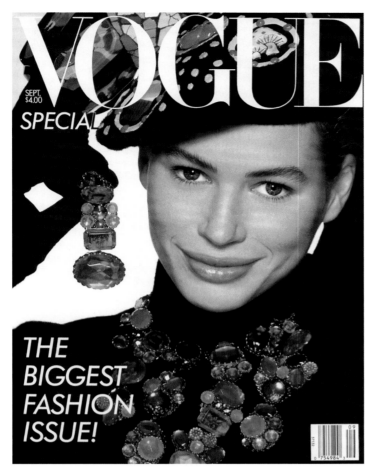

SEPTEMBER 1988
PHOTOGRAPH OF CARRÉ OTIS BY RICHARD AVEDON

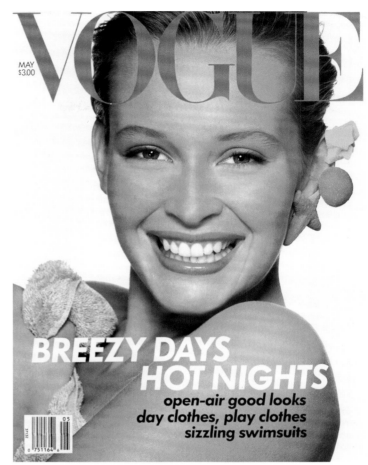

MAY 1988
PHOTOGRAPH OF ESTELLE LEFÉBURE BY RICHARD AVEDON

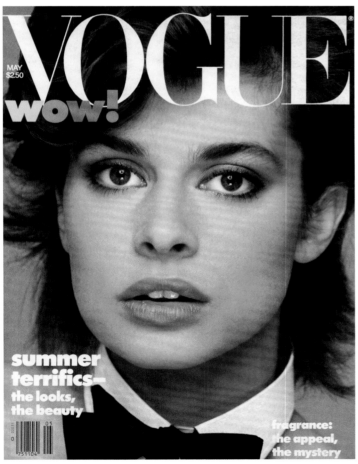

MAY 1982
PHOTOGRAPH OF NASTASSJA KINSKI BY RICHARD AVEDON

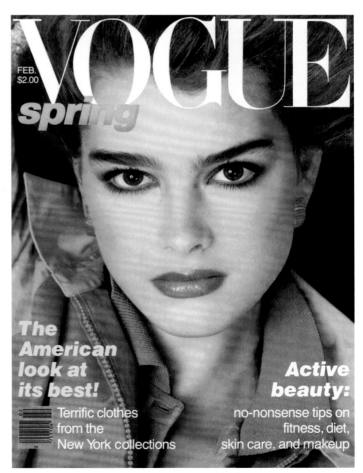

FEBRUARY 1980
PHOTOGRAPH OF BROOKE SHIELDS BY RICHARD AVEDON

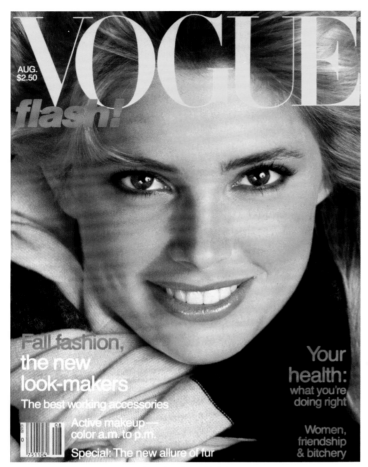

AUGUST 1981

PHOTOGRAPH OF KELLY EMBERG BY RICHARD AVEDON

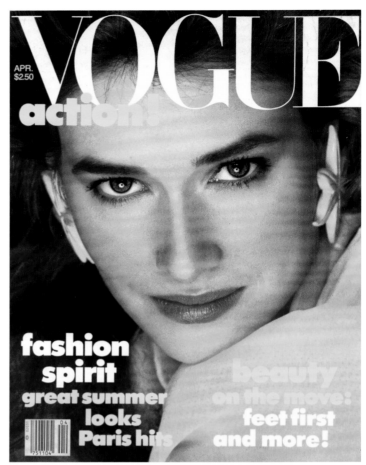

APRIL 1982

PHOTOGRAPH OF ROSEMARY McGROTHA BY RICHARD AVEDON

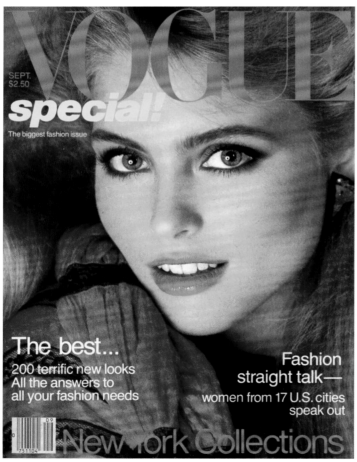

SEPTEMBER 1980

PHOTOGRAPH OF KIM ALEXIS BY RICHARD AVEDON

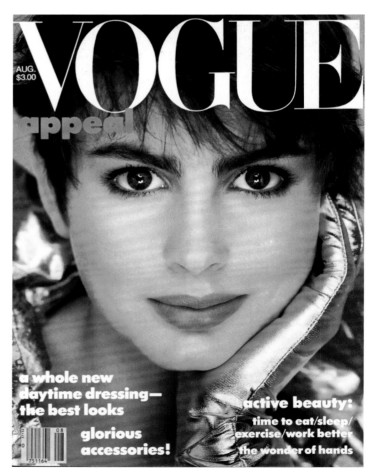

AUGUST 1985

PHOTOGRAPH OF ALEXA SINGER BY RICHARD AVEDON

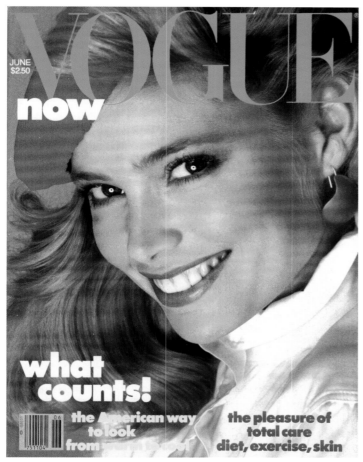

JUNE 1982

PHOTOGRAPH OF KELLY EMBERG BY RICHARD AVEDON

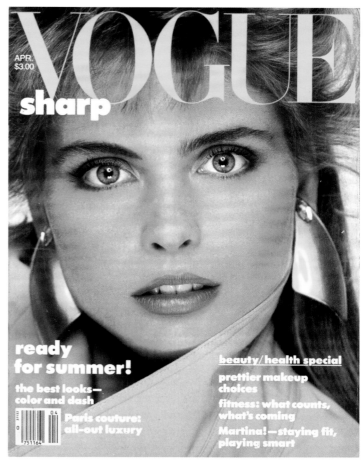

APRIL 1985

PHOTOGRAPH OF KIM ALEXIS BY RICHARD AVEDON

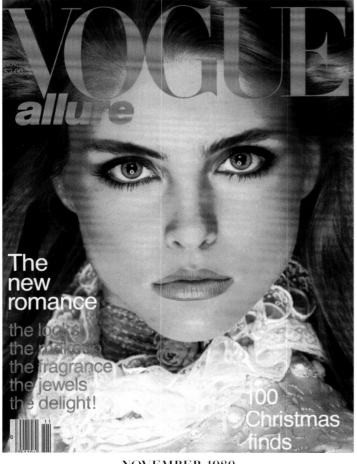

NOVEMBER 1980

PHOTOGRAPH OF KIM ALEXIS BY RICHARD AVEDON

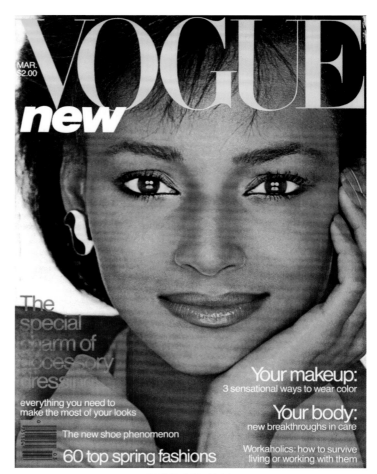

MARCH 1980

PHOTOGRAPH OF SHEILA JOHNSON BY PATRICK DEMARCHELIER

VOGUE

JULY
$3.00

TIP-OFFS

FALL
SIGNALS
**the
best looks
from
new york,
milan, paris**

THE JACKET, THE SHOES, THE HAIR:
WHAT REALLY COUNTS

FOOD STYLES
OF THE
RICH AND FAMOUS

07

37132

0 751164 6

JULY 1987
PHOTOGRAPH OF PAULINA PORIZKOVA BY RICHARD AVEDON

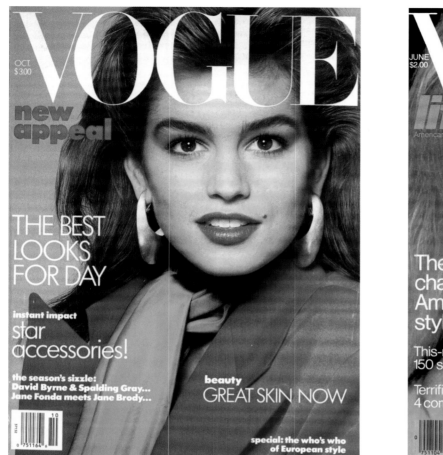

OCTOBER 1986

PHOTOGRAPH OF CINDY CRAWFORD BY RICHARD AVEDON

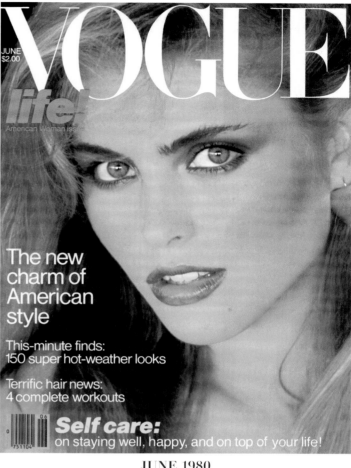

JUNE 1980

PHOTOGRAPH OF KIM ALEXIS BY FRANCESCO SCAVULLO

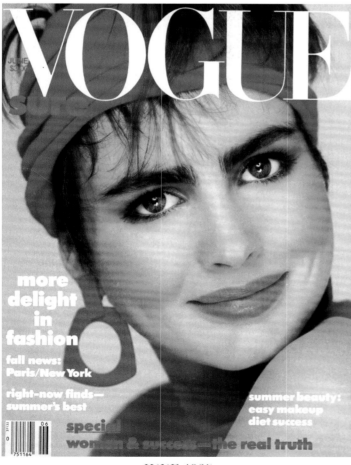

JUNE 1985

PHOTOGRAPH OF ALEXA SINGER BY RICHARD AVEDON

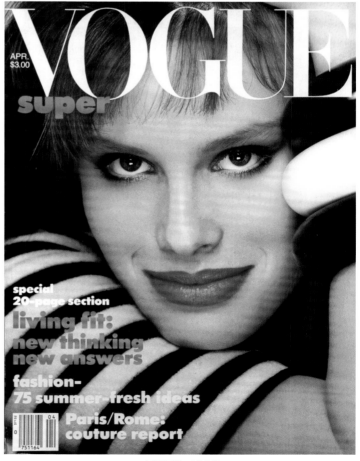

APRIL 1986

PHOTOGRAPH OF MONIKA SCHNARRE BY RICHARD AVEDON

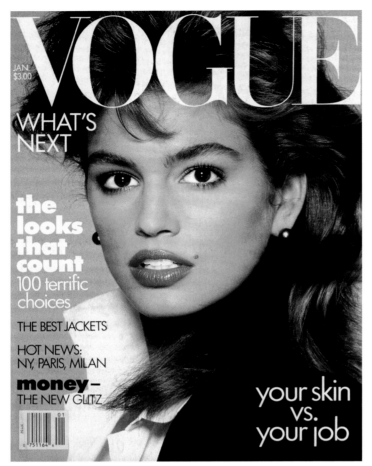

JANUARY 1987

PHOTOGRAPH OF CINDY CRAWFORD BY RICHARD AVEDON

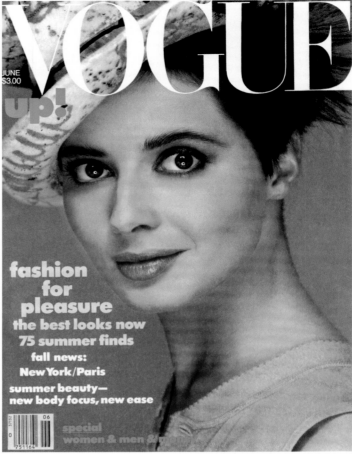

JUNE 1984

PHOTOGRAPH OF ISABELLA ROSSELLINI BY RICHARD AVEDON

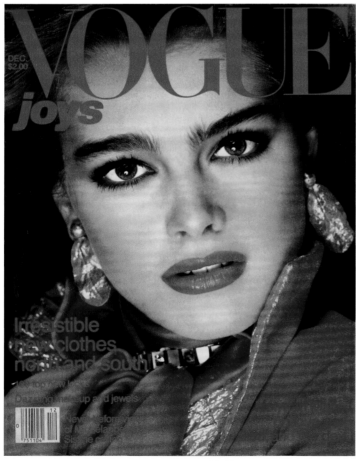

DECEMBER 1980

PHOTOGRAPH OF BROOKE SHIELDS BY RICHARD AVEDON

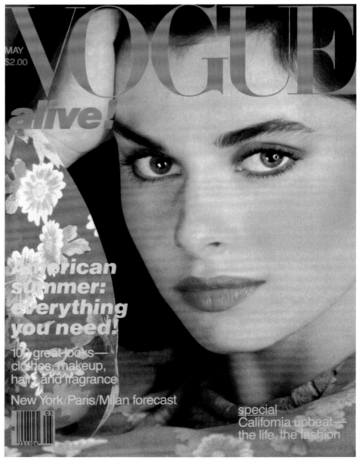

MAY 1980

PHOTOGRAPH OF NASTASSJA KINSKI BY RICHARD AVEDON

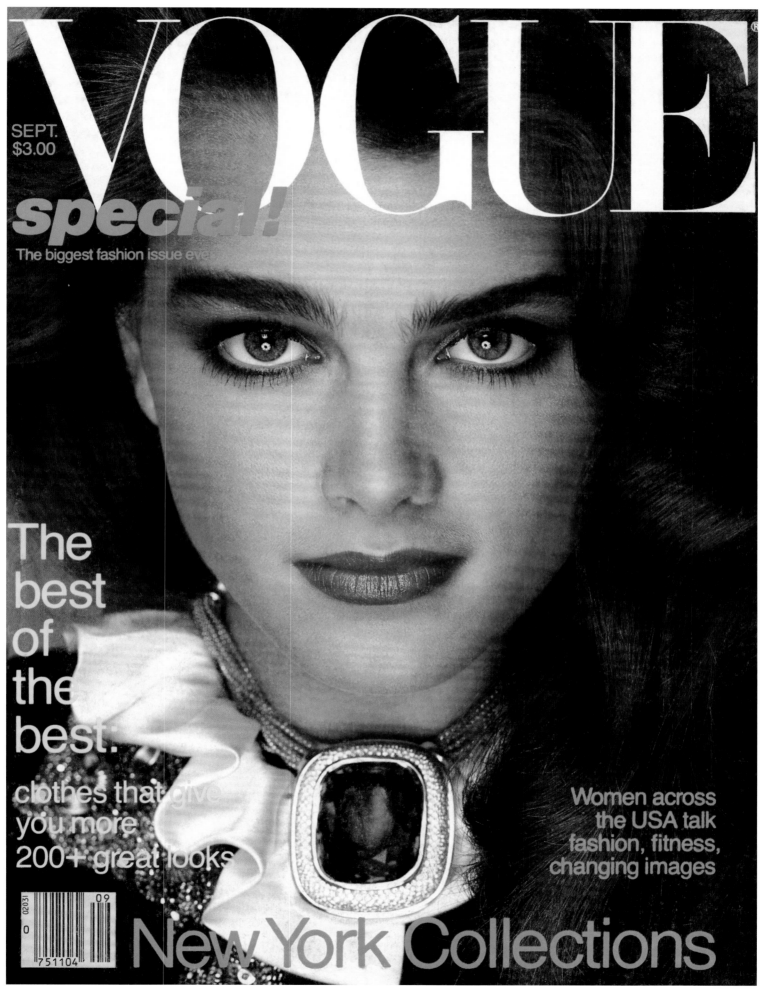

VOGUE

special!
The biggest fashion issue eve

The
best
of
the
best:

clothes that give
you more
200+ great looks

Women across
the USA talk
fashion, fitness,
changing images

New York Collections

SEPTEMBER 1981
PHOTOGRAPH OF BROOKE SHIELDS BY RICHARD AVEDON

205

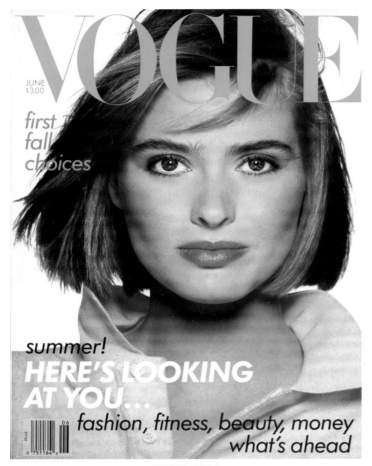

JUNE 1988

PHOTOGRAPH OF CATHY FEDORUK BY RICHARD AVEDON

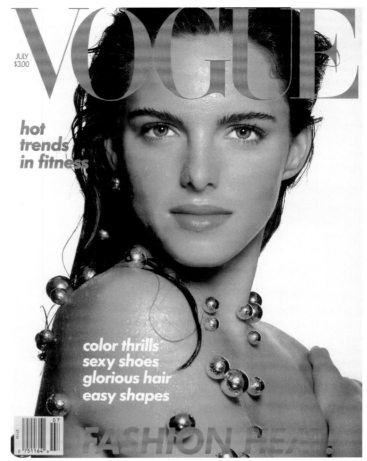

JULY 1988

PHOTOGRAPH OF SUSAN MINER BY RICHARD AVEDON

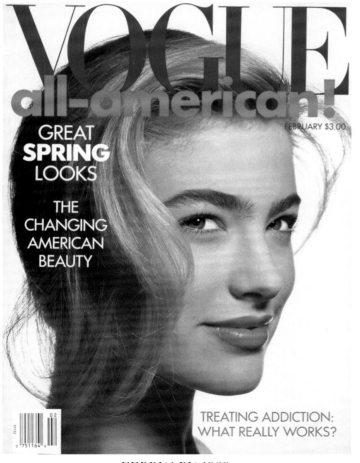

FEBRUARY 1989

PHOTOGRAPH OF ELAINE IRWIN BY IRVING PENN

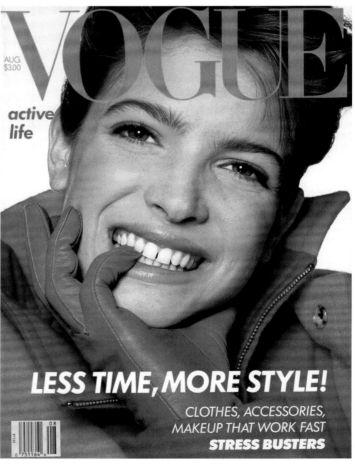

AUGUST 1988

PHOTOGRAPH OF STEPHANIE SEYMOUR BY RICHARD AVEDON

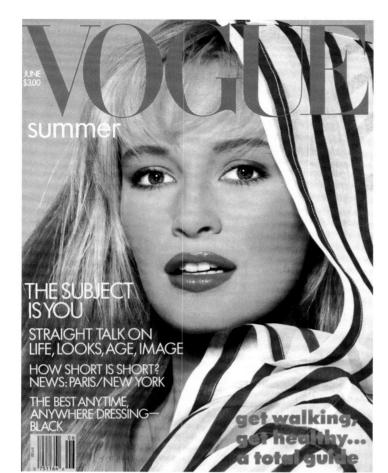

JUNE 1987

PHOTOGRAPH OF ESTELLE LEFÉBURE BY RICHARD AVEDON

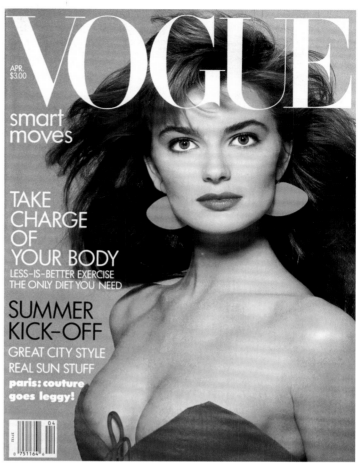

APRIL 1987

PHOTOGRAPH OF PAULINA PORIZKOVA BY RICHARD AVEDON

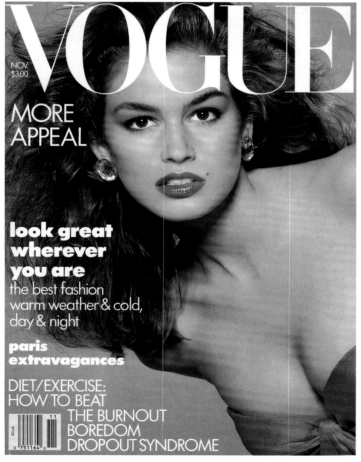

NOVEMBER 1987

PHOTOGRAPH OF CINDY CRAWFORD BY RICHARD AVEDON

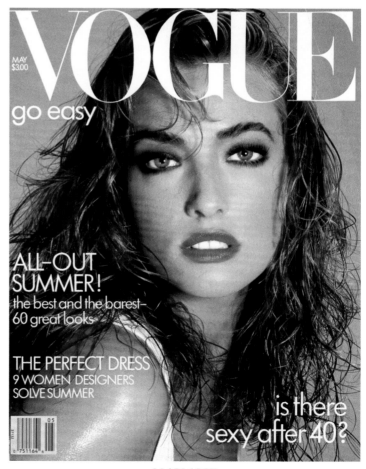

MAY 1987

PHOTOGRAPH OF TATJANA PATITZ BY RICHARD AVEDON

VOGUE

JAN.
$3.00

SIGNS OF THE '90s

no frills,
no ruffles,
no kidding:
**clothes
that
really count**
100 best looks

**paris/milan—
joie de spring!**

37132
0 751164 6
01

**SKIN IN THE
FAST-FIX AGE**

JANUARY 1988
PHOTOGRAPH OF RACHEL WILLIAMS BY RICHARD AVEDON

208

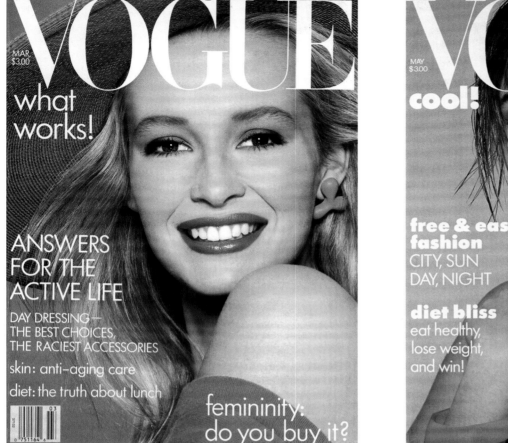

MARCH 1987

PHOTOGRAPH OF ESTELLE LEFÉBURE BY RICHARD AVEDON

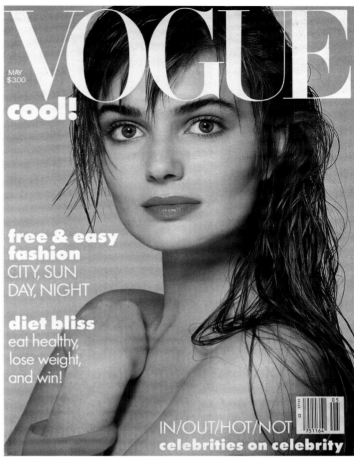

MAY 1986

PHOTOGRAPH OF PAULINA PORIZKOVA BY RICHARD AVEDON

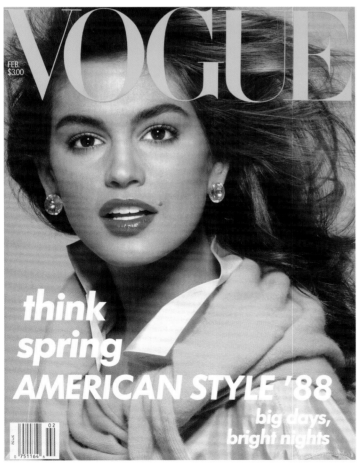

FEBRUARY 1988

PHOTOGRAPH OF CINDY CRAWFORD BY RICHARD AVEDON

JUNE 1986

PHOTOGRAPH OF SHARI BELAFONTE BY RICHARD AVEDON

AUGUST 1987
PHOTOGRAPH OF ESTELLE LEFÉBURE BY RICHARD AVEDON

JULY 1985
PHOTOGRAPH OF ISABELLA ROSSELLINI BY RICHARD AVEDON

FEBRUARY 1987
PHOTOGRAPH OF LOUISE VYENT BY RICHARD AVEDON

JULY 1986
PHOTOGRAPH OF ESTELLE LEFÉBURE BY RICHARD AVEDON

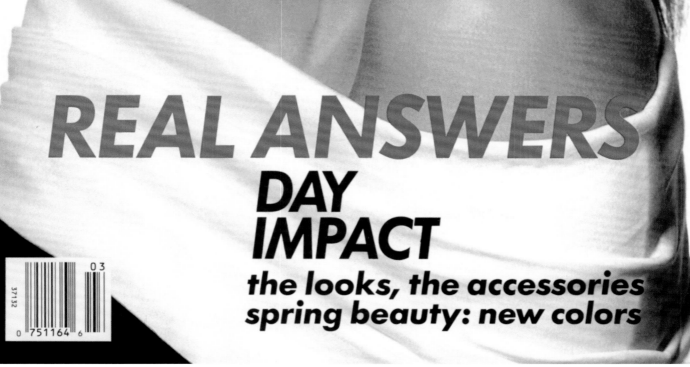

VOGUE

MAR.
$3.00

REAL ANSWERS
DAY IMPACT
**the looks, the accessories
spring beauty: new colors**

37132
0 751164 6
03

MARCH 1988
PHOTOGRAPH OF STEPHANIE SEYMOUR BY RICHARD AVEDON

VOGUE

DEC.
$3.00

STANDOUTS

glorious fashion!
new color excitement
freer, barer, softer looks

young hollywood—
after the brat pack

the best and
the worst of 87

GLORIOUS BROOKE:
BEAUTY/FITNESS
SPECIAL

37132

0 751164 6

12

DECEMBER 1987
PHOTOGRAPH OF BROOKE SHIELDS BY RICHARD AVEDON

212

VOGUE

SEPT.
$4.00

SPECIAL
THE BIGGEST FASHION ISSUE

go for the best!

american fashion in top form

200 key choices

NEW YORK COLLECTIONS

37132
0 754984 3
09

SEPTEMBER 1987
PHOTOGRAPH OF CINDY CRAWFORD BY RICHARD AVEDON

VOGUE

OCTOBER $3.00

FASHION FROM BASIC TO BLOCKBUSTER

BEAUTY FOR THE 90s: PLASTIC AND PERFECT?

PARIS: THE NEW SUIT

EVENING: THE VELVET TOUCH

OUTDOORS IN STYLE

37132

0 751164 6

10

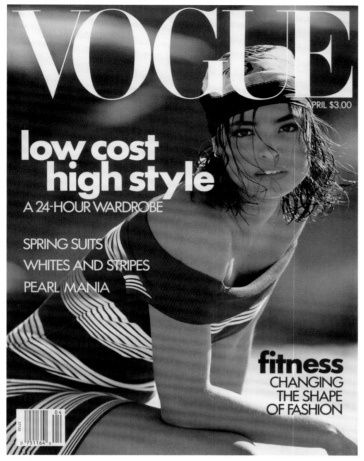

APRIL 1989

PHOTOGRAPH OF TALISA SOTO BY PATRICK DEMARCHELIER

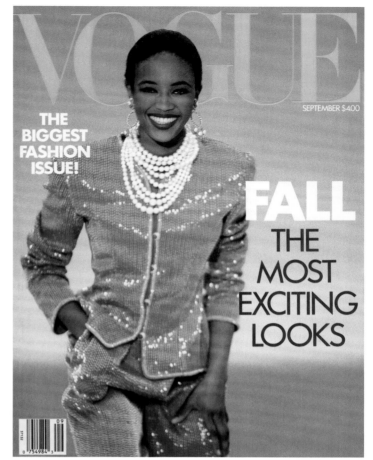

SEPTEMBER 1989

PHOTOGRAPH OF NAOMI CAMPBELL BY PATRICK DEMARCHELIER

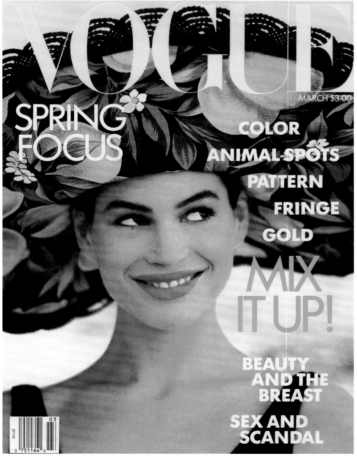

MARCH 1989

PHOTOGRAPH OF CARRÉ OTIS BY ARTHUR ELGORT

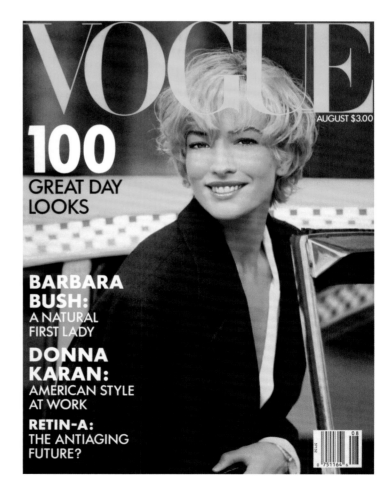

AUGUST 1989

PHOTOGRAPH OF TATJANA PATITZ BY PETER LINDBERGH

VOGUE

DECEMBER $3.00

color!

style on holiday

ALL THE NIGHT STUFF:
GOLD, TRANSPARENCY,
ORNAMENTATION

DECEMBER 1988
PHOTOGRAPH OF LINDA EVANGELISTA (LEFT) AND CARRÉ OTIS BY PETER LINDBERGH

216

VOGUE

MAY $3.00

SWIMSUITS HEAT UP

CHIC HITS THE STREETS

PRINTS EXPLODE

BODIES SHAPE UP

MADONNA AT HOME

summer starts here!

MAY 1989
PHOTOGRAPH OF MADONNA BY PATRICK DEMARCHELIER

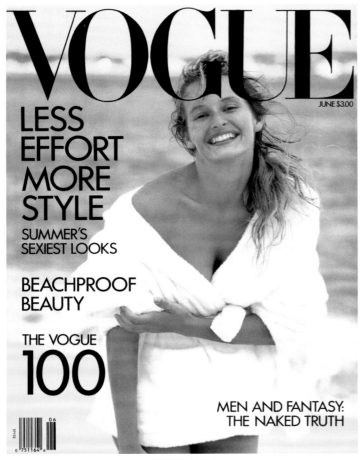

JANUARY 1989
PHOTOGRAPH OF KAREN ALEXANDER BY PETER LINDBERGH

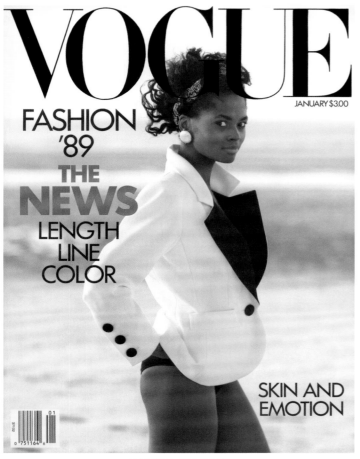

JUNE 1989
PHOTOGRAPH OF ESTELLE LEFÉBURE BY PETER LINDBERGH

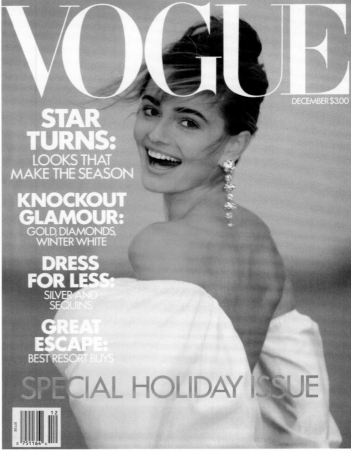

NOVEMBER 1989
PHOTOGRAPH OF MICHAELA BERCU BY PATRICK DEMARCHELIER

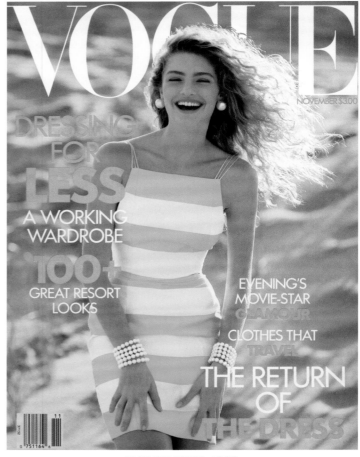

DECEMBER 1989
PHOTOGRAPH OF PAULINA PORIZKOVA BY PATRICK DEMARCHELIER

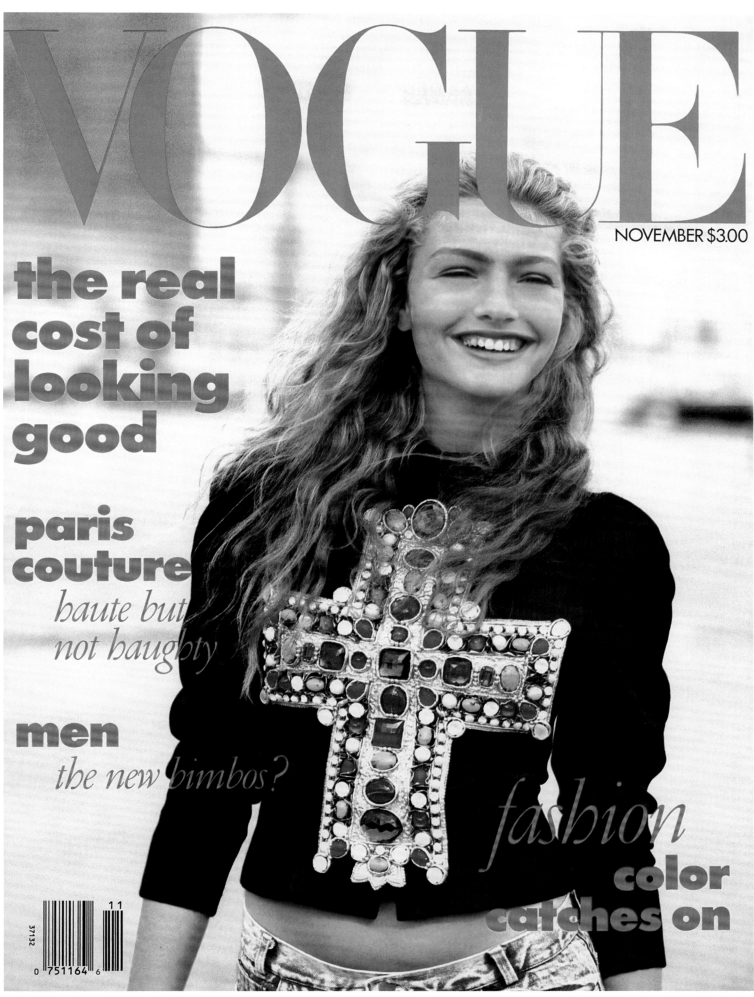

VOGUE

NOVEMBER $3.00

**the real
cost of
looking
good**

**paris
couture**
*haute but
not haughty*

men
the new bimbos?

fashion
**color
catches
on**

11
37132
0 751164 6

NOVEMBER 1988
PHOTOGRAPH OF MICHAELA BERCU BY PETER LINDBERGH

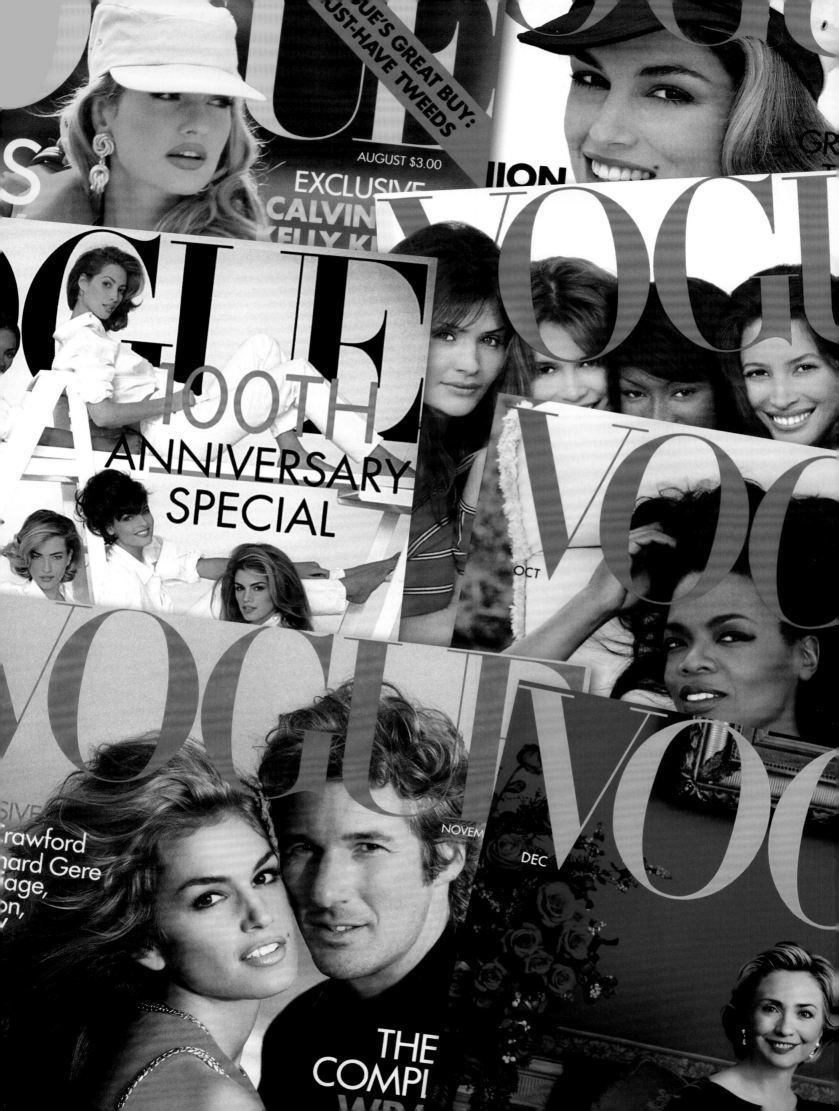

100TH
ANNIVERSARY
SPECIAL

rawford
hard Gere
age,

THE
COMPI

'90s

PULP FICTIONS

The Soviet Union breaks up. . . . Seinfeld obsesses. . . . The World Wide Web is born. . . . Marc Jacobs puts Kate Moss in grungy "heroin chic" (the antidote is Prada's understated elegance). . . . Smells like teen spirit. . . . A cell phone in every pocket. . . . *Angels in America* takes the Pulitzer. . . . Michael Jordan charges up the Bulls. . . . Damien Hirst jumps the shark. . . . Jeff Koons marries La Cicciolina. . . . Riots erupt over Rodney King's beating by L.A. police: "Can't we all get along?" . . . Uma Thurman's black bangs and bloodied white shirt in Quentin Tarantino's cult hit. . . . The Chunnel opens. . . . Alicia Silverstone is *Clueless,* and Jennifer Aniston is one of our best *Friends.* . . . Tom Ford to Gucci and John Galliano to Dior. . . . Low-rise jeans make a comeback, courtesy of Alexander McQueen. . . . Chasing O. J. Simpson's white Ford Bronco on TV. . . . Seamus Heaney gets a Nobel. . . . The film goddess returns—Julia Roberts (*Pretty Woman*), Gwyneth Paltrow (*Shakespeare in Love*), Nicole Kidman (*The Portrait of a Lady*). . . . Dolly, the first cloned sheep, joins the celebrity parade. . . . Everybody has to have Manolo Blahnik mules. . . . J. K. Rowling's *Harry Potter* series takes off. . . . Princess Di is gone. . . . Frank Gehry's titanium Guggenheim puts Bilbao on the map. . . . *Titanic* wins eleven Academy Awards. . . . Gianni Versace is shot dead in Miami Beach. . . . Sarah Jessica Parker and *Sex and the City.* . . . Monica Lewinsky and sex in the White House. . . . Bill Clinton is impeached but gets to stay. . . . Eminem cops two Grammys. . . . Lance Armstrong wins his first Tour de France.

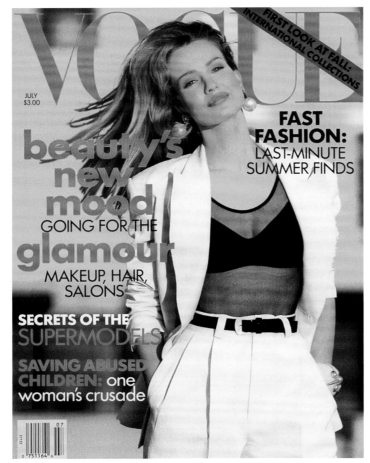

JULY 1991

PHOTOGRAPH OF KAREN MULDER BY MARC HISPARD

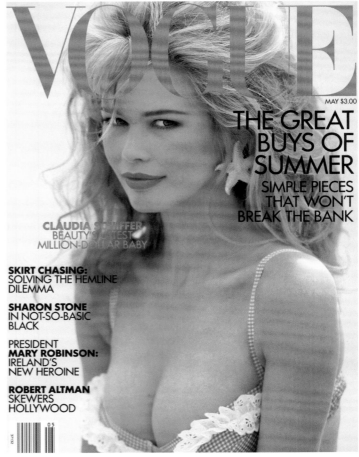

MAY 1992

PHOTOGRAPH OF CLAUDIA SCHIFFER BY PATRICK DEMARCHELIER

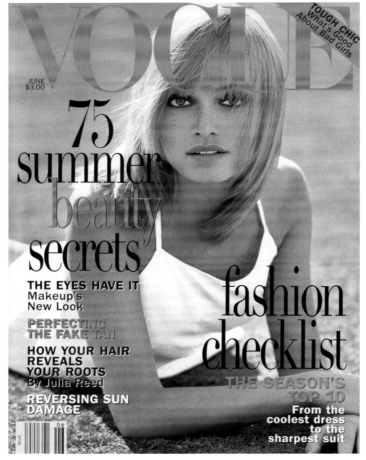

JUNE 1995

PHOTOGRAPH OF AMBER VALLETTA BY STEVEN MEISEL

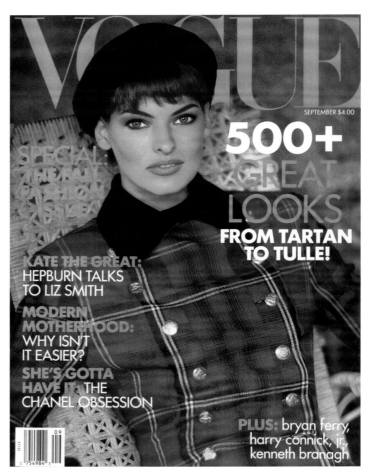

SEPTEMBER 1991

PHOTOGRAPH OF LINDA EVANGELISTA BY ARTHUR ELGORT

VOGUE

NOVEMBER $3.00

EXCLUSIVE
Cindy Crawford
and Richard Gere
on marriage,
meditation,
and MTV

**THE COOKIE-CUTTER
CANDIDATES' WIVES:**
was this any way
to win votes?

ON THE SET:
coppola's DRACULA
spike lee's MALCOLM X

TALKING TURKEY: the best
ways to cook the bird
by jeffrey steingarten

THE
COMPLETE
WRAP
ON WINTER
DRESSING

NOVEMBER 1992
PHOTOGRAPH OF CINDY CRAWFORD AND RICHARD GERE BY HERB RITTS

VOGUE

JUNE $3.00

BEST LOOKS
FOR SUN, SEA, AND SHADE

fast fashion
QUICK PIECES WITH IMPACT

tanning
WHY WOMEN WON'T QUIT

genetic discrimination
IS IT THE FUTURE?

JUNE 1990
PHOTOGRAPH OF LINDA EVANGELISTA BY PATRICK DEMARCHELIER

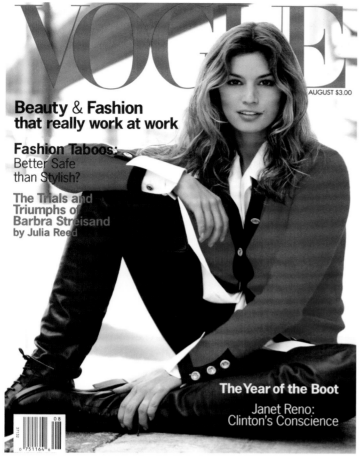

VOGUE

AUGUST $3.00

Beauty & Fashion
that really work at work

Fashion Taboos:
Better Safe
than Stylish?

**The Trials and
Triumphs of
Barbra Streisand**
by Julia Reed

The Year of the Boot

Janet Reno:
Clinton's Conscience

AUGUST 1993
PHOTOGRAPH OF CINDY CRAWFORD BY STEVEN MEISEL

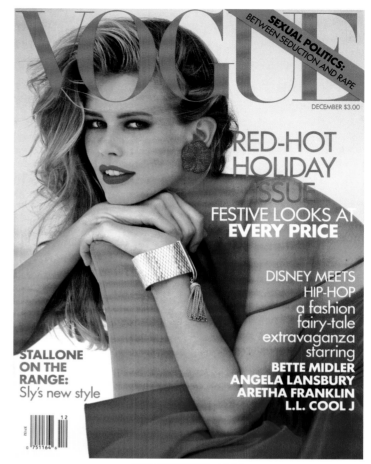

VOGUE

SEXUAL POLITICS:
BETWEEN SEDUCTION AND RAPE

DECEMBER $3.00

RED-HOT
HOLIDAY
ISSUE
FESTIVE LOOKS AT
EVERY PRICE

DISNEY MEETS
HIP-HOP
a fashion
fairy-tale
extravaganza
starring
**BETTE MIDLER
ANGELA LANSBURY
ARETHA FRANKLIN
L.L. COOL J**

**STALLONE
ON THE
RANGE:**
Sly's new style

DECEMBER 1991
PHOTOGRAPH OF CLAUDIA SCHIFFER BY PATRICK DEMARCHELIER

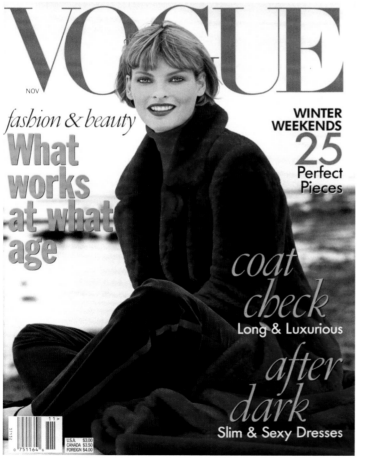

VOGUE

NOV

fashion & beauty
**What
works
at what
age**

WINTER
WEEKENDS
25
Perfect
Pieces

*coat
check*
Long & Luxurious

*after
dark*
Slim & Sexy Dresses

NOVEMBER 1996
PHOTOGRAPH OF LINDA EVANGELISTA BY STEVEN MEISEL

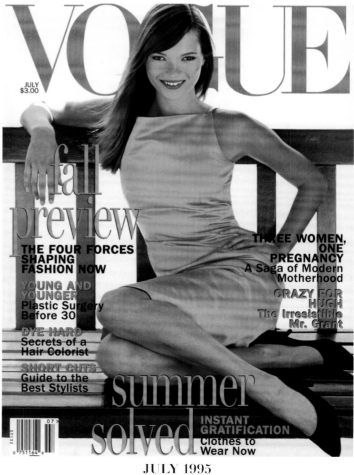

VOGUE

JULY
$3.00

*fall
preview*

**THE FOUR FORCES
SHAPING
FASHION NOW**

**YOUNG AND
YOUNGER**
Plastic Surgery
Before 30

DYE HARD
Secrets of a
Hair Colorist

SHORT CUTS
Guide to the
Best Stylists

*summer
solved*
**INSTANT
GRATIFICATION**
Clothes to
Wear Now

THREE WOMEN,
ONE
PREGNANCY
A Saga of Modern
Motherhood
**CRAZY FOR
HUGH**
The Irresistible
Mr. Grant

JULY 1995
PHOTOGRAPH OF KATE MOSS BY STEVEN MEISEL

225

VOGUE

APRIL $3.00

Special Issue
Fashion's New Deal
500 Choices from $5 to $500
Plus Great Buys in Beauty, Travel, Fitness Food, Design, and More

APRIL 1993

PHOTOGRAPH OF (FROM LEFT) HELENA CHRISTENSEN, CLAUDIA SCHIFFER, NAOMI CAMPBELL, CHRISTY TURLINGTON, AND STEPHANIE SEYMOUR BY HERB RITTS

37132

0 751164 6

04

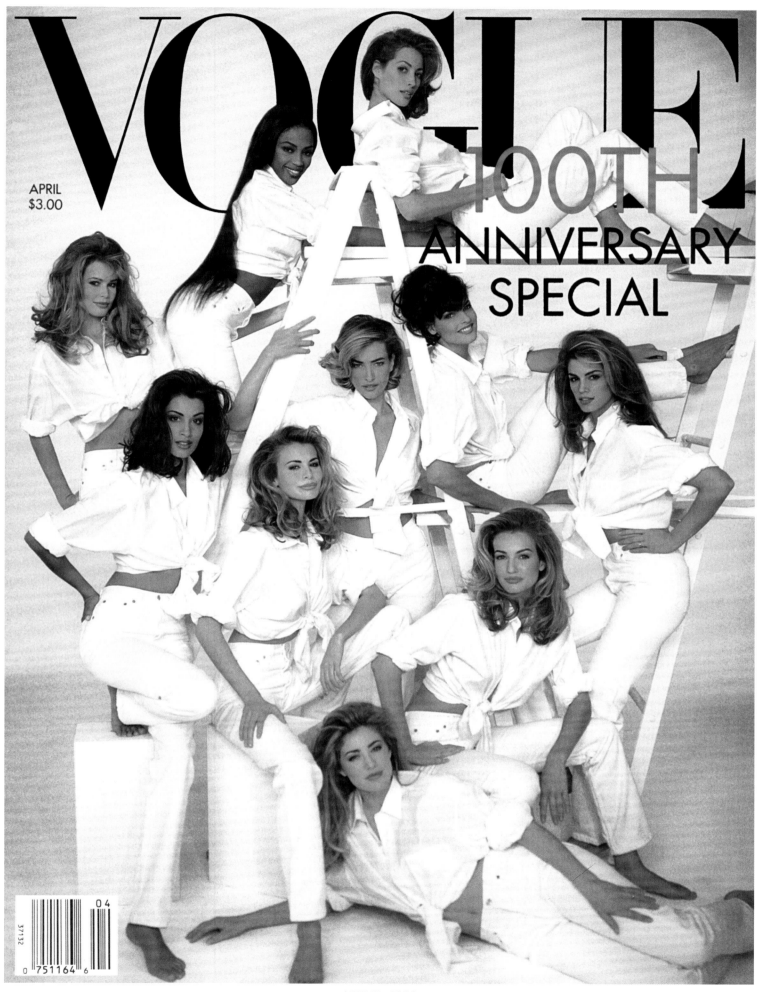

APRIL 1992

PHOTOGRAPH OF (CLOCKWISE FROM TOP) CHRISTY TURLINGTON, LINDA EVANGELISTA, CINDY CRAWFORD, KAREN MULDER, ELAINE IRWIN, NIKI TAYLOR,
YASMEEN GHAURI, CLAUDIA SCHIFFER, NAOMI CAMPBELL, AND TATJANA PATITZ BY PATRICK DEMARCHELIER

227

DECEMBER 1992
PHOTOGRAPH OF LUCIE DE LA FALAISE BY STEVEN MEISEL

OCTOBER 1992
PHOTOGRAPH OF MADONNA BY STEVEN MEISEL

SEPTEMBER 1990
PHOTOGRAPH OF TATJANA PATITZ BY PATRICK DEMARCHELIER

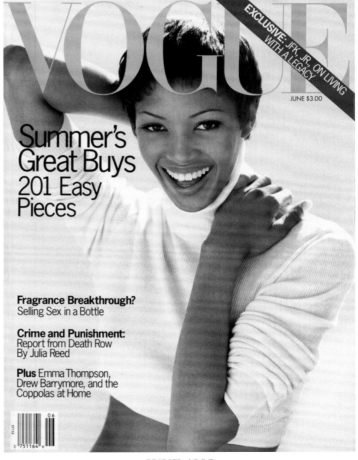

JUNE 1993
PHOTOGRAPH OF NAOMI CAMPBELL BY STEVEN MEISEL

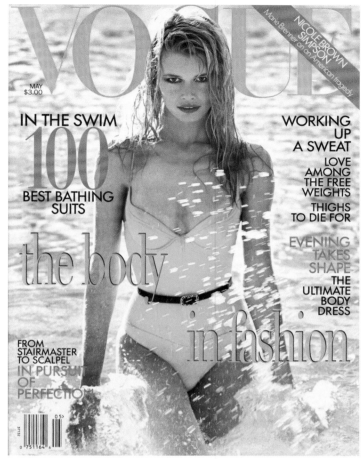

MAY 1995
PHOTOGRAPH OF CLAUDIA SCHIFFER BY STEVEN MEISEL

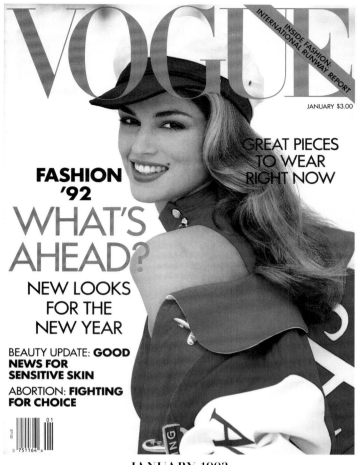

JANUARY 1992
PHOTOGRAPH OF CINDY CRAWFORD BY PATRICK DEMARCHELIER

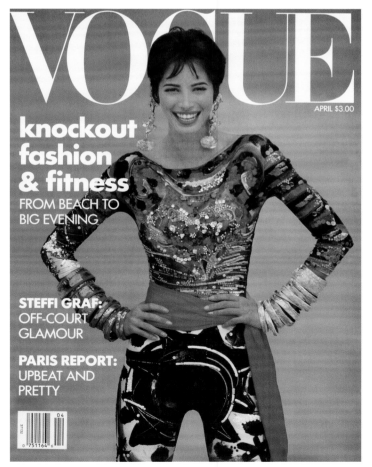

APRIL 1990
PHOTOGRAPH OF CHRISTY TURLINGTON BY PATRICK DEMARCHELIER

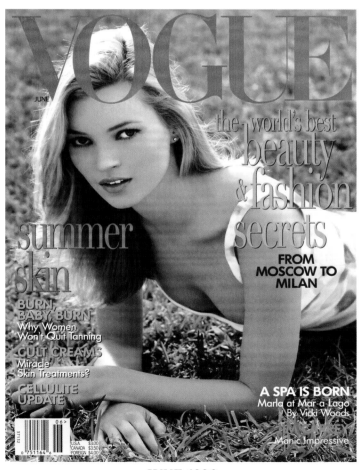

JUNE 1996
PHOTOGRAPH OF KATE MOSS BY STEVEN MEISEL

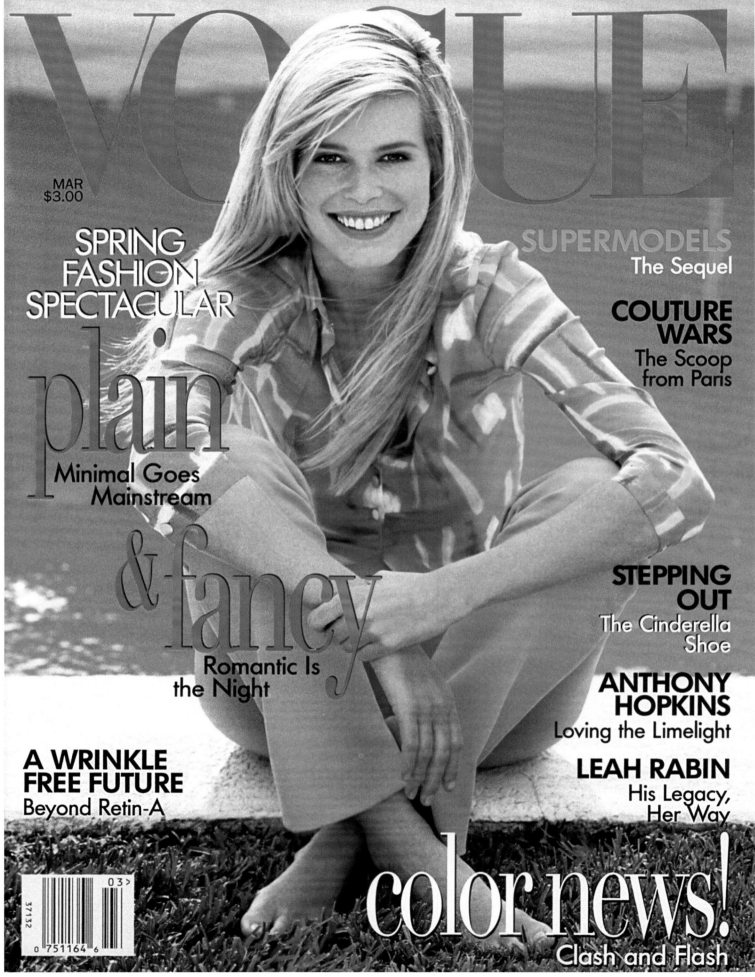

VOGUE

MAR
$3.00

**SPRING
FASHION
SPECTACULAR**

plain
Minimal Goes
Mainstream

&fancy
Romantic Is
the Night

**A WRINKLE
FREE FUTURE**
Beyond Retin-A

SUPERMODELS
The Sequel

**COUTURE
WARS**
The Scoop
from Paris

**STEPPING
OUT**
The Cinderella
Shoe

**ANTHONY
HOPKINS**
Loving the Limelight

LEAH RABIN
His Legacy,
Her Way

color news!
Clash and Flash

37132

0 751164 6

03>

MARCH 1996
PHOTOGRAPH OF CLAUDIA SCHIFFER BY STEVEN MEISEL

230

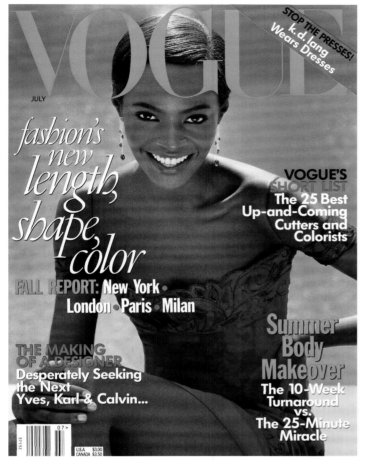

JULY 1997
PHOTOGRAPH OF KIARA KABUKURU BY STEVEN MEISEL

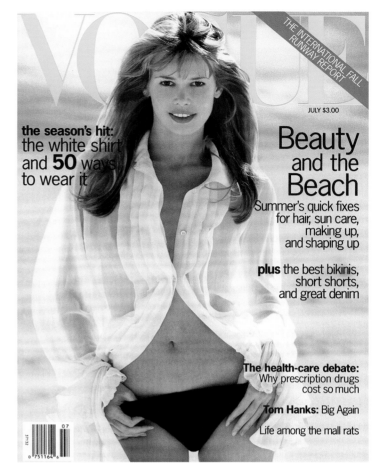

JULY 1993
PHOTOGRAPH OF CLAUDIA SCHIFFER BY STEVEN MEISEL

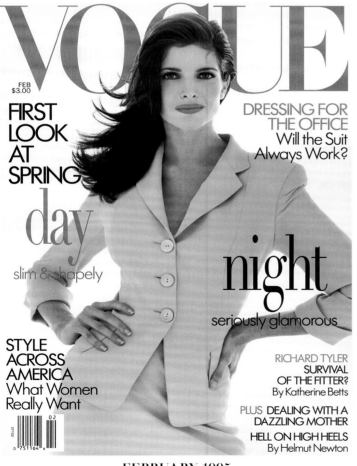

FEBRUARY 1995
PHOTOGRAPH OF STEPHANIE SEYMOUR BY STEVEN MEISEL

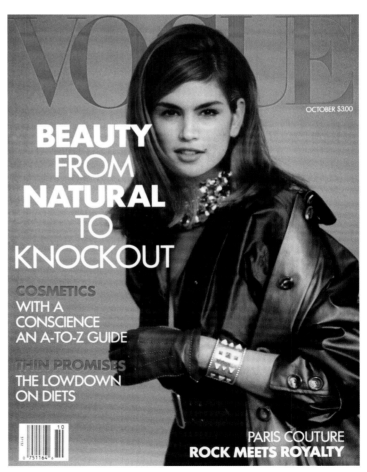

OCTOBER 1990
PHOTOGRAPH OF CINDY CRAWFORD BY PATRICK DEMARCHELIER

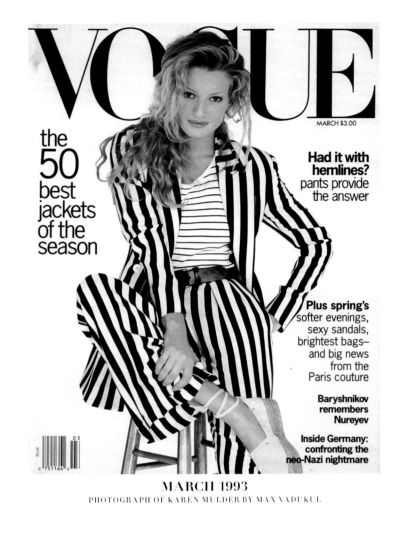

MARCH 1993

PHOTOGRAPH OF KAREN MULDER BY MAX VADUKUL

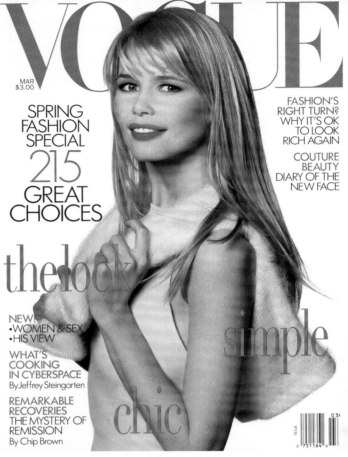

MARCH 1995

PHOTOGRAPH OF CLAUDIA SCHIFFER BY STEVEN MEISEL

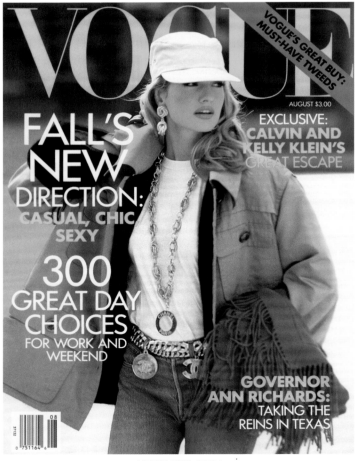

AUGUST 1991

PHOTOGRAPH OF KAREN MULDER BY PATRICK DEMARCHELIER

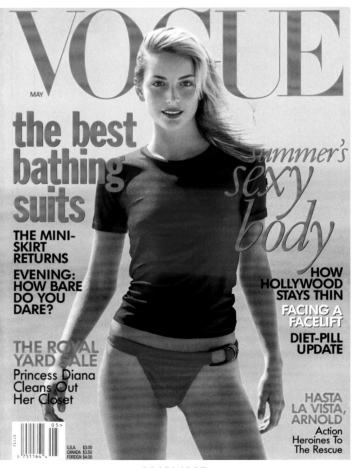

MAY 1997

PHOTOGRAPH OF GEORGINA GRENVILLE BY STEVEN MEISEL

VOGUE

JULY
$3.00

What's Sexy Now?

His Take, Her Take

Fall Preview

Putting the Fun Back in Fashion

By Katherine Betts

Summer Escapes

Wet Workouts
Mindless Movies
Beach Books

Face-lifts
for the Fainthearted

Lady Dye:
Hooked on Hair Color

JULY 1994
PHOTOGRAPH OF CINDY CRAWFORD BY STEVEN MEISEL

VOGUE

OCT

The Evening News!
From Couture's Glorious Excess to Velvet's Sleek Chic

Jessica Lange &
Michelle Pfeiffer
A PERFECT MATCH

Cameron Diaz
Hollywood's New Golden Girl

GOD SAVE McQUEEN
As Bad as He Is Brilliant

BLOWN AWAY
WHY IS HAIR SUCH HELL?

OCTOBER 1997
PHOTOGRAPH OF CAMERON DIAZ BY STEVEN MEISEL

VOGUE

APRIL

spring's perfect pieces
what's in, what's out

couture controversy
Inside the World of the $20,000 Dress

KISS & TELL
A HUSBAND ON HIS WIFE'S INCEST MEMOIR

THE NEW TECHNOFACIAL
Does the Laser Work?

END OF AN ERA
The Most Feared Man in Fashion Steps Down

U.S.A. $3.00
CANADA $3.50
FOREIGN $4.00

37132

0 751164 6

04>

APRIL 1997
PHOTOGRAPH OF (FROM LEFT) CAROLYN MURPHY, AMBER VALLETTA, AND SHALOM HARLOW BY STEVEN MEISEL

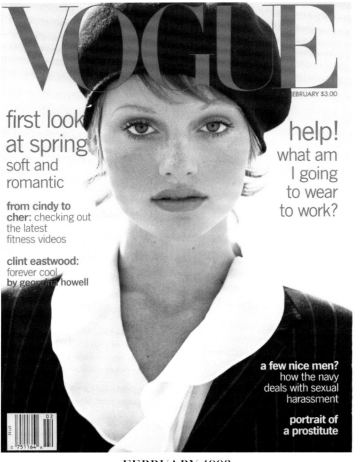

FEBRUARY 1993

PHOTOGRAPH OF AMBER VALLETTA BY ARTHUR ELGORT

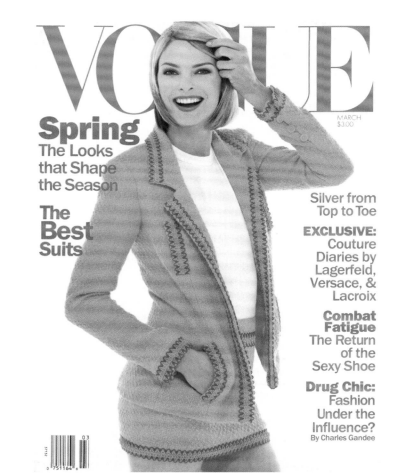

MARCH 1994

PHOTOGRAPH OF LINDA EVANGELISTA BY STEVEN MEISEL

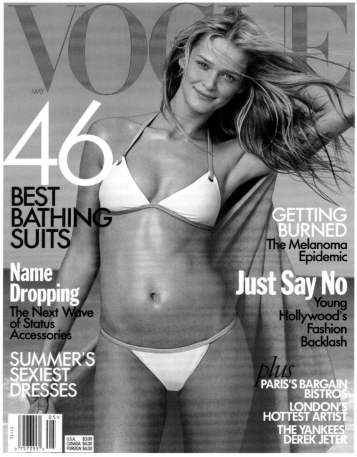

MAY 1999

PHOTOGRAPH OF CARMEN KASS BY STEVEN MEISEL

APRIL 1994

PHOTOGRAPH OF (FROM LEFT) BRIDGET HALL,
BRANDI, AND NIKI TAYLOR BY HERB RITTS

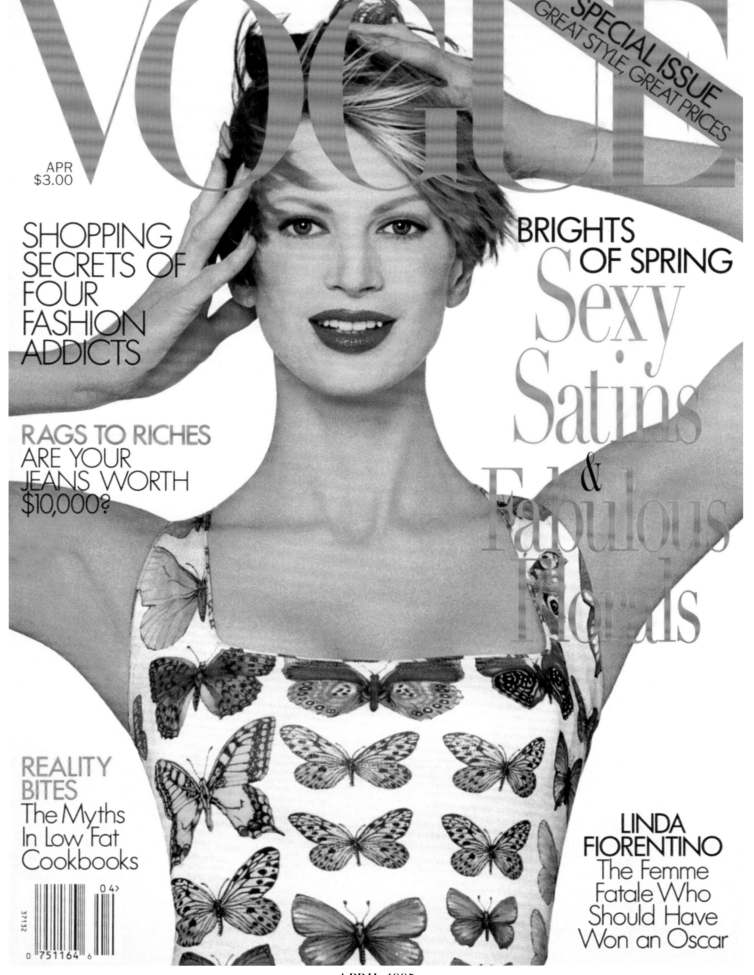

VOGUE

APR
$3.00

SHOPPING
SECRETS OF
FOUR
FASHION
ADDICTS

RAGS TO RICHES
ARE YOUR
JEANS WORTH
$10,000?

BRIGHTS
OF SPRING
Sexy
Satins
&
Fabulous
Florals

REALITY
BITES
The Myths
In Low Fat
Cookbooks

LINDA
FIORENTINO
The Femme
Fatale Who
Should Have
Won an Oscar

37132

0 751164 6 0 4>

APRIL 1995
PHOTOGRAPH OF KRISTEN McMENAMY BY STEVEN MEISEL

237

VOGUE

OCTOBER $3.00

Now the Good News!

The complete guide to fashion's best—for less

Plus great deals in travel, beauty, food, and fitness

Winona Ryder: Riding High

Armed and in Danger
The Truth About Women and Guns

37132

0 751164 6

10

OCTOBER 1993
PHOTOGRAPH OF WINONA RYDER BY HERB RITTS

238

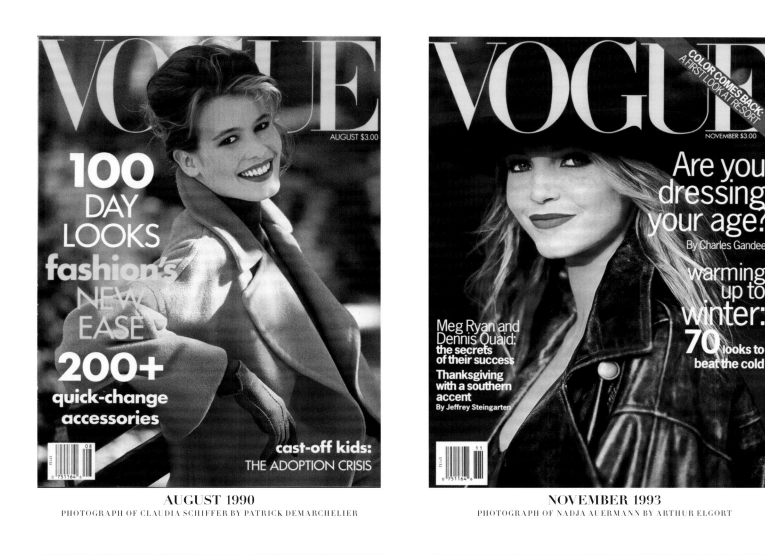

AUGUST 1990

PHOTOGRAPH OF CLAUDIA SCHIFFER BY PATRICK DEMARCHELIER

NOVEMBER 1993

PHOTOGRAPH OF NADJA AUERMANN BY ARTHUR ELGORT

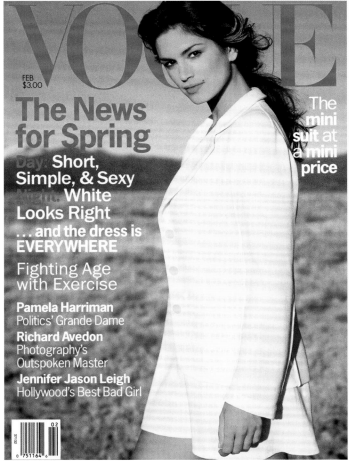

FEBRUARY 1994

PHOTOGRAPH OF CINDY CRAWFORD BY HERB RITTS

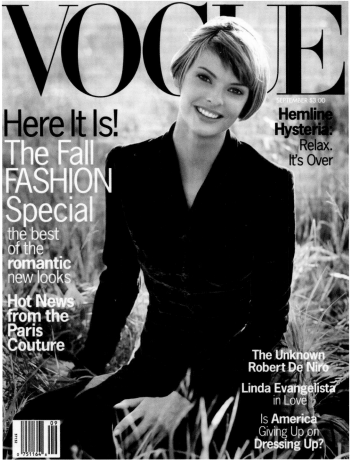

SEPTEMBER 1993

PHOTOGRAPH OF LINDA EVANGELISTA BY STEVEN MEISEL

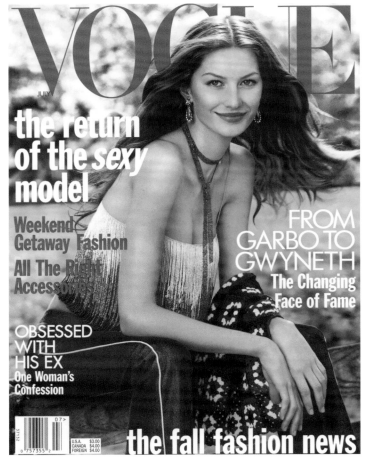

JULY 1999

PHOTOGRAPH OF GISELE BÜNDCHEN BY STEVEN MEISEL

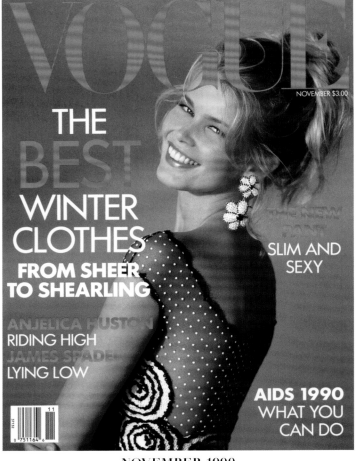

NOVEMBER 1990

PHOTOGRAPH OF CLAUDIA SCHIFFER BY PATRICK DEMARCHELIER

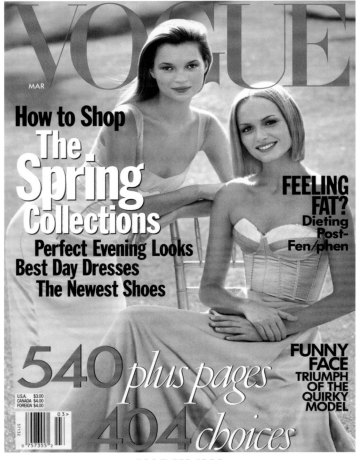

MARCH 1998

PHOTOGRAPH OF KATE MOSS (LEFT) AND
AMBER VALLETTA BY STEVEN MEISEL

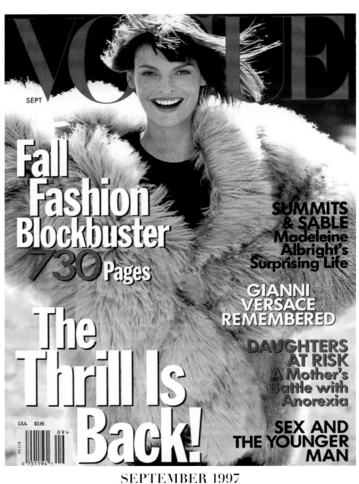

SEPTEMBER 1997

PHOTOGRAPH OF LINDA EVANGELISTA BY STEVEN MEISEL

VOGUE

SEPT
$3.50

finally!
THE FALL FASHION SPECIAL

all dressed up

ARE YOU A FASHION PHOBIC?

THE NEW AGE OF DONNA KARAN
By Katherine Betts

PARIS BULLETIN
BACKSTAGE AT THE COUTURE

THE BIG TEASE
HAIR ON THE RISE

SEAN PENN, GROWN-UP

THE REPUBLICAN CONTENDERS
NIXON'S GANG OFF AND RUNNING
By Julia Reed

AMERICA'S COOLEST HOTEL

SEPTEMBER 1995
PHOTOGRAPH OF SHALOM HARLOW (LEFT) AND AMBER VALLETTA BY STEVEN MEISEL

241

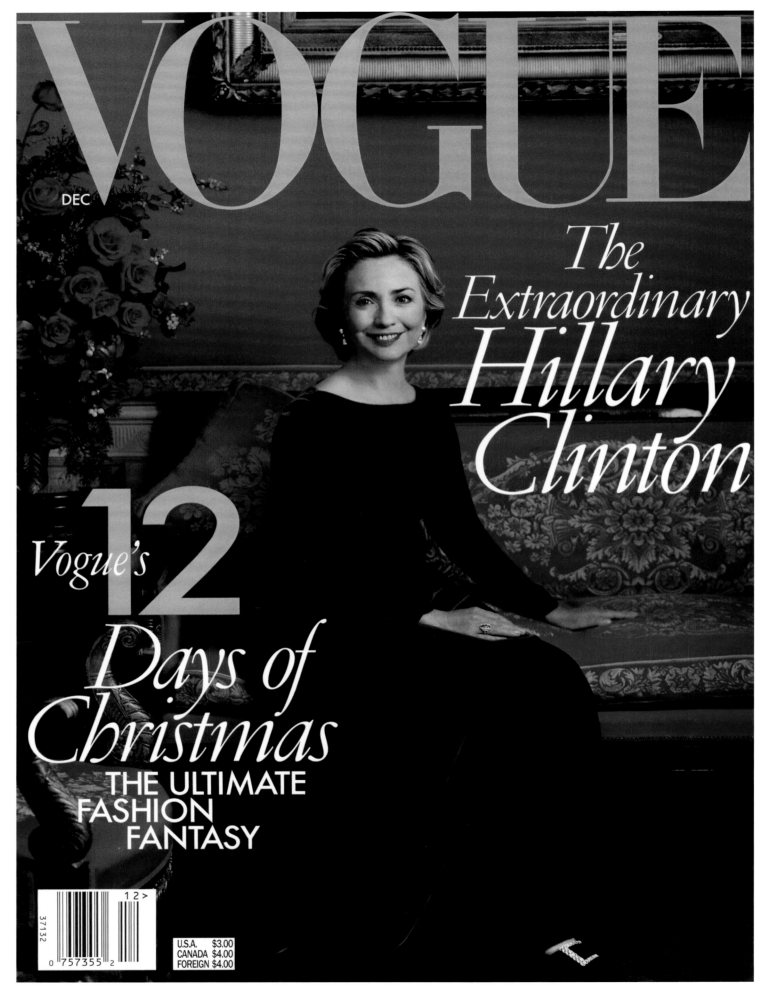

DECEMBER 1998
PHOTOGRAPH OF HILLARY CLINTON BY ANNIE LEIBOVITZ

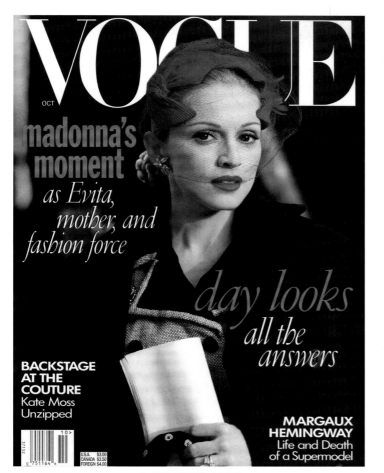

OCTOBER 1996
PHOTOGRAPH OF MADONNA BY STEVEN MEISEL

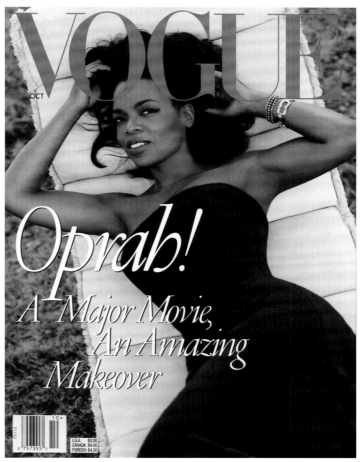

OCTOBER 1998
PHOTOGRAPH OF OPRAH WINFREY BY STEVEN MEISEL

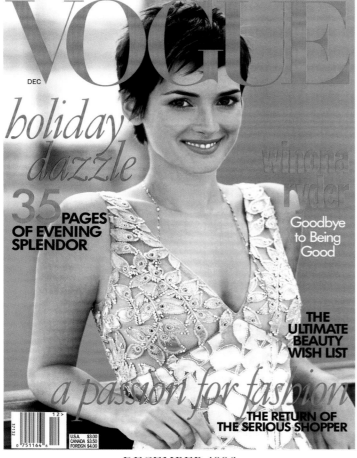

DECEMBER 1996
PHOTOGRAPH OF WINONA RYDER BY STEVEN MEISEL

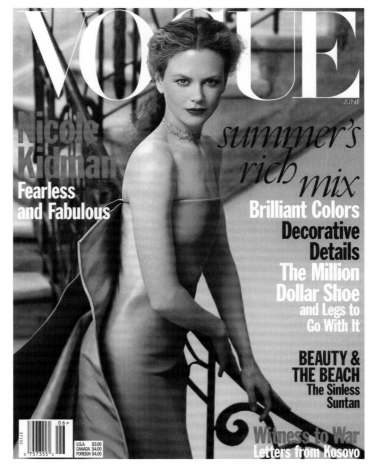

JUNE 1999
PHOTOGRAPH OF NICOLE KIDMAN BY STEVEN MEISEL

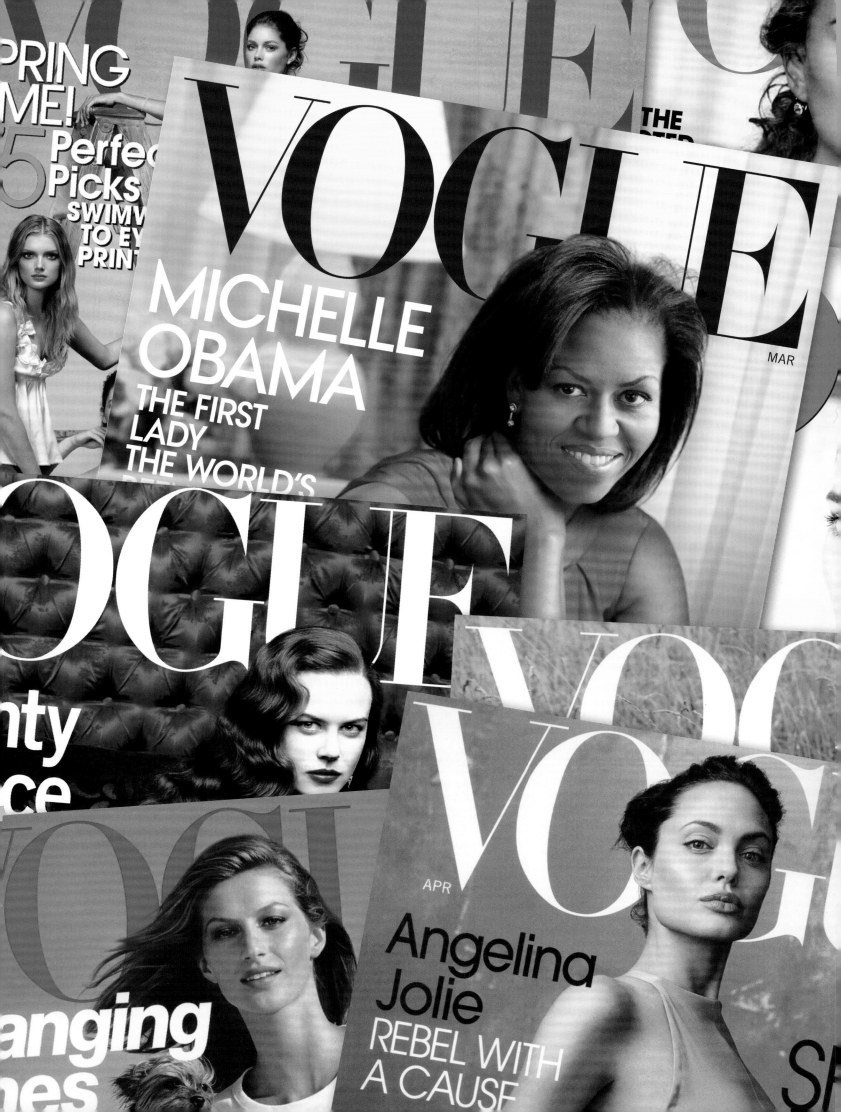

FASHION 2011

SEPT

SIENNA

THE

SURVIVORS

Supreme Court chooses Bush over Gore. . . . 9/11. . . . Osama bin Laden escapes from Tora Bora. . . . War in Afghanistan, then Iraq. . . . "Mission Accomplished," not. . . . Americans can't escape reality TV. . . . The iPod replaces conversation. . . . Botox replaces the brow lift. . . . Brangelina replaces Bennifer. . . . The legs have it—skinny jeans, black leggings, and the ubiquitous bootie. . . . The Tate Modern turns Brits on to contemporary art. . . . "Google it." . . . Sofia Coppola casts Scarlett Johansson in *Lost in Translation* and Kirsten Dunst in *Marie Antoinette.* . . . Zadie Smith bares her *White Teeth.* . . . Jon Stewart remakes the news. . . . We all go green. . . . Martha Stewart goes to jail. . . . Facebook goes global. . . . James Frey boots memoir mania into *A Million Little Pieces.* . . . Hurricane Katrina drowns New Orleans. . . . The Metropolitan Opera comes to movie theaters near you. . . . Gossip Girls and Mad Men storm Manhattan. . . . Roger Federer vs. Rafael Nadal. . . . Christo and Jeanne-Claude's saffron *Gates* light up Central Park. . . . Amazon Kindles the book business. . . . Gaga over Lady Gaga. . . . Vampire fever spreads like kudzu with *Twilight.* . . . Alex Rodriguez gets $275 million from the Yankees. . . . Madoff out-Ponzis Ponzi. . . . The economy goes south. . . . President Obama offers the politics of hope.

20 00s

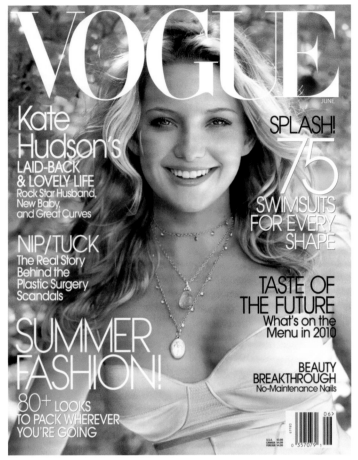

JUNE 2004

PHOTOGRAPH OF KATE HUDSON BY PATRICK DEMARCHELIER

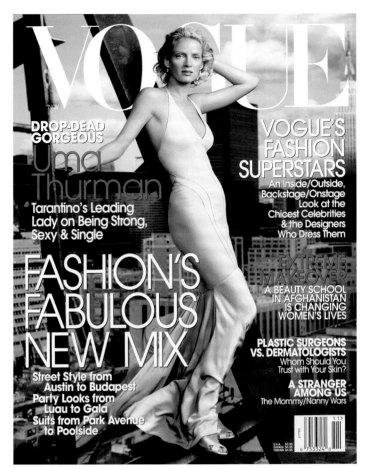

NOVEMBER 2003

PHOTOGRAPH OF UMA THURMAN BY ANNIE LEIBOVITZ

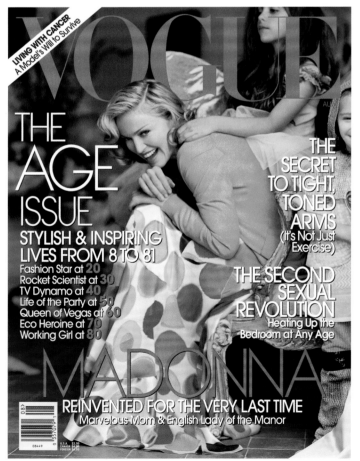

AUGUST 2005

PHOTOGRAPH OF MADONNA BY TIM WALKER

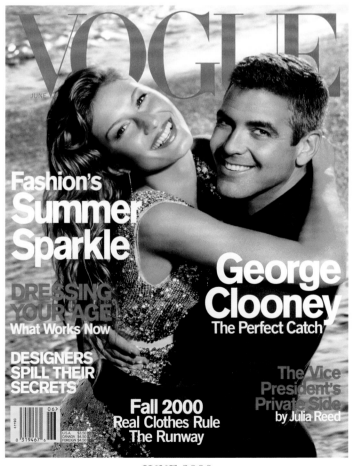

JUNE 2000

PHOTOGRAPH OF GISELE BÜNDCHEN AND GEORGE CLOONEY BY HERB RITTS

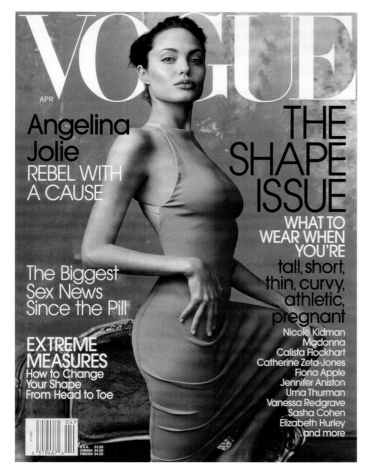

APRIL 2002

PHOTOGRAPH OF ANGELINA JOLIE BY ANNIE LEIBOVITZ

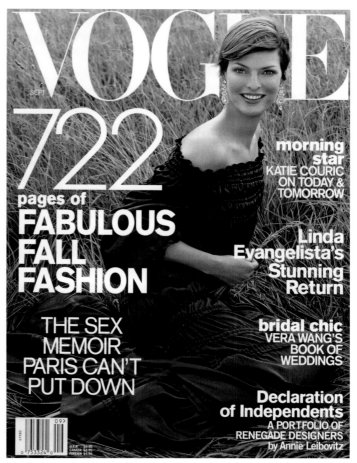

SEPTEMBER 2001

PHOTOGRAPH OF LINDA EVANGELISTA BY STEVEN MEISEL

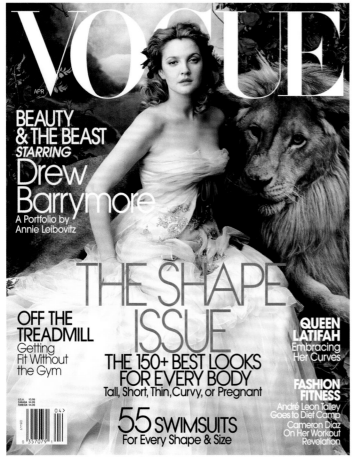

APRIL 2005

PHOTOGRAPH OF DREW BARRYMORE BY ANNIE LEIBOVITZ

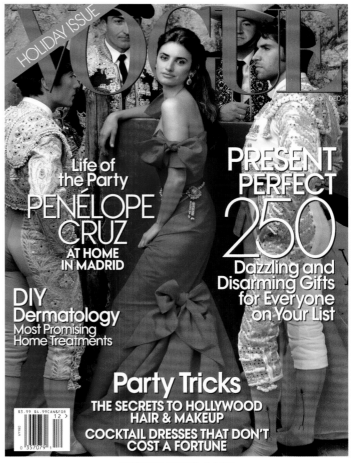

DECEMBER 2007

PHOTOGRAPH OF PENÉLOPE CRUZ BY ANNIE LEIBOVITZ

VOGUE

DEC

changing times

looking ahead
Fashion's New Romance, New Simplicity

looking back
Best and Worst Looks of 2001

SALMA HAYEK'S DREAM ROLE
The 20th Century's Most Shocking Painter

holiday
Buy This T-Shirt for America

DOCTORS WITHOUT BORDERS
Heroism on the West Bank

An American Childhood in Afghanistan

THE SURPRISING WOMAN BEHIND RUDY

U.S.A. $3.50
CANADA $4.50
FOREIGN $4.50

0 319467 6

12>

08449

DECEMBER 2001
PHOTOGRAPH OF GISELE BÜNDCHEN BY STEVEN MEISEL

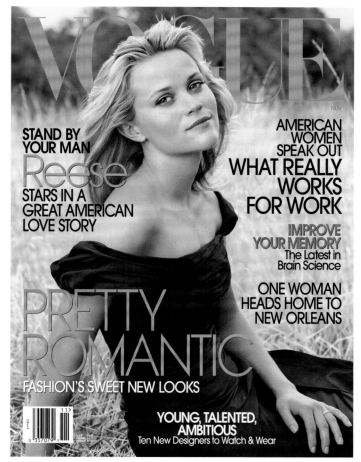

NOVEMBER 2005

PHOTOGRAPH OF REESE WITHERSPOON BY ANNIE LEIBOVITZ

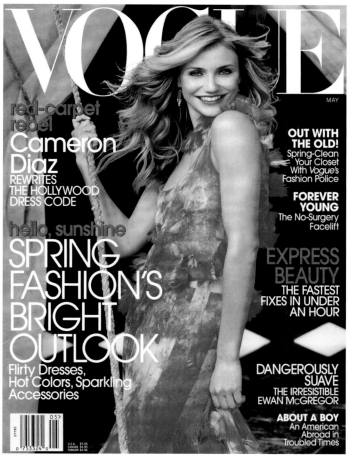

MAY 2003

PHOTOGRAPH OF CAMERON DIAZ BY ANNIE LEIBOVITZ

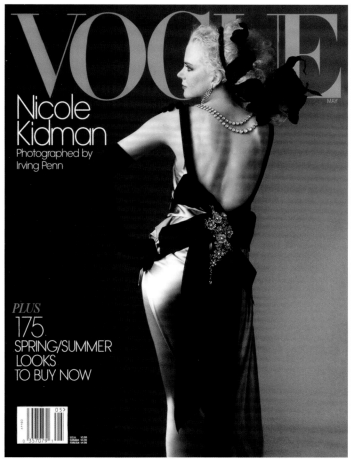

MAY 2004

PHOTOGRAPH OF NICOLE KIDMAN BY IRVING PENN

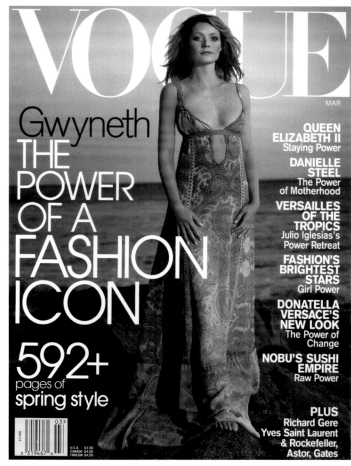

MARCH 2002

PHOTOGRAPH OF GWYNETH PALTROW BY HERB RITTS

VOGUE

SEPT

U.S.A. $4.50
CANADA $5.50
FOREIGN $5.50

0 74820 08449 6

09>

SEPTEMBER 2006
PHOTOGRAPH OF KIRSTEN DUNST BY ANNIE LEIBOVITZ

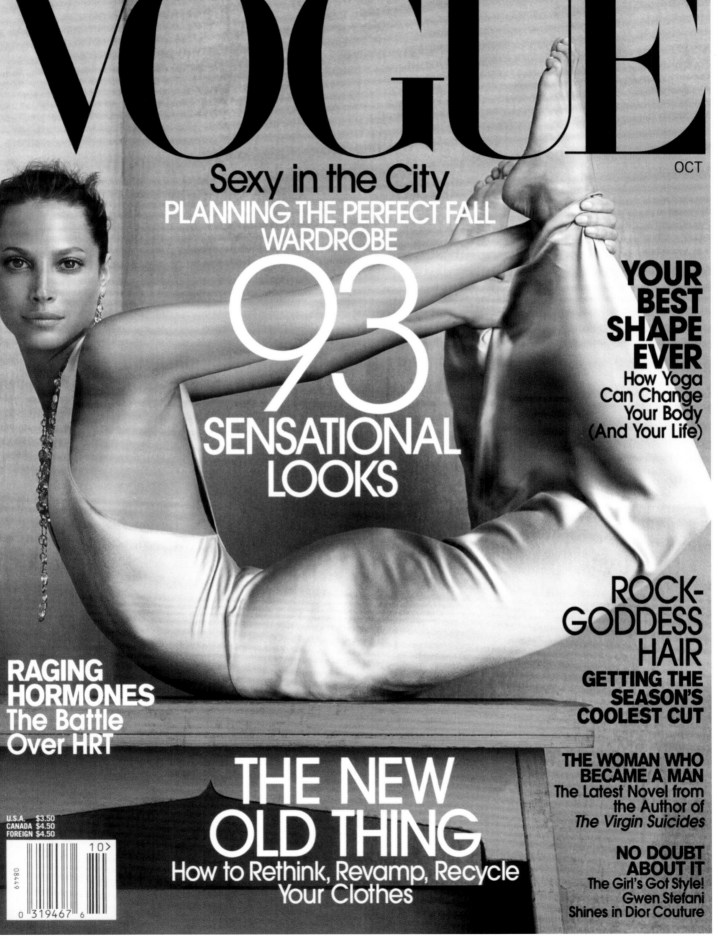

VOGUE

OCT

Sexy in the City
PLANNING THE PERFECT FALL WARDROBE

93
SENSATIONAL LOOKS

YOUR BEST SHAPE EVER
How Yoga Can Change Your Body (And Your Life)

ROCK-GODDESS HAIR
GETTING THE SEASON'S COOLEST CUT

RAGING HORMONES
The Battle Over HRT

THE NEW OLD THING
How to Rethink, Revamp, Recycle Your Clothes

THE WOMAN WHO BECAME A MAN
The Latest Novel from the Author of *The Virgin Suicides*

NO DOUBT ABOUT IT
The Girl's Got Style! Gwen Stefani Shines in Dior Couture

U.S.A. $3.50
CANADA $4.50
FOREIGN $4.50

10>

0 319467 6

OCTOBER 2002
PHOTOGRAPH OF CHRISTY TURLINGTON BY STEVEN KLEIN

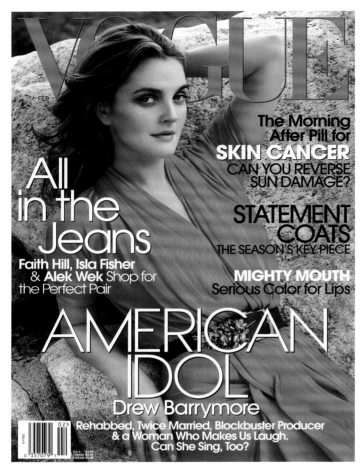

FEBRUARY 2006
PHOTOGRAPH OF DREW BARRYMORE BY MARIO TESTINO

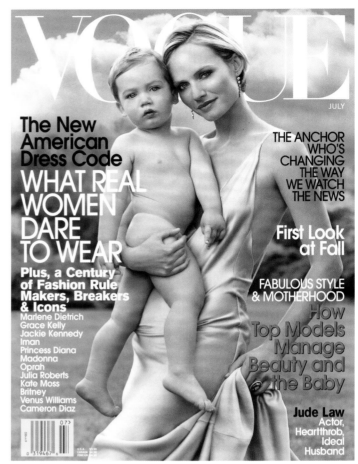

JULY 2002
PHOTOGRAPH OF AMBER VALLETTA AND SON
AUDEN McCAW BY ANNIE LEIBOVITZ

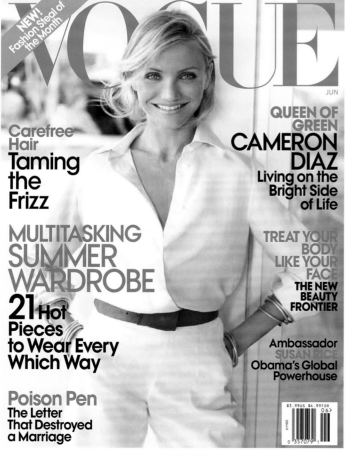

JUNE 2009
PHOTOGRAPH OF CAMERON DIAZ BY MARIO TESTINO

APRIL 2009
PHOTOGRAPH OF BEYONCÉ KNOWLES BY MARIO TESTINO

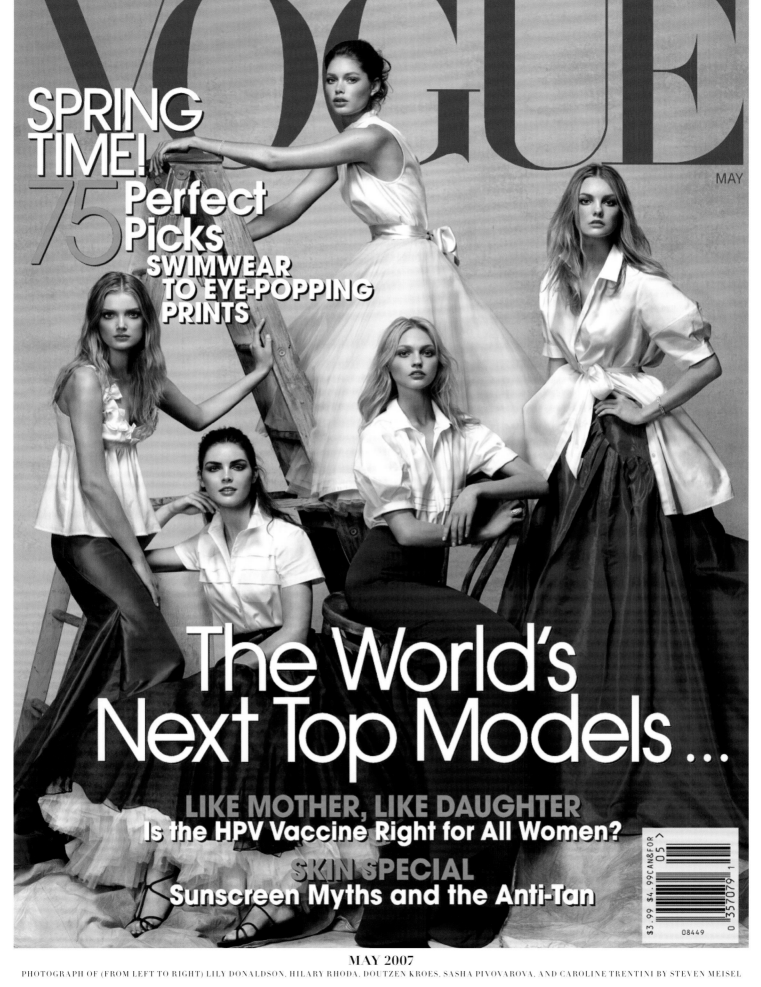

MAY 2007

PHOTOGRAPH OF (FROM LEFT TO RIGHT) LILY DONALDSON, HILARY RHODA, DOUTZEN KROES, SASHA PIVOVAROVA, AND CAROLINE TRENTINI BY STEVEN MEISEL

VOGUE

APR

THE SHAPE ISSUE

PRETTY BABY
Brooke Shields
On Marriage &
Motherhood

WHAT TO WEAR IF YOU'RE
tall, short, thin,
curvy, athletic,
pregnant
Serena Williams
Kim Cattrall
Cameron Diaz
Drew Barrymore
Salma Hayek
Catherine Zeta-Jones
Oprah Winfrey
Jennifer Lopez
...and more

LOSING IT
TRUE TALES OF
ATKINS, ORNISH
& WEIGHT
WATCHERS

WONDER WORKOUTS
Getting a Leg Up on
Spring's Short Skirts

CHANGE YOUR BODY, CHANGE YOUR LIFE

"YOU CAN'T WEAR THAT!"
TV's Style Dictators
Trash Your Fashion

U.S.A. $3.95
CANADA $4.95
FOREIGN $4.95

0 753324

APRIL 2003
PHOTOGRAPH OF BROOKE SHIELDS BY ANNIE LEIBOVITZ

254

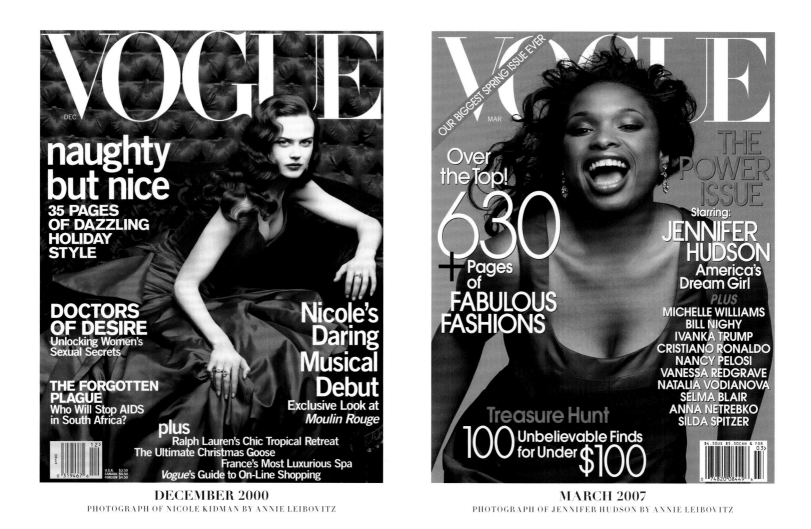

DECEMBER 2000
PHOTOGRAPH OF NICOLE KIDMAN BY ANNIE LEIBOVITZ

MARCH 2007
PHOTOGRAPH OF JENNIFER HUDSON BY ANNIE LEIBOVITZ

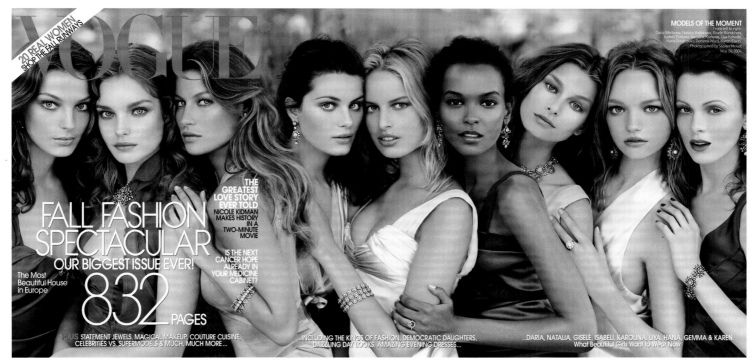

SEPTEMBER 2004
PHOTOGRAPH OF (FROM LEFT) DARIA WERBOWY, NATALIA VODIANOVA, GISELE BÜNDCHEN, ISABELI FONTANA,
KAROLINA KURKOVA, LIYA KEBEDE, HANA SOUKUPOVA, GEMMA WARD, AND KAREN ELSON BY STEVEN MEISEL

FEBRUARY 2007
PHOTOGRAPH OF RENÉE ZELLWEGER BY MARIO TESTINO

JUNE 2006
PHOTOGRAPH OF UMA THURMAN BY MARIO TESTINO

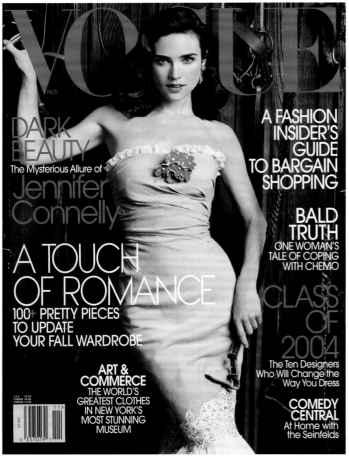

NOVEMBER 2004
PHOTOGRAPH OF JENNIFER CONNELLY BY CRAIG McDEAN

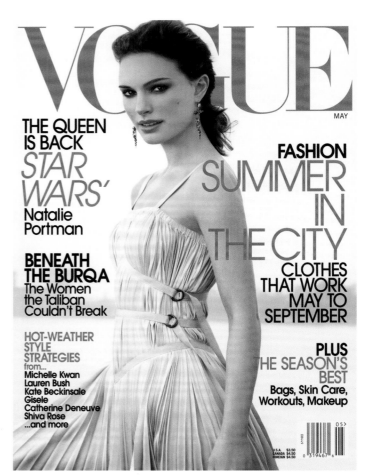

MAY 2002
PHOTOGRAPH OF NATALIE PORTMAN BY STEVEN KLEIN

VOGUE

APR

EMBRACE YOUR SHAPE!
Towering, Tiny, Thin, or Top Heavy?
What to Wear

NOBODY'S PERFECT
7 Women Obsess Over Their Body Flaws

THE TOO-THIN-OR-NOT MODEL CONTROVERSY
PLUS The War on Trans Fats

CURVY & COOL
SCARLETT JOHANSSON
"I can dress in whatever I want. Besides, some fellows like me!"

SPACE-AGE FITNESS
A Total Body Workout in 10 Minutes

$3.99 $4.99CAN&FOR

04

0 357079 1

67480

VOGUE

AUG

THE AGE ISSUE

WHAT TO WEAR
WHERE TO SHOP
WHEN TO LIE
HOW TO HAVE
SEXY LEGS
(*AND A SEX LIFE*)
FOREVER

PLUS

STYLE SETTERS FROM 16 TO 80+

C. Z. Guest
Diane Sawyer
Cindy Crawford
Elaine Stritch
Alicia Keys
Condoleezza Rice
Michelle Pfeiffer
Reese Witherspoon
Amanda Harlech
...and more

ALL-AMERICAN BEAUTY

Jennifer Aniston's EASY CHARM

Remembering the Great Bill Blass

SHE'S HOW OLD?
COSMETIC SURGERY
What's New, What's Next

Fashion for All

75

Looks for Day & Night

U.S.A. $3.50
CANADA $4.50
FOREIGN $4.50

0 319467 6

08>

08449

AUGUST 2002
PHOTOGRAPH OF JENNIFER ANISTON BY MARIO TESTINO

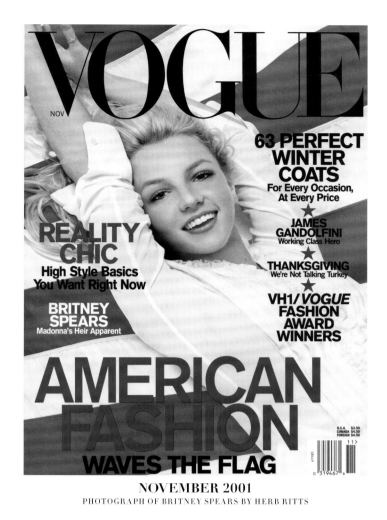

VOGUE

NOV

63 PERFECT WINTER COATS
For Every Occasion, At Every Price

★

JAMES GANDOLFINI
Working Class Hero

★

THANKSGIVING
We're Not Talking Turkey

★

VH1/VOGUE FASHION AWARD WINNERS

REALITY CHIC
High Style Basics You Want Right Now

BRITNEY SPEARS
Madonna's Heir Apparent

AMERICAN FASHION
WAVES THE FLAG

U.S.A. $3.50
CANADA $4.50
FOREIGN $4.50

NOVEMBER 2001
PHOTOGRAPH OF BRITNEY SPEARS BY HERB RITTS

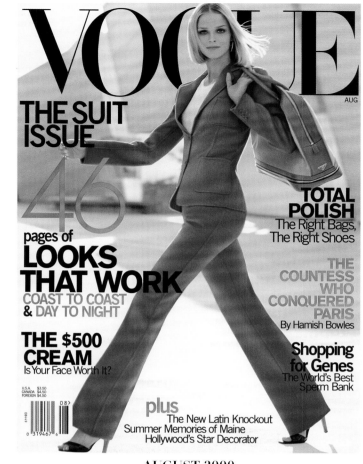

VOGUE

AUG

THE SUIT ISSUE

46

pages of **LOOKS THAT WORK**
COAST TO COAST & DAY TO NIGHT

THE $500 CREAM
Is Your Face Worth It?

TOTAL POLISH
The Right Bags, The Right Shoes

THE COUNTESS WHO CONQUERED PARIS
By Hamish Bowles

Shopping for Genes
The World's Best Sperm Bank

plus
The New Latin Knockout
Summer Memories of Maine
Hollywood's Star Decorator

U.S.A. $3.50
CANADA $4.50
FOREIGN $4.50

AUGUST 2000
PHOTOGRAPH OF CARMEN KASS BY STEVEN MEISEL

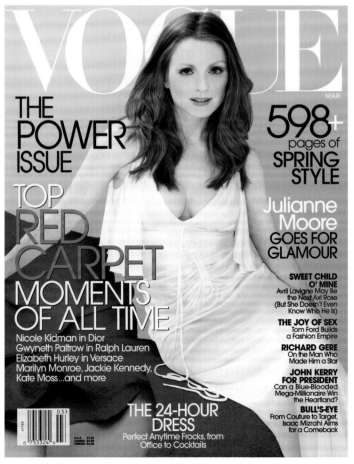

VOGUE

MAR

THE POWER ISSUE

TOP RED CARPET MOMENTS OF ALL TIME

Nicole Kidman in Dior
Gwyneth Paltrow in Ralph Lauren
Elizabeth Hurley in Versace
Marilyn Monroe, Jackie Kennedy,
Kate Moss...and more

598+
pages of **SPRING STYLE**

Julianne Moore GOES FOR GLAMOUR

SWEET CHILD O' MINE
Avril Lavigne May Be
the Next Axl Rose
(But She Doesn't Even
Know Who He Is)

THE JOY OF SEX
Tom Ford Builds
a Fashion Empire

RICHARD GERE
On the Man Who
Made Him a Star

JOHN KERRY FOR PRESIDENT
Can a Blue-Blooded
Mega-Millionaire Win
the Heartland?

BULL'S-EYE
From Couture to Target,
Isaac Mizrahi Aims
for a Comeback

THE 24-HOUR DRESS
Perfect Anytime Frocks, from
Office to Cocktails

U.S.A. $3.95
CANADA $4.95
FOREIGN $4.95

MARCH 2003
PHOTOGRAPH OF JULIANNE MOORE BY STEVEN KLEIN

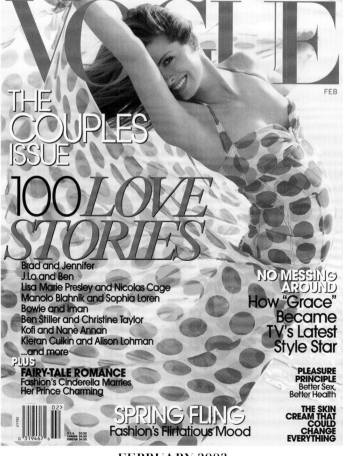

VOGUE

FEB

THE COUPLES ISSUE

100 LOVE STORIES

Brad and Jennifer
J.Lo and Ben
Lisa Marie Presley and Nicolas Cage
Manolo Blahnik and Sophia Loren
Bowie and Iman
Ben Stiller and Christine Taylor
Kofi and Nane Annan
Kieran Culkin and Alison Lohman
...and more

PLUS
FAIRY-TALE ROMANCE
Fashion's Cinderella Marries
Her Prince Charming

NO MESSING AROUND
How "Grace"
Became
TV's Latest
Style Star

PLEASURE PRINCIPLE
Better Sex,
Better Health

THE SKIN CREAM THAT COULD CHANGE EVERYTHING

SPRING FLING
Fashion's Flirtatious Mood

U.S.A. $3.50
CANADA $4.50
FOREIGN $4.50

FEBRUARY 2003
PHOTOGRAPH OF DEBRA MESSING BY HERB RITTS

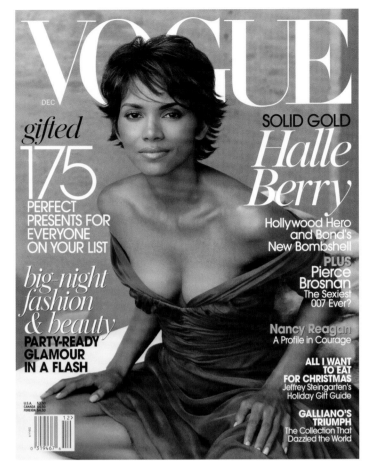

SEPTEMBER 2005
PHOTOGRAPH OF SARAH JESSICA PARKER BY ANNIE LEIBOVITZ

DECEMBER 2002
PHOTOGRAPH OF HALLE BERRY BY ANNIE LEIBOVITZ

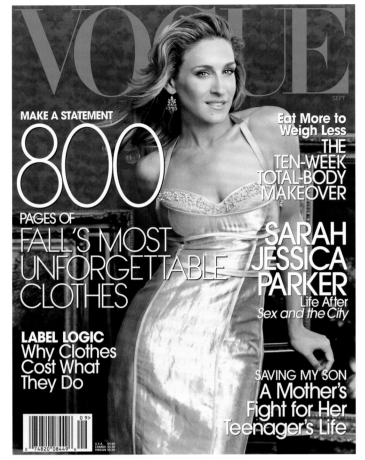

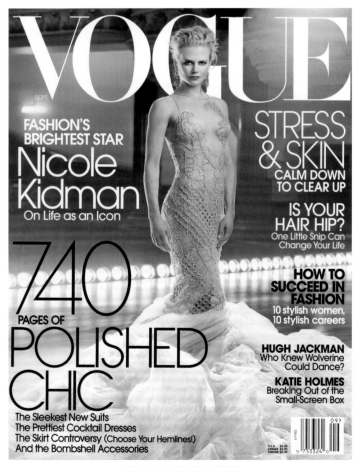

SEPTEMBER 2003
PHOTOGRAPH OF NICOLE KIDMAN BY ANNIE LEIBOVITZ

MARCH 2005
PHOTOGRAPH OF SANDRA BULLOCK BY STEVEN MEISEL

VOGUE

SEPT

EXTRA-EXTRA LARGE!
Our Biggest Issue Ever
840
pages of
FEARLESS FASHION

SIENNA MILLER
Fashion's Feistiest Icon

A MARRIAGE OF EQUALS
Michelle Obama, Perfect Political Partner

Magician of Makeup
THE MOST POWERFUL WOMAN IN BEAUTY

$4.99 $5.99CAN&FOR

09 >

0 751154 9

SEPTEMBER 2007
PHOTOGRAPH OF SIENNA MILLER BY MARIO TESTINO

VOGUE

JAN

75 LIFE-CHANGING IDEAS FOR 2007

PLUS

WHERE BEAUTY MEETS MEDICINE
Looking Good, No Longer an Art but a Science

COOK YOURSELF SLIM
Tips from a Master Chef

SPRING SNEAK PEEK

SUPERCHIC DAY DRESSES, SKINNY PANTS, ESSENTIAL JACKETS

ANGELINA JOLIE
Why Her Real Life Is More Romantic than Any Movie

50 BEST-DRESSED ORIGINALS
Past & Present

$3.99 $4.99CAN&FOR

01 >

0 357079 1

JANUARY 2007
PHOTOGRAPH OF ANGELINA JOLIE BY ANNIE LEIBOVITZ

VOGUE

MAR

THE POWER ISSUE

PENELOPE CRUZ
THE POWER OF BEAUTY

THE POWER OF FASHION
CLOTHES TO CONQUER THE WORLD IN

HILLARY CLINTON
POWERHOUSE

THE WILLIAMS SISTERS
POWER PLAYERS

JANE FONDA
WILLPOWER

JACQUELINE KENNEDY
THE POWER OF A LEGEND

CAMILLA PARKER BOWLES
THE POWER BEHIND THE THRONE

BUSH, GETTY
THE POWER OF A NAME

A PERFECT BABY GIRL
THE POWER OF CHOICE

A MOGUL'S BUDGET
THE PRICE OF POWER

RED LIPS
THE POWER OF SEDUCTION

CAVIAR
POWER FOOD

U.S.A. $3.50
CANADA $4.50
FOREIGN $4.50

03>

0 319467 6

MARCH 2001
PHOTOGRAPH OF PENÉLOPE CRUZ BY HERB RITTS

VOGUE

FEB

SPRING GOES SEXY

Daring Jumpsuits

Smoldering Makeup

Plunging Necklines

VITAMIN D
THE HEALTHY SIDE OF SUNSHINE

Blake Lively
THE *GOSSIP GIRL* STAR'S NEW LOOK

+ MORE MAGICAL MAKEOVERS

FROM THE WHITE HOUSE TO A FASHION EMPIRE

NEWMAN'S OWN
PAUL'S DAUGHTER ON HER FATHER'S LEGACY

$3.99US $4.99FOR

02>

0 357079 1

08449

FEBRUARY 2009
PHOTOGRAPH OF BLAKE LIVELY BY MARIO TESTINO

VOGUE

NOV

A BREATH OF FRESH AIR

ANNE HATHAWAY

"I'm Too Trusting"

Natural Beauty That Delivers

FALL ROMANCE

HOLD THE SALT?
WHAT YOU NEED TO KNOW

CAUGHT IN THE CROSSFIRE
A Palestinian Orphan's Life in Jerusalem

Effortless Day Dressing

Seductive Country Tweeds

Top Designers Tackle Accessible Eco Style

SITTING PRETTY
How to Stop Back Pain

NOVEMBER 2010
PHOTOGRAPH OF ANNE HATHAWAY BY MARIO TESTINO

265

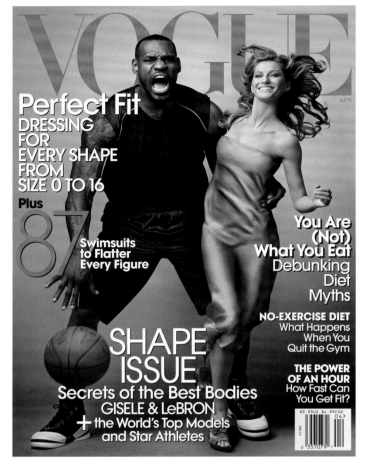

APRIL 2008

PHOTOGRAPH OF LeBRON JAMES AND GISELE
BÜNDCHEN BY ANNIE LEIBOVITZ

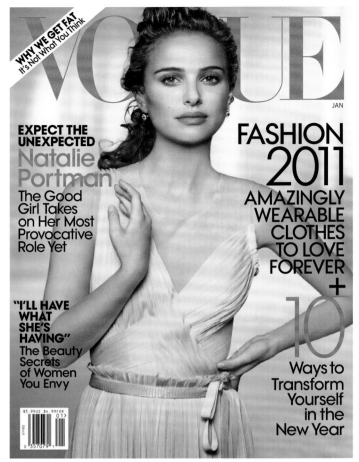

JANUARY 2011

PHOTOGRAPH OF NATALIE PORTMAN BY PETER LINDBERGH

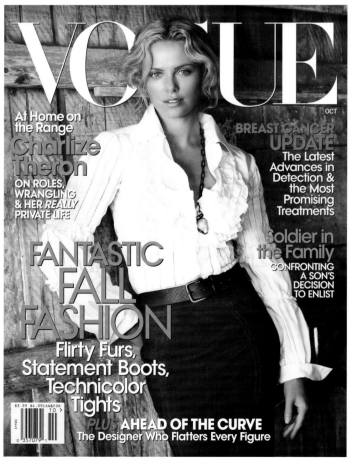

OCTOBER 2007

PHOTOGRAPH OF CHARLIZE THERON BY MARIO TESTINO

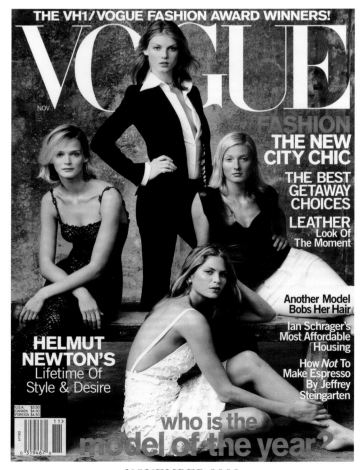

NOVEMBER 2000

PHOTOGRAPH OF (CLOCKWISE FROM LEFT) CARMEN KASS, ANGELA
LINDVALL, MAGGIE RIZER, AND FRANKIE RAYDER BY ANNIE LEIBOVITZ

VOGUE

MAR

MICHELLE OBAMA
THE FIRST LADY THE WORLD'S BEEN WAITING FOR

SPRING FASHION SPECIAL
Every Look That Matters

SUPER POWERS!
Queen Rania of Jordan
Carla Bruni-Sarkozy
Melinda Gates

$4.99US $5.99FOR
03>

MARCH 2009
PHOTOGRAPH OF MICHELLE OBAMA BY ANNIE LEIBOVITZ

VOGUE

MAR

574
Pages of
SHOWSTOPPING
SPRING FASHION

The Must-Have Looks
From Punk to Polish,
Romantic to Rebel

BORN THIS WAY
LADY GAGA

+

BURMA'S NOBEL HEROINE

SYRIA'S FIRST LADY

NEW YORK'S SANDRA LEE

HOLLYWOOD'S BREAKOUT EMMA STONE

STARVED FOR LOVE
A MOTHER'S AND DAUGHTER'S BATTLE WITH FOOD DEMONS

CRY FREEDOM
ONE WOMAN'S LIFE AFTER 29 YEARS IN A CULT

$4.99US $5.99FOR
03>

0 751154 9

MARCH 2011
PHOTOGRAPH OF LADY GAGA BY MARIO TESTINO

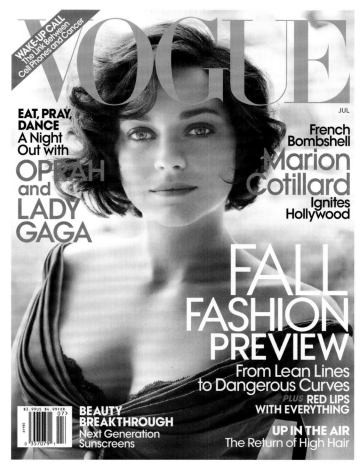

JULY 2010

PHOTOGRAPH OF MARION COTILLARD BY MARIO TESTINO

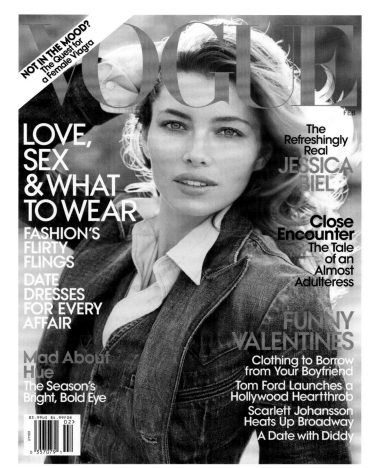

FEBRUARY 2010

PHOTOGRAPH OF JESSICA BIEL BY MARIO TESTINO

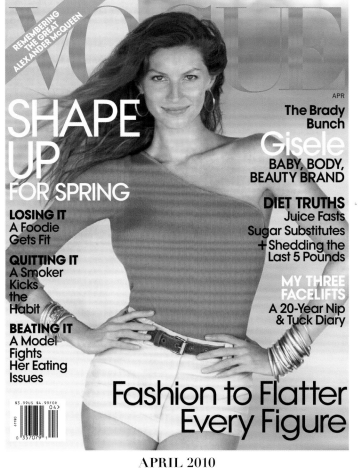

APRIL 2010

PHOTOGRAPH OF GISELE BÜNDCHEN BY PATRICK DEMARCHELIER

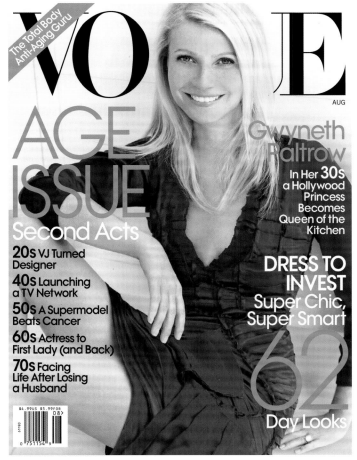

AUGUST 2010

PHOTOGRAPH OF GWYNETH PALTROW BY MARIO TESTINO

269

INDEX

ACKNOWLEDGMENTS

THANKS ALL AROUND to the brilliant editorial, design, and production team that brings this book to a coffee table near you . . . to *Vogue*'s Laurie Jones for her editorial acumen and Christiane Mack and David Byars for their development and production expertise . . . to Raúl Martinez for his endlessly imaginative layout . . . to Nobi Kashiwagi, Martin Hoops, Bonnie Shelden, Michelle Van Alstyne, Jason Roe, Sara Hall, Desirée Rosario-Moodie, Veronica Gledhill, Allison Brown, and Pierre Tardif for making it happen . . . to Antonina Jedrzejczak and Louise McCready for their unflagging and highly creative research . . . to Andrew Avery, Chris Donnellan, Noah Rosen, and Lee Gross in the Condé Nast permissions department, Shawn Waldron in the archives, and Cynthia Cathcart in the library . . . to Joyce Rubin, Caroline Kirk, Mimi Vu, Diego Hadis, Susan Sedman, and Pamela Vu for expert copy editing and fact-checking (i.e., correcting all my mistakes in the nick of time) . . . to Hamish Bowles for his warmly personal foreword . . . extra-special thanks to Valerie Steiker, my clear-eyed editor, for helping to shape 120 years of *Vogue* history into what we hope is readable prose . . . to Andrew Bolton, of the Metropolitan Museum's Costume Institute, for his historical and cultural insights . . . to my literary agents, Andrew Wylie and Jeffrey Posternak . . . to my husband, Calvin Tomkins, who is part of everything I do . . . and to Anna Wintour, the presiding genius who is the essence of contemporary *Vogue*. Finally, three heartfelt cheers to all the models and muses who inspired *Vogue*'s covers, and to the illustrators, photographers, art directors, and editors in chief who brought them to life.

—DODIE KAZANJIAN